THE HISTORY OF SURREALISM

THE HISTORY

BY MAURICE

TRANSLATED FROM THE

WITH AN INTRODUCTION BY

OF SURREALISM
NADEAU

FRENCH BY RICHARD HOWARD

ROGER SHATTUCK

THE BELKNAP PRESS OF HARVARD UNIVERSITY PRESS
CAMBRIDGE, MASSACHUSETTS 1989

Note to the 1989 Edition © 1989 by the President and Fellows of Harvard College
All rights reserved
Printed in the United States of America
10 9 8 7 6 5 4 3 2 1

This Harvard University Press paperback reprints Macmillan's edition of *The History of Surrealism*, © 1965 by The Macmillan Company, and is published by arrangement with Editions du Seuil, publisher of the French edition, *Histoire du Surréalisme*, © Editions du Seuil 1944, 1970.

Library of Congress Cataloging-in-Publication Data

Nadeau, Maurice.
 [Histoire du surréalisme. English]
 The history of surrealism / by Maurice Nadeau ; translated from
 the French by Richard Howard ; with an introduction by Roger
 Shattuck.
 p. cm.
 Translation of: Histoire du surréalisme.
 Bibliography: p.
 Includes index.
 ISBN 0-674-40345-2
 1. Surrealism—History. 2. Arts. Modern—20th century—History.
 I. Title.
NX456.5.S8N313 1989 88-39354
709'.04'063—dc19 CIP

CONTENTS

ILLUSTRATIONS

Giorgio di Chirico—*The Great Metaphysician.*

Marcel Duchamp—*To be looked at with one eye, close to for almost an hour.*

Marcel Duchamp—*Monte Carlo Share.*

Francis Picabia—*Dada Movement, Chart.*

Jean Arp—*Automatic Drawing.*

Max Ernst—*Woman, Old Man, and Flower (Weib, Greis, und Blume).*

Max Ernst—*Two Sisters.*

Max Ernst—*Birds above the Forest.*

Max Ernst—*Nature at Daybreak.*

Yves Tanguy—*Mama, Papa Is Wounded.*

René Magritte—*Souvenir de Voyage.*

Salvador Dali—Illustration (etching) for *Les Chants de Maldoror* by Lautréamont.

NOTE TO THE 1989 EDITION

THE fortunes of Surrealism have risen and fallen several times since the movement created and named itself in 1924, since Maurice Nadeau published a two-volume documented history of the movement in 1944, and even since I attached my rhapsodic introduction to its one-volume American translation in 1965. Barely thirty, Nadeau worked with sympathy, discrimination, and remarkable even-handedness toward persons and ideological quarrels. The long shelf of studies now available on Surrealism has not seriously modified the shape of events Nadeau proposed in his succinct account. *The History of Surrealism* remains the most appropriate book to read first on the subject.

For this reprint of the 1965 edition a few comments will help a contemporary reader. Nadeau does not discuss and I barely mention the most notorious and successful avant-garde movement in pre–World War I Europe: Futurism. Organized like an international political campaign with street demonstrations, press conferences, public meetings, poster manifestos, and leaflets, Futurism seemed to offer artists a new role in a belligerent social revolution. In 1916 two incorrigible pacifists launched Dada in a Zurich cabaret: Hugo Ball, an anarchist actor and piano player from Munich, and Jean Arp, a painter-poet from Strasbourg. Their good-humored antics were gradually eclipsed by the bellicose spirit of Futurism in the person of Tristan Tzara. The Roumanian draft-dodger admired and envied Filippo Marinetti, the Italian organizer and star of Futurism, more than any other contemporary figure. Undiminished by the war and the Soviet revolution, the Futurist model also affected the way the Surrealists set up shop in 1924. They did not wait for journalists to identify the group and find a name for it, as happened with the Cubists. The Surrealists drew up their own program and wrote their own publicity.

9

Several essays in *The Innocent Eye* (Washington Square Press, 1984) extend what I say in the following introduction. "The D-S Expedition" in particular identifies what I now believe to be the most important single observation about Surrealism. For a short incandescent period at the start, the writers and artists who formed the Surrealist movement attempted to reject art as an activity worthy of their time and attention. In their manifestos and in early numbers of *The Surrealist Revolution* they excoriated the novel as a trivial undertaking and doubted the status of painting. Automatic writing, dream narratives, collages and frottages, *cadavres-exquis*— these new genres and techniques aimed at avoiding not only the traditional categories but also the very notion of art. The fact that the techniques have now all been incorporated into new chapters of art and literary history should not make us forget that Marcel Duchamp made a great show of abandoning painting for chess and *objets trouvés* and that André Breton said, "I write in order to discover friends." The extended walking tours through the streets of Paris that the Surrealists improvised and then wrote about and the elaborate mock trials they staged are significant efforts to usurp the category of the aesthetic. In its place would reign Surreality, the marvelous.

But what could a swollen population of avant-garde artists and writers do to justify their lives without art? Part of Breton's genius consisted in finding other avenues. The Surrealist group engaged in a form of utopian political agitation that refused Communist Party directives, in scientific investigations of mind and social behavior coordinated by the short-lived Surrealist Research Bureau, and in raids on the spiritual in the form of trances, the occult, and magic. Despite the lameness of many of these projects, they demonstrated how hard it is to eliminate the realm of art. It's like getting rid of witch grass: it grows back everywhere. If nothing is art, then "the whole world is art," as Arp innocently observed. Since whenever human beings invented the notion of art, successive attempts have been made to subordinate it to the state, to religious orthodoxy, and to the taste of a patron. But even the fanatics of the iconoclastic controversy sought to repress only certain kinds of religious images. The aborted anti-art project of the D-S expedition demonstrates how completely the category of the aesthetic has permeated our cultural life. And by an inevitable irony many of the Surrealists' unruly works have earned an important place in the realm of art. The story is as instructive as it is entertaining.

ROGER SHATTUCK

LOVE AND LAUGHTER: SURREALISM REAPPRAISED

I

AFTER the Great Peace in Europe, nearly half a century of it, the Great War laid bare the purblind self-interest lodged at the core of Western civilization. The twin institutions of capitalism and the nation state had divided the continent against itself in the tricky game of alliances, and finally marched everybody off singing into the bloodiest conflict in history. No one believed it possible; yet there was no alternative. (We have not yet buried that reasoning.) Then, after the Great War came the Great Shock —a profound organic reaction that convulsed the entire system with vomiting, manic attacks, and semicollapse. The situation was so serious that the powerful serum of prosperity had to be administered to revive the patient. In such cases one does not talk of cure.

One of the major symptoms of that Great Shock was the enlargement and partial extrusion of an already existing growth called the avant-garde. For a time, while Paris newspapers tried to maintain a conspiracy of silence toward the young upstarts, the growth was believed to be malignant; in the Twenties and Thirties one encounters scattered attempts to remove the tumor by public reproof and prison sentences. Our common assumption today that the formation was benign after all and has been reabsorbed into the organism still needs to be examined and justified. Did the culture capers of the Twenties have the healthy effect of catharsis? Have we sublimated those urges into new art forms and social expressions? Or were they merely ineffectual and harmless? A

11

new round of histories, studies, editions, and exhibits of Dada and surrealist works all over the world makes it not easier but harder than ever to find a straight answer.

The current accepted usage of "surrealist" to designate something crazy, dreamlike, and funny strikes surprisingly close to the truth. The public carries the vague image of a widespread artistic hoax that embraced truly depraved mental tendencies and went on to shout and swagger its way into a successful snob cult. In recent years we have been more troubled than amused to see the whole bag of tricks spill over easily into the advertising culture and to watch the aging participants stand up and call one another's bluff. In stricter and safer usage, surrealism refers to literary-artistic activity that centered in Paris in the Twenties and profoundly affected two generations of poets and painters in Europe. Beyond this point, any concurrence of opinion on the nature and significance of surrealism goes to pieces. Ex-members and competent critics cannot agree even whether the movement was essentially pessimistic or optimistic in the face of decaying values; whether it represented a brilliantly planned fraud designed to promote the interests of its leaders or a courageous attempt to reach a higher level of sincerity on which to start living all over again; and whether it deserves a significant place in modern intellectual history or should dwindle into a mere blip on the graph of literary currents. I happen to believe that real importance attaches to the estimate we now make of surrealism. Like progressive education and pacifism, it lies close to the center of our immediate heritage; we ignore those matters at our own peril. To form any sound opinion of surrealism, we must pick our way through a thick haze of theory, social campaigning, and cultural propaganda (much of it fascinating) before reaching its lasting contribution to the arts.

The membership likes to represent the founding of the movement as a galactic event similar to those cited to explain the formation of solar systems. From Switzerland, from Germany, from New York, from Spain, from the near and distant spaces of literary history, a collection of supercharged particles converged at high speed on Paris around 1920. There they fused and spun and split in an intense period of some five years until the ex-

plosion moved powerfully outward again, scattering its energies in all directions and imposing a new arrangement upon everything that lay in the path of its shock waves. Of course, no such cosmic event ever took place outside the minds of a few zealots. But it is true that surrealism reverberated more deeply and widely than any movement since symbolism. The question is: Why?

In its sixty-year international exposition of the arts since *la belle époque*, Paris has welcomed post-impressionism, fauvism, futurism, cubism, Dada, surrealism, expressionism, existentialism, and many more schools. Yet it is high time we perceive the remarkably clear line that connects the impish figure of Alfred Jarry in 1896, calmly saying *merdre* (shite) to bourgeois culture, with Albert Camus, the impassioned humanist who wanted to bring all the black sheep back into the fold. In Europe a fierce debate still smolders about who started it all. Were the Dada activities of 1916 in Zurich, New York, and Barcelona the origins of postwar protest and subversion? Had Jarry and Guillaume Apollinaire and the futurists set it all in motion many years earlier? It would be nice to know, but these discussions should not distract us from observing what is slowly coming into sight: a sustained artistic adventure extending from 1885 to 1939 and reaching a paroxysm of public demonstration in the Twenties. The name, "Age of Surrealism," has already been proposed for the years between wars, and there is some basis for picking surrealism as the epitome of the artistic schools. It lasted longer than the others, attracted (and repelled) a great variety of talent, pounded its drums loud and long, and spread its roots into philosophy, science, and social action.

In my book *The Banquet Years* I examined the origins of the avant-garde in France in the light of several central characteristics: the cult of childhood, humor as a major discipline, direct use of unconscious and dream materials, acknowledgment of the essential ambiguity of experience, and the unpolished style ot juxtaposition that suited those preoccupations. In order to see the modernist movement whole, as a development reaching at least up to existentialism and possibly as far as the *nouveau roman*, three items at least should be added. The ancient problem of

identity and non-being comes more and more to the fore in sur-
realist prospecting of the unconscious and in Sartre's circular self
of the *pour-soi*. The problem of the artist's social commitment has
reasserted itself with a vengeance after the nineteenth century par-
tial retreat to art for art's sake. And, following long official banish-
ment, pure chance has won its way back into the repertory of
compositional techniques. I think we can regard the past eighty
or so years in the arts, particularly in France, not as a series of
islands with names ending in *ism*, but as forming a still little-
explored continent whose jagged coast line we have begun to
leave astern without knowing whether the land is habitable. In
particular we have never established the topography and re-
sources of the promontory called surrealism around which we
were sailing for so many years.

II

*Surrealism was not a literary school.
It was above all a common ground and
meeting place for young petit-bour-
geois intellectuals particularly aware
of the futility of every activity ex-
pected of them by their background
and their era.*

(ROGER VAILLAND, *Le Surréalisme
contre la révolution*)

Roger Vailland's observations are accurate except for the first
sentence. Surrealism was one of the most highly disciplined and
tightly organized artistic schools that ever existed. The first
tremors occurred in the form of a series of encounters between
individual writers and painters during the First World War:
André Breton and Jacques Vaché in a mental hospital in Nantes;
Marcel Duchamp and Francis Picabia in New York; Tristan
Tzara and Richard Huelsenbeck and Hans Arp in Zurich. When
they all reached Paris around 1919, the superinduced yet effective
high jinks of Dada opened with the blessings of established
writers like Paul Valéry and André Gide and Jacques Rivière.
The easiest way to follow the splintered course of Dada into

surrealism and its vagaries is in the published reviews and in the manifestos with which they punctuated their progress from time to time. The wildest gestures never shake free of troublesome self-consciousness, for both groups were highly aware of not wanting to crash literary history as just another school, and of being engaged in activities that would carry them to exactly that civilized fate. For better or for worse, almost every curse and obscenity was recorded. The review *Littérature* founded by Aragon, Breton, and Soupault in March 1919 remained a sober and even distinguished publication for some six months before it began to feel its oats. From 1920 to 1922 the "construction of the ruins" by Dada demolition teams existed side by side with an increasingly ambitious attempt to find new channels for the creative mind in dream states. The celebrated disputes and polemics of 1921 over the proposed "International Congress for the Determination of the Directives and the Defense of the Modern Spirit" widened the split in the Dada group. Three years later surrealism found its name, declared its intentions in the First Manifesto, founded a "Surrealist Research Bureau," and set out under shared leadership, with Breton rapidly taking moral and executive control. (Before long he had earned the unofficial title of Pope of Surrealism.)

The external and internal history of surrealism from here on throws up a series of personal quarrels, experiments, fruitful collaborations, corporate decisions, posturings, mutual backscratching, and incidents of minor gangsterism, of which the written accounts give only a muted version. All this is nothing new in the history of French artistic movements. But the constant crossfire should not obscure the fact that the surrealists formed the first important group of artists since the Romantics to attempt political action in order to improve society. Here lies the basic cause of many disputes from about 1925, when the first temptation was felt to join the Communist Party, until the early Thirties, when Breton carried a slightly dwindled group out of reach of the party. The years between had put the surrealists in the curious position of entering the party at the moment of its greatest intellectual slackness. The cream of its membership had just defected as Trotskyites, and not until the early Thirties under Thorez

did the Communists again display real concern with culture and the intellectuals. The uneasy period of "collaboration" between 1927 and 1935, in which the surrealists yielded little of their independence of action and proved unassimilable in any local cell, was also the period of their most active literary and artistic production. They wished to "change life" as Rimbaud had declared, but they could not stop producing literary works as well. The highly successful international surrealist exhibition in 1938, instead of preparing a new departure for the group and significant political association with Trotskyism, now appears to mark the end of the movement proper. Granted, the aftermath has been singularly lively. But since 1939 it is the shadow of surrealism that has been lengthening, not its stature.

Not because anyone can at last set the record straight, but rather because certain events, even in seriously conflicting versions, divulge a good deal about the integrity and audacity of surrealism, I should like to examine two *causes célèbres* that involve leaders of the group. Around 1920 when the future surrealists were still demonstrating happily with the Dada group, they gathered frequently in a café called the Certá near the Opéra. Toward the end of one meeting they discovered that the waiter had forgotten his wallet, containing the day's tips, on a bench close by. As was inevitable in that era of gratuitous acts and against-the-grain behavior, they filched the wallet, carried it off to another café, and argued violently over whether they could practice their liberated morality at the expense of a poor hardworking waiter. Principles were at stake. Finally Paul Eluard was appointed to keep the wallet until a final decision could be reached the following day. On his own initiative Eluard returned it anonymously to the waiter. At the next meeting everyone attacked him bitterly for having acted without a collective decision and turned his back on the new morality. At least so Georges Ribémont-Dessaignes tells it. But the first appearance of his version (*Nouvelle Revue Française*, July 1931) provoked four excoriating replies: from Louis Aragon (who signed "salutations communistes"), Guiseppe Ungaretti (who added the expletive "fascist" after his signature), Tzara (who rejected the entire article as a distortion), and Éluard. He maintained that the

facts were completely different: he had originally stolen the wallet from a priest, brought his booty to the Certá so that the group could consider his action, and following the discussion presented the priest's wallet to the waiter as a deserving beneficiary. Many later accounts quote the Ribémont-Dessaignes version as accurate and show no knowledge of Éluard's rebuttal. It did not require too much courage to call Paul Claudel and the Prefect of Police and the French Army foul names in print; stealing a trivial sum from a waiter in one's habitual café tests a more sensitive set of reflexes and scruples. Such a gratuitous act surely does violence to our selves and our souls. Yet should we believe Eluard and see the incident as a charitable prank in the tradition of Robin Hood and his merry men? As soon as one pursues some of these anecdotes beyond the accepted version, one touches troubled individuals vacillating before decisions they have forced upon themselves. Matthew Josephson, in his lively book of gossip, *Life Among the Surrealists*, makes a good number of revelations between the lines about the way the surrealists sustained their honor. They seemed to put themselves on a perpetual dare. Yet Josephson concludes a few pages describing "dapper dans" like Aragon and Philippe Soupault by exclaiming over their simple humanity. "Sometimes we even played tennis!"

A far more publicized event concerns the prolonged gymnastics that finally carried Aragon, one of its staunchest spirits, out of the surrealist group. In 1930 he traveled to Moscow and there signed documents and made statements that clearly compromised his former views on morality and psychoanalysis. Aragon also composed *Red Front* (see page 285), a shrill polemic poem attacking the bourgeois regime in France and calling for assassination as the proper response to repression. On returning to Paris he turned his coat once again, reaffirmed his surrealist convictions, and accepted the loyal support of Breton who was circulating a petition in defense of *Red Front*. The government finally dropped its charge of incitement to assassination against Aragon. Then, within a few months, he did a third about-face and joined the Communists to stay. In his volume of *Interviews*, Breton takes a surprisingly magnanimous position on "The Aragon affair" (see page 175) by suggesting that the two prime motives

for Aragon's trip to Russia were not really political. He had just fallen under the spell of the Russian woman who was to become his wife, Elsa Triolet, Mayakovski's sister-in-law. Furthermore, Breton points out, a fellow surrealist, Georges Sadoul, anxious to flee France so as to escape a three-year prison sentence for sedition, urged Aragon to accept Elsa Triolet's suggestion that the three of them go to Russia. Roger Garaudy, Aragon's semiofficial biographer, approaches the same events by speaking of "the contradiction he carried within him"—namely between dialectic materialism and surrealist idealism. The ensuing events, with their unaccountable zigzags from one side of the street to the other, convince Garaudy of the profound moral crisis Aragon was undergoing at the time. In referring to the affair in one of his essays, Jean-Paul Sartre lights on Breton's defense of *Red Front* as the most revealing aspect of the whole story. (Breton's petition declares Aragon not personally answerable to the penal code, because a poet is merely the "objective interpreter" of the struggle around him. Sartre dismisses that defense of what he considers a probably inflammatory work written by a responsible person.) So we wade into the events with little certainty of what truly happened and having to pick our significances with the utmost care. And we wonder if we will ever strike a clear principle or theme that guided the movement through twenty years of complex evolution.

III

For a long time I have felt the need to distinguish two contrasting ways of grasping experience. On the one hand, a deep-seated continuity appears to link all things and all events and to lend them a significance that provokes our wonder. Whether this continuity is seen as material or ideal, magical or rational, it fills us with a sense of being able to reckon with life; we shall always be able finally to relate one segment to another if we possess the patience and the insight and the energy to enter fully into the world within our reach. On the other hand, we frequently reach the point at which the routine, falsity, and injustice of life inflict on us a feeling of senselessness; things happen without any

evident explanation beyond mechanical temporal sequence. In this vision of the world no meaning attaches to events and things, and any effort at insight or sympathy ends in despair. To fill the void we may assign arbitrary meanings to familiar objects and actions, but such meanings shrivel up and die under our very eyes. Life never holds its savor. In the first view, everything has significance; the world is filled and its parts held in place by connections. (Leonardo said he could literally see them, "lines crossing and interweaving.") In the second view, nothing has structure or significance; the world barely holds its own against collapse.

Radical as this distinction may appear, it will be very hard to keep it in sight. A few examples will first still, then trouble the waters. In their very massiveness, the fully fleshed-out universes of Dickens and Balzac represent the first vision of life; even a vast conspiracy of opposing forces gives substance and excitement to the hero's struggle to establish himself. The word I would plant here as incorporating this attitude toward life is *destiny:* a sense of personal fulfillment (or failure) in an arena of events where one earns one's place. Now consider the vastly different medium of, say, Louis-Ferdinand Céline's *Voyage to the End of Night* or Camus' *Stranger* or Franz Kafka's *The Trial.* They narrate (though it may not at first appear so) just as great a quantity of occurrences, but with no sense of their accumulating into a personal destiny, a meaningful life. The word that belongs here is *chance:* blind accident working as the minimal propulsive force between one instant and the next but never bestowing meaning on happenings thus touched off. But too clean a discrimination here unsettles us. I should contend that our current usage of the word *fate* (with its quirks, its ironies, and its justice) retains both these meanings. We usually leave the ambiguity undisturbed because *we sense* that it belongs.[1]

The precariousness of my original distinction is by now evident. Either one of these attitudes remains in danger of flipping over

[1] We also use the word *lot* in this sense. "My lot in life" implies a destiny determined by a game of chance. A few hours after writing the above lines I stumbled across this sentence in Henry Miller's *The Wisdom of the Heart:* "I mention this only as an example of the strange fatality by which two men of kindred spirit are brought together."

into its opposite. In fact a plausible definition of art consists in saying that it is an extraction of one out of the other: Baudelaire distilling flowers from evil, Dostoevsky finding despair in the deepest impulses of charity and love. Nevertheless we would do well to hold onto the distinction as forming something like the grain of experience. Most of us are disposed to regard one of these two directions as the true one, just as in any reciprocal action, like that of a piston or eyes reading a page or a comb arranging hair, one movement does the work and the return movement prepares a new stroke. Thus we usually assimilate and store experience so that it shows a grain and a direction pointing toward meaningful destiny or empty accident. The genius of artists we call classic, like Homer and Shakespeare, is to have worked so deep into the fabric of life as to expose both directions. They make us feel blind chance dogging conscious effort at every turn.

It is in this perspective, I believe, that we can make some sense of surrealism without distorting it. For one of the few values that remained at the center of surrealist thinking was "objective chance," or more loosely, coincidence. Poets have always lingered over accidents, chance occurrences, whims, and hunches, moments that appear to break the pattern of events. Their anomalous randomness deprives them of meaning, yet their singularity fills them with heightened significance and even ominousness.

You are driving slowly at night up the ramp of an elevated highway in a Texas town, recalling with amusement a letter in which a friend inquired how local customs have survived in the "Wild West." A huge luminous shape materializes against the black sky and suddenly looms up right next to the car. A harsh scraping noise reaches you from all directions at once. The moving mass of colors comes into focus as a giant cowboy in full regalia; he whirls, draws, and fires a rapid burst from his pistol point blank at the car and disappears. A child in the back of the car screams and hides its head; an older child observes calmly, "Let's park right here and watch the rest of it." And as you swing onto the thruway, the screen shows a wide arid plain in the middle of which two horsemen are raising plumes of dust as they whip their horses into a seemingly motionless and silent chase.

You start up from a catnap in your chair with a sentence etched in your mind. A hairspring of motivation leads you to note it

down before it fades: "Laughing incidentals of hoarhound drops plumped for the king."

The opening night of Apollinaire's *Couleur du Temps*, at the Conservatoire Renée Maubel, while I was talking in the balcony with Picasso, a young man came up to me, mumbled a few words, and finally blurted out that he had taken me for one of his friends reported killed in the action. Naturally, we let it go at that. A while later, through Jean Paulhan, I began corresponding with Paul Éluard without our having the slightest idea of one another's physical appearance. He came to see me during one of his furloughs: he is the person who approached me during Apollinaire's play.

(ANDRÉ BRETON, *Nadja*)

What significance, if any, should we attach to such occasions? Normally we dismiss them, laugh them off, or at most mention them to a friend as a curiosity and then forget them. The tiny epiphany of involuntary memory around which Proust spun out the three thousand pages of his novel bears a considerable resemblance to these occurrences. The difference is, he did not dismiss it but faced around and entered it like a secret opening in the fabric of ordinary experience. The surrealists went even further. Driven by extreme inquisitiveness and self-imposed daring, they dropped everything else and affirmed these moments as the only true reality, as expressive of both the randomness and the hidden order that surrounds us.

Thus *surreality*. In his book of *Interviews* Breton states flatly that objective chance ("which is nothing else than the geometric locus of these coincidences" and whose importance he tracks down in Engels' writing) constitutes "the problem of problems" because it embodies the relationship of necessity and freedom. To create a life entirely made up of such startling coincidences would be to attain surreality. And that appears to be exactly what Soupault was attempting in his behavior during the early days: to induce coincidences. He asked people at random in the street where Soupault lived, proposed that everybody switch drinks in the cafés he entered, opened his umbrella on sunny days, and offered to escort the first attractive woman that came along. In an era of the long hangover, there remains something not only courageous but even touching in this effort to draw out objective chance, the most reticent of creatures. Most surrealist narratives like Aragon's

Le Paysan de Paris and Breton's *Nadja* (oftened mistermed "novels") simply relate a quest for reality and freedom in coincidence without any effort to transpose the quotidian into fiction. Apollinaire's mysterious wanderings into neglected quarters of Paris set a precedent for this "automatic life." Any illumination of Giorgio di Chirico's or René Magritte's painting must begin in this realm of casual fatality.

Unfortunately, most accounts of surrealism have accepted as authoritative Breton's grandiloquent pronouncement that opens the Second Manifesto; it gives a far more transcendental ring to surreality than what I have described or than the handy "definitions" released in the First Manifesto. The surrealists, Breton states in the later document, strive to attain a "mental vantage point *(point de l'esprit)* from which life and death, the real and the imaginary, past and future, communicable and incommunicable, high and low, will no longer be perceived as contradictories." The Pope, even speaking *ex cathedra,* can be misleading. What finally comes clear when one examines both the extended antics of the outward movement and the significant works of poetry and painting, is that the contradictions have been accepted and exploited, much as in contemporary music previously forbidden intervals have emerged as the basis of a new harmony. The excitement of the surrealist object or work is its attempt, not to obliterate or climb higher than the big contradictions, but to stand firmly upon them as the surest ground. "Reality," writes Aragon at the close of *Le Paysan de Paris,* "is the apparent absence of contradiction. The marvelous is the eruption of contradiction within the real." He is not writing gibberish, nor has he dressed things up for a manifesto. He and his friends were indeed trying to juggle chance and destiny, passive automatism and active revolution, optimistic faith in man's future and pessimistic doubt over the disasters of civilization, the conviction that "life lies right here" and the conviction that "life lies elsewhere," the marvelous and the absurd. The experiment was keeping them all in the air, not scaling the heights to reach a master synthesis of all such values; our misunderstanding has prevented us from absorbing the true lesson of surrealism and from moving beyond it. Little wonder that it has become

one of the hardest lessons to present in the institutionalized arena of higher education in the United States. Because of an imposing terminology and a certain high seriousness, existentialism has already been coupled to the other coaches of intellectual history, whereas surrealism has been left behind, waving its arms frantically at the disappearing train. Yet we cannot afford this mistake. Surrealism, inheriting a long tradition of underground thought, embodies an insight into the impossibility of life as we have created it for ourselves and the beginnings of a worthwhile criticism of that life.

Three favorite surrealist metaphors are particularly apt as expressions of the disequilibrium and latent pressure with which we increasingly live. All three belong to physics: *interference,* the reinforcement and canceling out that results from crossing different wave lenghts; the *short circuit,* the dangerous and dramatic breaching of a current of energy; and *communicating vessels,* that register barely visible or magnified responses among tenuously connected containers. In other words, the ingredients and forces of life intermingle in more ways than we know, and here Freud is the phophet not only with his *The Interpretation of Dreams* but equally with *The Psychopathology of Everyday Life* and *Wit and Its Relation to the Unconscious.*

The surrealists emphatically did not achieve any "mental vantage point" or synthesis to dissolve the contradictions they wallowed in; their accomplishment took another direction. They found a middle term, or rather two middle terms. In contemporary science, as profoundly challenged as surrealism by the conflict between chance and determinism in the universe, the magic wand of probability has held things together. Without the statistical formulations of wave mechanics, quantum physicists would have to maintain two legal domiciles supporting indeterminate particles and lawful waves. Camus' famous consignment of surrealism to the trash can in *The Rebel* implies that the movement went to pieces because of a similar dilemma: "Breton wanted both love and revolution at the same time; but they are incompatible." Camus has picked his terms injudiciously, however, for the opposition lies off to one side. The surrealists did set out in search of both revolution and dream, social action and the unconscious,

and indeed these goals come close to being incompatible. But *love*, most perennial of myths, and with it *humor*, the anti-myth, formed a middle ground from which they produced their most genuine and imaginative works. Any major painting by Max Ernst bears witness.

Now, a few public pronouncements and gestures linking sexual freedom with social revolution, plus juicy titles like Aragon's *Le Libertinage* and Breton's *L'Amour fou*, could lead to the conclusion that "love" in the surrealist vocabulary refers to a fleeting and not a lasting union between two individuals. But any responsible generalization would have to affirm the opposite view. Those two books, for example, explore a realm quite remote from uninterrupted erotic adventure. Both alternate between semi-philosophical reflection and everyday actions that seek to transcend the chance encounter. Breton reached the point of quoting both Engels and Freud in support of the institution of monogamy as the form in which love will make its truest contribution to "moral as well as cultural progress." (In *Arcane 17* he eloquently defended his own advocacy of "love in the form of an exclusive passion.") Aragon went on to celebrate a single woman, his wife Elsa; for years Éluard identified poetic inspiration with his wife, Gala.

> She is standing on my eyelids
> Her hair mingles with mine
> She has the contour of my fingers
> She has the color of my eyes
> She sinks into my shadow
> Like a pebble against the sky
> (Capitale de la Douleur)

Against the background of misogyny, homosexuality, Don Juanism, and masculine confraternalism that formed part of the heritage from decadence and symbolism, the surrealist group takes on the status of modern troubadors. Their love poetry earns the comparison. Yet it is worth remembering that they reached this personal conviction while at the same time advocating a total sexual liberation. For they defended Charlie Chaplin's loves, gave serious attention to Sade as critic of human be-

havior, and published in surrealist reviews outspoken opinions and documents on all aspects of sex. The point is this, however. Much more than in any "mental vantage point," they found in passionate devotion to a single woman over a long period of time the surest means of liberating desire. And for "desire" read "imagination." They wished to release the imagination as completely as Lautréamont had done in conceiving the still unsurpassed surrealist image applied to his Englishman hero: "He is as handsome . . . as the fortuitous encounter on a dissecting table of a sewing machine and an umbrella." Amazingly enough, that kind of imagination, kindled in the house of love, brought back to poetry the long lost figure of woman as embodiment of magic powers, creature of grace and promise, always close in her sensibility and behavior to the two sacred worlds of childhood and madness. The cult of the mythical woman, foreign as it may be to some contemporary readers, lies at the heart of the surrealist credo. Not inappropriately Benjamin Péret, one of the most aggressive and unwavering surrealists, has edited an *Anthology of Sublime Love*.

Lautrémont's same violent image stakes out the other middle ground cleared and actively cultivated by nearly all the surrealists. "Laughter," wrote Jarry, "is born out of the discovery of the contradictory." Behind their growls and screams, the devotees of Dada were laughing; that saved them.[2] In the work of Soupault, Max Ernst, Robert Desnos, Picabia, Duchamp, Benjamin Péret, Jacques Prévert, and Salvador Dali, the contradictions and incompatibilities of experience lead straight toward laughter. Even the gentle Éluard composed "proverbs" with Péret: "Beat your mother while she's still young." "One good mistress deserves another." No surrealist wrote a tragedy; the suicides of Vaché, Rigaut, and Crevel should be seen as attempted affirmations. It is the massive, stentorian style of Breton that has deflected attention from the delight these poets and painters took in the bizarre inconsistencies of life. Years later Breton ponderously redeemed

[2] Jacques Vaché, experimental dandy and patron saint of both Dada and surrealism, stammered out a bleak definition of "umor" (sic): "I believe it's a feeling—I almost said sense—and that too—of the theatrical uselessness (and no joy there) of everything. *When you know*." (*Lettres de Guerre*)

his own ponderousness by compiling the *Anthology of Black Humor,* a remarkable attempt to establish a new canon of literary greatness. (Without the surrealists, the reputations of Rimbaud, Lautréamont, and Jarry would be considerably dimmer than they are today.) Since it is often sardonic or fleeting, surrealist laughter tends to escape us and we remember only the catcalls that accompanied the theatrics. But particularly in painting and experimental collaborations, a spirit of delight keeps breaking through the pretense.

The two domains, then, to which surrealism made a lasting contribution are love and laughter. Other activities of the group look less important now. The lengthy flirtation with the Communist Party makes an absorbing story for anyone concerned with the temptations and delusions of the literary species. My own opinion is that the surrealists, both as individuals and as a group, came off fairly well in their ultimately abortive attempt to keep their freedom of action and at the same time to participate in a centrally organized revolutionary party answerable to Moscow. For Breton, Communism remained an ideological step he argued himself into taking and which immediately led into a dead end; he scrambled out as fast as he could. Aragon I cannot fully understand—whether he became Communist out of opportunism, in an attempt to mock all his friends and enemies, or under the spell of Elsa Triolet. Éluard slithered about in many directions and allowed himself to be used, but politics rarely tainted the inspiration of his poetry. "The time has come," he says in the first sentence of *Poetic Evidence,* "when poets have the right and duty to maintain that they are deeply involved in other lives, in the common life." Yet his poetry remains intimate and often private. Outside of a few manifestos and inflammatory public letters, the political turmoil and conscience-searching have lost their urgency for us.

I am inclined to think that the techniques of composition tried out or refurbished by the surrealists served a reasonable purpose, though not the one they put forward. Automatic writing, collaborations, experiments with random assemblages, simulations of paranoid states, dream journals, party games—all these means shoveled out into the open a vast quantity of raw material that is

still being picked over. It was a useful mistake to believe that these materials were worth publishing or exhibiting *tel quel*. Without them surrealism could never have commanded so much attention, but most of those unretouched works relied on a shock of surprise that perished in monotony or obscure topicality. I wonder if in our age automatic writing and similar techniques do not fill the role of the great public contests in declaiming improvised verse, which in earlier eras associated artistic creation with physical prowess and produced a trickle of good literature on the side.

Something of a problem presents itself in the form of books like *Nadja* and *Paysan de Paris*. Both are direct personal accounts of a short period spent in pursuit of "surreality," plus lengthy reflections on the very meager events reported. Their frankness and the occasional power of the prose make up for the desultory form and the unblinking egoism of every page. But they fall about halfway between purely experimental writing and exposition. *Nadja* particularly begs for thorough interpretation and analysis. The narrative has been authenticated as the unretouched story of Breton's chance encounter with a strangely alluring and unpredictable young woman who drew him into a long exploration of her identity and his own. Together they brave a series of coincidences, or "traps," or "reference points" *(repères)*, or "signals," that alert Breton to the heavy significance of their friendship. In a remarkable piece of surrealist legerdemain masked under shifty syntax, Breton implies that he discovers in Nadja his familiar spirit, an intercessor with whom he finally identifies himself at the moment she vacates her personality to enter an asylum. The scene in which Nadja looks up at an unknown window and predicts, correctly, that in a moment it will light up, illustrates the mystery-story element in such an oblique account of existence. (See page 272.) Despite an overextended and ungainly opening, *Nadja* offers one of the most accessible entries into the surrealist state of mind.

The most acute criticism of that state of mind has come from a not unexpected quarter. In a dozen pages toward the end of *What is Literature?*, and also in a lengthy footnote answering the controversy stirred up when that text appeared in *Les Temps*

Modernes, Sartre slashes swiftly through to the evident dilemma of surrealism. If one establishes the supreme authority of automatism and reduces the individual consciousness to (in Breton's words) "a modest recording device" for unconscious or collective experiences, the mind has then lost its integrity and merely yields to forces outside itself. Sartre refers to the "surrealist quietism" that obliterates all categories of opposition and choice which render individual action possible. Yet the surrealists passionately asserted their individuality, social responsibility, and revolutionary activism. Sartre goes on to attack this "confusion" by describing the surrealist position as a foundered synthesis, a "flickering" or "flitting" between these opposed points of view, with "objective chance" providing a "magic unity" that leaves mind undefined. The passage displays Sartre's muscular grasp of a debate and his remarkable powers of deflation. But let us not be too quickly put off by his polemical vocabulary. "Flickering" is not at all a bad word to describe the behavior of a mind intent on registering a wide range of experience, a mind seeking both to be itself and to put itself in communication with other minds or forces.[3] In fact when Sartre falls back on words like "surpass" in these pages, the surrealist concept of mind begins to sound a good deal like the writhings of Sartre's own *pour-soi* to achieve consciousness of being what it no longer is. The great difference—and Sartre leads us away in an entirely different direction as if he did not want us to notice—is that surrealism holds at all costs to the possibility of communion between minds, between persons, with forces outside us. Love thus claims its central role. Sartre, on the other hand, seems to force himself to portray the illusory or destructive nature of all relationships.

[3] An even richer term, "turbulence," has been appropriated by William Arrowsmith to desribe how classic Greek theater incorporated in its characters, structure, action, morality, and ideas "the actual disorder of experience." (*See Tulane Drama Review,* March 1959 and *Arion,* Autumn 1963.) The surrealists were nobody's Greeks, but "turbulence" describes the medium in which they lived and created. The fact that these writers produced no important stage works testifies, not to their lack of theater sense, but to the theatrical nature of the entire movement. Surrealism has long since begun to look like a twenty-year mock-heroic morality play whose structure and detail convey the turbulence we increasingly churn up about us.

His criticism of surrealism is partly neutralized by his acknowledgment that it represents "the *only* poetic movement during the first half of the twentieth century." Still, he has revealed that much of the fluttering we associate with the avant-garde between the wars arose from the desire simultaneously to affirm the individual mind as active consciousness carving out experience and to abdicate the individual mind in "automatic" behavior. All right. The surrealist "revolution" failed to alter either the human psyche it claimed to have plumbed or the society and culture which tolerated it so sniffily—yet tolerated it nevertheless. But those artists and writers succeeded in holding open for love and for laughter a wide space in our lives that might otherwise have closed over or have been filled with the hatred that began seeping across Europe in the same period.

IV

Surrealism in the United States was from the start a mongrel in which native and foreign strains never blended completely. No one will ever have to write a systematic history of it here as has been done for Dada and surrealism in Europe, where literary polemics have gone a long way toward supplanting duels. But it may be of some help to distinguish three periods in development of surrealism in this country.

Between 1913 and 1916, the Armory Show and the war together brought to New York three great loners in the art of protest: Arthur Cravan, ex-prizefighter and self-proclaimed nephew of Oscar Wilde; Picabia, the cosmopolitan Spanish painter who started a rowdy new magazine of the arts wherever he went; and Duchamp, the sensitive French chess player and wit, graduate of futurism and cubism, whose sceptical intelligence colors a whole forgotten side of the era. Inevitably they met—each other and with others—in Stieglitz' gallery and in Brentwood, New Jersey, a resort visited by Man Ray, Alfred Kreymborg, William Carlos Williams, Mina Loy (who later married Cravan), and others from Greenwich Village. The Europeans issued the review *291* from Stieglitz' gallery, and Kreymborg put out from Brentwood two important poetry magazines, one after the other: *Glebe*

and *Others.* This was pre-Dada and pre-surrealism in New York, a meeting of minds and talents free of doctrine, thrown together as much by general cultural unrest as by the catalyzing action of the Armory Show that ironically gave two hundred thousand people in three cities of the United States the opportunity to see a better collection of modern art than had been assembled in Europe to date. The terrain was better prepared than anyone knew.

The next stage forms around the little magazines of the Twenties, published often in Europe and thus staying very close to Dada and surrealist goings-on. By 1921 *The Little Review* had published Aragon, Picabia, and Soupault, and went on to give steady attention to the surrealists between 1924 and 1926. Kreymborg's *Broom* and Gorham Munson's *Secession* both drew heavily on surrealist material, and Eugene Jolas' *Transition* was long associated as closely with surrealism as with Joyce's work in progress. Texts by Hart Crane, E. E. Cummings, Wallace Stevens, and Gertrude Stein alternated with those of the French poets and polemicists; there was far more mixing in the pages of reviews than in the cafés and studios of Paris. For a moment, when the exiles began straggling back to New York about 1923, there were even a few incidents that sounded like Paris. The supporters of both *Broom* and *Secession,* tired of squabbling and squeezed by censorship, met to compose their differences and plan a Dada-style performance of protest and scandal in a New York theater. Instead, the meeting broke up in a row and led to a celebrated near-comic fistfight in Woodstock between Munson and Matthew Josephson. A surprising attempt at unity among American writers was made the following year in response to a derisive article by Ernest Boyd, "Aesthete, Model 1924," that appeared in the first number of H. L. Mencken's *The American Mercury.* The putative victims assembled in a New York hotel for a twenty-four-hour binge and writing session, and out of it came a prickly little pamphlet called *Aesthete, 1925,* to throw back at the *Mercury.* The editorial, declaring "Every article contained in this issue of *Aesthete, 1925* is guaranteed to be in strictly bad taste," was followed by parodies, poems, a story, expostulations, and "advertising," composed by Allen Tate, Kenneth Burke, Malcolm

Cowley, John Wheelwright, Hart Crane, Matthew Josephson, and William Carlos Williams. Such demonstrations of solidarity are rare in American literary history.

Through the Twenties and Thirties, magazines little and big kept readers aware of what was going on in Paris under facetious titles that ended up under the entry "Superrealism" in the Readers' Guide. Then another eruption of history brought on the third stage of surrealism in the United States. The war drove to New York Breton, Max Ernst, and Dali a few months after the publication in *New Directions 1940* of two hundred pages of surrealist texts in translation, still the best selection in English, plus two trenchant essays by Herbert J. Muller and Kenneth Burke. (Two other anthologies edited by Herbert Read and Julien Lévy had appeared in English in 1936.) When Breton arrived, he proceeded to found the magazine *VVV* and assembled a group of painters and writers about him. In 1942 he gave a moving talk in defense of freedom at Yale University. Some of us will also remember the occasion for the students' and New Haven ladies' confused reaction when he alluded poetically to his wife's private parts—she was sitting in the front row. (As I recall it, he read "Free Union," included on page 283.) By this time surrealist painting had reached most of the alert art galleries and museums, and in college classrooms across the country the movement was already being fitted into its waiting place in literary history. Today, twenty years later, we are beginning to have access to the memoirs of participants like Man Ray and Matthew Josephson. Both men fall into the trap of being patronizing about their youthful follies.

Now the United States has an important tradition of cranky eccentricity in the arts. It includes contrasting figures like Edgar Allan Poe, Ambrose Bierce, Charles Fort, and Gertrude Stein in literature, Albert Pinkham Ryder in painting and Charles Ives in music. But with the exception of Gertrude Stein, the recluse strain was very strong in all of them; their hopes and hoaxes remained very individual affairs. We will not find a native surrealist strain in this direction. However, one can put together an impressive array of exchanges between European surrealists and Americans. On leaving Russia in 1931, E. E. Cummings

translated Aragon's *Red Front* as a gesture of friendship toward the author. William Carlos Williams served as the American correspondent for Ribemont-Dessaignes' *Bifur* in 1930, and Gertrude Stein carried on a lively correspondence with René Crevel. In 1921 and 1922 Ezra Pound became embroiled in some of the Dada demonstrations and counterdemonstrations, to the point of signing a letter along with Picabia, Erik Satie, and Guillermo de Torre. It was Duchamp who in 1932 suggested to Alexander Calder the name for his new free-swinging sculpture: mobiles. But every one of these items stands for little more than a fleeting engagement in the course of a full career. The only Americans absorbed into the European stream of surrealism were Man Ray, whose temperament clung to the Dada spirit of deflation, and Eugene Jolas, who soon abandoned surrealist politics in favor of Jungian collective myths. When, in 1945, Wallace Stevens contributed a poem to the neo-surrealist New York magazine, *View*, the situation had in a sense come full circle and matched the moment in 1919 when Valéry was contributing to *Littérature*.

It is practically impossible in the case of profoundly American writers like Cummings, Henry Miller, Gertrude Stein, and William Carlos Williams to detect any evidence of more than minor surrealist influence. They had found their voice before coming upon the theory and practice of the Paris schools. The author whose near-automatic writing appears to be most closely related to the surrealists is Gertrude Stein; yet her preoccupation with her own genius and style made her practically impervious to influence except from painting. Insofar as one can trace effects of surrealism on the other arts in this country, they crop up along the trajectory that carried abstract-expressionist painting into action painting and more recently into pop art. Many of the tenets of Dada and surrealism return almost unchanged, but not love, alas, which must be languishing at the bottom of the Atlantic. The reasons for this response of the arts to surrealist background noise when literature has merely cocked an ear can be attributed to the advanced centralization of artistic production and training in New York and to the immediate importance for painting and sculpture of innovations in materials and technique. Writing, because of its format and utilitarian conventions, has had a far

more difficult time responding to such crucial esthetic contributions as photography (Breton uses photographs instead of descriptions in *Nadja* and numbers them in the text), *montage* (film has the most serious claim), and *objets trouvés*.

A fascinating and amusing development has occurred in the past few years during which objective chance has lain down with the computer in delighted experiments by linguist-poets. The random permutations so produced (and lengthily discussed in recent special numbers of the *Times Literary Supplement* on "The Changing Guard") display what we might have surmised: that the computer can, for speed and surprise, come close to matching the unconscious. Quaint or savage programed texts can now be turned on in centers all over the world and confront us with the same problem as automatic writing: what do you do with the results? For they usually present the same aspect of monotony and irrelevance.

v

Maurice Nadeau's *History of Surrealism,* having now gone through three editions in the French, can claim the rank of semiofficial document. Considering the highly conflicting and elusive materials he had to sort out, his version of the events between the two wars maintains a high level of accuracy and impartiality. Nadeau's eclecticism induces him to give both sides of most important disputes and to steer away as much as possible from the purely human factors that lay behind many of the shifts in doctrine, defections, and explosions of feeling. (Even Breton's criticisms of the text are mild and stick to protocol.) As an account of the public record of surrealism, its performances and its declared positions, the *History* frees us from the illusion that it was a monolithic and unchanging group of artists who held the same ideas for twenty years. The evolution in personnel and in political and esthetic commitment stands out clearly, with documents to support it.

But let us be even clearer about what Nadeau does *not* set out to do. He directs his attention exclusively to history and theory— as expressed in statements, manifestos, expository texts, programs,

and anecdotes—and thus does not convey any sense of the works produced. If the publication of this history in English generates only a new round of critical studies on surrealist doctrine, the psychological viability of automatic writing as a method, and the philosophic implications of objective chance and black humor, the full value of the book will have been overlooked. But if, on the contrary, it answers enough questions about what was actually said and done on certain much-disputed occasions so that critics and readers will move on at last to look at what surrealism *produced*, then it will have performed a great service. For we have had far too much rehash of the doctrine by critics with a psychoanalytic or sociological ax to grind. The major experimental works like *L'Immaculée Conception* by Breton and Éluard, the work of Robert Desnos, René Daumal, René Crevel, and Péret, Aragon's exasperating *Traité du Style*, many remarkable films— too much has gone unexamined. Here is the next order of business. "There is nothing ridiculous in such an experiment as hers," writes E. M. Forster of Gertrude Stein. "It is much better to play about like this than to rewrite the Waverly novels." The surrealists deserve the same respect.

With so coherent a synthesis in our hands as Nadeau's history, we can afford to dismantle the movement, to look behind the blunted generalities for the individual members, and above all to evaluate the works. The more carefully we define it, the more the very term surrealism tends to thicken into a screen hiding from us the particulars we seek. The old passwords "automatism" and "revolution" will not guide us any further. Love and laughter, I repeat, are the areas in which surrealism left its mark most deeply on the evolution of the avant-garde in this century.

We had best be attentive to this intense catharsis-sublimation of the Twenties and Thirties. More urgently than ever our children face the challenge of liberating their desire, and here for their scrutiny lies one of the great corporate case histories of that search. By listening carefully we may hear the dark muttering with which René Crevel ended *Les Pieds dans le Plat (Putting Your Foot in It):* "And anyway . . . etc. . . . etc. . . . (to be continued after the next war)."

ROGER SHATTUCK
November 1964

FOREWORD

A HISTORY of surrealism—then surrealism must be dead! Not to our way of thinking. The surrealist state of mind, or, better still surrealist behavior, is eternal. Understood as a certain tendency, not to transcend but to penetrate reality, to "arrive at an ever more precise and at the same time ever more passionate apprehension of the tangible world,"[1] goal of all philosophies whose object is not merely the preservation of the world as it is, eternally unslaked thirst in the heart of man. It is in this sense that Breton could call "Heraclitus a surrealist in dialectic . . . Lulle in definition . . . Baudelaire in morality . . . Rimbaud in the practice of life, and elsewhere . . ."[2]

All the same, there was, strictly speaking, a *surrealist movement,* its birth more or less coincident with the end of the First World War, its dissolution with the beginning of the Second; promoted by men expressing themselves by poetry, painting, essays, or the conduct of life, the movement as a sequence of facts belongs to history, for it is a series of manifestations *in time.* It is the history of this movement that we have undertaken.

Not just to glory in the past, however glamorous; not only to fix outlines that will be as exact as possible, before the subject becomes the pretext of doctoral dissertations; nor because this pursuit of an utter liberation of the mind is inspiring, but also to assign its limits, to show that *in terms of mind* it is difficult to go

[1] André Breton, *Qu'est-ce que le surréalism?* (Henriquez, 1934).
[2] André Breton, *Manifeste du surréalisme* (Kra, 1924).

further and deeper, and that if surrealism produces, in spite of itself, a magnificent artistic explosion, it also leads to an ideological dead end. It must be "surmounted and left behind" by its continuers.

By what dialectic will this movement be effected? That is what we must determine. Probably elsewhere than on the level of art. For this antiliterary, antipoetic, antiartistic movement leads only to a new literature, a new poetry, a new painting, infinitely valuable of course, but a poor excuse for what we had been promised. So much energy, so much ardor and faith, so much purity merely to add some new names in a manual of literary history or to make the fortune of a few art dealers? This is a long way from the *total transformation of life* proposed as a goal. The fault, we need scarcely add, was not that of the surrealists alone, as Breton must have realized when he sent out this S.O.S. in the *Deuxième Manifeste*:[3] "The innocence, the anger of several men to come will be responsible for releasing from surrealism what cannot fail to be still vital, for restoring it, at the cost of a splendid havoc, to its true purpose." This duty Breton defines is not presently our own. We have confined ourselves to recounting, to reliving certain experiments which will not remain inconsequential. We have tried to describe them as they were carried out, with as little inexactitude as possible.

The author of the following work has not lived the surrealist life *from within,* and his undertaking will seem incomplete or inadequate to those who have been its protagonists. This is inevitable. If he has nonetheless chosen to discuss it from the margin, it is because this position also affords advantages: if only that of objectivity, which exceeds the qualification of pure testimony. Not in relation to the general design (some readers may even regard our sympathy and the admiration for surrealism and the surrealists as excessive) but in relation to persons, their connections and the events that resulted therefrom. Nonetheless the author has had the opportunity to approach Breton and his friends at the moment when the storm of the Second World War was about to break. He is fortunate in having for a friend one of the men who counted for a great deal in the genesis and

[3] December 1929.

development of surrealism. Since his adolescence he has been interested in the surrealist works and manifestations. Moreover, with the present work in mind, he has consulted men who participated in the movement at different periods and who, like Georges Hugnet and Raymond Queneau, have granted him access to their libraries and their documents, not to mention their suggestions and advice, which were even more precious. He has conversed with Michel Leiris, Jacques Prévert, J. A. Boiffard. He has not been an eyewitness, but at least his documents have been drawn from excellent sources. Whether they have been used well or badly is another matter.

There are always, of course, disadvantages in talking about living men, in passing judgments on them, in expressing preferences which cannot help being personal. It is true that the echoes of the disputes are dying away, that everyone has the feeling, today, of having lived through an important period, of having participated in a movement which, even for those who have repudiated it, remains a matter of pride. May they be persuaded, and the reader with them, of our good faith.

Yet this work should not be consulted for what cannot be found in it. The author has had the weakness to take surrealism seriously. He is not so naïve as to think that everything about it was serious, yet even farce and burlesque have a meaning which transcends them. That is what it was essential to discover.

MAURICE NADEAU
November 1944

You can be sure it is the enemies of order who are circulating this philter of the absolute. They sneak it past the guards in the form of books, poems. The harmless pretext of literature allows them to offer at a price defying all competition this deadly brew whose use it is high time to generalize . . . Buy, buy the damnation of your soul, you will destroy yourself at last, here is the machine for capsizing your mind. I announce to the world this page one headline: a new vice has just been born, one madness more has been given to man: surrealism, *son of frenzy and darkness. Step right up, here is where the kingdoms of the instantaneous begin . . .*

—LOUIS ARAGON, *Le Paysan de Paris,* 1924

THE ELABORATION

THE WAR

It is no longer possible to consider surrealism without situating it within its time. —ARAGON

T O S T U D Y a movement of ideas without attending to what preceded or followed it, ignoring the social and political situation that nourished it and on which, in its turn, it may have acted, is a futile effort. Surrealism, especially, is deeply embedded in the period between the two world wars. To say as some have that on the level of art it is only a manifestation of the period is oversimplified materialism: surrealism is also the heir and extender of the artistic movements which preceded it and without which it would not have existed. Hence we must consider it in both these aspects at once.

Between 1918 and 1940, surrealism was the contemporary of social, political, scientific, and philosophic events of major importance. Some marked it deeply; to others it gave its own color. Created in Paris by some dozen men, it did not remain confined to France but enlarged its scope to the ends of the earth. Far from being a small Parisian sect, it had adepts and influenced men in England, Belgium, Spain, Switzerland, Germany, Czechoslovakia, Yugoslavia, and even on other continents: Africa, Asia (Japan), America (Mexico, Brazil, the United States). At the Surrealist International Exhibition held in Paris (January–February 1938), fourteen countries were represented. Surrealism had exploded the nationalized compartments of art. It crossed frontiers. No previous artistic movement, including romanticism, has had this

43

international influence and this international audience. It has been the heady nourishment of the best artists in every country, the reflection of a period that, on the artistic level as well, was to envisage its problems on a worldwide scale.

Yet it would be a mistake to believe that a movement of this breadth was the product of a few isolated minds. The public which it found, the admiration and the hatred it provoked, prove that surrealism corresponded to needs and aspirations that are eternal of course, but which assumed a special acuity at the period that witnessed its birth. Then again, it was preceded by cubism, futurism, Dada. The leaders of surrealism—Aragon, Breton, Éluard, Péret—even constituted the French Dada group until 1922, and Dada in particular is not to be accounted for if we forget that it was born during the war, in 1916, that it spread like a train of powder into the conquered Germany of 1918, finally reaching the anemic France of 1919–20.

At the Armistice, the political and social situation of Europe was exceptional. Theoretically there were two camps: the victors and the vanquished, but the former found themselves facing a state of destitution hardly less severe than the latter's. Not only material destitution, but a total impoverishment that was already raising, after four years of slaughter and destruction of every kind, the question of confidence in the regime. Had it all come to nothing more than this? Had it taken so many gigantic means to end in a rectification of borders, in the conquest of new ports for some and their loss for others, in the theft of colonies already stolen? It was in this disproportion between means and ends that the madness of the system appeared. A regime incapable of disciplining its forces except to make them serve the diminution and destruction of man is bankrupt. Bankrupt, too, the elites applauding the generalized massacre in every country, doing their best to find ways of making it last. Bankrupt the science whose noblest efforts produced nothing better than a new explosive, perfected only another extermination weapon. Bankrupt the philosophies seeing nothing in man but his uniform and eagerly fabricating excuses to keep him in ignorance of the shameful trade he was

being made to ply. Bankrupt the art good for nothing better than camouflage, bankrupt the literature, merely an appendage to the military communiqué. Universally bankrupt the civilization turning against itself, devouring itself.

And was it to be endured that poetry, in this cataclysm, should go droning on, that men who had lived through the nightmare should bother about the beauty of roses and of the "vase in which the verbena dies"? Breton, Éluard, Aragon, Péret, Soupault were profoundly affected by the war. They had fought in it by obligation and under constraint. They emerged from it disgusted; henceforth they wanted nothing in common with a civilization that had lost its justification, and their radical nihilism extended not only to art but to all its manifestations. For the society which had sent them so gaily to death was waiting for them on their return, if they managed to escape, with its laws, its morality, its religions. Sixteen years later, looking back at this period, Breton remarked, perhaps giving his ideas at the time of the Armistice a clearer focus than they had actually had:

> I say that what the surrealist attitude initially shared with that of Lautréamont and Rimbaud and what definitively linked our destiny to theirs was the DEFEATISM of war . . . In our eyes, the field was free only for a Revolution, fantastically radical, extremely repressive, that extended to every realm. Insofar as a man is ignorant of this attitude, I consider that he is unable to comprehend the surrealist approach. Only this attitude corresponds adequately to all the excesses which can be attributed to us, but which can be deplored only to the degree that one gratuitously supposes we could have started from another point.[1]

Unequivocal words which account for the joy with which Breton and his friends flung themselves into Dada, an unprecedented attempt to destroy traditional value, the rejoinder—however ineffectual—to the patching-up being done by the international diplomats at the Peace Conference in Paris.

In fact 1920 was the year of the signing of the last peace treaties, the beginning of the war's liquidation. The capitalist

[1] André Breton, Qu'est-ce que le surréalisme? (op. cit.)

world inaugurates a new stabilization, however provisional. The problems whose solution this four years' carnage was supposed to provide have not been solved, and everyone knows it. A new civilization, based on new values, is born on the eastern edge of the continent and enjoys an enormous prestige in the eyes of those who have "nothing to lose but everything to gain" from the change. Out there, beyond Clemenceau's *cordon sanitaire*, men are trying to live another life, while the West's excombatants fall back into a chaos they know too well. Is it surprising that they should feel frustrated in their aspirations and that the best should become aware of the deception by which they have been victimized?

The machine, once certain gears have been repaired, begins grinding again. There are hitches, jams: revolutionary movements of all kinds; but the longed-for change still doesn't come. The masters have been able to stop in time, and even exchange favors in order to bring the "world underneath" into line. A tremendous revolution, already necessary years ago, is aborted.

The survivors soothed, the wounds bandaged, the ruins restored, not without jolts and risks of all kinds, the regime is entitled to suppose that a new age of prosperity is about to begin. The underfed masses, their most elementary needs unsatisfied for years on end, become greedy consumers with exorbitant desires. It is the temporary and factitious euphoria that follows every war. Automobiles are manufactured; the airplane becomes the habitual means of transport for big businessmen; the railroad and the ocean liner diminish distances. Scientific discoveries enter everyday life: crowds flock to the movies, abandoning their horn-phonographs for the hissing, whining radios that still require earphones but that constitute, nonetheless, a tremendous progress. The world has shrunk to man-size. About this sphere 40,000 kilometers in diameter, a littérateur can write: "nothing but the earth" [*Rien que la terre*, title of a travel booy by Paul Morand.—Tr.]. It is this new aspect of the planet which had already naïvely exalted the futurists, and some men, Apollinaire among them, had even found a singular poetry in the "beauties" of war.

*I admit that two-and-two-makes-four
is an excellent thing, but if all things
are to be praised, I should say that
two-and-two-makes-five is also a de-
lightful thing.* —DOSTOEVSKY

What has not progressed at the same rate is man's knowledge—
man, who can apply his reason, his logical faculties to changing
the world, but who has turned out to be powerless to change
himself. He has remained the savage using machines of which he
knows only the approximate function. Worse, he becomes the
prisoner of these machines he mass-produces. He begins adoring
them as the savage adores his idols; he asks them to create the
very fabric of his life, he asks them to change his life. Not only
do they remain deaf to his appeal, they make him realize his
slavery more cruelly than ever. And at the end of the race: the
collapse into a new war. Progress indeed! Man makes a beautiful
cage to imprison the forces of nature; he succeeds in doing so,
but does not realize that he is locking himself inside. No matter
how much he screams and shakes the bars, the bars resist, for
they are the fruit of a truly rational, truly perfect labor. Indeed
the evil is not only in his creations, it is in himself. Man has pro-
duced a terrible civilization because he has become a cerebral
monster with hypertrophied rational faculties. Reason, logic,
categories, time, space, two-and-two-makes-four have ultimately
come to seem the only living realities, whereas they were nothing
but convenient forms, practical and provisional means to his ends,
infinitely superior to primitive empiricism and religious mysticism,
but merely a stage in the development of thought, a stage which
must be transcended. Old Hegel and his dialectic are the guaran-
tors of this necessary transcendence, and it is no accident that
the surrealists will make him a pillar of their philosophy. He still
belongs, of course, to the camp of the "reasoners," the logicians,
the strait-jacket system-makers, but maybe even in this camp some
men have grown aware of the basic divorce between man and the
world and will sound the alarm. It seems so, in fact. People crowd
to the lectures at the Collège de France to hear Bergson vituper-
ate reason and proclaim the omnipotence of *élan vital*. But unable
to define this *élan vital*, he can only propose the old fideist solu-

tion all over again. Einstein is more serious, his scientific language is not always understandable, but strange illuminations gleam here and there like an aurora borealis. "We have made a mistake," he says in substance, "the real world isn't what we thought, the best-founded conceptions apply only to our daily round, out there they're false. False our old conception of space, false the time we've fabricated. Light is propagated in a straight line, and the mass of bodies is a kind of rubber band." The epistemologists fall into step, questioning the conditions and limits of knowledge. It seems that knowledge is something else besides action, for which science furnishes recipes that apply to it. The two can no longer be identified: here are the mathematicians with a geometry that dispenses with Euclid and his famous postulate. Reason, all-powerful reason, stands accused, and stands mute: she has nothing to say in her defense. Reality is something besides what we see, hear, touch, smell, taste. There exist unknown forces that control us, but upon which we may hope to act. We have only to find out what they are.

Man torn between his reason—discredited but still arrogant—and an unknown realm which he feels to be the true source of his acts, his thoughts, his life, and which has been revealed to him in the sleep that devours nearly half his existence, man dares turn his eyes upon it. He becomes acquainted with strange creatures; he moves in landscapes never seen before; he performs enthralling actions. A Viennese psychiatrist, armed with a dark lantern, seeks to penetrate the dim labyrinth. His discoveries are so horrifying that the bourgeoisie is scandalized. The surrealist doctors follow in the tracks of the Viennese. They, on the contrary, are amazed, dazzled by the new treasures they have discovered. The wall that so jealously, so immutably separated private life from public, unconscious from conscious, dream from logic and "directed thought" crumbles; the leaning tower of bourgeois respectability is reduced to rubble. Are we on the road to unity? Will Orpheus be able to reassemble the pieces of his torn body? A tremendous hope is born. The surrealists find a temporary solution in Freud's discoveries. It is henceforth demonstrated that man is not just a "reasoner" nor even a "sentimental reasoner" as too many poets have been up till now, but also a sleeper, a

confirmed sleeper who wins every night, in his dreams, the treasure that he will dissipate by day in small change. Man was not only a prisoner of nature, and of his triumphs over nature, but of himself; he had wrapped his mind with mummy cloths that were gradually smothering him. Down with syllogisms, corollaries, Q.E.D., cause and effect, the whole and the sum of its parts: open the gates to the dream, make room for automatism! We are about to see a man as he is, we shall be whole men, "unchained," delivered, daring at last to be aware of our desires, and daring to fulfill them. Away with darkness! We shall all live in "glass houses"; we shall see each other as we are, as anyone who wants to can see us.

But the surrealists are not politicians nor scientists, philosophers nor even physicians. They are poets, specialists in language, and it is language they will attack first.

First of all, no more logic. In language especially it must be hunted down, beaten to a pulp, reduced to nothing. There are no more verbs, subjects, complements. There are words that can even mean something other than what they actually say.[2] Like science, like philosophy, poetry is a means of knowledge; like politics, like medicine, a means of action. Knowledge dispenses with reason, action transcends it. Beauty, art have been the conquests of logic; they must be destroyed. Poetry must be "soul speaking to soul," dream must be substituted for "directed thought," images must no longer be the foxfire running on the surface of thoughts or feelings, but lightning flashes, continually illuminating "the caverns of being." Only one prescription: let the "unknown guest" express himself in his depth, his totality, automatically. Only one precaution: do not interfere. Poets of the past have been inspired from time to time, and that is what constitutes the value of their productions; today's poet is not only inspired continually, but from object becomes subject: he becomes the one "who inspires." He is no longer merely "sounding echo," "prophet," "seer"; he is all these at once, and more as well: he is a *magician*. It is he who changes life, the world, who trans-

[2] One can know the word Hello perfectly well and still say Good-bye to the woman one sees again after a year's absence." (André Breton: *"Deux manifestes dada,"* in *Les Pas perdus.*)

forms man. He knows how to "mix action with dream," "identify internal and external," "arrest eternity within the moment," "dissolve the general in the particular."[3] He makes of man and the world a single diamond.

But he is not, thereby, above other men. He walks "in broad daylight" among them.[4] The miracle he achieves can be achieved by all. Everyone is among the elect. "Poetry must be made by all, not by one."[5]

This is a true revolution, Poetic first, because it denies poetry by transcending it. The arrangement as a poem is banished in favor of the automatic text, the dictation of the unconscious, the dream narrative. No concern for art, for beauty. Those are paltry goals, unworthy of attention. The poet's *soul* is what it is: a whirling magma of sensations, feelings, desires, aspirations expressed in tumult, incoherently, gratuitously, by the intermediary of language or writing, that immemorially logical mold which must be smashed, reduced to its simple elements: words, alone capable of faithfully expressing the poetic trance in all its integrity. The surrealist poets, since this name has been accorded them, wonderingly observe the flow of an inexhaustible spring, bearing gold nuggets along with the mud. What they do can no longer be compared with what has been done before them. At the cost of a radical and necessary destruction they have created new values, in an atmosphere of Genesis.

This poetic revolution has been made possible by man's inner revolution, a revolution affecting his relations with the world. Twenty centuries of Christian oppression have not been able to keep man from having desires, and from longing to satisfy them. Surrealism proclaims the omnipotence of desire, and the legitimacy of its realization. The Marquis de Sade is the central figure of its pantheon. To the objection that man lives in society, surrealism replies by the total destruction of the bonds imposed by family, morality, religion. "Laws, moralities, esthetics have been created to make you respect fragile things. What is

[3] André Breton, *Les Vases communicants*.
[4] *Ibid.*
[5] Lautréamont.

fragile should be broken."[6] "Our heroes are the parricide Violette Nozière, the anonymous criminal of common law, the conscious and refined perpetrator of sacrilege." The traditional opposition of "bourgeois" and "artist" is replaced by the violent antinomy of the revolutionary and the property-owner, the slave and his master. Having started from a rather mystical idealism of the omnipotence of spirit over matter, the surrealists arrive at least in theory, at a materialism of revolution in things themselves. Several of them will even take the plunge and furnish militants to the revolutionary political parties. The destruction of traditional human relations leads to the construction of new ones, and of a new type of man.

Thus the surrealist movement functions on different levels. It has lacked only scientists, mathematicians, engineers applying its methods in their special fields, to attempt to give, in all its complexity, the image of the man of tomorrow.

[6] Aragon, *Les Aventures de Télémaque.*

THE POETS IN THE WAR

*All things considered, I think sur-
réalisme would be better than surna-
turalisme, which I had used originally.
Surréalisme doesn't yet exist in the
dictionaries, and it will be easier to
handle than surnaturalisme, which is
already employed by those gentlemen
the philosophers.*
—GUILLAUME APOLLINAIRE, *(letter
to Paul Dermée, March 1917)*

D URING the First World War, the young poets who were mo-
bilized one after the other found no answer in the poetry of
the past to the questions they were beginning to ask. There had
been Nerval, Baudelaire, Rimbaud, Lautréamont especially, but
they were dead, and their times quite different. There were, of
course, living men in France: Apollinaire (who, having requested
front-line service, was now with them, but in a somewhat different
frame of mind), Picasso whom they revered, Henri Matisse,
Marie Laurencin, Max Jacob, the *douanier* Rousseau, Derain,
Braque, Fernand Léger—new painters or poets who, breaking
with traditional ideas, proclaimed themselves modernists and
whose works the future surrealists, even if they didn't know
them well, had read or seen, even before the war, in the maga-
zine *Les Soirées de Paris* edited by Apollinaire and Paul Cérusse
(Serge Férat). At the war's darkest hour (in 1917), they medi-
tated Apollinaire's manifesto-program, entitled *L' Esprit nouveau:*

To explore the truth, to seek it in the ethnic domain, for in-
stance, as well as in that of the imagination, such are the chief

characteristics of this new spirit . . . The new spirit, then, admits even daring literary experiments, and these experiments are on occasion anything but lyrical. That is why lyricism is merely a realm of the new spirit in today's poetry, which is often content with experiments, with investigation, without being concerned to give a lyrical signification . . . But such research is useful, it will constitute the basis of a new realism . . . Surprise is our greatest new resource. It is by surprise, by the rank it accords surprise, that the new spirit is distinguished from all previous artistic and literary movements . . . There is no need, in making a discovery, to select by rules, even rules applied with taste, a subject classified as sublime. One can start with an everyday subject: for the poet a falling handkerchief can be the lever with which he will raise a whole universe . . .

Wasn't this what all of them really believed, these twenty-year-olds: André Breton, Paul Éluard, Benjamin Péret, Louis Aragon, Philippe Soupault, and is it surprising that Apollinaire should appear to them at this point as a kind of god? "To have known him will pass for a rare advantage," Breton said in 1917, celebrating the "enchanter's" poetry with all his heart.[1] For it was in poetry and its practice that these poets found a refuge in spite of everything—Breton perhaps most of all, seeking in the wake of Mallarmé to extend the master's subtle discoveries.[2] Yet a decisive encounter was to influence his life in an entirely different direction. This was the meeting with Jacques Vaché, in Nantes, early in 1916. *"Le pohète"* (as Vaché called him) was at the time assigned as an intern to the Neurological Center in the Rue du Boccage, where Vaché was being treated for a wound in the calf. The behavior of this "elegant young man with auburn hair" began to fascinate Breton:

[1] André Breton, "Guillaume Apollinaire" (*Les Pas perdus*).
[2] Poem published in *La Phalange* (1914), reprinted in *Mont-de-Piété*.

D'or vert les raisins murs et mes futiles voeux
Se gorgeant de clarté si douce qu'on s'étonne
Au délice ingénu de ceindre tes cheveux,
Plus belle, à n'envier que l'azur monotone.

Je t'invoque, inquiet d'un pouvoir de manteau
Chimérique de fée à tes pas sur la terre,
Un peu triste peut-être et rebelle plutôt
Que toute abandonnée au glacis volontaire

Obliged to remain in bed, he entertained himself by drawing and painting a series of post cards for which he invented strange captions. Men's fashions provided almost the only substance that nourished his imagination. He liked those glabrous faces, those hieratic postures to be seen in bars. Every morning he spent a good hour arranging one or two photographs, some saucers, a few violets on a little lace-top table within reach of his hand . . . We talked about Rimbaud (whom he still detested), Apollinaire (whom he had merely heard of), Jarry (whom he admired), cubism (which he regarded with suspicion). He was reluctant to discuss his past. He reproached me, I think, for that insistence on art and moderation which subsequently . . . Jacques Vaché was a past master in the art of attaching little or no importance to everything. . . . In the streets of Nantes, he strolled sometimes in the uniform of a hussar, an aviator, a doctor. Occasionally he would pass and not seem to recognize you and go on his way without turning around. Vaché never held out his hand to say hello or goodbye. . . .[3]

They met subsequently only five or six times, notably at the première of *Les Mamelles de Tirésias,* Apollinaire's "surrealist" play, on June 24, 1917:

It was at the Conservatoire Maubel that I met Jacques Vaché again. The first act had just ended. An English officer was making a great racket in the orchestra: it had to be Vaché. The scandal of the performance had excited him. He had come into the theater with a revolver in his hand, and was threatening to fire into the audience.[4]

We find the echo of this recollection over ten years later, in the *Deuxième Manifeste du surréalisme,* in which Breton declares that "the simplest surrealist act consists of going out into the street revolver in hand and firing at random into the crowd as often as possible." This simple juxtaposition also shows Jacques Vaché's tremendous influence on surrealism. His enigmatic death, shortly after the armistice, suitably crowning the life of this strange character, was to help make him one of surrealism's most vivid figures. Hence we shall meet him again along our winding path. For the moment, let us merely record Breton's testimony as to his friend:

[3] André Breton, "La Confession dédaigneuse" (*Les Pas perdus*).
[4] *Ibid.*

Every literary and artistic case I must consider is secondary to him, and even then concerns me only to the degree that I can evaluate it, in human significance, by his infinite measure . . .[5]

and as to himself:

Without him I would perhaps have been a poet; he released in me that conspiracy of obscure forces which leads one to believe in oneself something as absurd as a vocation . . .[6]

Breton also heard about another adventurer on the grand scale named Arthur Cravan, whose life and death have both become legendary. His butcher-paper broadside, *Maintenant*, which he started publishing at irregular intervals in 1913, he distributed in person at the entrance of the Salon des Indépendants. Almost nothing is known of the man himself, though the fact of having been "a deserter of seventeen nations" is enough to insure his glory. Was it his activity as a boxer that permitted him, during the war, to draw a crowd to his lecture on modern humor at the New York Independents'? He gave them a good specimen by "having himself dragged on stage to utter nothing but belches and to begin undressing, to the great agitation of the audience, until the police came and brutally put an end to his performance . . ."[7]

Vaché, Cravan: two meteors, two fixed stars in the surrealist firmament.

In this same year, 1916, appeared the first number of *Sic*, a periodical edited by Pierre Albert-Birot and militantly championing *l'art moderne*. In it were to be found Apollinaire, Reverdy, the partisans of literary cubism and futurism. Among its (episodic) contributers were Breton and Aragon. Reverdy also had his own review: *Nord-Sud* (1917–1918). He exerted, and continued to exert, despite his Catholicism, and for reasons to be discussed later, a great influence over the founders of surrealism.[8]

[5] *Ibid.*
[6] *Ibid.*
[7] André Breton, "Caractères de l'évolution moderne" (*Les Pas perdus*).
[8] *Les Nouvelles Littéraires* had objected to the awarding of the *Nouveau Monde* prize to Reverdy, asserting that Max Jacob, Delteil, Philippe Soupault, Aragon, or Breton were better qualified. Aragon, Breton and Soupault sent the journal the following letter: ". . . Our literature, which we are grateful

Also writing in *Nord-Sud* were Apollinaire and Max Jacob, whose names appear beside those of Breton, Aragon and Soupault. *Sic* and *Nord-Sud*, though presenting a certain subversive character, nonetheless belong to the futurist and cubist arsenal.

It was outside France, in Switzerland, that construction began on a weapon much more dangerous to traditional art and poetry. On February 8, 1916, in Zürich, the refuge for émigrés of all kinds and from all nations, Tristan Tzara, a young Rumanian poet, R. Huelsenbeck, a German, and Hans Arp, an Alsatian, opening a dictionary at a random page, baptized *Dada* a movement which was to fill the years to come with its explosions and to affect the fortunes of the nascent surrealism strongly. Without Dada, surrealism would doubtless have existed, but it would have been quite different.

Not that the movement's founders had particularly fixed ideas at this moment. Dada too evolved, and did not immediately achieve the utter intransigence and negation that subsequently characterized it; the publications of this period (the *Cabaret Voltaire* of 1916–1917) are a mixture of cubism, futurism (with Marinetti) and Tzara's strictly Dada spirit. Tristan Tzara had just distinguished himself by the publication of *La première aventure céleste de M. Antipyrine* (July 28, 1916) in which appeared side by side words having no apparent sense. Until his arrival in Paris, Tzara produced magazine after manifesto (*Dada I, Dada II, Dada III . . .*) and formulated this decisive proposition: "Thought is made in the mouth," which dealt a mortal blow to philosophical idealism and already opened the door to automatism. In Zürich, too, began the period of pro-vocation-performances, which were to be given in Paris only much later. Here is Georges Hugnet's description of one of them:

> On the stage, keys and boxes were pounded to provide the music, until the infuriated public protested. Serner, instead of reciting poems, set a bunch of flowers at the foot of a dress-maker's dummy. A voice, under a huge hat in the shape of a sugar-loaf, recited poems by Arp. Huelsenbeck screamed his

to you for appreciating, is quite inferior to that of Reverdy. We do not hesitate to declare, in fact, that Reverdy is at present the greatest living poet. We are merely children beside him . . ." Etc. (*Journal littéraire*, May 31, 1924).

poems louder and louder, while Tzara beat out the same rhythm *crescendo* on a big drum. Huelsenbeck and Tzara danced around grunting like bear cubs, or in sacks with top hats waddled around in an exercise called *noir cacadou*. Tzara invented *chemical and static poems* . . .[9]

Dada III's cover was embellished with a new name: Francis Picabia, who returned from America bringing the Dadaists the collaboration of Marcel Duchamp. Duchamp's activity as a painter had begun well before the war with "Nude descending a staircase," "Sad young man in a train," "Bride," "The king and queen traversed by nudes at high speed," and the "Chocolate grinder." After 1912 he had confined the exercise of his tremendous talent and his preternaturally acute mind to signing ready-made objects, thereby proclaiming his disgust with the work of art and proving that a manufactured object can be raised to such "dignity" by the mere choice of the artist. The "Bottle-rack" is well known, and the famous urinal shown at the New York Independents' exhibition in 1917 under the name of "Fountain." Duchamp's obsession with the laws of chance subsequently led him to produce all kinds of machines with precisely arranged workings and disturbing effects, not to mention the painting on glass "The bride stripped bare by her bachelors, even," which took several years to make and which represents a quest for the impossible. Picabia had collaborated on Duchamp's reviews: *Camera Work, 291, The Blind Man, Wrongwrong,* and it may have been from Duchamp too that he derived his taste for paintings and drawings with mechanical subjects: wheels, gears, machinery, which he revealed to the Barcelonese, after his stay in Zurich, in his own magazine *391*.

At this period, the French were not aware of the activity in Zürich. Breton did not see the issues of *Dada* until 1917, at Apollinaire's; Dada was born in Paris only with the arrival of Tzara, "awaited like a messiah," in 1919. For the time being, there were the poems of Éluard, *Le devoir et l'inquiétude* (1917), and of Soupault, *aquarium* (1917), personal experiments not at all influenced by Dada.

[9] Georges Hugnet, "L'esprit dada dans la peinture" (*Cahiers d'Art*, 1932-1934).

By the time the armistice was signed, the future founders of surrealism were steeped in a wartime atmosphere particularly tonic for their movement. They were swept along, willy nilly, by that great current Albert-Birot had baptized *L'Esprit moderne*. The elders they admired were Picasso, who continued to astound them; Apollinaire, "the last great poet" (Breton); Reverdy, already using a number of surrealist methods in the composition of his admirable poems; Max Jacob, "fraud of genius." Apollinaire's *Calligrammes*, published in *Sic*, Albert-Birot's poems "to be shouted and danced" were innovations considerable enough to amaze and delight them. They broke, quite late, with this school of literary cubism only when they discovered that though it claimed to bring something new (and the partisans of *L' Esprit moderne* certainly did so), it could only ask the same questions over again without answering them. Was it always to be a matter of diverting the eye, the ear or even the mind? Jacques Vaché had written to Breton: "Art is nonsense," and from Zürich, Tzara answered like an echo: "Everything one looks at is false." Wasn't it better, henceforth, instead of this perpetual merry-go-round, to smash the carrousel itself? This was what Tzara turned to, making enthusiastic converts in a conquered Germany at grips with famine, poverty, and revolutionary riots. It was finally what Breton and his friends turned to as well.

DADA

What is beautiful? What is ugly? What is great, strong, weak? Who are Carpentier, Renan, Foch? Unknown. What am I? Unknown, unknown, unknown, unknown.

—GEORGES RIBEMONT-DESSAIGNES

V ACHÉ had not known Dada, was never to know it. The publication, in 1919, of his *Lettres de guerre* does not even suggest that he would have played any role in it, steeped as he was in the "theatrical and joyless futility of everything." Still, the letters he sent to his friends, and which everyone may now read, go far in the direction of the task Dada has assigned itself:

We care for neither art nor artists (down with Apollinaire) . . . we ignore Mallarmé, without hatred, but he's dead. We no longer know who Apollinaire is—BECAUSE—we suspect him of producing art too consciously, of patching up romanticism with telephone wire, and of not knowing that the dynamos THE STARS are still disconnected!—it's a bore—and then sometimes they talk so seriously! A man who believes is peculiar. BUT SINCE SOME ARE BORN PLAYACTORS . . .

In the case of Jarry, the one poet he admires, he believes only in the writer's "*umour.*"

The man who never lets himself be caught by the hidden and SECRET life of everything will be *umore*. O my alarm-clock —eyes—and a liar—that hates me so! . . . and the man who realizes the dreadful *trompe-l'oeil* of the universal simili-symbols will be *umore*. It is in their nature to be symbolic . . ."

59

And this unambiguous declaration, key to his sterility: *"umore must not produce,"* an absolute he knows is unrealizable.

> But what of it? I concede a little affection for LAFCADIO because he doesn't read and produces only by amusing experiments, like the murder—and then without satanic lyricism—my old rotten Baudelaire!—what he needed was a little of our dry air: machinery—presses with stinking oil—throb—throb—throb—whistle! Reverdy—the *pohète* amusing, and boredom in prose; Max Jacob my old fraud—PUPPETS—PUPPETS—PUPPETS—Want some pretty painted puppets? Two burnt-out eyes and the crystal circle of a monocle—with an octopus typewriter—I prefer it.

Jacques Vaché's *Lettres de guerre* was published under the auspices of the *Littérature* group in a little yellow-covered magazine that had three editors: Louis Aragon, André Breton, Philippe Soupault. A certain distance was still kept from the Dada spirit. What writers were published in it? André Gide, who since *Les Caves du Vatican* enjoyed great esteem among the editors of *Littérature,* Paul Valéry, silent for twenty years, making his official return to literature, Léon-Paul Fargue, André Salmon, Max Jacob, Reverdy, Cendrars, Jean Paulhan. And the *Poésies* of Isidore Ducasse, Comte de Lautréamont, and if, in the numbers for the next two years, we make the acquaintance of young men who come to learn their trade: Radiguet, Drieu la Rochelle, Paul Morand, we find others who are not so young, like Jules Romains, father of *unanimisme.* The memory of Apollinaire is revered, as are those of Mallarmé, Cros, and Rimbaud, whose childhood memories are sketched by the popular novelist Jules Mary. And there are articles about Raymond Roussel, author of *Impressions d'Afrique,* and J. M. Synge. The *Littérature* group is modern in the best sense of the word, with certain nascent preoccupations nonetheless: the revision of certain values, the search for the sources of artistic creation, the value of the poet's human destiny, which explode in the famous questionnaire "Why do you write?"[1] The flabbergasting, or cynical, or lack-luster answers were classified in order of mounting value by the young editors of *Littérature,* which allows us to take our bearings

[1] For this whole period, aside from examining the documents in question, we have followed the study by Georges Hugnet already referred to.

as to the group's development. Soon other answers will be required to the questions it will ask: For despite Breton's statement quoted above, it was not purely destructive activity which was envisaged. The rediscovery of Lautréamont and of Rimbaud, the purely poetic researches of Mallarmé, of Cros, of Valéry even, suggest a "less anarchistic, less offhand systematization of a struggle to be joined."[2] This was also the moment when people began discussing the disturbing investigations of Professor Freud, who appeared to hold the keys to a mysterious region the editorial trio of *Littérature* was eager to explore. Perhaps here, after all, the perpetually sought for, perpetually refused path was to be found.

But then came Tzara, who called everything into question once again.

He arrived, preceded by a reputation which, as we have seen, was not usurped. His own role aside, and it is an enormous one, he was to serve as the catalyst of the revolutionary tendencies which animated the *Littérature* group and those it influenced.

Indeed his arrival cut short all those good old arguments that wore down the streets of the capital a little more every day. He never compromised at all with the backward fractions . . .

Breton was to acknowledge in the heat of the dispute with the man who walks "with that defiance in his eyes."[3] From the moment of his arrival, in fact, something else is at stake. With him, Dada truly begins its astonishing Parisian career. And first of all he decides to give the capital's elite a glimpse of his talents by repeating, on a larger scale, the Zürich provocation-performances. On the first of the *Littérature* Fridays (January 23, 1920):

André Salmon spoke first, reciting poems. The public was pleased, for after all there was a certain art apparent in these, but their pleasure was soon spoiled. Masks appeared and recited a disjoined poem by Breton. Calling it a poem, Tzara read a newspaper article, accompanied by an inferno of bells and rattles. The audience of course could stand no more and

[2] Georges Hugnet, "L'esprit dada dans la peinture" (*Cahiers d'Art*, 1932-1934).
[3] André Breton, "Caractères de l'évolution moderne" (*Les Pas perdus*).

began whistling and booing. To conclude this splendid chaos, paintings were shown, among them one by Picabia, scandalous from a plastic point of view, with the same title as several other paintings and manifestos by Picabia of this same period: LHOOQ.[4]

The tone was set. The February *Dada* bulletin includes the names of Picabia, Tzara, Aragon, Breton, Ribemont-Dessaignes, Éluard, Duchamp, Dermée, Cravan, and proclaims: "The true Dadas are anti-Dada. Everyone is a leader of *Dada*." Meanwhile the manifestations continued. The second, which took place on February 5 at the Salon des Indépendants, mobilized thirty-eight performers for the reading of the manifestos. It is true that Picabia's was read by ten people once, Ribemont-Dessaignes' by nine, etc. Let us select from one of them these lines which are actually a whole program:

> No more painters, no more writers, no more musicians, no more sculptors, no more religions, no more republicans, no more royalists, no more imperialists, no more anarchists, no more socialists, no more Bolsheviks, no more politicians, no more proletarians, no more democrats, no more armies, no more police, no more nations, no more of these idiocies, no more, no more, NOTHING, NOTHING, NOTHING.
> Thus we hope that the novelty which will be the same thing as what we no longer want will come into being less rotten, less immediately GROTESQUE.[5]

The audience, there to see Charlie Chaplin whose presence the organizers had fraudulently announced, left the hall in the dark, in indescribable disorder, after having cannonaded the readers with coins. Later, audiences were to replace the coins by eggs, which produced a more decorative effect (gala in the Salle Gaveau). The journalist d'Esparbès, an avowed adversary of Dada, describes a show of Max Ernst collages in these terms:

> With characteristic bad taste, the Dadas have now resorted to terrorism. The stage was in the cellar, and all the lights in the shop were out; groans rose from a trap-door. Another joker hidden behind a wardrobe insulted the persons present . . .

[4] Georges Hugnet, *loc. cit.* [When pronounced, the letters produce a vulgar French equivalent for "she has hot pants." Tr.]
[5] Manifesto by Aragon.

the Dadas, without ties and wearing white gloves, passed back and forth . . . André Breton chewed up matches, Ribemont-Dessaignes kept screaming: "It's raining on a skull," Aragon caterwauled, Philippe Soupault played hide-and-seek with Tzara, while Benjamin Péret and Charchoune shook hands every other minute. On the doorstep, Jacques Rigaut counted aloud the automobiles and the pearls of the lady visitors . . .[6]

Harmless amusements, we would think today. They were more than that. This constant provocation of a public greedy for modern art and new esthetic emotions, a public that came to see Dada because that was where it expected to find them, a public that might even have adopted Dada had the latter been willing, was paralleled by collective and individual experiments in many areas, attacks against official art and literature that were less gratuitous. This more effective battle, moreover, was waged by the original members of the *Littérature* group, and by others like Picabia who broke with Dada when they observed that it merely replaced the impasse of official art by the dead end of sterile agitation. Attacks against men: "If you read André Gide aloud for ten minutes, your mouth will smell bad" (Picabia, in Paul Dermée's review Z); attacks against sacrosanct works by painters of the past: Picabia's magazine *391* appears with a cover by Duchamp showing the Mona Lisa with her famous smile disguised by mustaches and a goatee. *Cannibale,* which has only two numbers (April 25–May 25, 1920), is another weapon in the arsenal of Picabia, who ends up firing red-hot broadsides into Dada.[7] Paul Éluard, in his little review *Proverbe,* whose first number appeared in February, quotes these lines of Apollinaire:

O bouches, l'homme est à la recherche d'un nouveau langage
Auquel le grammairien d'aucune langue n'aura rien à dire.
[O mouths, man is looking for a new language
No grammarian can legislate.]

[6] Quoted by Georges Hugnet, *loc. cit.*
[7] One of Picabia's articles: . . . Dufayel seems to me more interesting than Ribemont-Dessaignes, Capablanca or Ford more interesting than Marcel Duchamp, Victor Hugo more interesting than Max Stirner, Pasteur more interesting than Nero, Mme. Boucicaut more interesting than Paul Poiret, and Mme. de Noailles pleasanter to look at than Tristan Tzara . . . (*La Vie moderne,* February 25, 1923).

as authority for his experiments on language, whose revision he is undertaking. He finds in commonplaces, in "proverbs," in ready-made phrases, the explosive value which they originally possessed and which they have lost with use.[8] He restores it by puns, spoonerisms, reversing the usual order of words in the sentence.[9] Among the collaborators of *Proverbe* we encounter the already familiar names of Breton, Aragon, Paulhan, Picabia, Soupault, Tzara, Ribemont-Dessaignes.

Breton too fired from his own lines. After recommending a series of "excursions and trips through Paris" to nonsensical places (a visit to Saint-Julien-le-Pauvre, April 14), he withdraws from a Dada manifestation at the Galerie Montaigne and, against Tzara's advice, organizes the great machinery of the Barrès Trial.

Dada, he considers, cannot confine itself to outcry, it must take action. Action that will first of all be less anarchic, more effective; no longer limited to opposing official art, which will not continue to flourish any the less, but to attack its leaders by name, to denounce them as "traitors" to the cause of the mind and of man, to judge them with all the apparatus which bourgeois justice employs on such an occasion. No defendant could be better chosen than Maurice Barrès. This writer, equipped with definite literary gifts and a moral ideal which in his early work was not entirely displeasing to the future surrealists, had ultimately put his talent at the service of the land, the dead, and *la patrie,* all values indignantly rejected by the *Littérature* group. The undertaking, in Breton's eyes, seemed all the more necessary since this man still influenced a certain public and risked seducing from the true path thousands of young people eager only to employ their talents. By the same token Breton was instituting the trial of *talent,* literary or other, which for the future surrealists never figured as more than a booby trap.

The "accusation and judgment of Maurice Barrès by Dada" was announced in *Littérature* for Friday May 13, 1921, at eight-thirty sharp, in the Salle des Sociétés Savantes, 8 rue Danton.

[8] "Is there . . . anything more charming, more fruitful and of a more positively *stimulating* nature than the commonplace?" (Charles Baudelaire, *Salon de 1859*).

[9] Example: *"Je me demande un peu: qui trompe-t-on ici? Ah! je me trompe un peu: qui DEMANDE-t-on ici?"*

"Twelve spectators will comprise the jury."[10]

What might have seemed an innocent farce to the usual spectators of the Dada manifestations assumed quite a different complexion, thanks to Breton, and it may not have been entirely a coincidence that Barrès temporarily abandoned the capital at this time. The Dadas had no such thing in mind, of course, and had no designs on his life. A wooden mannequin was seated in the defendant's box as a suitable substitute. The judges, lawyers, and prosecutor were dressed in white caps, shirts, and aprons; the rest of the court wore scarlet caps. Benjamin Péret represented the German Unknown Soldier. Let us extract from the accusation drawn up by Breton these considerations which do not apply only to Barrès:

> Dada, resolved that it is time to put at the service of its negating spirit an executive power and determined above all to wield that power against those who risk hampering its dictatorship, is as of today taking measures to annihilate their resistance,

> considering that if a given man at a given period is in a position to solve certain problems, is guilty if, either by a desire for peace and quiet or by a need for external action, or by autocleptomania, or for some moral reason, he renounces what may be unique within himself, if he yields to those who claim that, without experience of life and awareness of responsibilities, there can be no human proposition, that without such a proposition there is no true self-possession, and if he disturbs in its potential revolutionary power the activity of those likely to be influenced by his earlier teaching,

> accuses Maurice Barrès of a crime against the safety of the mind.

Let us excerpt, too, these exchanges between Breton and Tzara who, faithful to his purely destructive program, chose to indulge in his habitual activity, whereas already Breton no longer understood the matter in this way:

[10] The court was as follows: president: André Breton; assessors: Th. Fraenkel and Pierre Deval; public prosecutor: G. Ribemont-Dessaignes; the defense: L. Aragon, Ph. Soupault (an odd defense, that demanded its client's head more insistently than the prosecution); witnesses: Tzara, Jacques Rigaut, Benjamin Péret, Marguérite Buffet, Drieu la Rochelle, Renée Dunan, Gonzague-Frick, Henri Hertz, Achille le Roy, Georges Pioch, Rachilde, Serge Romoff, Marcel Sauvage, Giuseppe Ungaretti, etc.

The witness, Tristan Tzara: You will agree with me, Sir, that we are all nothing but a pack of fools, and that consequently the little differences—bigger fools or smaller fools—make no difference.

The president, André Breton: Does the witness insist on acting like an utter imbecile, or is he trying to get himself put away?

The minutes continue: "The defense notes that the witness spends his time making jokes," obviously a capital sin in this undertaking.

This swift passage of arms between the founder of Dada and that of surrealism merely inaugurates the combat which will be joined by these two men, representing two different states of mind, two opposing "systems," one of which, historically speaking, needed the other to be born, but needed just as much to abandon the other in order to live. It was Barrès who was arraigned, of course, but the trial of Dada was also beginning.

As was proved the following year (1922) when Breton, feeling the need to take his bearings in relation to this agitation after the armistice and eager to clarify the new tendencies of "modern" art in a constructive direction, decided to convene an "international congress for the determination of the directives and the defense of the modern spirit." With this intention, he turned to men of an altogether different orientation: painters like Fernand Léger, A. Ozenfant, Delaunay, musicians like Georges Auric, writers like Paulhan. Tzara, invited, could only refuse politely.[11] For him, indeed, this was a stage already transcended: "Dada is not modern," he had said, it being understood that Dada repudiated modern art as well as traditional art, and art itself. But was a "Congress of the modern spirit" conceivable without Dada? Tzara's abstention caused the collapse of Breton's attempt and made the break definitive. The matter finally came to blows: Breton and Péret were physically abused during a performance of Tzara's *Coeur à gaz* (July 1923) which they had attended in order to demonstrate. Pierre de Massot escaped with a broken

[11] It is with great regret that I inform you that the reservations which I had formulated as to the very notion of the Congress do not change merely because I am to participate in it, and that it is quite unpleasant for me to be obliged to refuse the invitation you have extended to me.—Tristan Tzara, "Réponse à Breton."

arm, and Éluard, after having fallen into the scenery, received a bailiff's note demanding 8,000 francs damages.

It was with relief that Breton and his friends abjured Dadaism. Alongside petty attacks on Tzara, going so far as to contest his paternity of the word *Dada*, Breton clearly expressed the reasons for his decision. He notes, first of all, the death of Dada,[12] and no longer accepts the notion of following only stray impulses.[13] It is because Dadaism "like so many other things has been for some merely a way of sitting down" that Breton breaks out of the vicious circle and continues the march forward:

> Leave everything. Leave Dada. Leave your wife. Leave your mistress. Leave your hopes and fears. Leave your children in the woods. Leave the substance for the shadow. Leave your easy life, leave what you are given for the future. Set off on the roads.[14]

Fortunately, he is not alone. In passing he can greet his old friends:

> Picabia, Duchamp, Picasso are still with us. I grasp your hands, Louis Aragon, Paul Éluard, Philippe Soupault, my dear friends forever. Do you remember Guillaume Apollinaire and Pierre Reverdy? Isn't it true that we owe them a little of our strength?[15]

And he welcomes the newcomers:

> But already Jacques Baron, Robert Desnos, Max Morise, Roger Vitrac, Pierre de Massot are waiting for us. It shall not be said that Dadaism served any other purpose than to keep us in that

[12] "The cortège, scanty as it was, followed those of Cubism and Futurism, which the Beaux-Arts students drowned in effigy in the Seine. Dada, though it had, as we say, its hour of fame, left few regrets: in the long run its omnipotence and its tyranny had made it unendurable . . . If I abstained, last year, from participating in the manifestations organized by Dada at the Galerie Montaigne, it was because this mode of activity already no longer attracted me, because I saw in it the means of attaining my twenty-sixth, my thirtieth year without running a single risk, and because I decided to avoid anything that assumes the mask of such convenience . . ."—"Après Dada" (in *Les Pas perdus*).

[13] "Though our age is not one of strong concentration, must we abide by nothing more than stray impulses? . . ." *Ibid.*

[14] André Breton, "Lachez tout!" reprinted in *Les Pas perdus*.

[15] *Ibid.*

state of perfect availability in which we are and from which we shall now set out with lucidity toward what claims us for its own.[16]

One might say that, from this moment on, the new series of *Littérature* (March 1922–June 1924) has nothing more to do with Dada; it is the organ of a new current which no longer intends to confine itself to destructive agitation.

[16] *Ibid.*

CHAPTER 4

THE "STIMULATORS"
OF SURREALISM

*The science I am engaged in is a
science distinct from poetry. I am not
singing this latter. I am trying to dis-
cover its source. Through the helm that
steers all poetic thought, the billiard-
teachers will distinguish the develop-
ment of sentimental theses.*

—LAUTRÉAMONT

IN MATTERS OF REVOLT, none of us should need ances-
tors," Breton proclaimed in 1929.[1] Perhaps, but in matters of
poetry, the surrealists applied themselves to discover such ances-
tors, thus shedding new light on established poets, reviving
forgotten poets who did not deserve their oblivion. The criterion
of their choice, thereby proving the avowed or concealed in-
fluences they underwent, was formulated most lucidly by Tristan
Tzara in 1934:

Let us immediately denounce a misunderstanding that claimed
to classify poetry as a *means of expression.* The poetry which
distinguishes itself from novels only by its external form, the
poetry which expresses either ideas or sentiments, no longer
interests anyone. To it I oppose poetry as an *activity of the
mind* . . . It is perfectly evident today that one can be a poet
without ever having written a line, that there exists a quality
of poetry in the street, in a commercial performance, anywhere,
the confusion is great, it is poetic . . .[2]

[1] André Breton, *Deuxième Manifeste du Surréalisme.*
[2] Tristan Tzara, "Essai sur la situation de la poésie" (*Le Surréalisme au
service de la révolution,* No. 4).

Looking back in time, this new optic makes them admire the *fatrasies* of the Middle Ages, which mingle incoherence with a debauch of preposterous images.[3] Whereas the seventeenth century draws a total blank for the surrealists, the eighteenth century sees the birth of that spring which swells as it flows toward them in the form of the gothic novel (*roman noir*) which opposes its

> love of ghosts, witchcraft, occultism, magic, vice, dreams, madness, passions, true or invented folklore, mythology (even mystifications), social or other utopias, real or imaginary voyages, bric-a-brac, marvels, adventures and customs of savage peoples, and generally everything that exceeded the rigid frames in which beauty had been fixed so that it could be identified with the mind . . .[4]

to the logical and learned structures of the rationalists, whose truly revolutionary contribution the surrealists will nonetheless soon see. The only figures of this period they choose to contemplate are those of Horace Walpole, author of *The Castle of Otranto,* Ann Radcliffe, Maturin, M. G. Lewis, and of course the Marquis de Sade, who made his own life a veritable *roman noir.* The surrealists wove a legend around his name; for them he represented the highest and most stirring example. His lucid materialism, his search for the absolute in all forms of pleasure, notably in the sexual realm, his opposition to the traditional values and to those representing them, his gifts as a visionary, form the perfect figure of man as they conceived him.

With romanticism—French, English, and especially German— there burst into literature and art the taste not only for the strange, the bizarre, the unexpected which had constituted the substance of the *roman noir,* but the love of the ugly as opposed to the beautiful, dream, revery, melancholy, a nostalgia for every kind of "paradise lost" as well as the yearning to express the ineffable. In France, higher than the Victor Hugo of "Fin de Satan" and "Dieu," the surrealists place Aloysius Bertrand, the "agitators": Petrus Borel and Charles Lassailly, who give this

[3] *La Révolution surréaliste,* No. 6.
[4] Tristan Tzara, "Essai . . ." (*loc. cit.*)

"minor" romanticism its tonality of revolt, risk and authenticity, so different from the rhymed dissertations of Lamartine or Vigny. Above all, Nerval who described his own dream states as "supernaturaliste" and who so tragically transposed poetry into everyday life, proved to Tzara that poetry escapes the poem, that it can exist without it. Translator of Goethe's *Faust*, impenitent traveler, lover of the countries across the Rhine, Nerval at his best supplies the link with that dreamy, mystical, idealist, metaphysical German romanticism,[5] that had found its expression a few years earlier in Jean Paul's dreams, in Novalis' *Hymns to the Night*, in Hölderlin's poems and in Achim von Arnim's fantastic tales. The German romantics opened a new realm which the surrealists were to explore lovingly, before turning away in the name of more efficient researches, for they decided it was not these "dreamers" who could break the prison in which man is confined; with a few exceptions, notably von Arnim, the German romantics escape upward, by means repugnant to Breton and his friends.

We must wait for Baudelaire, "first seer, true poet,"[6] to *show the way*. He could do no more, caught still in the formal preoccupations of an art which he carries of course to perfection, but which he spoils, too, in the surrealists' eyes, by a cheap romanticism, a "corrupt satanism." For them, the real Baudelaire is to be found less in *Les fleurs du mal* than in the *Scènes parisiennes* and the *Poèmes en prose*, where he was able to express that mysterious side of everyday life which is the true surrealist domain. And if he was able to show the way, it was because of his "opposition to the bourgeois world"[7] which sent him to the barricades of June 1848, his "spiritual appetite, his continual dissatisfaction,"[8] his search for "something more" which he was vainly to pursue all his life.

The immediate or remote successors of Baudelaire, with the exception of Lautréamont, Rimbaud and Jarry (whom we must

[5] Cf. Albert Béguin's, *L'âme romantique et le rêve* (Corti).
[6] Rimbaud.
[7] Tzara, "Essai . . ." (*loc. cit.*)
[8] *Ibid.*

discuss separately, by reason of their determining influence on surrealism) applied their efforts to the form of the poem, which they aimed at liberating from traditional molds, or to language, which they sought to make into a more precise instrument. In most cases quite consciously, which diminishes the range of their attempt. In this sense, Mallarmé's contribution—"disintegrating the hard cement of a fortress that appeared impregnable: syntax"[9] —was not vain. We know in what esteem Breton first held him; we know too how quickly he turned from him. Not negligible either were the contributions of Charles Cros, Huysmans, Germain Nouveau; but alongside certain poetic discoveries, rare words, momentary breaks toward the "azur," how much dross, how many affectations and literary poses! Defects that were multiplied in the symbolist school which, in the surrealists' eyes, cut a "paltry figure."[10] From it they except the official introduction of free verse, a few poems from Maeterlinck's *Serres chaudes,* most of the work of Saint-Pol-Roux. The night of oblivion has already swallowed Stuart Merrill, René Ghil, Viélé-Griffin. Poetry does not ask for knights-errant, it demands lovers who can, if necessary, violate her. None do so better than Alfred Jarry, Arthur Rimbaud, Isidore Ducasse, Comte de Lautréamont. All three, for different reasons but with the same desperate enthusiasm, identified their lives with that of poetry, bringing it down from the pedestal on which it had been set to roost and embracing it in love's wildest transports.

Jarry, confusing in a perpetual hallucination his own existence with that of Père Ubu, identifying himself with his creation in every detail, to the point of forgetting his civil status, signifies the eruption into life of humor, the supreme value of "those who know": that humor which he managed to exude with even his last breath.[11] Ubu, "admirable creation for which I would give

[9] *Ibid.*

[10] Tristan Tzara, "Essai . . ." (*loc. cit.*)

[11] "During the last visit I paid him, I asked if he wanted anything; his eyes brightened; yes, there was something that would please him greatly. I assured him he would have it at once. He spoke: 'something' was a toothpick."—Dr. Saltas: Preface to *Ubu Roi.*

all Shakespeare and a Rabelais" (Breton), is the bourgeois
of his time, and still more of ours.[12] He coagulates in himself the
cowardice, the ferocity, the cynicism, the disdain for the mind
and its values, the omnipotence of *la gidouille* (the belly). He is
the prototype of a class of tyrants and parasites the extent of
whose misdeeds Jarry, dead too soon, was unable to contemplate.

The answer to Père Ubu is Docteur Faustroll, *savant pata-physicien*, imperturbable logician, carrying to their ultimate con-
sequences the "speculations" of the geometricians, physicists,
and philosophers, and quite at ease in a world grown utterly
absurd. For even more than the types created, it is the atmosphere
of Jarry's work which is unique and inimitable. Humor is the
fourth dimension of this world, without it futile and unlivable. It
seems to sum up Jarry's testament. A secret conquered at the
cost of long suffering, humor is the answer of superior minds to
this world in which they feel themselves alien. More than a
natural secretion, as it has too often been regarded, humor mani-
fests, on the contrary, the heroic attitude of those who are un-
willing to compromise. It is as far from the famous "romantic
irony" that considers with a detached expression and from a supra-
terrestrial world the unimportant events of this one, as from the
cubist and futurist fantasies, diversions of esthetes or bohemians
who still imagine they have a part to play. Jarry never played a
part, any more than he lived his life. He made himself another
life, a marginal one which he fulfilled perfectly. He thus set an
example difficult to follow, one which Vaché had assimilated and
which the surrealists, through him, attempted on occasion to imi-
tate.

Rimbaud had expressed the same experiment on a tragic level.
It is one we can follow through his work and his life. Starting out
with imitations of Victor Hugo, he ends with silence, scorn-
fully condemning his dazzling poetic career. For the surrealists,

[12] "M. Ubu is a Papal Count, of course. M. Ubu does not conceive of the
possible utility of the railroads. M. Ubu picks on his enemies. M. Ubu weighs
heavily on the colonial empire and oppresses it. M. Ubu is fierce, without
subtlety, he isn't really cruel! His nastiness is more a kind of violence.
M. Ubu is an intestinal intelligence of genius. As Jarry would say, he
governs by his 'instinct.'"—Sylvain Itkine: Program for the performance
of *Ubu-enchaîné* (1937).

he represented the very graph of art, figuring even its future destiny. "There roam the world today certain individuals for whom art, for instance, has ceased to be an end," Breton said in 1922.[13] Rimbaud was one of these. "His work deserves to stand like a sentry on our route," he added, for it expressed "a difficulty which doubtless thousands of generations have not avoided, and to it imparts that voice which still echoes in our ears": the eternal questions of man's destiny—"why were we made, what can we consent to serve, must we abandon all hope?.," questions to which philosophies and religions have given disappointing answers, questions perpetually asked by "free" men and which, for the surrealists, constitute the issue.

To answer them by poetic behavior, such was their ambition. They wanted, like Rimbaud, "to knock at the doors of creation" with, on the strength of his experience, a few less illusions. After Rimbaud, it became impossible not to appeal to the authority of his work, and the surrealists have been his consistent disciples.

> For *I* is someone else. If the brass wakes up as a bugle, it is not any fault of its own. This is evident to me: I observe the flowering of my thought: I watch, I listen to it: I make a stroke of the bow: the symphony stirs in the depths, or bounds out onto the stage.

Was he not formulating here the true nature of inspiration, which is not a voice from "on high," from some mystical heaven, but from the "depths" of being, from the unconscious, to which the surrealists were to fling wide the gates? "If what it brings back from *there* has form, it gives form; if it is formless, it gives the formless." The important thing is not to break the current, to maintain this activity outside the preoccupations of art and beauty. The goal is worth the trouble: it is a matter of nothing less than reaching the unknown. With this intention, the poet makes himself "a seer," a "thief of fire," a "multiplier of progress," at the cost of a "horrible labor":

> The poet becomes a seer by a long, enormous and reasoned *derangement of all his senses*. All the forms of love, of suffering, of madness. He seeks himself, he exhausts in himself every poison, retaining only their quintessences. Ineffable torture, in

[13] André Breton, "Caractères de l'évolution moderne" (in *Les Pas perdus*).

which he requires supreme faith, superhuman strength, in which he becomes among all men the great invalid, the great criminal, the great accursed—and the supreme sage! . . .

Rimbaud was not able to realize this ambitious program. It seems that, having reached the gates of the unknown, he lost his nerve, turned away. Perhaps we must see in this failure the source of the disfavor he eventually found with Breton, who "took leave" of him, in 1929, with these words:

> He is guilty in our eyes of having allowed—of having not made entirely impossible—certain dishonoring interpretations, Claudel's for instance, of his thought.[14]

But what is to be said in this regard of Germain Nouveau, of Apollinaire, and of others?

Lautréamont's star, on the other hand, never suffered an eclipse. "Incumbent to a major degree upon this man is the responsibility for the present poetic state of affairs," Breton said in 1922.[15] In 1929, at the height of an iconoclastic fury that spared neither Rimbaud, nor Baudelaire, nor Poe, Breton still maintained:

> I insist upon specifying that, as I see it, we must distrust the cult of men, however great they may appear to be. With one exception, Lautréamont, I know of none who has not left some equivocal trace of his passage.[16]

and in 1934, Tzara could still describe Lautréamont as:

> He who transcends the problem [of poetry as a means of expression or as an activity of the mind] to the point of remaining truly alive among us, a fabulous being who yet is familiar to us, for whom poetry seems to have surpassed the stage of mental activity to become in truth a dictatorship of the mind.[17]

It is to him that the surrealists will appeal most frequently; it is his work that they will try to equal by their own. He, more than

[14] André Breton, *Deuxième Manifeste du Surréalisme* (in a footnote).

[15] André Breton, "Caractères de l'évolution moderne" (*loc. cit*): ". . . His was an attitude toward the world which hurled defiance at every enterprise of vulgarization, of self-seeking classification, every impulse of opportunism, which derived from only the eternal. We oppose, we continue to oppose the placing of Lautréamont in history, his assignment to a place between This figure and That one . . ." Aragon, Breton, Éluard (*Lautréamont envers et contre tout,* tract on the occasion of a new edition of his works.)

[16] André Breton, *Deuxième Manifeste* . . .

[17] Tristan Tzara, "Essai . . ." (*loc. cit.*)

any other, has truly been the inspiration of the movement. Let us
turn to Breton once more:

> For Ducasse, the imagination is no longer that abstract little
> sister who skips rope in a square; you have seated her on your
> knees and you have read your perdition in her eyes. Listen to
> her. You will think at first that she doesn't know what she is
> saying; she knows nothing, and in a minute, with that little
> hand you kissed, she will caress in the darkness the hallucina-
> tions and troubles of the senses. No one knows what she wants,
> she makes you aware of several other worlds at once, until soon
> you don't know how to behave in this one. Thus is instituted
> the trial of everything all over again . . .[18]

And it is apropos of the *Chants de Maldoror* that Breton wrote
this key sentence for surrealist activity: "We know now that
poetry must lead somewhere."[19] The surrealists required nothing
less than Lautréamont's guarantee to "satisfy [their] will to
power" in the "literary realm." Which shows how high they placed
him, and indicates his determinant and continuing influence.
Compared to his, the other influences we have enumerated remain
minor and episodic.

[18] André Breton, "Caractères . . ." *(loc. cit.)*
[19] André Breton, "Les Chants de Maldoror" (in *Les Pas perdus*).

THE HEROIC PERIOD
1923—1925

CHAPTER 5

THE PERIOD OF TRANCES

Who's there? Ah, splendid, show in the
infinite. —ARAGON

THE formal break that Breton, Aragon, Éluard, and Péret made with Dadaism occurred in 1922, following the failure of the "Congress for the determination of directives and the defenses of the modern spirit." This break had been made necessary by the antagonistic preoccupations of Breton and Tzara. Still, the specific ideas of individuals count less than the objective conditions that make them act. Tzara wanted to prolong artificiality, on the ideological level, the anarchic state of the armistice. Now this state appeared merely a transition to a new economic, social, and political stabilization of Europe that would last for at least several years. New ways of thinking were being created by scientific, philosophical, and psychological discoveries of Einstein, Heisenberg, Broglie and Freud, who were inaugurating a new conception of the world, of matter, and of man. The notions of universal relativism, of the collapse of causality, of the omnipotence of the unconscious, breaking with the traditional notions based on logic and determinism, imposed a new point of view and suggested fruitful and dedicated research that rendered protest futile and agitation sterile. In short, Dada had emerged victorious: now it was a question of exploiting, not enjoying its triumph.

Breton's genius was to have had the intuition of the new point of departure. By remarking that Dada had been merely a "state of mind"[1] for himself and his friends, he wanted to make it clear that if they had participated in the movement, they were now passing it by. He expected to escape Dada by surmounting it.

[1] André Breton, *Après Dada* (reprinted in *Les Pas perdus*).

The fact still remains that, thanks to Dada, surrealism in its early days rejected the literary, poetic, or plastic solution. Dada had dealt art so powerful a blow that it was not to recover for several years. The surrealists' ambition was not to build a new esthetic upon its ruins. It has been noted that art ultimately found a place within surrealism. This was not entirely the fault of the surrealists. The movement was envisaged by its founders not as a new artistic school, but as a means of knowledge, a discovery of continents which had not yet been systematically explored: the unconscious, the marvelous, the dream, madness, hallucinatory states—in short, if we add the fantastic and the marvelous as they occurred throughout the world, the other side of the logical decor. The final goal remained the reconciliation of two hitherto warring realms: man and the world. The accent, perhaps in reaction to Dada's destructive anarchism, was on the systematic, scientific, experimental character of this new method. The first surrealist work, *Les champs magnétiques* (1921), written by Breton and Soupault in collaboration, was offered as an experiment, in the scientific sense of the term, not as a new piece of "avant-garde" literature. One source of confusion: this new method of knowledge mistrusted the habitual procedures of scientific method, in this case the logical apparatus, and resorted to the means traditionally utilized by the poets: intuition, inspiration, chiefly concretized in images.

There was no evidence, as the surrealists aspired to prove, that these methods were inferior to their predecessors. In fact, they claimed for them an infinitely greater value.[2]

[2] ". . . The logical methods of our time no longer apply except to the solution of secondary problems. The absolute rationalism still fashionable permits consideration only of facts closely related to our experience . . . Needless to add that experience itself has been assigned limits. It inhabits a cage increasingly difficult to coax it out of. Experience too relies on immediate utility and it is guarded by common sense . . . By virtue of these [Freud's] discoveries, a current of opinion is finally appearing by means of which the human explorer can extend his investigations, henceforth authorized to take into account more than superficial realities. But it is important to note that no means is indicated *a priori* for the conduct of this enterprise; that until further notice it may be regarded as the resource of poets as well as of scientists; and that its success does not depend on the more or less capricious paths taken . . ." André Breton, *Le Surréalisme et la peinture* (1928).

Long after the founding of the movement, this determination to experiment in the domain discovered by Freud persisted. It is from this point of view that we must judge the poetic and plastic results they achieved, and not according to canons of art and beauty which they did not accept from the outset.

We know how Breton first came to suspect the existence of the strange realm which he and his friends were to explore for years on end:

It was in 1919 that my attention was fastened upon the more or less partial phrases that, in utter solitude, as sleep approached, became perceptible to the mind without its being possible to discover in them (without a rather elaborate analysis) a previous determination. One evening, in particular, before falling asleep, I perceived distinctly articulated—so that it was impossible to change a word—but absent nonetheless from the sound of any voice, a rather strange phrase that came to me without bearing a trace of the events with which, by the admission of my consciousness, I happened to be concerned at that moment, a phrase that seemed insistent, a phrase, I should say, that *knocked at the window*. I rapidly noted it and was about to pass on when its organic character arrested me. In truth, this phrase astonished me; I have not, unfortunately, remembered it to this day, but it was something like: "There is a man cut in two by the window," yet it offered no ambiguity, accompanied as it was by the faint visual image of a walking man truncated at the waist by a window perpendicular to the axis of his body. No doubt about it, what was involved was the simple righting in space of a man leaning out of a window. But this window having followed the man's shift of position, I realized that I was dealing with an image of a rather rare type which I decided to incorporate into my stock of poetic constructions. I had no sooner accorded it this credit than, in fact, it was followed by a continuous series of phrases which surprised me no less and left me under the impression of an extreme gratuitousness . . .

Obsessed as I still was with Freud at this period, and familiar with his methods of analysis, which I had had some occasion to practice upon patients during the war, I determined to obtain from myself what one attempts to obtain from them—a monologue spoken as rapidly as possible, on which the subject's critical spirit brings no judgment to bear, which is subsequently unhampered by reticence, and which is, as exactly as possible, *spoken thought*. It had seemed to me, and seems still—the way

in which the phrase about *the man cut in half* had come to me bore witness to it—that the speed of thought is not greater than that of speech, and that it does not necessarily defy the tongue, nor even the pen. It was under these conditions that Philippe Soupault, to whom I had confided these first conclusions, and I undertook to "write" with a praiseworthy scorn for what might follow in literary terms . . ."[3]

Following the example of Breton and Soupault, all the surrealists enthusiastically began conducting similar experiments. This was the period of the first automatic texts, which begins with Dada, and no one has described its amazing revelations better than Aragon:

> What strikes them is a power that they did not know they had, an incomparable freedom, a liberation of the mind, an unprecedented production of images, and the supernatural tone of their writings. They recognize, in everything they produce in this fashion, without feeling that they are responsible for it, the incomparable quality of the few books, the few words that still move them. They suddenly realize a great poetic unity that proceeds from the prophetic books of all peoples to *Les Illuminations* and *Les Chants de Maldoror*. Between the lines, they read the incomplete confessions of those who once *maintained the system:* in the light of their discovery, *Une Saison en Enfer* sheds its riddles, along with the Bible and several other confessions of man that lay hidden under their masks of images . . ."[4]

Nor has anyone been able to express so well that impassioned joy which possessed these explorers confronting their finds, this first booty wrested from the unknown,[5] or to retrace the strange effect of the experiment upon them: hallucinations, hypnosis, sympathetic magic, alienation from life as it is led by other men.[6]

[3] André Breton, *Manifeste du surréalisme* (1924).
[4] Aragon, *Une vague de rêves*, in *Commerce* (Autumn 1924).
[5] "It was a time when, meeting in the evening like hunters after a day in the field, we made the day's accounting, the list of beasts we had invented, of fantastic plants, of images bagged . . ." *Ibid.*
[6] "First of all, each of us regarded himself as the object of a special disturbance, struggled against this disturbance. Soon its nature was revealed. Everything occurred as if the mind, having reached this crest of the unconscious, had lost the power to recognize its position. In it subsisted images that assumed form, became the substance of reality. They expressed themselves according to this relation, as a perceptible force. They thus assumed the characteristics of visual, auditive, tactile hallucinations. We experienced

The first results of these frenzied experiments were not negligible; they recognized by the daily practice of automatic writing:

the existence of a mental substance whose similarity to hallucinations and sensations obliged us to regard as different from thought, of which thought could be, and in its apparent modalities as well, only a particular case . . .

Then, it appeared to them, thanks to a brief spiritualistic initiation by René Crevel, that the hypnotic trance was capable, with even more guarantees, if possible, of revealing in its purity and its integrity that vast dark continent whose marvels they had glimpsed. It was then, at the end of 1922, that

an epidemic of trances broke out among the surrealists . . . There were some seven or eight who now lived only for those moments of oblivion when, with the lights out, they spoke without consciousness, like drowned men in the open air . . ."[7]

André Breton, in an issue of *Littérature*, wrote the first account of these sessions during which René Crevel, Robert Desnos, and Benjamin Péret spoke, wrote, drew like true automatons, animated by a prophetic frenzy.[8]

Soon there was no further need for preliminary steps. Some, like Robert Desnos, fell asleep at will:

In a café, amid the sound of voices, the bright light, the jostlings, Robert Desnos need only close his eyes, and he talks, and among the steins, the saucers, the whole ocean collapses with its prophetic racket and its vapors decorated with long oriflammes. However little those who interrogate this amazing sleeper incite him, prophecy, the tone of magic, of revelation,

the full strength of these images. We had lost the power to manipulate them. We had become their domain, their subjects. In bed, just before falling asleep, in the street, with eyes wide open with all the machinery of terror, we held out our hand to phantoms . . . We experienced this mental substance in its concrete power, its power of concretion. We saw it pass from one state to another, and it was by these transmutations which revealed its existence to us that we were also informed of its nature. We saw, for example, a written image which first presented itself with the characteristic of the fortuitous, the arbitrary, reach our senses, lose its verbal aspect to assume those fixed phenomenological realities which we had always believed impossible to provoke." *Ibid.*

[7] *Ibid.*

[8] See Surrealist Periodicals, etc., pp. 325-331.

of revolution, the tone of the fanatic and the apostle, immediately appear. Under other conditions, Desnos, were he to cling to this delirium, would become the leader of a religion, the founder of a city, the tribune of a people in revolt.[9]

But Desnos' remarkable ease in expressing himself, by whatever means, was already well known, and some wondered if he was not simulating trance. Actually a question of no importance, to which Aragon replied:

> Is simulating a thing any different from thinking it? And what one thinks exists. You will not alter my conviction on this. Besides, how can simulation account for the inspired character of the spoken dreams that paraded past me.[10]

Precisely. What is harder to accept are Aragon's explanations of this phenomenon at the time, explanations which he was not the only one to propose, and which lead us to accuse surrealism, at least initially, of having fallen prey to a highly suspect idealism.[11] Why appeal for help to the Beyond, to metempsychosis? It was no use bringing *inspiration* back down to earth merely to escape into the supernatural all over again, apropos of phenomena which psychoanalysis, among other disciplines, explained at that very time.

Automatic texts and speeches made in a state of trance were complemented by accounts of dreams: nocturnal dreams, daydreams, immediately expressed—by Desnos, for instance, who had no need to sleep to dream, and "to speak his dreams" at will.

Let us measure the ground covered since the time when man could express himself only by means of logical artifices. Henceforth surrealism could boast of having extended a certain number of frontiers.

[9] Aragon, *Une vague de rêves, op. cit.*
[10] *Ibid.*
[11] "The great shock of such a performance necessarily required frenzied explanations: the Beyond, metempsychosis, the marvelous. The price of such an interpretation was incredulity and sneers. In truth, they were less false than was supposed. . . ." *Ibid.*

THE FOUNDATION OF
THE MOVEMENT

*Tell yourself that literature is the sad-
dest path that leads to everything.*
 —ANDRÉ BRETON
*Artistic skill is a mummery that com-
promises all of human dignity.*
 —ARAGON

A RAGON'S *Une vague de rêves,* published in 1924, summa-
rizes the surrealist activity for 1922-1923, as expressed in
Littérature, which remained the movement's organ until June
1924. In it occur the already familiar names of Picabia, Breton,
Aragon, Éluard, Péret, Jacques Baron, Max Ernst (who had come
from Germany and was successfully employing collage technique
already utilized by Picasso) and Desnos, who under the pseudo-
nym of Rrose Sélavy (borrowed from Marcel Duchamp) repro-
duced trance-phrases for which he was quite unable to provide
an equivalent in a waking state. "Word games of a mathematical
rigor" from which the "comic element was entirely lacking,"[1]
games to which Breton attached an extreme importance, for they
showed that words had their own lives, that they were "creators
of energy," and that they could henceforth "command thought."[2]
For in the domain of language, the experiments begun by Lautréa-
mont, Mallarmé, Apollinaire, and continued by Picabia, Paulhan,
and Éluard also advanced.

[1] "In a temple of apple plaster, the pastor distilled psalm cider."
[2] André Breton, *"Les mots sans rides,"* in *Littérature* (reprinted in *Les
Pas perdus*).

New forces had arrived to swell the surrealist ranks: Georges Limbour, André Masson, Joseph Delteil, Antonin Artaud, Mathias Lübeck, J.-A. Boiffard, Jean Carrive, Pierre Picon, Francis Gérard, Pierre Naville, Marcel Noll, Georges Malkine, Maxime Alexandre, etc. Almost all were young, some were even adolescents, and it was with a splendid ardor that they dashed along the trail blazed by Breton, who henceforth assumed the lead, indeed the command, by reason of his theoretical contribution, and also because of the special magnetism of his person, which few of those close to him have been able to withstand. His face was massive, noble, majestic, and at this period he protected his eyes behind green glasses, out of a desire to astound. Occasionally he replaced them with a monocle. His fame was already great.

Despite his youth, Breton was not playful: he rarely laughed and his gestures were severe. Those who were not fond of him began calling him The Pope on account of his majestic airs. It was not respect he demanded, but a sense of seriousness in love. And all these men loved him madly: "like a woman," as Jacques Prévert was to say. Those who enjoyed the moments of his unforgettable friendship, which he begrudged no one, were ready to sacrifice everything to him: wife, mistresses, friends; and some, in fact, did sacrifice these things. They gave themselves entirely to him and to the movement.[3]

The year 1924 saw the official foundation of the surrealist group. It is often said of a movement that it is "in the air," and it is true that such was the case with this one. Not only around Breton, but nearly everywhere else, attempts were made to collaborate with a view to a new and effective work. Apollinaire had already coined the word. The first issue of a review edited by Yvan Goll was published: *Surréalisme*.[4] Ultimately the movement aggregated

[3] Maurice Martin du Gard wrote in *Les Nouvelles Littéraires* (October 11, 1924), apropos of Breton: ". . . He is one of the most attractive figures of the generation now reaching thirty, and of an intellectual stature evidently superior to that of Goll and Dermée, whose surrealist manifestos are less debatable than his . . . He has the bearing of an inquisitor; what tragic deliberation in his eyes, his gestures! And he is a magus. Perhaps indeed a story-book variety, with the magnetic authority over his disciples of an Oscar Wilde . . ." Breton was not to forgive Martin du Gard these *double entendres*.

[4] Among the contributors: Marcel Arland, P. Albert-Birot, René Crevel, Joseph Delteil, Robert Delaunay, Paul Dermée, Jean Painlevé, Pierre

around Breton, rich in unique experiences and alone capable of giving it its charter: the *Manifeste du surréalisme*. Moreover the group had its own premises: the *Bureau de recherches surréalistes*, at 15, Rue de Grenelle and, starting December 1, its own organ: *La Révolution surréaliste*. It also manifested itself by leaflets with disturbing or incendiary texts[5] and by an extremely virulent pamphlet against Anatole France who died that year, while an intense life, especially marked by an escapade of Paul Éluard's, agitated all its members.

THE SURREALIST MANIFESTO

> *When you're dry, Apollinaire used to advise his friends, write anything, any sentence, and forge straight ahead.*
> —ANDRÉ BILLY, *Apollinaire vivant.*

We have already discussed Breton's generating ideas closely enough to have no need to examine the *Manifeste du surréalisme* in detail. Let us nonetheless review its essential characteristics: an attack first of all upon a realism "hostile to any intellectual and moral advance," and of which Breton had a horror because he found it consisted of nothing but "mediocrity, hatred and banal complacency." Then an attack on the productions such realism engenders, notably on the *novel*, which had become the privileged form of literature to which each author added, in the course of endless pages, a vacuum of niggling descriptions to the banality of his characters. No risk was taken, and the outcome could not be anything but indifferent by its avoidance of the problems of man and his destiny.[6] Was it the fate of literature to afford a

Reverdy. Apollinaire was also annexed. It opened with a *Manifeste du surréalisme,* from which we isolate the following definition: "The transposition of reality to a higher (artistic) level constitutes surrealism." Evidently this version of surrealism is worlds apart from Breton's.

[5] *See* Surrealist Periodicals, etc., pp. 325-331.

[6] "An amusing result of this state of affairs in literature, for instance, is the abundance of novels. Here everyone has his little 'observation' to make . . . a style of information, pure and simple . . . the circumstantial, pointlessly specialized character of each of their notations . . . tedium of the descriptions. I have too unstable a notion of life's continuity to make my

recreation scarcely superior to a game of bridge, and could one afford to be interested in the life of more or less well-controlled puppets?

Why had the novel become the almost universal form of literature? Because it satisfied its readers' appetite for logic, affording them the pleasure, even and especially when wretched passions were involved, of adding and subtracting forces, as in mechanics. Because it required, of its creator, only the setting-in-motion of logical faculties. All that was necessary was a setting scrupulously described (O Balzac!), carefully reduced characters with suitable names and ages, whose interrelations were in no danger of engendering the miracle.

Was it for such a ridiculous use that man was given language? Was he not, rather, to make a "surrealist use" of it? To give form to that imagination which each of us bears in himself, which is alone capable of entering the domain we cannot penetrate without it. *Folle du logis!*, the madwoman on the premises, as the French call the imagination. A logician believed that by this supposedly insulting epithet he could cast suspicion upon it, though it is all too sane, too far this side of madness—the real kind, the kind that is locked up—for the spectacle of its freedom not to scandalize and contaminate the hosts of pathetically rational men.[7] Could such men take their dreams seriously, give themselves up to them, believe that they are true? When will man, greedy for the small change of his reason, stop neglecting the treasures of his dreams?[8]

moments of depression, of weakness equivalent to the best . . . I do not take into account the blank moments of my life . . . on the part of every man, it may be unworthy to crystallize those which seem so to him. A simple game of chess that utterly fails to interest me—man at his average level being a mediocre adversary for me. What I cannot endure are those pathetic arguments about this move or that, once there is no question of either winning or losing . . ." —André Breton, *Manifeste* . . .

[7]"To reduce the imagination to slavery, even by what is crudely called happiness, is to avoid all one finds, deep within oneself, of supreme justice. Imagination alone accounts to me for what *can be,* and this is enough to raise the terrible prohibition; enough, too, for me to abandon myself to it without fear of deceiving myself . . .

"I could spend my life provoking the confidences of madmen; they are people of scrupulous honesty, whose innocence is equalled only by my own. Columbus had to set out with madmen in order to discover America. And see how this madness has taken shape and permanence . . ." *Ibid.*

[8] "Man that definitive dreamer . . ." *Ibid.*

When will he realize that this treasure has been given to him, and for all his nights? By taking as much inspiration form it as from his reasoning faculties, by wedding two states that are contradictory only in appearance, he could achieve the absolute reality, surreality,[9] that Golden Fleece which the Argonaut-surrealists had set out to win. They would find, they had already found on the road leading to it the *marvelous,* the reflection and perhaps the essence of what they were to discover.[10]

Alone? No. These realms are not closed. On the contrary they are open to all. It is poetry that points the way. But poetry practiced according to a certain method: that of automatism, developed by surrealism and defined by Breton:

> Surrealism. *n. masc.* pure psychic automatism, by which an attempt is made to express, either verbally, in writing or in any other manner, the true functioning of thought. The dictation of thought, in the absence of all control by the reason, excluding any esthetic or moral preoccupation.
> *Philos. Encycl.* Surrealism rests on the belief in the higher reality of certain hitherto neglected forms of association, in the omnipotence of the dream, in the disinterested play of thought. It tends to destroy the other psychical mechanisms and to substitute itself for them in the solution of life's principal problems . . .

The conception of a surrealist voice, which some hear to the exclusion of others who refuse to do so, led to the rejection of talent, literary or otherwise. The surrealists were the first to proclaim that they had no talent,[11] that talent does not exist. For what is talent? The given or acquired possibility of subtly or powerfully adjusting little stories, discovering ingenious ways of telling what exists, inventing at best rare sounds. Down with the writer,

[9] "I believe in the future resolution of these two states, in appearance so contradictory, which are dream and reality, in a kind of absolute reality, *surreality,* one might call it. It is toward this conquest that I proceed, certain of not attaining it but too unconcerned with my own death not to count somewhat on the joys of such a possession . . ." *Ibid.*

[10] "Once and for all: the marvelous is always beautiful, anything marvelous is beautiful; in fact, it is only the marvelous that is beautiful . . ." *Ibid.*

[11] "We have no talent . . . we who have made ourselves, in our works, the deaf receptacles of so many echoes, the modest *recording devices* that are not hypnotized by the designs they trace . . ."—André Breton, *Manifeste. . . .*

down with the poet, down with man himself! "The self is more hateful here than anywhere else" because its heavy mass chokes the mouth of the cavern from which all these overwhelming voices proceed. They are here around us; there is no need of a trained ear to hear them, it is enough to listen, it is enough to be docile. And what an absurd pretension to exercise some right over them! Is the poet who listens to his own unconscious of any account in the latter's magnificence? Everyone is a poet once he agrees to obey orders, and if surrealism means no more than this "obedience," everyone can practice this "magic art"; its formula is of an absurd simplicity; "Surrealism is within the compass of every unconscious":[12]

> Secrets of the surrealist magic art. Written surrealist composi-
> tion, or first and last attempt: Have someone bring you writing
> materials after getting settled in a place as favorable as possi-
> ble to your mind's concentration on itself. Put yourself in the
> most passive, or receptive, state you can. Forget about your
> genius, your talents, and those of everyone else. Tell yourself
> that literature is the saddest path that leads to everything.
> Write quickly, without a preconceived subject, fast enough not
> to remember and not to be tempted to read over what you
> have written. The first sentence will come all by itself . . . It
> is rather difficult to make a decision about the next . . . But it
> shouldn't matter to you anyway. Continue as long as you like.
> Trust in the inexhaustible character of the murmur. If silence
> threatens to take over because you have made a mistake . . .
> following the word whose origin seems suspect to you, put
> down any letter, the letter l for instance, always the letter l,
> and restore the arbitrary by imposing this letter as the initial
> of the word that will come next . . ."[13]

Does this mean that all who apply it will become great poets thereby, that discoveries will appear thick and fast before their dazzled eyes? The range of the splendors of our unconscious is

[12] André Breton, Manifeste . . .

[13] Aragon put matters quite clearly a few years later: "Surrealism is in-
spiration recognized, accepted and practiced. No longer as an inexplicable
visitation, but as a faculty that is exercised. Normally limited by fatigue.
Of a variable scope, depending on individual forces. And whose results are
of an unequal interest . . . Thus the content of a surrealist text is decisively
important, it is what gives it a precious character of revelation. If you write,
by a surrealist method, wretched idiocies, they will be wretched idiocies.
Without excuses . . ." Aragon, Traité du style (1928).

infinite, and if its liberation is nothing but inspiration, inspiration is not the same for the same individual at every moment of his life, of his day. It has its diseases, its exhaustions; it differs particularly according to individuals. On the other hand, those who possess a lively and rich inspiration henceforth have the means of translating it into dazzling images, startling comparisons, of performing, in fact, continuously and no longer in a momentary fashion, the act of a poet, of exploring the unknown with the same facility with which the reasoning faculties permit man to control himself in practical life.

This was to be the means most often employed by the surrealists, though not always and not by all, (Éluard, for example, practiced automatic writing very little), and which was to produce, depending on the individuals involved, unequal results, fruits not of different talents but of variously rich unconsciouses. If a whole portion of surrealist production has become, and why deny it? unreadable, it has, nevertheless, for some, played its revealing role, produced works on a level with the most inspired of all time. Poetry becomes a practice which reveals the personality in its integral wholeness and its authenticity, which influences others by means of mysterious communications. The poet "inspires," provokes new acts, unknown thoughts, transfigured lives. He no longer works in an ivory tower, he secretes poetry naturally into the everyday life of which he is a part and from which he constantly seeks new stimuli.

THE CENTRALE SURRÉALISTE

We must regard this conception of poetry as one of the main reasons for the creation of a Bureau of Surrealist Research open to all who had something to say, to confess, to create, and who, caught in the meshes of a banal existence, dared not free themselves of the burden that was crushing them. The experiences they contributed enlarged the surrealist scope; those they examined increased the number of adherents and the force of the movement. The *centrale surréaliste* fully deserved its name. It was the generator of new energies. Aragon, who has traced the history of this period, described it in these terms:

We hung a woman on the ceiling of an empty room, and every day received visits from anxious men bearing heavy secrets. This was how we came to know Georges Bessière, like a blow of the fist. We were working at a task enigmatic to ourselves, in front of a volume of Fantomas, fastened to the wall by forks. The visitors, born under remote stars or next door, helped elaborate this formidable machine for killing what is in order to fulfill what is not. At number 15, Rue de Grenelle, we opened a romantic Inn for unclassifiable ideas and continuing revolts. All that still remained of hope in this despairing universe would turn its last, raving glances toward our pathetic stall. It was a question of formulating a new declaration of the rights of man.[14]

Press releases were issued. Each "leaflet" carried the address of the Bureau. The greatest agitation let it be known that there existed in Paris, well on in the twentieth century, a laboratory of a new kind where all could contribute to the invention of a new life. An advertisement in the papers specifies that the *centrale surréaliste* is nourished by life itself, that it receives all bearers of secrets: inventors, madmen, revolutionaries, misfits, dreamers. Their confidence would form the raw material of a new alchemy, and the philosophers' stone will be given to all. Georges Bessière and Dédé Sunbeam were among those who, having answered the siren's call, could not cast off her charms; they became active members of the movement.

Its organ, *La Révolution surréaliste,* differed considerably from an ordinary literary magazine. It was deliberately severe in appearance, imitating that of a scientific periodical. Pierre Naville, its co-editor with Benjamin Péret, had sought this resemblance to a magazine like *La Nature,* a well-known scientific journal. There was little likely to catch the eye: a few drawings, a few photographs; no typographical experiments; deliberately neutral titles for articles; unexceptionable signatures. A subtle camouflage! Despite this determination to concede nothing to the pleasure of the eyes, *La Révolution surréaliste* was to become "the most scandalous magazine in the world."

The cover was embellished with this prefatory declaration: "We must formulate a new declaration of the rights of man," while on the back was printed the following:

[14] Aragon, *Une vague de rêves (loc. cit.).*

Surrealism does not present itself as the exposition of a new doctrine. Certain ideas which serve it today as a point of departure must not be allowed to prejudice its later development. This first number of *La Révolution surréaliste* offers no final revelation. The results obtained by automatic writing, by the account of dreams, for instance, are represented here, but no result of research, experiments, or works is as yet published: we have everything to expect from the future.

A *préface* signed by J.-A. Boiffard, Paul Éluard and Roger Vitrac offers an apology for the dream described each morning *en famille*,[15] and proclaims that if "it is realism to prune trees, it is surrealism to prune life."

Following this is a symposium on a fundamental question, indeed "the question":

We live, we die. What is the share of will in all this? It seems that we kill ourselves the way we dream. It is not a moral question we are asking: *is suicide a solution?*

Then the flood-gates of the unconscious are opened: accounts of dreams by Giorgio di Chirico, André Breton, Renée Gauthier; surrealist, i.e., automatic texts by Marcel Noll, Robert Desnos, Benjamin Péret, Georges Malkine, J.-A. Boiffard, Max Morise, Louis Aragon, Francis Gérard. A poem by Paul Éluard:

> *L'hiver sur la prairie apporte des souris*
> *J'ai rencontré la jeunesse*
> *Toute nue aux plis de satin bleu*
> *Elle riait au present mon bel esclave . . .*

> (Winter over the meadow brings on mice
> I met youth herself
> Naked in the folds of blue satin
> Laughing at the present my lovely slave . . .)

Then a precious text by Pierre Reverdy on the value of dreams, again and as always,[16] and on what may be expected of the poet.[17]

[15] "Parents, tell your children your dreams!" (Surrealist leaflet).

[16] "I do not believe that the dream is precisely the contrary of thought. What I know of it inclines me to think that it is merely a freer, more abandoned form of thought. Dreams and thought are the two sides of the same material, dreams constituting the side whose texture is richer but looser—thought the side whose texture is more restrained but tighter."

[17] "For it is not a matter of making something true—today's true is

The reviews, under a still from a Buster Keaton film, contain a text by Louis Aragon ("The concrete is the last moment of thought, and the state of concrete thought is poetry") in which humor is accorded the place to which it is entitled in poetry—the first place, as Lautréamont and Jarry had realized, for humor achieves surreality without effort, being indeed its tangible and recognized manifestation.[18] Finally, a text by Philippe Soupault, an art chronicle by Max Morise, a piece by Joseph Delteil on love, which Breton will bitterly reproach him for when he breaks with surrealism, an observation by Francis Gérard on "the state of a surrealist" in a trance of automatism.

What most struck the readers of this first issue were primarily: a systematic listing, for a given period, of all cases of suicide reported in the newspapers, transcribed without commentary; the photograph of Germaine Berton who had just murdered the royalist Marius Plateau, surrounded by those of all the surrealists or of men they revered, such as Freud, Chirico, Picasso. Among them we find: Aragon, Artaud, the two Baron brothers, Boiffard, Breton, Carrive, the youngest surrealist (sixteen years old), Crevel, Delteil, Desnos, Éluard, Ernst, Gérard, Limbour, Lübeck, Malkine, Morise, Naville, Noll, Péret, Man Ray, Savinio, Soupault, Vitrac. A remark of Baudelaire's serves as a caption for this group: "Woman is the being who projects the greatest shadow or the greatest light in our dreams. Ch. B." The woman in this instance is a murderess.

Let us add that this first number was printed at the Imprimerie Alençonnaise (Alençon), which specialized in Catholic publishing. But perhaps no one saw any malicious intent in this.

This first number of La Révolution surréaliste contrasts by its abundance, its variety, its emphasis on research and experiment, its revolutionary "aura," with the last issues of Littérature. The last trace of Dadaism has evaporated. Henceforth "these young people" would have to be reckoned with.

tomorrow's false. Which is why poets have never had any concern for the true, but always for the real. Now be careful, words are accessible to everyone, so you have to make them into what no one has made . . ."

[18] "Humor is a determination of poetry, insofar as it establishes a surreal relation in its complete development . . ."

Meanwhile, they enjoyed themselves tremendously. On February 8, at the Polti banquet, Mme. Aurel, well-known at the time in the world of letters, was speaking extemporaneously when her flowery phrases were suddenly interrupted by vigorous "enoughs!" shouted by Breton and Desnos who added: "For twenty-five years now she's bored the shit out of us, but no one's had the nerve to tell her." The audience reproached the gentlemen for their lack of gallantry. To which Desnos replied: "Just because she's a woman's no reason for her to bore the shit out of people all her life." The newspapers seized on the incident and made great copy of it the next day.[19] A trivial incident which nonetheless recalls Rimbaud's constant punctuation of a poetry recital by Jean Aicard in select company by the same offensive word. So that these troublemakers too had a tradition![20]

Of another nature was the pamphlet against Anatole France, entitled: *Un Cadavre.* Here the surrealists were dealing with a man of recognized glory, who had died amid national mourning. To the Right, he represented *le style français* wrought to perfection, and they prized the Voltairean fragrance of *Penguin Island* less than the harmless *Crime of Sylvestre Bonnard.* On the other hand, the Left did not want it forgotten that Anatole France had marched beside Jaurès and that he had almost become a socialist. To attack the late tenant of the Villa Saïd, especially on the occasion of his death, was to commit iconoclasm, pure and simple. The surrealists, for whom he represented "art" in all its vacuum and hideousness, the "pure French genius" in his style, did not

[19] Letter from Robert Desnos to Mme. Aurel, "Madame, Mme. Tailhade, whom I did not know before the Polti banquet, has sent me your letter. I beg you to note that: 1) If my friends and I are "unconscious," so are you; 2) I could not be your *brother in arms,* at most your grandson; 3) You make me laugh. Best regards. Robert Desnos."

[20] One press clipping among others: "Hoax. *Le Journal* recently published a poem by Jean Moréas to an actress who had just died. It was discovered that this poem was merely a pastiche. *Le Figaro's* "alguzils" give the names of the authors: Louis Aragon, André Breton, Paul Éluard, Marcel Noll, Roger Vitrac, Max Morise, etc. If these young writers went to a good deal of trouble over this joke, it is evident that they succeeded. But "le Chat," in *Le Journal* for November 19 showed his claws: he discovered that these "stanzas" formed this acrostic: "un triste sire"; then, doubly annoyed, he threatened the overingenious pasticheurs and urged Moréas' executor to take legal action.

proceed lightly: "An old man like the rest," Éluard proclaimed; "a comic and empty character," said Philippe Soupault. "This grandfather either ignored or flauted all those we love among our fathers or our uncles," added Drieu la Rochelle. Dr. Guillaume, responsible for removing his brain (hadn't studies been made of the brains of Goethe, Lamartine, Gambetta, Hugo?), spoke at great length of this precious viscera. His words were faithfully reported: "The finest brain that can be imagined, in the extent, number and delicacy of circumvolutions, the curliness, as we say: this is a unique case . . . Not to preserve such a brain would be a crime against science . . . France's brain corresponds in every point to his genius at the same time that it explains it . . ." Remarks comic enough for the surrealists to refrain from comment. As for Breton, he signed a "Refusal to Inter" that has become classic:

> Loti, Barrès, France, any year deserves a gold star that lay these three sinister gentlemen to rest: the idiot, the traitor and the policeman . . . With France, a little bit of human servility leaves the world. Let the day be a holiday when we bury cunning, traditionalism, patriotism, opportunism, skepticism and lack of heart! Let us remember that the lowest actors of this period have had Anatole France as their accomplice, and let us never forgive him for adorning the colors of the Revolution with his smiling inertia. To bury his corpse, let someone on the quays empty out a box of those old books "he loved so much" and put him in it and throw the whole thing into the Seine. Now that he's dead, this man no longer needs to make any dust.

Aragon's bouquet was even more select, if possible: "Have you ever slapped a dead man?" he asked:

> In France, they say, everything ends with a song. Then let this man who has just expired amid general beatitude go up in smoke, in his turn! Little enough of a man is left: even so, it's revolting to imagine about this one that in any case *he has been*. There are days when I dream of an eraser to rub out human filth.

The scandal was tremendous. Were people being allowed themselves to insult the dead nowadays? Rimbaud was content with not saluting them. And the surrealists were eager to go even further, announcing: "On the next occasion, there will be a new 'cadavre'."

In all, the year 1924, if it saw the official founding of the movement, merely indicated the way in which it would proceed. We have noted how carefully the surrealists avoided giving a clear outline to their activity. Not that it was equivocal: these rebels wanted to change not only the traditional conditions of poetry, but also, and especially, of life. They had no doctrine, but certain values which they brandished like flags: omnipotence of the unconscious and its manifestations: dreams and automatic writing; and consequently the destruction of logic and of everything based on it. Destruction also of religion, of morality, of the family, those straitjackets that kept man from living according to his desires. But their great illusion was to suppose that their enemies would collapse at the mere sound of their words or upon reading their writings. They still believed, according to Breton's phrase, in the "omnipotence of thought." Their idealism was pure, but inoperative; they gradually sloughed it off amid grave internal crises, endless questions of confidence. It was the inclination of experimenters and scientists of a new kind that would permit them this development. Yet let us not forget that this revolution they hailed was one they intended to create in their own existence first of all. Surrealism is not written or painted, it is lived, and they were so many apostles of a new religion celebrated in cafés: the Certa, the Grillon of the Passage de l'Opéra, the Cyrano, on whose tables amid cigarette smoke, the clatter of saucers, bursts of laughter and the faint intoxication afforded by orange-curaçao, Aragon accumulated like so many good jokes the dazzling images of *Le Paysan de Paris*. Certainly this wasn't literature, he would never have been allowed to produce literature. Artistic work and work in general were in fact vilified and dismissed, life was to be consumed as it was given, not *earned*.[21] And living meant looking, listening, savoring the atmosphere of those inspired places in postwar Paris: the Passage de l'Opéra, the Boulevard Bonne-Nouvelle, the Porte Saint-Denis, the Buttes-Chaumont. The surrealists crowded to the Cinéma Parisiana to see *L'Étreinte de la Pieuvre* (The Grip of the Octopus), to the Théâtre Moderne

[21] For the members of the group, work was forbidden: Aragon, Breton, Boiffard and Gérard abandoned their medical studies; others left the Sorbonne; all rejected whatever might have afforded a "situation" in life.

to enjoy the stupid plays performed there or at the Porte Saint-Martin. The most ridiculous shows were the most prized, for they put on stage the popular sentiments and emotions that had not yet been spoiled by culture. The surrealists haunted brothels, treasuring the uncorrupted nature of the whores. They sought cretinization for its own sake. The means was simple enough: merely buy a Sunday ticket at a suburban railway station and shunt for hours and hours on all the tracks of a landscape of desolation, on a journey whose end is never fixed in advance. One day, without a word of warning, Éluard vanished from the group; the credulous claimed he was dead and proclaimed the birth of a new Rimbaud; his poems were reread in this new perspective, his presence was reported by the newspapers in the New Hebrides; then he was back again: he had merely extended the cretinizing journey to the limits of the earth.[22]

When the Passage de l'Opéra was demolished to make way for a new spur of the Boulevard Haussmann, the site of the daily meetings shifted to a café on the Place Blanche: the Cyrano, near the Rue Fontaine where Breton had chosen to live, welcomed the surrealists to this Montmartre of suspect boulevards swarming with the odd fauna of whores and their pimps, the crowd of those who pretend to amuse themselves. Encounters here were astounding: circus people (the Cirque Médrano was two steps away) accompanied by trapeze girls with their eyes "elsewhere," Americans with their gold-filled mouths, who were to be avoided like the plague, tiny humans, so tiny and so filled with mysteries. The surrealists ventured as far as the Faubourg Montmartre where the Nadjas walk past in pursuit of their secrets. Sundays, they escaped as far as the Clignancourt or Saint-Ouen flea markets where wonders leaped out of each stall, each stray object, each pavingstone.

The important thing was to rediscover life under the thick carapace of centuries of culture—life pure, naked, raw, lacerated. The important thing was to bring the unconscious of a city into unison with the unconscious of men.

"Distractions of cultivated, overcultivated men," it has been called. "Distractions" perhaps, but in the Pascalian sense of up-

[22] See *Paul Éluard* by Louis Parrot (Seghers).

rooting from a sick society; "cultivated men" perhaps, in the sense that some of them had studied their "humanities" but had suffered too much from the "advantages" of culture not to try to regain their childhood vision. The important thing was to make the great experiment again: the experiment of life, this time not for oneself but in a group, collectively.

They realized as they proceeded that to try to change one's life, one's own individual life, is to shake the very foundations of the world. The prospect of such a goal was not likely to alarm them. Quite the contrary.

FIRST WEAPONS

All writing is garbage.

—ANTONIN ARTAUD

THE second issue of *La Révolution surréaliste*, which begins the year 1925, was not much different from its predecessor. Perhaps though it reveals a desire to give the movement a social tinge by the publication of the Manifesto: "Open the prisons, disband the army,"[1] which ends with this appeal to general sentiments: "In sentry-boxes, in electric chairs, men in their death-throes are waiting: will you let them be court-martialed and shot?"

A new concern: the surrealists appeal to feelings of pity which they had hitherto dismissed out of hand. Yet they remain on the level of ideas: the "idea of prison, of barracks," is attacked, and nothing shows this better than the polemic between Aragon and the editor of the leftist review *Clarté*, Jean Bernier.

In the *Cadavre*, apropos of Anatole France, Aragon had written: "It delights me that the man of letters hailed today by both the tapir Maurras and *moronic Moscow* should have written . . ." Naturally the italicized phrase was bitterly censured by Bernier, to whom Aragon replied in these terms:

You have chosen to isolate as an attack a phrase which bears witness to my lack of enthusiasm for the Bolshevik gov-

[1] "Social constraint has had its day. Nothing—neither the rebirth of a past error nor the contribution to national defense—can force man to give up his freedom. Today the idea of prison, of barracks is commonplace; such monstrosities no longer surprise us. The outrage lies in the calm of those who have evaded the problem by various moral and physical abdications (respectability, disease, patriotism)."

ernment, and with it for all communism . . . If you find me
closed to the political and even violently hostile to that shame-
ful pragmatic attitude which permits me to accuse those who
ultimately have accepted it of ideal moderantism, you may
be sure that this is because I have always placed, and place
today, the spirit of revolt far above *any* politics . . . The Russian
Revolution? Forgive me for shrugging my shoulders. On the
level of ideas, it is, at best, a vague ministerial crisis. It would
really be more prudent of you to deal a little less casually with
those who have sacrificed their existence to things of the mind.

I want to repeat in *Clarté* itself that the problems raised by
human existence do not derive from the miserable little revolu-
tionary activity that has occurred in the East during the course
of the last few years. I shall add that it is only by a real abuse
of language that this latter activity can be characterized as
revolutionary . . .

As we see, the Revolution is in *ideas*. The surrealists' conception
of it permits them to scorn all pragmatism, all concrete material
activity. Further: they find this activity *shameful*. We must take
note of this position, which is not Aragon's alone, if we wish to
understand their eventful development.

Breton perceived the weaknesses of such a position, and the
reproaches it was likely to incur. He attempted to remedy it by
advocating a general strike of everyone who wielded pen or
brush. In *Le bouquet sans fleurs* he forbids himself not to act
according to his ideas, and denies his intention to take refuge,
like his predecessors, in the practice of an art which excuses
everything.[2] He asserts that he is not concerned to create a new
avant-garde school in search of "novelty" for its own sake; the
pathetic attempts of surrealism's predecessors to discover a
novelty that faded as soon as it flowered was enough to dis-
suade him from such a course.[3]

[2] "I have been greatly blamed, recently . . . for not acting in a fashion
more in accord with my ideas. As if, answering their first summons, obeying
the most frequent and powerful impulse I experience, I merely had to go
down into the street with a revolver in my hand and . . . it is apparent
what would happen . . . What indirect action would satisfy me? Once I
begin looking, then, apparently, I retreat into art, that is, into some social
order where impunity is assured me but where, to a certain point, I cease
to be of any importance . . ."

[3] "In recent years, I have been able to observe the harm done by certain
intellectual nihilism which in every case raised the most generalized and

Hence there was no question of starting Dada all over again. One must be engaged in a *valid experiment,* as the founders of surrealism kept repeating.

The investigation they had undertaken on the subject of suicide was notably to focus on this question: "Is suicide a solution?" The most various answers, even from the surrealists, are listed for several pages, ranging from that of Dr. Maurice de Fleury, "that ominous idiot," to those of Francis Jammes and Fernand Gregh, and including Clément Vautel. Pierre Reverdy gave an answer which did not satisfy the investigators, obliged as they were to appeal to the dead: Jacques Vaché, Rabbe, Benjamin Constant. Let us nonetheless single out René Crevel's answer, which was not to be limited to a mere questionnaire:

> Is it true, as people say, that one commits suicide for love, for fear, for syphilis? It is not true. Everyone loves, or thinks he does: everyone is afraid; everyone is more or less syphilitic. Suicide is a means of selection. Those men commit suicide who reject the quasi-universal cowardice of struggling against a certain spiritual sensation so intense that it must be taken, until further notice, as a sensation of truth. Only this sensation permits the acceptance of the most obviously just and definitive of solutions: *suicide.*

And were not the lines Crevel was to write in *Détours,* which had just been published by Gallimard, a prefiguration of his fate:

> A pot of tea on the gas stove; the window tightly closed, I turn on the gas; I forget to light the match. Reputation safe and the time to say one's *confiteor . . .*

When, at dawn, one day in 1935, his corpse was found beside a hissing gas stove, it was realized that these lines had little enough to do with literature, except that Crevel was not concerned to save his reputation or to "say his *confiteor.*"

the most futile question of confidence. In the moral chaos that followed, only a few modes of superficial activity and some wretched paradoxes found favor. Thus novelty, in the most whimsical sense of the word, passed in every area for a sufficient criterion. Without it, there was no solution: novelty insistently justified the most absurd undertakings in painting, in poetry, of valid experiments on the limits of life and art, of ordeals by love, of personal sacrifice, not a trace. It was essential to remedy this at any price . . ."

The review posters announced, along with *Détours*, other surrealist works: *Les Reines de la main gauche* by Pierre Naville, a rigorously automatic text, Antonin Artaud's *Ombilic des Limbes*, Robert Desnos' *Deuil pour Deuil*, *Simulacre* by Michel Leiris and André Masson, *152 Proverbes mis au goût du jour* by Paul Éluard and Benjamin Péret, *Mourir de ne pas mourir* by Paul Éluard, Roger Vitrac's *Les Mystères de l'amour* and Aragon's *Le Libertinage*, tempting first fruits of automatism, all works which, in the perspective of time, appear decisive in the individual production of the surrealists.

However, "surrealist life" developed, in general, apart from a review which appeared quite irregularly. For the group's history, the review is useful only for its concrete evidence of stands taken, definitions published. More interesting, for our purposes, is this *Déclaration du 27 janvier 1925*, first published as a tract and, to our knowledge, never reprinted. Here we find:

1) We have nothing to do with literature. But we are quite capable, if need be, of making use of it like everyone else.
2) Surrealism is not a new means of expression, nor a simpler one, nor even a metaphysic of poetry. It is a means of total liberation of the mind and of everything resembling it.
3) We are determined to create a Revolution.
4) We have bracketed the word Surrealism with the word Revolution solely to show the disinterested, detached and even quite desperate character of this revolution.
5) We lay no claim to changing anything in men's errors but we intend to show them the fragility of their thoughts, and on what shifting foundations, what hollow ground they have built their shaking houses.
6) We hurl this formal warning into the face of society: whatever protection it affords its disparities, each of the false moves of its spirit, we shall not miss our aim . . .
7) We are specialists in Revolt. There is no means of action we are not capable of using if the need arises . . .
Surrealism is not a poetic form.
It is a cry of the mind turning toward itself and determined in desperation to crush its fetters.
And, if need be, by material hammers.[4]

[4] Text furnished by Raymond Queneau.

Does this declaration need any commentary? Already we see, with the announcement of "material hammers," a suggestion that the surrealists are ready to abandon the level of writing alone.

Another document, an interior one, reveals still better the true nature of the surrealist movement, which was not an association of men of letters patting each other on the back to insure their success, nor even a school with various theoretical ideas in common, but a collective "organization," a sect of initiates, a *Bund* subject to collective imperatives, whose members were linked by a common discipline. One entered it with one's eyes open, one left it or was excluded by it for specific reasons, and its members functioned as a team. Individual works were censored by the group as a whole, and saw the light of day only if they brought something new to the movement. *Défense de l'infini,* a novel in three volumes which Aragon was to write and for which he had already signed a contract, never appeared because the group, suspecting the temptation of "literature," opposed it.

Thus what was at stake was not writing, but revolution—that is, effecting as complete a change as possible:

> Adherence to a revolutionary movement of any kind supposes a faith in its possibilities of becoming a reality.
> The immediate reality of the surrealist revolution is not so much to change anything in the physical and apparent order of things as to create a movement in men's minds. The idea of any surrealist revolution aims at the profound substance and order of thought . . . It aims at creating above all a mysticism of a new kind . . .
> Every true adept of the surrealist revolution is obliged to believe that the surrealist movement is not a movement in the abstract, and particularly in a certain poetic abstract that is utterly detestable, but is really capable of changing something in the minds of men.[5]

The terms are clear: "creation of a new kind of mysticism." Breton, summarizing the surrealist activity later, will see its fundamental ambition in the "creation of a collective myth." From this moment, we perceive the distinct intention of proceeding to the concrete, toward a certain form of the concrete.

[5] Text furnished by Raymond Queneau.

Within the group, moreover, discussions and disputes were frequent; fractions meet and even raise the question: is surrealism equivalent to a revolution, or are they two different things? and which should one choose? If the choice is not determined, at least a common denominator is achieved: "a certain state of fury," which is not given a point of application but which is certainly the indispensable path to revolution. Perhaps the signers of a resolution[6] summarizing one of these discussions were no longer in agreement with the rest of the group as to this "new kind of mysticism," which they suddenly believed they had found in the mysterious East of the Buddha and the Dalai Lama, an East suitable for confounding the West and its logical values of course, but quite incapable by its very nature of causing that tidal wave the surrealists desired: at best it seemed likely to win over a few individual souls by a slow penetration.

Nonetheless a hosannah in honor of the East and its values constitutes almost the whole of the third issue of *La Révolution surréaliste*. An editorial called "dinner is served," unsigned but which must be attributed to Antonin Artaud, reveals that logic must yield its supremacy to this new love.[7] And in a "Letter to the Rectors of the European Universities" we seem to have reached the roots of the evil, the deadly Western education barely capable of producing "whited sepulchers": false engi-

[6] "The undersigned members of *La Révolution surréaliste*, having gathered on April 2, 1925, in order to determine which of the two principles, surrealist or revolutionary, was the more likely to direct their course of action, without reaching an agreement on the subject, have come to the following conclusions:
1) That before any surrealist or revolutionary preoccupation, what predominates in their mind is a certain state of fury;
2) That it is by means of this fury that they are most likely to achieve what may be called the surrealist illumination . . . ;
3) That there now exists a single positive point around which all members of *La Révolution surréaliste* ought to rally: i.e., that the mind is an essentially irreducible principle which cannot be fixed either within life nor beyond it. Antonin Artaud, J.-A. Boiffard, Michel Leiris, André Masson, Pierre Naville." Text furnished by Raymond Queneau.

[7] "We are within the mind, within the head. Ideas, logic, order, Truth (with a capital T), Reason—we consign everything to the nothingness of death. Watch out for your logics, Gentlemen, watch out, you don't know how far our hatred of logic can take us . . ."

neers, false scientists, false philosophers, blind to the true mysteries of life, of the body and the mind, mummified in the shrouds of logic. The remedy is to be found in Asia, "citadel of every hope,"[8] love for which is expressed in inflamed declarations:

> We are your faithful servants, O great Lama, give us, send us your illumination, in a language which our contaminated European minds can understand, and if need be, change our mind, give us a mind oriented toward the perfect peaks where the spirit of Man no longer suffers . . .[9]
> Logical Europe crushes the mind endlessly between the hammers of two terms, it opens and closes the mind. But now the strangulation is at its crisis, we have suffered in harness too long. The Mind is greater than the mind, life's metamorphoses are many. Like you, we reject progress: come, demolish our houses . . .[10]

Robert Desnos also appeals for help to the Asian barbarians capable of following in the footsteps of the "archangels of Attila."[11] And the dead themselves, those like Théodore Lessing who believed in the omniscience of Asia, are enlisted in this crusade.[12]

We see why such an Asia necessarily pleased the surrealists. Had not the sages of the Orient already answered the questions the surrealists were asking? At the price of a radical destruction or of an utter oblivion—but could one forget what one had never known?—of logic, of mechanistic knowledge, of the compartmentalizations of science, of everything that ultimately granted supremacy to the West, these men seemed to live in a perpetual communion with the essence of things, with the spirit of the Whole, if not in a perfect happiness—that vulgar ideal—at least in a total freedom. No lacerating contradictions as in the West,

[8] Robert Desnos.
[9] *Adresse au Dalaï-Lama.*
[10] *Lettre aux écoles du Bouddha.*
[11] "Déscription d'une révolte prochaine."
[12] "We seek to know the realization, the *fait accompli*, the real causes of things and thereby we lose sight of their life, all our sciences dissolve the world into a nothingness of realizations. The wisdom of Asia is invincibly pessimistic. In its thousands of works, it has searched out the inseparable connections of spiritual maturity with suffering. It penetrates the reciprocal dependence of knowledge and pain, and knows that consciousness is the unalterable function of agony . . ."—Théodore Lessing.

no exhausting struggles against a world so badly constructed. It seemed as if they had discovered the secret which the best minds of the West were painfully attempting to track down.

The Orient was not only the land of the sages, but also for the surrealists the reservoir of untapped forces, the eternal fatherland of the "barbarians," the great destroyers, enemies of culture, of art, of the ridiculous petty manifestations of the West. Perpetual revolutionaries, armed with flaming torches, they had sown ruin and death behind Attila's horses, envisaging a rebirth. And the Russian Revolution itself, mysterious because Asiatic, no longer seemed to Breton and his friends "a vague ministerial crisis." On it they would finally base all their ardent but vague desires for a universal revolution borne by a negating and regenerating East.

Nonetheless, as we have already had occasion to observe, surrealism was never a *bloc*. Consisting of individuals from extremely diverse backgrounds, it was not to suffer serious internal contradiction so long as it did not exceed its vague aspirations and indefinite ideas. Revolution, anticulture, the battle against reason and society in the name of an individualism of desire, primacy of the unconscious, rallied all allegiances. But a movement is, quite literally, an *idea on the move*, and if the goal to be achieved is vaguely known, the paths leading to it may be divergent, even diametrically opposed. If agreement is reached as to the necessity of a destruction "as radical as possible," it does not necessarily exist concerning what must be reconstructed or even concerning the means of such destruction. Literature, art have always been the refuge of rebels, all too often impotent to free themselves except in words and colors. Now it seemed, inevitably, that all these "individualities" did not produce the same crystalline sound when struck. It seemed, in particular, that they were gradually sliding down the slope of art "which forgives everything," or at least toward *expression*, whether artistic or not, the pathetic avatar of that "fury" to which the surrealists had so ardently aspired. Were they merely to produce, alongside a literature of logic, a literature of the dream, automatic texts, "surrealist" poetry or painting? The question, had it

been raised at this moment, would have received the most scornful denial. But men's image of themselves is one thing, and what they are doing is another. A fundamental contradiction began to appear, glimpsed by the most clear-sighted among them. It was to appear to all, as a result of men and events. We have already referred to meetings to discuss "which of the two principles, surrealist or revolutionary, was the most likely to direct their action." Symptomatic is the alarm sounded by Pierre Naville in the back pages of this third issue of La Révolution surréaliste.[13]

> I have no tastes except distaste. Masters, master-crooks, smear your canvases. Everyone knows there is no *surrealist painting;* neither the lines of the pencil abandoned to the accident of gesture, nor the image retracing the images of the dream nor imaginative fantasies, of course, can be so described.
> But there are *spectacles.*
> Memory and the pleasure of the eyes: that is the whole esthetic.

This radical point of view was not accepted by the group. The poets and especially the painters objected. Their activity, initially an experiment, had ultimately produced tangible results which, not being disdained by admirers, could not be entirely disclaimed. Éluard and Aragon were gaining status as poets; Max Ernst and Masson were sought after by dealers. Was all this to be abandoned on the pretext of a "search for the absolute"? Was Dada going to begin all over again? Breton did not allow this. He too claimed to reach a conclusion.

First of all, he took the helm. In the inaugural articles of the fourth issue of La Révolution surréaliste, "Why I have become editor of La Révolution surréaliste," he first defined the desire that animated the movement's founders:

> With a common accord, we determined once and for all to be rid of the mind's old regime . . .

and the results after six months of struggle:

> Around us, we have seen Surrealism benefit from a considerable credit abroad as well as in France. People are expecting some-

[13] Pierre Naville gave up editing the publication at this time and joined the army.

thing from us. If the words "surrealist revolution" leave the majority skeptical, at least no one denies us a certain ardor and a destructive potential. It is up to us not to limit such a power . . .

But what was to be done now? If the movement never sought a factitious unity but rather agreement on certain general values, it had nonetheless reached the point where violent contradictions now appeared, and Breton, excellent tactician that he was, sought to reduce the right (the literary men) and the left (the agitators[14]), at the same time that he tried to define the "original claims of the surrealist cause,"[15] whose broad orthodoxy was based on:

> . . . the conviction that here we share all—i.e., that modern society survives by a compromise so serious as to justify any excess on our part . . . Who speaks of controlling us, making us contribute to the abominable earthly comfort? We want, we shall have the Beyond in our time. For this we need heed only our own impatience and remain perfectly obedient to the commands of the marvelous . . .

Nonetheless, with Naville temporarily out of the way, experiment yielded to practical applications. Hitherto, *La Révolution surréaliste* had confined itself to publishing a few drawings by Masson that might pass for automatic, a few reproductions of Picasso and Chirico that served especially as witness and anterior and external confirmations of the movevment. Now there appeared a deluge of reproductions and above all a veritable retrospective of Picasso's works (from whom Breton was careful, nonetheless, to withhold the label "surrealist"[16]), to

[14] "Should the scope of the surrealist movement suffer thereby, it seems to me essential to open the pages of this magazine only to men who are not searching for a literary alibi. Without implying any ostracism, I further insist on avoiding above all the repetition of such petty acts of sabotage as have already occurred in the heart of our organization . . ."

[15] "Is surrealism a force of absolute opposition, or a group of purely theoretical propositions, or a system based on the confusion of all levels, or the cornerstone of a new social structure? Depending on the answer such a question seems to require, each man will attempt to contribute all he can: contradiction does not in the least disconcert us . . ."

[16] They date, moreover, from 1908, like *Les Demoiselles d'Avignon;* from 1913: *Étudiant;* from 1920: *Écolière;* and even if the *Jeunes filles dansant devant une fenêtre* or *Harlequin* date from 1924-25, they belong more to Picasso than to surrealism.

prove that there existed such a thing as "surrealist painting."[17] Further, Breton undertakes a history of modern painting to show its relations with the movement. This study continued for several issues, under the title "Surrealism and Painting." Of course painting is a "lamentable expedient," but the sleight-of-hand consists in regarding the works of Picasso as "beyond" painting, that is, as the proof that surrealist painting can exist. Must we accord the same quality to Chirico's pre-1913 work (discussed by Max Morise in the same issue) and finally to any painting that leaves the beaten paths of official or even advanced art? If Breton granted painting a power equivalent to that of language, a power "no more artificial than the other," if he believed that once painting refuses to copy nature in order to concentrate its forces on the "internal model" the risk is quite different, if he considered in particular that without Picasso "the part that concerns us is at least deferred if not lost,"[18] he was right to proclaim that surrealist painting did exist and that there might soon be a surrealist poetry as well. Did not Éluard prove as much?[19] And was it not symptomatic that the strictly automatic texts were reduced to four,[20] the accounts of dreams to only two?[21]

It would nonetheless be a mistake to suppose that *La Révolution surréaliste* had grown tame or was tending to become an "artistic" periodical. Its emphasis was still on the necessary revolt, basis and goal of the movement. As is evidenced by Aragon's *Fragments of a Lecture given at Madrid at the Residencia des Estudiantes* on April 18, 1925, directly attacking the avowed representatives of a dead civilization in his audience:

Ah, bankers, students, workers, officials, servants, you are the ,fellators of the useful, the masturbators of necessity. I shall never work; my hands are pure. Madmen, hide your palms

[17] Miró's *Maternité* and *Le Chasseur;* Max Ernst's *Deux enfants sont menacés par un rossignol* and *La révolution la nuit;* Masson's *L'armure.*

[18] "His admirable perseverance is a sufficiently precious pledge for us to need no appeal to any other authority."

[19] He published 6 poems in this issue.

[20] By Soupault, Noll, Malkine, Éluard.

[21] By Max Morise and Michel Leiris.

from me, and those intellectual calluses that are the source of
your pride. I curse science, that twin sister of labor. Knowl-
edge! Have you ever reached the bottom of that black pit?
What did you find there, what corridor to the sky? So I wish
you a huge fire-damp explosion that will finally restore you
to the sloth that is the only fatherland of true thought . . .

And what must these young people have thought of the perora-
tion:

We shall triumph over everything. And first of all we'll destroy
this civilization that is so dear to you, in which you are caught
like fossils in shale. Western world, you are condemned to
death. We are Europe's defeatists . . . Let the Orient, your
terror, answer our voice at last! We shall waken everywhere
the seeds of confusion and discomfort. We are the mind's
agitators. All barricades are valid, all shackles to your hap-
piness damned. Jews, leave your ghettos! Starve the people,
so that they will at last know the taste of the bread of wrath!
Rise, thousand-armed India, great legendary Brahma. It is your
turn, Egypt! And let the drug-merchants fling themselves upon
our terrified nations! Let distant America's white buildings
crumble among her ridiculous prohibitions. Rise, O world! See
how dry the earth is, and ready, like so much straw, for every
conflagration. Laugh your fill. We are the ones who always hold
out a hand to the enemy . . .[22]

This extravagance is not merely formal; it derives from a funda-
mental conception which makes Revolution into a transcendent
value which Éluard counters once again, apropos of an article
in *Philosophies*,[23] to revolutionary pragmatism:

There is no total revolution, there is only perpetual *Revolution*,
real life, like love, dazzling at every moment. There is no
revolutionary order, there is only disorder and madness. "The
war for freedom must be waged with anger" and waged with-
out ceasing by all those who do not accept . . .[24]

A magnificently intransigent position, but all too accessible to
the ridicule of politicians, so long as it did not escape its own
phrases, manifestations without real effect. The surrealists were
not insensitive to the reproach of being "revolutionary phrase-

[22] *La Révolution surréaliste*, No. 4.
[23] May 18, 1925.
[24] *La Révolution surréaliste*, No. 4.

makers," and it was partly to rid themselves of it that they intensified their habitual manifestations in number and in seriousness.

A play by Aragon having been rehearsed at the Vieux-Colombier and scheduled for performance one evening in June 1925, the organizers had the untoward idea of starting the proceedings with a lecture by a certain M. Aron on "the average Frenchman." The surrealists attended the performance and sabotaged the entire proceedings, causing a scandal which was reported at length by the *Journal littéraire* for June 13, 1925.[25] The Saint-Pol-Roux banquet had still more reverberations, and provoked a nearly universal protest against them.

The surrealists admired Saint-Pol-Roux as a magnificent poet, and if his Catholicism had kept them from taking him as a sponsor for their action, they did not forget the brilliant images of *Les Reposoirs de la Procession* or of *La Dame à la faulx*. Even the Camaret poet's curious vocabulary, gleaming with precious jewels and strange lights, seemed to confirm their claim that it was a direct product of the poet's unconscious. Hence, following an *Hommage à Saint-Pol-Roux* organized by *Les Nouvelles littéraires* and in which they had participated, they appeared, early in July 1925, at various *agapes* offered in honor of the "Magnificent" by a group of friends and disciples under the patronage of *Le Mercure de France*. These took place at the

[25] ". . . I had heard no more than twenty words . . . when a tall joker sitting behind me began talking louder than the lecturer. The latter waited patiently for him to be finished, in order to continue his remarks, but eight seats to my right, another gentleman began speaking. Replies flew through the air. And suddenly from various parts of the hall echoed a word that was quite familiar but worthier of the Napoleonic armies than of a respectable assemblage. Unfortunately this word was emphasized until it became the only thing one could hear. [M. Aron tried to regain the floor] Interrupters appeared in every corner. One voice proclaimed: 'We will not let you speak. Signed: the surrealists.' Then things grew nastier . . . the police intervened . . . Philippe Soupault leaped onto the stage and stood there, arms folded, defying anyone to remove him save at bayonet-point . . . Robert Desnos violently harangued the crowd, striding up and down the stage . . . Meanwhile the gentle poet Éluard had been punched; Vitrac dashed forward to defend him . . . the whole house was standing, and threats and insults flew through the air."

Closerie des Lilas. Among those present, some appeared frankly undesirable to the surrealists. Naturally these did not include the belated and harmless symbolists à la Paul-Napoléon Roinard, but rather personalities like Lugné-Poë and Rachilde, whose ideas seemed to them conservative or even reactionary. During the banquet, Rachilde actually went so far as to repeat the words of an interview she had given earlier, and loud enough for the entire audience to hear, "that a Frenchwoman could not marry a German." Now at this time the surrealists were mad about Germany; first of all, because this nation represented for the French bourgeoisie the hereditary, incompletely conquered enemy whom the chains of the Versailles treaty could not keep from trying to rise again, the defaulting prayer of Reparations whom Poincaré had exasperated by occupying the Ruhr; secondly because she was, according to Desnos, one of the Oriental forces called upon to destroy Western civilization; and finally because, as Aragon had said: "We are the ones who always hold out a hand to the enemy." Upon Rachilde's remark, Breton stood up with great dignity and reminded Mme. Rachilde that the remark she had just made was insulting to his friend Max Ernst, who had been invited to this dinner.[26] Suddenly a piece of fruit, thrown by an unknown hand, flew through the air and splattered on some official, while shouts of "Vive l'Allemagne!" rang out. The uproar quickly became general and turned into a riot. Philippe Soupault, swinging from the chandelier, kicked over plates and bottles on all the tables.[27] Outside, idlers gathered. Blows rained down right and left. Rachilde later claimed that she had been kicked in the stomach by a big lout with a German accent (she meant, of course, to suggest Max Ernst himself). The Sage of Camaret, like the pilot of a boat foundering in a gale, appalled by these incidents, attempted to restore order. His words of appeasement were not heard by his official friends. It was too good an opportunity for reducing "those surrealist provocateurs" to dust. And since this proved impossible, recourse was had to

[26] There exist as many versions of this banquet as there were witnesses. According to some, Breton threw his napkin into Mme. Rachilde's face and called her a "camp-follower."

[27] "The tables were knocked over, the dishes trampled. The adversaries came to blows, while the windows were smashed." (Rachilde's interview.)

those natural defenders of flouted poetry: the police, who were directed to the miscreants deserving of a trouncing. While shouts of "Long live Germany! Bravo China! Up the Riffs!" echoed out, Michel Leiris, opening a window overlooking the boulevard, shouted at the top of his lungs, "Down with France!" Asked by the crowd to explain himself, he lost no time doing so: the riot continued out on the Boulevard Montparnasse. Leiris, continuing to defy both police and mob, was nearly lynched. Taken to the commissariat, he was roughed up considerably.

The scandal was enormous, and has not been forgotten even today. The newspapers unanimously attacked the surrealists, publishing outraged interviews with Mme. Rachilde, the victim of "German agents." Orion, in *l'Action française*, suggested in an "Open letter to all literary editors" that the surrealists be quarantined.[28] They were to be punished by a conspiracy of silence. The very word "surrealism" was to be banished from the papers forever: it was impossible to believe the surrealists were animated by anything more than the desire for publicity.

Especially since the surrealists did not stop there. They published at the same period the "Open letter to Paul Claudel, French Ambassador." His Excellency, it appears, in an interview published in *Comoedia,* had found no better word to describe the surrealists' activity than *pédérastique,* adding this unexpected detail, that he deserved well of his country for having permitted the sale by America of "large quantities of lard" to France during the war. The answer was virulent:

[28] "It is a question of fair reprisal, of barring to them the road that leads to the great public . . . Each of us . . . will in the future say nothing of their articles, their books, until they have adopted somewhat less unworthy methods of publicity. A first sanction, which may be followed by others of another kind, if they are not content with merely writing . . ."—Orion (*l'Action française,* July 6).
Clément Vautel was also there: "These 'terrors' of the Boulevard Montparnasse are spared by a cowardly, faltering, intimidated criticism. Ah, the fear of being called 'Philistines' . . ." Two agendas were sent to the newspapers, one by the *Société des Gens de lettres* that "castigated the scandalous behavior of some of those present who have insulted a woman of letters and shouted 'Down with France!'", the other from the *Association des Écrivains combattants* that "condemned to public disgrace those responsible for this premeditated demonstration . . . an insult to French thought . . . an outrage to all who fought and died for France. . . ."

Creation matters little to us [said the surrealists], we pro-
foundly hope that revolutions, wars, and colonial insurrections
will annihilate this Western civilization whose vermin you
defend even in the Orient, and we call upon this destruction
as the least inacceptable state of things for the mind . . .
We take this opportunity to dissociate ourselves publicly from
all that is French in words and in actions. We assert that we
have found treason and whatever else can harm the security of
the State more reconcilable with poetry than the sale of "large
quantities of lard" to a nation of pigs and dogs . . .

Another protest. *Le Journal littéraire* for July 4, 1925 proposes
putting the surrealists out of harm's way.[29]

No one, in fact, had any further illusions as to the ideology and
the activity of the surrealists. Hitherto their anathemas had not
been taken very seriously, for it was hoped that after having sown
their wild oats, they would return like so many others before them,
to their proper place, and as long as these anathemas remained on
the literary plane, this safety valve could be left open, a liberal act
with regard to so many *enfants terribles.* But the situation grew
worse: facing a serious monetary crisis at home, France had also
been waging a veritable war for several months with the Riff
gangs of Abd-el-Krim; while the revolutionary government of
Canton, extending its influence in China seemed, on the interna-
tional scene, to show the symptoms of a new revolutionary crisis
among the Asian masses. The USSR, contrary to "authoritative
expectations," had not collapsed, and if it faced undeniable diffi-
culties, it nonetheless was attracting the active sympathy of the
international working classes. This was no longer the moment for
liberalism. It was essential to close ranks against the common
enemy, to establish once again, notably on the plane of art, a
"sacred union" around the traditional values of Nation, Family,
and Religion, mercilessly opposing the surrealist energumens.

[29] Reconsidering the Saint-Pol-Roux banquet "It remains to be seen if the
courts will treat as they deserve men who are not only bad Frenchmen and
scoundrels, but of whom several were armed and behaved as common law
criminals . . . Efforts will be made to reduce them to silence." (*l'Action
française*).
 Paul Souday, in *le Temps*, wrote jokingly, apropos of the letter to Claudel:
"When M. Louis Aragon or M. Philippe Soupault stand for the Académie
Française in some thirty years' time, they will be rather embarrassed if a
rival should exhume these pathetic lucubrations."

Challenged by events, the surrealists determined to enter the lists. In truth, their choice had been made since the beginning; what had not always been decided, as we have shown by the declarations of Aragon, Breton, and Éluard, was the desire to express it on the level of political action. It seemed to them futile and dangerous to "concretize" their ideal of "total revolution" on this level, collaborating with political specialists, if not actually absurd. Several reasons of varying importance brought them to this turning-point, from which they set out in a direction that would have seemed to them impossible a few months earlier.

THE MOROCCAN WAR

*Today's authentic art goes hand in
hand with revolutionary social activity:
like the latter, it leads to the confusion
and destruction of capitalist society.*
—ANDRÉ BRETON

FIRST came the Moroccan War. We have shown how profoundly World War I had marked the surrealists, how its horrors and futility had instilled in these men a fierce desire for total destruction, for which they sought equivalents in Sade, Borel, Rimbaud, Lautréamont. Now war was starting again, with soldiers being sent to the "theater of operations," masked mobilization, the death of young men—and this time not in a struggle against another capitalist nation, but against a colonized people seeking its freedom. Their leader, Abd-el-Krim, promised that the Riffs wanted only to live on good terms but on equal footing with the French who, he said, could not make a universally infamous oppression last indefinitely. Not only was all the machinery of modern warfare set in motion against these rebellious tribes, but the "intellectuals" were called upon to justify the instigators of the repression. If the Academicians and official men of letters took sides with "la Patrie menacée" (Manifesto: *Les Intellectuels aux côtés de la patrie*), the surrealists, on the contrary, tended to favor the rebels and their supporters in Metropolitan France: the communists, who proclaimed their desire to join Abd-el-Krim in the name of the very principles of the Communist International.

This desire for rapprochement did not lead them to seek membership in the Communist Party. Breton and his friends were too jealous of their autonomy and of the value of their own ideas to

identify them with a revolutionary doctrine chiefly based on economics and the history of social relations. But they were ready to form a kind of "united front" with para-communist organizations or with revolutionary intellectuals seeking the enlightenment of Lenin and Trotsky. On the first level was the *Clarté* group, with which there had been bitter polemics in the past (the Aragon-Bernier dispute), and which was the only one to take any effective action against the Moroccan War on the ideological level. The editors of *Clarté*, Jean Bernier and Marcel Fourrier, had gradually moved away from the pacifist and humanitarian influence of Henri Barbusse, who had founded the movement at the end of the war (1919), to follow a revolutionary path parallel to that of the Communist International. They created around this organization an "aura" of intellectuals and sympathizers; they delivered severe blows to bourgeois ideology, and attempted to create in opposition new values, following the example of the Soviets. If the surrealists had hitherto regarded the Russian experiment as hardly inspiring, they were nonetheless attracted to *Clarté* by the force of events.[1] They began to meet in order to discuss basic problems. One typical agenda is marked by a desire for collaboration that prefigures complete fusion: it proclaims the necessity of a common discipline and of a censorship of individual activity. It even discusses, though this would prove more difficult to effect, the possibility of a common ideology with regard to the great problem of relations between individual and Revolution.[2] Finally a parity committee is formed responsible for making decisions.

[1] "The events of the War with the Riff literally hurled us into each other's arms". Marcel Fourrier (*Clarté*, November 30, 1925).

[2] Agenda for the meeting of Wednesday October 8, 1925, *Clarté* offices, at 8:00 (strictly confidential):
 I Ideological position. Political level, moral level.
 A Political. With regard to the Communist International.
 With regard to the French Communist Party.
 With regard to the bourgeois parties.
 B Moral. With regard to the individual, the Revolution, other disciplines (artistic, philosophical, religious).
 II Necessity of a discipline based on trust. Means of assuring it: principle of the ballot.
 III Formation of a Committee. Its duties, powers. Censorship of individual activity. Its duration, composition.
 (Text furnished by Raymond Queneau.)

The agreement is less distinct with the *Philosophies* group, in which young philosophers like Henri Lefebvre, Georges Politzer, Norbert Guterman, Georges Friedmann and Pierre Morhange kept not only at some distance from communism, which they would come to later on, but even from a consistent materialist philosophy. They tried at least to establish values likely to destroy the ideological state of things as the bourgeoisie had produced it and continued to defend it.

The agreement between the surrealists, *Clarté, Philosophies,* and *Correspondence* (a Belgian surrealist periodical edited by Camille Goemans and Paul Nougé), found its concrete expression in a Manifesto, *La Révolution d'abord et toujours,* in which we find, after a bow to eternal Asia, other new ideas accepted by the surrealists and quite alien, at least as formulated, to their earlier preoccupations. Here we find them discussing the problems of the wage-earner, that is, in the midst of political economy.[3]

This was only a preamble. The Declaration itself discussed "the magnificent example of an immediate, complete and unopposed disarmament which Lenin gave the world in 1917 at Brest-Litovsk," the refusal to be mobilized under "the pathetic horizon-blue overcoat . . . given the fact that for us France does not exist," the desire to denounce and confound on every occasion: "priests, doctors, professors, literary men, poets, philosophers, journalists, judges, lawyers, police, academicians of all kinds."[4] What must be further emphasized is a proclamation entirely new for the surrealists: "We are not utopianists: *we conceive of this Revolution only in its social form.*"[5] Hence it was no longer a question of a "revolution of the mind," without changing "anything in the physical and apparent order of things." Quite the contrary, no revolution seemed possible on the mental level, the

[3] "For over a century, human dignity has been reduced to the rank of an exchange value. It is already unfair; it is monstrous that a man who owns nothing should be enslaved by a man who owns property, but when this oppression exceeds the form of a simple salary to be paid and assumes, for instance, the form of slavery which international high finance imposes upon whole populations, it is an iniquity which no massacre will ever succeed in expiating . . ."

[4] "All of you signed this imbecile sheet: *Les Intellectuels aux côtés de la patrie.* . . . Dogs trained to benefit the nation, the mere thought of this bone sets you quivering . . ."

[5] Italics mine.

surrealists' basic goal, without first effecting a revolution in social realities. The surrealists even suggested that the latter had become the most urgent, the most immediately necessary, and that to attempt to avoid it would be to give evidence of "utopianism."

This text marked a turning point in the movement's development. It inaugurated what Breton has called its "rationalizing period"[6] and it was from this moment that he dates the shift from idealism, as championed by the surrealists, to "dialectical materialism." This is perhaps too abrupt a transition; nonetheless we may observe the need for this shift, which was to be made "definitive." And henceforth the discussions dealt at length with the means of effecting it. Breton adds that in 1925 surrealist activity became aware of its "relative inadequacy," he indicates how it "ceased to be content with the results (automatic texts, accounts of dreams, improvised speeches, poems, spontaneous drawings or acts) it had initially proposed, how it came to consider its first results only as raw *materials,* as a result of which the problem of knowledge tended ineluctably to appear in an entirely new form."

Another phenomenon, apparently less significant but whose consequences were not negligible, added its effect to that of events themselves: this was Breton's reading of Leon Trotsky's *Lenin,* a work which showed, in a new light for the surrealists, the extent of the overthrow effected in eastern Europe, as well as the boldness and lucidity its protagonists had evidenced. What were Sade, Borel, or Rimbaud, compared to these titans who had solved for themselves, before doing so for all, the problems of man's fate? Who had undergone a voluntary discipline far exceeding the individual moral preoccupations of the West's revolutionary intellectuals. Breton, whose intuitive genius never failed

[6] *"La Révolution d'abord et toujours* . . . doubtless rather confused ideologically . . . nonetheless marks a characteristic precedent which was to decide the whole of the movement's subsequent conduct. Surrealist activity, confronted with this brutal, revolting, *unthinkable* phenomenon [the Moroccan War], was led to question its own resources, to determine their *limits;* it forced us to adopt a specific attitude, external to itself, in order to continue confronting what exceeded those limits. This activity, at this moment, entered its *rationalizing* phase. It suddenly felt the need of crossing the trench that separates absolute idealism from dialectical materialism."—André Breton, *Qu'est-ce que le surréalisme?* (1935).

him, became aware of "these new sensations that filled the atmosphere,"[7] and it was in a tone of the most enthusiastic admiration that he hailed both the Russian Revolution and its leaders.[8] He showed a particular admiration for Trotsky, an admiration which he maintained for a long time, still characterizing in 1938 the period that came to an end with the outbreak of the Second World War as "the age of Lautréamont, of Freud, and of Trotsky."[9] These three names, which he sought to make into more than symbols, summarized for Breton the most inspiring effort to transcend poetry, to explore man, and transform society.

It seems, then, that the surrealists wanted to take the step toward social and political action. By the end of 1925, collaboration was established with the *Clarté* group. As early as May, one editor of *Clarté*, Victor Crastre, under the title *Explosion surréaliste*, rescued the little surrealist group from the ostracism to which the revolutionary intellectuals had previously consigned them. He showed the "points of contact between the surrealists and the rest of us, points of contact which we do not find so marked in relation to any other literary group active today." In November, Jean Bernier himself introduced them to his readers as "the most active and most determined group of the intellectual youth, the very ones in whose originality, in whose 'talent,' as they say, the cultivated bourgeois put their highest hopes"; he described them as "rejecting the successes of a literary career sought after with such servility by the great majority of their elders and their contemporaries in order to join us, finally, for a fresh start." Bernier further emphasized a public declaration, recently made *in the name of our new alliance*, published by *L'Humanité* on November 8, 1925, in which the surrealists, along with their new comrades, expressly indicated that there had never been a "surrealist theory of revolution," that they had

[7] *Lautréamont.*

[8] ". . . I give up trying to describe our impressions. Trotsky remembers Lenin. And with good reason passes over so many difficulties that it is like a superb storm coming to an end. Lenin, Trotsky, the mere discharge of these two names will once again make heads and heads sway. Do they understand? Do they not understand? Hurrah for Lenin then! I bow here to Leon Trotsky . . ."—André Breton "Léon Trotsky: Lenin," *La Révolution surréaliste,* No. 5.

[9] André Breton, flyer for Nicolas Calas' *Foyers d'incendie* (Denoël).

never believed in a "surrealist revolution." Let us regard these statements as the manifestation of their state of mind in 1925 rather than as a specific expression of the truth. What matters is that the surrealists said they no longer wanted to consider the revolution except "in its economic and social form," and even employed strict Leninist formulas to define it.[10]

This unequivocal declaration left the polemic with Aragon far behind. Bernier explained this new position by the fact that Breton and his friends had come to grips, as had the editors of *Clarté*, with "implacable realities": war, man's exploitation of his fellow man, the prostitution of art and literature.[11]

Hence the December issue of *Clarté* announced on the cover: "*Clarté* is ceasing publication, to be succeeded by *La Guerre civile*," at the same time that it named the founders, both surrealist and Clartéist, of this new publication: Louis Aragon, Jean Bernier, André Breton, Victor Crastre, Robert Desnos, Paul Éluard, Marcel Fourrier, Paul Guitard, Benjamin Péret, Michel Leiris, André Masson, Philippe Soupault, Victor Serge. Things had gone far enough so that Marcel Fourrier, in the editorial, could present the future new organ as the expression of the

> first evidence to appear in France since 1919 of a young revolutionary intelligence acquired from communism, a current which combines for the first time minds that have come to the Revolution by the most diverse paths, and which expresses in particular the valuable effort of the young postwar generation.[12]

The surrealists produced the same announcement in *La Révolution surréaliste* for March 1, 1926, with this difference, that they do not say *La Révolution surréaliste* must give way to the common tribunal. As a matter of fact, the alliance was not total, nor did it proceed as far as the dissolution of the surrealist group; Breton explained himself on this matter in his first article in *Clarté*. Certainly the surrealists had left their ivory tower, hence-

[10] "They can conceive the revolution only in its economic and social form: the Revolution is the total of the events that determined the shift of power from the hands of the bourgeoisie to those of the proletariat and the maintenance of this power by the dictatorship of the proletariat . . ."

[11] In this same issue of *Clarté*, Aragon contributes a study on the "Proletariat of the mind," characterized by Bernier as "irreproachably Marxist."

[12] *Clarté*, No. 79.

forth they believed that the struggle could not be confined to the realm of ideas alone, and Breton, who had once written that surrealism would not be made to serve the "amelioration of the abominable earthly comfort," now acknowledged that any work of the mind could be valid only if it contributed to "changing the living conditions of an entire world."[13] Yet the surrealist experiment exists too. It had already produced results and was not at all in conflict with the Revolution. According to Breton, it even exceeded in its scope the narrow specialization of the economic and the social, and couldn't, without serious danger, be identified and limited to them. Those who regarded it as a mere annex of revolutionary action were mistaken, and Breton warned his political friends not to expect from him either a disavowal of this action or a renunciation. It was useful, it was necessary that the surrealist experiment continue.[14]

This intransigence of Breton's as to the strict autonomy of surrealism, which he was quite willing to put in the service of the revolution but which he would not sacrifice to it, ultimately caused the project of the new alliance to collapse. *La Guerre civile* was not to appear.

The surrealists, aside from these theoretical *donées,* offered no official explanation before 1927 as to the abandonment of the project. *Clarté,* whose first issue (of the new series) appeared June 15, 1926, attempted on the other hand to discover the reasons for the failure.[15] Marcel Fourrier finds them in an absence of a true collective life in the new alliance, a collective life that

[13] I am willing to believe that there is no work of the mind which has not been conditioned by the desire for *real* amelioration of the living conditions of an entire world . . . The important thing is that, for us, despair, that famous despair that has always been attributed to us as a motive, ceases on the threshold of a new society. We have only to turn our eyes toward Russia . . . We belong body and soul to the Revolution and if, hitherto, we have never accepted orders, it was to keep ourselves at the orders of those who animate it . . ."—André Breton, *La force d'attendre* (*Clarté,* No. 79).

[14] "I do not believe that at the present time there is occassion to oppose the cause of pure spirit to that of the Revolution and to demand of us, of certain individuals among us, a still greater specialization. Still less would I understand that for utilitarian ends I should be asked to disavow surrealist activity, for instance." *Ibid.*

[15] Marcel Fourrier, "Lettre au lecteurs de *Clarté*" (No. 1, new series, June 15, 1926).

alone would be capable of transmuting the surrealist and Clartéist values and, lacking this, in a misapprehension as to the true use that should be made of the forces temporarily accumulated: the surrealists and the Clartéists must be left to the specialization which had been their *raison d'être*, the notion of an impossible and undesirable fusion must be abandoned for a collaboration which would be only all the closer. Only an unchecked enthusiasm was responsible for this temporary failure, and Fourrier himself showed no animosity toward the surrealists, convinced that "when the decisive test comes, they will take their place in the communist ranks . . ." He went further: he forgave; with fraternal comprehension Fourrier evoked the problems peculiar to surrealism, acknowledged that they were not those of political and social action. In this case:

> It would obviously be absurd at the present time to ask the surrealists to renounce Surrealism. Have they asked the communists to renounce communism? In short, it is better that the projected experiment has not *yet* occurred, but still remains in the future.

Since the politicians had not been intractable, no bridges were burned. The projected fusion became a collaboration: this consisted in the publication, in *Clarté*, of surrealist poems and essays by Aragon, Éluard, Péret, Leiris, Desnos, until 1927. A reciprocal hospitality was shown by *La Révolution surréaliste* to social and political studies by Marcel Fourrier and Victor Crastre.

THE ANALYTICAL
PERIOD, 1925–1930

THE NAVILLE CRISIS

Our age is not one of prophecies, but of expectations. —PIERRE NAVILLE

T H E question of surrealism's political and social commitment was not thereby settled. In the very heart of the surrealist group, it was to be raised again and to occasion, as Breton observed, "characteristic altercations."[1] Inevitable ones, for surrealism was never a doctrine but an attitude of mind, and that it was animated by individualities of extremely diverse determinations. The force of circumstances, and in a more intimate manner the experiment conducted in common with *Clarté,* led some of the group's members to raise the question once again: "What can the surrealists do?" Pierre Naville answered by criticizing the surrealist attitude as it was expressed at the end of 1925 and the beginning of 1926.[2] For him, if the intellectuals were capable of playing a more decisive role in France than in other countries, they were nonetheless of no direct help to the revolutionary proletariat, the only force capable of carrying out the revolution hailed by the surrealists. The surrealists themselves, despite their noisy demonstrations, were incapable of constituting a force likely to alarm the bourgeoisie because these demonstrations were confined to the moral level, and on this level the bourgeoisie readily forgives, strong in its assurance that moral scandals cannot result in a social or even an intellectual upset.[3]

[1] André Breton, *Qu'est-ce que le surréalisme? (op. cit.).*
[2] Pierre Naville, *La Révolution et les intellectuels (Que peuvent faire les surréalistes?).*
[3] "The moral scandals provoked by surrealism do not necessarily suppose an overthrow of social and intellectual values; the bourgeoisie does not fear

Even supposing that the surrealists abandoned an ineffectual moral level, they could orient themselves usefully—a problem of a different order of importance—only after resolving the basic antinomy of surrealism, divided between a *metaphysical attitude* which Naville characterized as a "theoretical speculation on the data of internal experience and of a certain experience of external objects and events," and a *dialectical attitude* which was nothing other than the "progress of the mind according to its conscious- ness of itself." Now these two attitudes were mutually exclusive. Hence the dilemma: was it necessary to believe in "a liberation of the mind anterior to the abolition of the bourgeois conditions of material life and to a certain point independent of such a life? Or, on the contrary, was the abolition of the bourgeois conditions of material life a necessary condition of the mind's liberation?" Depending on the answer given to this question, surrealism could take one of two opposing directions:

1) either persevere in a negative attitude of an anarchic order, an attitude false a priori because it does not justify the idea of revolution it claims to champion, an attitude dictated by a refusal to compromise its own existence and the sacred char- acter of the individual in a struggle that would lead to the disciplined action of the class struggle;

2) or resolutely take the revolutionary path, the only revolu- tionary path, the Marxist path, which would mean realizing that spiritual force, a substance which derives from the indi- vidual, is intimately linked to a social reality which it in fact supposes.[4]

It is because these two attitudes were at this moment equally possible that the alternative was expressed in this clear-cut form. There is no doubt that Pierre Naville was a partisan of the second solution. Hence, pursuing his line of reasoning, he undertook to undermine individualism as a revolutionary force, an attitude which, despite appearances, won the assent of almost all the surrealists. What could the individual reduced to his own powers

them. It absorbs them easily. Even the surrealists' violent attacks against patriotism have assumed the nature of a moral scandal. Such scandals do nothing to depose the ruler of the intellectual hierarchy in a bourgeois republic . . ." P. Naville, *La Révolution* . . . (*op. cit.*).

[4] P. Naville, *La Révolution* . . . (*op. cit*).

do? Naville asked. Nothing, except to prophesy. The surrealists had proclaimed the vanity of literary activity, they had even acknowledged the effectiveness of collective activity by the existence of their own group. This collective activity resolved nothing if it confined itself to extolling individual values. It was no more than an addition instead of a conversion from quantity to quality.

Hence it was time to abandon, first of all, "the abusive use of the Orient myth" which could mean nothing for a revolutionary thinker, for its opposition to another myth called the Occident had no valid basis. And it was also time to stop parading a "reactionary" scorn for the conquests of science and technology; were not machines "the realm in which the surrealists among others had sought the marvelous?"

And after asking if the revolution the surrealists desired was "that of the mind a priori or that of the world of facts," Pierre Naville offered an extremely clear conclusion:

> Wages are a material necessity by which three-quarters of the world's population are bound, independent of the philosophical or moral conceptions of the so-called Orientals or Occidentals. Under the rod of capital, both are exploited. That is all their present ideology. Intellectual disputes are absolutely futile before this unity of condition . . .

These declarations "provoked among us very noticeable anxieties," Breton acknowledged.[5] They stimulated new arguments within the group, they even risked dislocating the group altogether. The problem was raised in terms so clear that an answer was unavoidable, taking sides essential. This was why Breton published *Légitime défense*. In this brochure (September 1926) he reiterated his enthusiastic adherence in principle to the communist program, "although this is, in our eyes, a minimum program of course." Without dealing directly with the questions raised by Naville, he turned his fire, excellent tactician that he was, against the politicians. He complained of the "secret hostility" of the communists toward himself. With what justification? Were the communists achieving the revolutionary will any better? This was far from certain: it was enough to read

[5] André Breton, *Qu'est-ce que le surréalisme?* (*op cit.*).

L'Humanité, "puerile, declamatory, uselessly *cretinizing,* an un-readable paper, entirely unworthy of the role of proletarian educa-tion it claimed to assume." Why? Because the Communist Party was based solely on the defense of material interests,[6] and because this preoccupation alone had never been capable of producing revolutionaries. One became a revolutionary only after having made a certain number of sacrifices: social position, freedom, life itself if necessary. Hence it was not the hope of a better individual life that produced the revolutionary, but on the contrary a life of voluntary renunciations and sacrifices. The communist psychology was false in attempting to produce revolutionaries by promising them an easier life in material terms. The contrary was the truth.

This first error, an error of principle, made it difficult to regard the communists as the only revolutionaries. A more general ques-tion arose: why should they monopolize the revolutionary de-termination?[7] Was it not characteristic of many? Who would draw the line between the revolutionaries and the others? Did there exist a frontier on one side of which one was a revolutionary, and beyond which one was a revolutionary no longer? Who would draw such a line? In one stroke Breton indicated the ambi-tion of the surrealists and defined their role.[8] Their ambition? To serve as best they could the cause of the Revolution by constantly appealing to principles which risked adulteration in contact with everyday action. Their role? To make use of this activity, to keep "outside."

The attack against the Communist Party had a goal: to discredit in advance the questions raised by Pierre Naville, since Breton pretended to take them as coming from the Party itself, whereas Naville was still a member of the surrealist group. By dealing more specifically with these questions, he could not be accused

[6] "It is not the material advantages each man may hope to drive from the Revolution that will dispose him to gamble his life—his life—on the red card . . ."

[7] "I say that the revolutionary flame burns where it chooses, and that it is not up to a small group of men, in *the period of waiting we are now living through,* to decree that it can burn only here or there . . ."

[8] "We believe that, having nothing to gain from placing ourselves directly in the political realm, we may, in matters of human activity, justifiably make use of the appeal to principles and thereby serve the cause of the Revolution . . ."

of being evasive, still less of shirking his duty. His answer deserves to be quoted by reason of its clarity:

> In the realm of facts, on our part no ambiguity is possible: there is not one of us who does not *desire* the shift of power from the hands of the bourgeoisie to those of the proletariat. *Meanwhile,*[8] it is no less necessary, as we see it, for the experiments of the inner life to continue and this, of course, without an external check, even a Marxist one.

This was a demurrer to the demand for commitment to the political realm. It even marked a retreat from an earlier position: the shift of power was *desired,* etc., *meanwhile* the surrealists chose to conduct their experiments in freedom.

Then Breton took the offensive again. Starting from an ideal fusion of the subjective and objective states, he justified the value of "certain buffer-words" such as the word *Orient.* Again he criticized on a moral level—deliberately and exclusively on that level—technology, attribute of the Western peoples, denying that wage-earning was "the efficient cause of the state of things we are now enduring." Finally, he denied the existence of a fundamental antinomy underlying surrealism. In truth, he said, there were two different problems: the problem of knowledge "which has presented itself to us electively," and the problem of the appropriate social action to be taken, which he would not and could not discard, but whose solution he left to others:

> The two problems are essentially distinct, and we believe that they would be deplorably confused if we did not choose to leave them so. Hence there is a justification in opposing any attempt to combine their data, especially the order to abandon all such experiments as ours in order to devote ourselves to the literature and art of propaganda.

Actually, Breton was begging the question: he was not being asked to abandon surrealism for a literature of propaganda, but to orient surrealism in the direction of a revolutionary *action.*

Perhaps it had been ingenuous to attempt to force Breton to choose? At least this insistence had produced a clearly defined position: active sympathy for the proletarian Revolution, obedience to its orders when the moment came; "meanwhile," on the

[9] Italics mine.

level of the mind, continuation of the habitual activity of research and revelation of the unconscious, efforts to unite this unconscious with the consciousness at the heart of a higher reality, and on the social level: resolution of moral problems that faced the free individual.

"AU GRAND JOUR"

The time is coming when seas of boiling rage will reverse the icy current of rivers, overflow and fertilize, fathoms deep, a crusted, petrified soil, tear away frontiers, uproot churches, clean the hills of bourgeois complacency, decapitate the headlands of aristocratic insensitivity, drown the obstacles the exploiting minority set in the way of the mass of the exploited, restore humanity to its future by freeing it from outdated institutions, religious fears, jingoistic mysticism and all that constitutes and consecrates the evils of the majority for the benefit of the two-legged sharks, their mates and the whole gang. —RENÉ CREVEL

N UMBERS 6, 7, and 8 (March 1, June 15, December 1) of *La Révolution surréaliste* for 1926 revealed nothing of the dispute that agitated the surrealist group during this entire period. Accounts of dreams, surrealist texts, reproductions of surrealist paintings, poems, essays constituted its usual contents. Proclamations, once so numerous, were henceforth absent. Apparently after the distance it had traveled together with *Clarté*, surrealism needed to turn back on itself, to reflect on its limits, at the same time that it deepened its substance.

It won curious adepts, such as Gengenbach, whose presence in the surrealist group at this time afforded a spectacle that was disturbingly picturesque. A Jesuit Abbé, he had fallen in love with an actress at the Odéon and in her company frequented restau-

rants and dance-halls. Defrocked by his bishop, he had lost his mistress, who loved him only in his cassock, and had happened to pick up an issue of *La Révolution surréaliste* at the moment he was thinking of suicide. Hence he did not fling himself into the Gérardmer lake as he had planned, but entered into relations with Breton and his friends. He was to be seen at the Dôme or the Rotonde, a flower in the buttonhole of his soutane, which he had begun wearing again as a provocation, a woman on his lap, vilified by the respectable passers-by whom he delighted in scandalizing. He divided his time between a scabrous worldly life, periods of calm with a Russian woman, an artist, in Clamart, and retreats at the Abbey of Solesmes. When there were rumors that the prodigal was about to return to the bosom of the Church, Gengenbach enlightened the surrealists in a letter to Breton:

> It is my custom to go several times a year to rest and recover my spirits with the monks . . . and the surrealist circle is well aware of my pronounced taste for escapades in monasteries . . . As for the ecclesiastical habit, I wear it by caprice for the moment, because my suit is torn . . . I also find it affords me certain advantages in initiating sadistic relations with the American women who pick me up in the Bois at night . . .
>
> I have found *no solution,* no escape, no pragmatism that is acceptable. There remains my faith in Christ, cigarettes, and the jazz records I love—"Tea for Two," "Yearning"—and above all, there remains *surrealism.*

This curious individual was to end badly all the same. Trying to reconcile Christianity and surrealism, after writing such works as *Judas ou le Vampire surréaliste* (Aigle noir, Paris 1930) and *Satan en Espagne,* he denounced Breton as the living incarnation of Lucifer and the surrealists as "conscious demoniac victims of possession or demons incarnate." Exorcism, he added, was "unfortunately relegated to the remote Middle Ages," but he nursed hopes that "suffering and the vicissitudes of life would fling these conquistadors of Hell at the foot of the Cross." Unfortunately, "no theologian's argument will convince a surrealist, only the love of some passionately desired female saint can transform a surrealist."[1]

One suspects that despite his sincere return to "the faith of

[1] E. Gengenbach, *Surréalisme et christianisme.*

his childhood," Abbé Gengenbach was not likely to be regarded by his ecclesiastical superiors as an orthodox believer in good standing.

Surrealism, then, continued. Pierre Naville, who had not been able to inflect its development toward a consistent political position, took a "secret leave" and became co-director of *Clarté*, where he nonetheless continued to publish the essays and poems of his friends. Aragon, Breton, Éluard, Péret, Unik, shaken by his arguments nonetheless, decided to offer hostages to the position he defended by joining the Communist Party. An odd choice after what we have said of Breton's fierce intractability with regard to the autonomy of surrealism.

In reality, a step had to be taken which Breton and his friends, rightly or wrongly, were unwilling to take. It was not contempt and fear of action which held them back; by giving their adherence to the Communist Party they sought to offer proof of that. Yet since they either could not or would not become political militants, their adherence was formal and had only the value of a manifestation, sincere and deliberate of course, but by which the Party, while admitting them into its ranks, was not deceived. When it asked them to abjure what it regarded as a heresy (the surrealist attitude, whose elements we have attempted to define), they were to rebel and withdraw. For the moment, they sought to give their adherence to its full value; they saw it "in the logic" of their surrealist attitude and proselytized among their friends at the same time that they attempted to avoid a totalitarian absorption by the Communist Party. Hence the explanations on either side, exchanges of letters, ultimatums and denials which constitute the brochure *Au grand jour* (1927).

This records the crisis that broke out among the group, and at the same time proclaims the desire to bring it to an end. To do so, according to Breton, it was enough to illuminate a certain number of problems and to make positions explicit.

That surrealism had lost none of its rigor, is the first thing we notice; as a matter of fact the Five (Aragon, Breton, Éluard, Péret, Unik) had announced the expulsion of Antonin Artaud and Philippe Soupault the year before (November 1926), for incom-

patibility of goals: once the expelled members acknowledged literary activity as a value, they had no place in a group which had proclaimed its vanity. It was on quite different conceptions that the surrealist pact had been founded. It appeared nonetheless that it was not enough to proclaim these conceptions, nor even to live them, a further step must be taken: one must adhere to the party of the Revolution. This the Five did: they announced the fact publicly and, overstepping their individual positions, they committed the sympathy of the entire movement to this political organization.[2] Mistakenly, it would appear, for they observed that some of their friends "pretended not to understand," notably the Belgian surrealists Paul Nougé and Camille Goemans, who wrote them: "You have decided to join the Communist Party. No one has understood the true meaning of this step. An attempt is being made to diminish you." The Five answered that it was nonetheless a perfectly natural step to take, and that there was greater danger in refusing to take it than in making a decisive stand.[3] A simple argument of expediency, then; which they repeated for the sake of their reticent comrades in the French group. Further, they added that they regarded communism as the "only ideological safeguard" of the surrealist idea. Pure anarchy had become, they said, sterile because it was ineffectual. It had to be transcended by submission to an element that was external, of course, but one that was capable of giving a meaning to pure protest, of making it valid. Their desire was that this divergence in attitude should not compromise the mutual labor that was more necessary than ever and demanded every effort from the surrealist forces as a group.

Did this mean that they were entirely in agreement, and on every level, with the politicians? No. In the camp of close friends, at *Clarté*, the surrealist collaboration was apparently held rather

[2] "If elsewhere, and exclusively as a result of our respective humors, we have not all chosen to adhere to the Communist Party, at least none of us has assumed the responsibility of denying the great bond of inspiration that exists between the Communists and ourselves . . ."

[3] "We have joined the French Communist Party, considering first that not to do so might imply on our part a reservation which did not exist, a hesitation beneficial only to its enemies (who are ours as well, and our worst) . . ."

cheap. "Why," they wrote to Marcel Fourrier, "are we used only for 'literary chores'? It that what you mean by specialization? That we are just good enough to liven up the dry political pages of *Clarté*? Furthermore, why are you so timid in our defense? If we need to be defended against the narrow-mindedness of the militants who do not appreciate the message of human liberation transmitted by Sade and Lautréamont, why don't you defend us openly and responsibly and deliberately, since we are not strangers to you?"

Pierre Naville appeared to be the chief target of these *Letters*.[4] He was still—at least nominally—a member of the group, and since he had best effected the transition to political action, which remained endowed with a great prestige among the Five (who were nonetheless reluctant to abandon their earlier ideas), it was to him in particular that they turned for discussion and it was Naville above all whom they reproved. They recalled their common past; and it was in the name of this past that they justified themselves, that they attempted to explain themselves. Certainly the positions were different, since Naville had broken *in fact* with the movement, and the Five claimed to continue it. But they now acknowledged that it was Naville who had raised the question and raised it well. Still, they could not consent to the same sacrifice by shifting to political action, because unlike him they did not regard themselves as free to do so.[5] Ultimately, who was right? The Five admitted, but only in part, the cogency of his arguments. And emphasized this concession only to enhance their reproaches, and true purpose of the Letter. Of what was he guilty? Of having suggested that there was no compatibility between Marxism and surrealism. Which would imply that the

[4] "It is not without thinking of you that we are writing these Letters." (*Lettres à P. Naville*)

[5] "There is Pierre Naville who circulates, without any known risk, among the ideas of his choice, and we who, in general, would have everything to lose by such haste . . . We still have doubts: who is in command here, and there? Who answers for the adequacy of what is undertaken? . . . In your brochure *La Révolution et les intellectuels*, you were the first to raise the question we are discussing here. You were put, on that occasion, to the test of incomprehension and routine. Even minds that had glimpsed revolutionary illumination reproached you for the sacrifice you had consented to make . . ."

latter sought to pass itself off as a positive doctrine of Revolution, an ambition which the surrealists had rejected since 1925. He was therefore asked to correct these matters publicly for, they said, he knew better than anyone that surrealism, a revolutionary attitude of mind, infinitely exceeded mere political recipes for the Revolution.[6]

After the close friends, those who were more distant: the members of the French Communist Party whose hopes they had come to share. These were suspicious friends, whom it was essential to pacify first: "Never, as we must insist with all our might, have we dreamed of asserting ourselves in your presence as surrealists." So why these tactics of which the surrealists were the victims within the Party? Why this neglect, whereas *L'Humanité* publishes stories by M. Blaise Cendrars, author of *J'ai tué* and of whom the least that can be said is that he is not a communist, or serials by M. Jules Romains "glorifying crime, stupidity, cowardice"?

After these clarifications, these explanations, these demands for explanations, the situation was not improved. If, within the surrealist movement, the Five had easily been able to gain acceptance for their position, they did not return to favor with the Communist Party, which did not forgive them their criticism and which, despite their denials, persisted in regarding them as partisans of a political and cultural heresy which it continued to ask them to abjure.

The surrealist activity as such suffered from these disputes. During the year 1927 there appeared only one number of *La Révolution surréaliste* (October 1), a Manifesto apropos of Rimbaud: *Permettez!* and André Breton's *Introduction au Discours sur le peu de réalité.*

It even seems that surrealism withdrew into itself, that having taken an unequivocal part in political activity as such, it chose to tighten its hold on the autonomous treasure it had discovered,

[6] "It is regrettable that you should have permitted, in *Clarté* or on *Clarté*'s behalf, a slur on surrealism which affords none for you. This slur is the one that tends to pass off surrealism as an *a priori* distortion of Marxism . . . We must also protest your insistence on presenting surrealism as a positive political doctrine . . ."

and cherish it all the more in that its value seemed contested by these close political friends. The surrealists claimed not to lose caste by regarding problems from a higher level, the heights of the moral realm.

For it was once again a moral problem that was raised in the editorial of number 9–10 for October 1, 1927: *Hands off Love,* apropos of Charlie Chaplin. Did the latter have the right to regard love, and to practice it, in his own way, or was he to become the slave of his wife, who was suing him for divorce because he was "unfaithful" and did not want to be the father of her children? The surrealists sided vigorously with Charlot, whose freedom of behavior and mind delighted them, and by denouncing his wife attacked bourgeois love confined to the marriage laws.[7]

And the strictly surrealist work continued: alongside Max Ernst's *visions de demi-sommeil,* dreams by Aragon and Naville, Robert Desnos in the *Journal d'une apparition* traced a phantom that visited him every night from November 16, 1926 to January 16, 1927. Further, the surrealists continued to revive obscure poets like Xavier Forneret, who was utterly unknown at this time: thanks to them, he was rescued from an oblivion he did not deserve.[8] Poems by Paul Éluard *(Défense de savoir),* Raymond Queneau *(Le Tour de l'ivoire),* Jacques Baron and Fanny Beznos, who had been discovered by Breton at the Saint-Ouen flea-market where she ran a stall, a text by Benjamin Péret, the conclusion of Breton's study *Le surréalisme et la peinture* form the properly surrealist section of the number. An unpublished text by Freud: "The question of lay analysis" recalled the philosophical

[7] "She, supposed she was denouncing her husband, the stupid cow, whereas she simply occasioned the spectacle of the human greatness of a mind which, accurately conceiving so many deadly things in the society in which his life and even his genius confine him, has found the means of giving his thought a perfect and vigorous expression without betrayal, an expression whose humor and power, whose poetry, in a word, suddenly suffers before our eyes an enormous setback in the light of the little bourgeois lamp shaken over his head by one of those bitches out of whom, in every country of the world, are made *good* mothers, *good* sisters, *good* wives, those plagues, those parasites of feeling and love . . ."

[8] "Who is Forneret? We don't know. He is the *Black man* . . . Forneret, a man whom we have met in the darkness and whose hands we have kissed."

principles of the movement, while Aragon exalted Heraclitus as the father of dialectics. And if Pierre Naville offered *Mieux et moins bien* in this issue, it was not by concession to the ideas which he himself regarded as outmoded, but again to urge that the surrealists leave their habitual terrain which, whatever they said, seemed cramped to him. Once again he denounced "the charms of individual psychology," chiding Breton without naming him for supposing that *meanwhile* he could continue to be excited by his own experiments,[9] and after observing that "this impulse toward the Bolshevik methods which the surrealists experienced, despite all the blunders with which it was surrendered, has been very badly received," Naville undertook to invoke as a common denominator to surrealist and revolutionary activity "a notion quite natural after all: pessimism":

> A certain despair is the lot of serious, unwearied minds, severely applied to their object (almost always to themselves) in every age . . . Vague yearnings, weakness of temperament, whimsy, spite are out of the question. We are talking of the *human—* that is, all in all, of the *living* sense of desertion and perdition . . . Pessimism is at the source of Hegel's philosophy, and it is also at the source of Marx's revolutionary method . . ."

which permits him to denounce as blemished "with definitive optimism" the productions and objurgations of M. Drieu la Rochelle (who regrets in surrealism the "miscarriage of a splendid artistic movement"), humanism in general and "particularly the intelligence of M. Paul Valéry."[10]

[9] "It was not *meanwhile* that Rimbaud so cruelly frequented the Somali coast, it was not *meanwhile* that Lautréamont so magnificently dismantled logic, nor was it *meanwhile* that Berkeley or Locke—or Hegel—distilled that tragic incandescence into which they dissolved their world; that we know . . ."

[10] "Still humanism. Still the absurd need to reread his sentences, still the inability to transcend the limits assigned to our need for 'demoralizing syllogisms,' that is, to take these limits into account once and for all . . . The organization of pessimism is truly one of the strangest 'watchwords' a conscious man can obey. Yet it is the one which would have him follow. This method, if one may call it that, and one might more accurately say this tendency, permits and will perhaps further permit us to observe the highest partiality, the one which has always cut us off from the world; it also will keep us from stagnating, from dying, that is, we shall maintain our permanent right to existence in this world . . ."

This was the last article Naville was to give to *La Révolution surréaliste*. His efforts to elucidate a common revolutionary content did not permit the surrealists to shift more easily to a consistent political action. From this point, the paths inexorably diverge.

But on the level they stipulated for themselves, the surrealists still did not disdain a good scandal. Witness the Manifesto: *Permettez!* composed by Raymond Queneau and signed by the entire group, including Naville, apropos of the erection at Charleville, in the famous Station Square, of a statue to Arthur Rimbaud. Queneau reminds "Messieurs les Réprésentants des Ardennes, M. le Maire de Charleville, MM. les Notables, M. le Président de la Société des Poètes ardennais" who Rimbaud really was, simply citing the works in which the poet expresses his defeatism, his horror of France, and the famous "French taste," his execration of the Church, his contempt for work and culture, and lastly his "communardisme." Which leads Queneau to conclude:

> The statue inaugurated today will perhaps suffer the same fate as its predecessor. This latter, which the Germans removed, was melted down for the manufacture of shells, and Rimbaud would have gleefully waited for one of them to smash to smithereens your Station Square or reduce to dust the museum in which base preparations are being made to traffic in his glory.

On the level of strictly surrealist research, Breton published, this same year, his *Introduction au Discours sur le peu de réalité*, in which he offers ideas that were to be much expanded. They are not new in his work, since the essay must have been written in 1924. In it, however, he already raised the problem of "surrealist objects":

> One night recently, *in my sleep*, at an open-air market near Saint-Malo, I had picked up a rather curious book. The back of this book consisted of a wooden gnome whose white beard, curled like that of an Assyrian statue, fell to his feet. The statuette was of normal size, yet made no difficulty in turning the pages of the book, which were of heavy black wool. I was eager to purchase it and, wakening, regretted not having it beside me. It would be relatively easy to reconstruct. I should like to put in circulation several objects of this nature, whose fate seems to me infinitely problematical and disturbing . . .

After proposing several examples of these imaginative but quite real constructions, Breton added:

> Are poetic creations soon likely to assume this tangible character, to displace so singularly the limits of what is called reality? It is desirable that the hallucinatory power of certain images, that the true gift of evocation possessed, independently of the faculty of memory, by certain men be no longer disregarded . . . I claim that *this* exists as much as *that,* in other words neither more nor less than the rest. There is nothing I find inadmissible . . .

THE YEAR OF ACHIEVEMENTS

You must beat your mother while she's young.
—PAUL ÉLUARD–BENJAMIN PÉRET
(surrealist proverb)

IN THE EVOLUTION of surrealism, 1928 is a calm year. No apparent frictions in the group. In the absence of events likely to reawaken the questions argued during the course of the three preceding years, the surrealist current returned to its channel and stayed there. This was the year of achievements: the publication by Breton of *Nadja* and *Le Surréalisme et la Peinture,* a general exhibition of surrealist works at the "Sacre du Printemps," a Max Ernst show at Bernheim Georges. It seemed as though the era of pitched battles was over. Surrealism had finally gained *droit de cité.* It was admitted as an avant-garde movement, it had produced works which were read and seen, its audience was quite large, its influence, particularly among the young, not negligible. It contributed a great deal to changing the climate of painting and poetry. Magazines were published by young disciples in which surrealist ideas already constituted a common body of doctrine, notably *Le Grand Jeu,* edited by Roger Gilbert-Lecomte, René Daumal, Roger Vailland and Joseph Sima, a review which, steeped in the same sources, inevitably claimed inspiration from Rimbaud—"mystic, occultist, revolutionary, poet"—and announced:

Above all, men must be made to despair of themselves and of society. From this massacre of hopes will be born a bloody and

143

pitiless Hope: to be eternal by the refusal to endure. Our dis-
coveries are those of the explosion and dissolution of all that
is organized, etc.

In the Summer 1928 issue, R. Gilbert-Lecomte asked the question
already raised by the surrealists: "Since Rimbaud, have all the
writers, the artists who were of any value for us . . . had any
goal but the destruction of 'literature' and of 'art'?" In a foreword,[1]
he proclaimed:

> We shall always give all our strength to all new revolutions.
> We are not individualists . . .

All the same, *Le Grand Jeu* was not admired by the surrealists.
It seemed that these young men were keeping too easily within
the bounds the surrealists had already left behind. There was
too much talk of "mysticism," too much frequentation of the great
mystics, the great Initiates, too much Plato-Hegel-Buddha-Christ-
Balzac-Rimbaud-and-Saint-Pol-Roux. They were, in short, still
too close to literature. And then, what did this letter from Rolland
de Renéville to Saint-Pol-Roux mean?

> We believe that all roads lead to God and that our task is to
> rediscover the lost unity . . . You once said: "Beauty being
> the form of God, it appears that to seek it leads to seeking God,
> and that to show it is to show Him." . . .

After a moment of fraternal hope in these young men, the
surrealists turned away from them. The question was elsewhere.
And if Breton returned, in the *Second Manifesto,* to occultism and
the Initiates, it was a long way from his methods to those of these
"God-seekers."[2]

The surrealists preferred to attack concrete problems—fre-
quenting political revolutionaries had at least established that
need—like love, for example, and to try, through a broad discus-
sion, to reach a provisional solution. These "Researches in sexual-
ity, degree of objectivity, individual determinations, degree of
consciousness" were published in the form of a questionnaire-

[1] "Signed in complete agreement by Cramer, René Daumal, Artur Har-
faux, Maurice Henry, Pierre Minet, Roland de Renéville, Joseph Sima,
Roger Vailland.

[2] Only Ribemont-Dessaignes, who after Dada was never a surrealist, and
Robert Desnos agreed to collaborate with them.

discussion in the single number of *La Révolution surréaliste* for 1928.

Love, to the same degree as revolution, was one of the funda-mental inspirations of the surrealists. Their reiterated attacks against society were also inspired by the fact that it did not permit the free and complete realization of a desire no less demanding than hunger. Freud had made the libido the essential motive-force of behavior, and the study of his patients had convinced him that the metamorphoses imposed by society were far from being uni-versally beneficial to the individual. In this sense, Freud had taken love down from the literary pedestal, not by diminishing it of course, but by showing, on the contrary, its universal empire. The surrealists, who more than anyone else have magnified love (and woman), sought to transcend the psychological realm in which it had immemorially been confined and to pin it, too, on the dis-secting table. It is from this point of view that we must judge their discussions on the subject, conducted with the desirable objec-tivity and frankness by means of questions and answers exploding in a rather exhilarating atmosphere. Beyond the level of mere confessions, discoveries multiplied by individual confrontations were brought to the level of consciousness.[3]

The surrealists also celebrated the fiftieth birthday of hysteria. Appearing around 1878, this curious disease, maintained so in-genuously by Charcot himself, could justifiably be described by Breton and Aragon as "the greatest poetic discovery of the nine-teenth century." How did it appear, in fact? Essentially as a pathological mental attitude, but exclusive of any organic lesion, often generated by the mere power of suggestion, disappearing in the same way, as Babinski was later to prove. "Complex and proteiform," it escaped, according to Bernheim, any definition, and was it not the point of departure for the discoveries of one of Charcot's most gifted pupils, Freud? The surrealists were able to annex it as a manifestation of infinitely disturbing "emotional

[3] Two sessions took place, on January 27 and 31, 1928. The interrogations were conducted by each member in turn. Under discussion were: the degree to which a man takes a woman's pleasure into account, love between women, between men (this last form almost unanimously condemned, Breton taking the strongest part), masturbation, orgasm by succubi, prosti-tution, perversions, etc.

attitudes," release it from the pathological domain in which it had been confined in order to make it a supreme means of expression.[4]

The number of *La Révolution surréaliste* for 1928 in which these problems are discussed also contains fragments of Aragon's *Traité du style* and Breton's *Nadja*, an automatic text by Queneau, a dream by Morise, a "tale" by Péret, some poems by Desnos and Aragon, a letter to Breton from Jean Genbach, in treatment at a military hospital for misdemeanors during his service and obsessed by his terrestrial and demoniac loves. In addition appeared a text by Antonin Artaud (vilified by the group and Breton in particular a few years earlier) with this curious note:

> There will be no lack of good souls indignant at seeing on the title page of this issue the names of Antonin Artaud and Roger Vitrac[5] . . . Our contradictions should be regarded as the sign of that spiritual disease which may pass for our highest dignity. We repeat that we believe in the absolute power of contradiction.

An offensive return of Dada?

Contrary to our practice up to this point, we must dwell on the two key surrealist works which appeared in this year: Aragon's *Traité du style,* and Breton's *Nadja*, first because they testify to what surrealism could produce, and because they are not without their use for the history of the movement's fundamental conceptions.

The title of Aragon's work is deliberately paradoxical. The surrealists concerned with style? Had they not—quite noisily—repudiated it? And yet the contents of the work correspond to its title. Of course it is not a manual of "how to write," and its first lines will reassure the most demanding in this regard.[6] It is, first of all—notwithstanding the notion that "surrealism is defined by those who defend it and by those who attack it"—a deliberate

[4] And to give it the following definition: "Hysteria is a more or less irreducible mental state characterized by the subversion of the relations between the subject and the moral world to which be believes he belongs in practical terms, outside of any system of disorder or delirium."

[5] Also excluded from the movement.

[6] "In French, to *do* means to *shit*. For example: let us not force our talent, we shall *do* nothing with grace."

attack on the literature of the period and its thurifers, a pulveriza-
tion of the intellectual fashions of the years 1925–1928:

> Names of clowns that come to mind: Julien Benda, M. Thiers,
> Goethe, Paul Fort, Abbé Bremond, the author of *Rien que la*
> *terre*, Raymond Poincaré, Gyp, Pastor Soulié, André Maurois,
> Ronsard, Julien Benda especially.
> Baron Seillières is more of a stableboy.
> André Gide is neither a stableboy nor a clown, but a fucking
> bore.

It is a veritable indictment of his age that Aragon is writing.
He first undertakes to thrash both the traditional criticism which,
armed with a candle-end, proceeds to the discovery of barbarisms,
and the advanced criticism which he himself helped establish by
discussing certain surrealist works.[7] But how can we follow any
order in this generalized slaughter? What we must note, though,
is Aragon's violent hostility to everything that helped establish
surrealism and that he might thus be expected to spare. There is
no "feeling," for example, for Dada, guilty of having vulgarized
itself in banalities,[8] and only a profound disgust for the entire
posterity of Rimbaud, now claimed, moreover, by the least es-
timable people. If there exists a universal infatuation for Rimbaud,
this can only be the sign of a profound vulgarity.[9] Then all
the literary themes of the period are pitilessly ridiculed and dis-
missed: departure, adventure, escape, vulgar aspects of a uni-
versal optimism, belief in a "beyond," an "elsewhere," a paradise

[7] "The young oil-lamps of criticism are more seraphic, woolier. If they
mention *Hernani* you can search high and low to learn the name of Doña
Sol . . . The authors of reviews would regard themselves as dishonored if,
as they should, they discussed the subject of the book . . ."

[8] "Thus everyone begins supposing that nothing is worth the trouble,
that two and two do not necessarily make four, that art has no importance
whatever, that it is rather nasty to be a literary man, that silence is golden.
Banalities instead of flowers worn around one's hat . . ."

[9] "Every filthy *petit-bourgeois* still wiping his snot on his mother's skirts
begins worshipping idiotic pictures and exclaiming: 'Three naked girls, ter-
rifying!' Every wretched little shopkeeper, every officer's son, every fat-
ass white-collar worker, every one of those happy fools who are given a
motorcycle for Christmas, every abortion raised in tissue-paper thinks Rim-
baud is another version of himself . . . This seems to me a good occasion
for saying that any allusion to this poem ["Le Bateau Ivre"] is the surest
sign of vulgarity . . ."

where life is happy. Even the worshipers of the *impasse,* the chatterboxes of suicide, do not find grace in Aragon's eyes:

> Kill yourself or don't. But don't drag your slugs of agony all over the world, your anticipated carrion, don't leave that revolver butt hanging out of your pocket any longer, irresistibly tempting a good kick in the ass. Don't insult the true suicide by this perpetual panting . . .

And the religious solution, then quite fashionable with Maritain, Cocteau, Massis and others? Aragon shows its duplicity as a "solution to the problem of existence" and accuses it of betraying the innocents to the "managers of the prayer brothels,"[10] which furnish all the drugs necessary for the satisfaction of quite human vices.[11]

No such thing as a paradise exists, and on this earth, no hope of ever achieving happiness: hope is a false attitude of the mind, with a view to a state that does not exist. How escape? By *humor,* enemy of solutions, of all solutions, denying them by its very existence. Aragon even turns against those who have tried to offer a solution, even those without whose life and work the surrealists would never have seen the light of day: Freud, Einstein:

> Thus Freud, outrageously rouged, in a suggestive outfit surveying the asphalt of surprise, walks the streets like any writer past his prime . . . *Paul and Virginia* would pass for an astonishing new work today, provided Virginia made a few reflections on bananas and Paul now and then absentmindedly yanked out a molar . . . All the Austrian psychiatrist needs now is Papal consecration, with the Thomist reconciliation of psychoanalysis and religion, for him to be cooked like any goose . . .

[10] Aragon *dixit.*

[11] "The various images of Jesus, from the little underpants on the cross to the unbelievable Sacred Heart, all the martyrs, etc.—what pickings for the sadists. For masochists, the sufferings of hellfire, threats, and the whip actually permitted. For scapular fetishists, relics, Mary's garters, saints' slippers. Every inversion without a thought—how convenient for people who are ashamed of them! How many virgins for Lesbos, Saint Sebastians for Sodom! . . . Thus every perverted power finds in the Church a use which spares the world the breath of scandal. Maniacs of impotence become the voyeurs of divinity, but if your temperament permits, once hysteria has done its work, you will become saints, you will dirty your pants in your ecstasies, you will hear voices, you will even touch the robes of the angels . . ."

Or rather, it is not against them that the polemicist turns, but against the abusive use of their discoveries, against the vulgarization into which their teaching has fallen. The entire work, moreover, is an attack against the vulgar, against those who reduce to their own tiny measure the ideas they transform into clichés, into banalities—in other words, against those who produce *literature*.

In the second part of his work, Aragon explains and justifies surrealism, trying, here too, to tear it from the vulgarizers' hands:

> There is a legend current nowadays that it is enough to learn the trick, and that forthwith texts of a great poetic interest will escape from the pen of anyone at all, like an inexhaustible diarrhea. On the excuse that he was producing surrealistically, the first dog on the street would suppose he was authorized to compare his little excretions with true poetry . . .

Whereas in reality, "in surrealism, everything is rigor, inevitable rigor." And this rigor is based above all on language, that is, ultimately, on words, on their meaning, which is not that of the dictionary but which flowers in each syllable, each letter.[12]

And here is the heart of the matter, the meaning of Aragon's whole diatribe: he does not want surrealism to pass for what it is not, a liberation from the literary rules, when it has actually taken a place outside of literature, has nothing to do with literature. He sees quite clearly where the critics are ready to pigeonhole it in their little collections; after the classical Alexandrine, romanticism, then symbolist poetry, free verse; surrealism appearing as the tailpiece of the parade.[13] Aragon fights to keep surrealism from being reinstated as literature; for him, surrealism implies certain general ideas, a certain conception of the world which generates certain methods giving it "a particular position among intellectual values," and it is because certain poets like Petrus Borel, Rimbaud, and especially Lautréamont had such a

[12] "It is known, or should be known, that words bear sounds in each syllable, in each letter, and it is obvious that this spelling out of words which leads from the word-as-heard to the written word is a particular mode of thought, whose analysis would be fruitful . . ."

[13] "Besides, I do not desire—hear me, O multitude—that the surrealist text, any more than the dream, should pass into the pigeonhole of fixed forms, as a patented form of freedom, with the consent of the imbeciles who already find free verse boring. A step ahead of free verse! That is what people would like to hear next about surrealism!"

conception of the world that surrealism claims them as its fathers.

It is very agreeable to vituperate literature, but in doing so, one does not leave the realm of style. All these revolts in which the surrealists indulge, this desire for omnipotence which they proclaim, this insistence on the radical destruction of the world and the mind, with a view to constructing a new world and a new mind—is this not still literature? It is to this key objection that Aragon replies last of all, for this is the essential point of the discussion.[14]

He remarks first of all that in general: "The agreement reached is only between well-behaved words and acts utterly lacking in interest."[15] Why stop here? Why not also relate present words to past actions? And it is ultimately a philosophical debate that is joined: to what degree are my words my own, and to what degree have I chosen my actions? Doubtless in the mind of the public, the question is simpler. But it would not be asked, if the surrealists were merely literary entertainers.[16] There are even certain actions which they would not be asked to relate to their words, provided the latter did not proceed counter to received ideas. If they supported nationalist propaganda and promised, for example, to put all Germans to the sword, would they then be asked to account for their abstention when it came time for action? Hence one does not constantly arrive at the same representation of the thought-action relationship,[17] or rather one regards it as unnecessary that "good thoughts" be realized in actions, while one obliges those who complain, those who think that "all is not for the best in the best of all possible worlds" and propose solutions to apply those solutions immediately, to execute their anticonformist proposals, or else, if they cannot, be discredited. In this way, one is sure of winning on every count. The victory will be complete if we manage to persuade the rebels themselves that

[14] "We are criticized for shouting: 'Kill!' and keeping out of harm's way."

[15] "This goes no further than: if it rains tomorrow, I'm staying indoors."

[16] The surrealists should consent "to be tenors or baritones who sing anything society wants, but who sing it well of course, and then shut up."

[17] "It is laughable that one should regard thought as immediately and invariably executive. You can conceive of a man who is violently opposed to all that surrounds him or nearly so. This makes a terrible lot of work for him just to get rid of his concierge!"

they would do better to keep still, that their revolt is not serious since it does not leave the realm of words. To fall into the trap, Aragon proclaims, is to resolve to protest no longer against anything, to keep silence. Then actions will truly be in agreement with words, or rather the absence of actions to the absence of words; and the conformists ask for nothing better than this reassuring prospect.[18]

It is surprising that Aragon needed to spin out this long chain of arguments. What if he had merely remarked that writing is a manifestation, like speech, like action, like all other human manifestations which, though at various levels, connect and commit the man who performs them? It is true that the surrealists claimed to be unwilling to assume responsibility for their writings, but that is another story which we shall tell in its proper place.

As it is, the *Traité du style* constitutes a valuable document for the history and comprehension of surrealism. It treats erroneous arguments as they deserve, when they attempt to show surrealism yielding to the snobberies of the period, or attempt to regard it as a snobbery of a certain period. Actually, surrealism never fought so hard as against what others tried to relate it to: Freudianism, relativity, the gratuitous in thought and expression, the idolatry of Rimbaud, the cult of suicide, purposeless and unprincipled prophecy, even automatic writing, to which Aragon assigns strict limits. The fact is that we must seek farther than its surface, which is all this, to reach its core, which is more than all this: an intransigent attitude of life, based on a conception of the world and of man which is not that of the period, but ahead of it.

With *Nadja*, we have the antithesis of Aragon's polemical style, so much so that Breton's book has been taken for a novel, and a successful one at that. The facts related seemed, indeed, so hard to believe that the public has preferred to assume that they were invented. Yet nothing is imagined in *Nadja*, everything is utterly, rigorously true. Nadja really existed, several people knew her,

[18] "This conception has the appreciable advantage of imposing silence on all those who might protest against anything. A soothing prospect. They would docilely conform their words to their actions, and we would no longer hear any more of those nasty words, those insults that might end by sullying our reputation . . ."

and her dazzling and lamentable fate is indeed the one Breton recalls.

A woman whom Breton meets one day, by accident, in the Rue Lafayette and who, like many women he falls in love with, attracts him by eyes "which he has never yet seen." Her name is "Nadja, because in Russian that is the beginning of the word for hope, and because it is only the beginning." "Who are you? . . ." Breton asks. "I am the soul-errant." It seems that she is always and naturally in what the spiritualists call a "state of clairvoyance," in a perfect and constant *accessibility.* She tells herself stories, and lives them: "In fact, that is altogether the way I live." After this first interview, there occurs a succession, a cascade of coincidences: she arranges to meet him, does not come, yet Breton and Nadja keep meeting in strange places, at hours not agreed upon. It seems that destiny bears them toward one another, no matter what they do. The conversations occur in an atmosphere which is no longer normal, in which Breton often loses his way. What she says always seems to proceed from a transcendant realm in which she lives quite naturally. She has visions, hallucinations which she shares with her companion; she lives in other periods, other milieux, with an amazing precision; she uses expressions, images which bear a close relation to Breton (a book he has just read, phrases he has used and which she could not know, etc.). She seems to possess an inexplicable influence over people whose habitual behavior she disturbs. She draws strange compositions steeped in mysterious significance, writes incoherent phrases that terrify her: "The lion's claw embraces the breast of the vine":

> I took Nadja for a free spirit from the first day to the last, something like one of those genii of the air which certain magical practices permit us to apprehend momentarily, but which we can never subjugate . . . Soon the poet can no longer follow her: "I have perhaps not been equal to what she was offering me . . ." He gradually withdraws. Nadja goes mad. She is confined.
> It is a slight story, but bears an enormous weight. It constitutes an entry into the lives of beings who are beyond life; it is the eruption of ghosts who quite naturally hold out their hands to the living. Madness? The word is easily said. And what is

madness? What difference does madness make in the facts reported? How does it explain the countless coincidences and the true predictions of events which depend on neither of the partners? Did Nadja go mad as soon as she was confined? Was she mad before? Did Breton, as some have said, cause a deterioration of her state? What matter! Beyond appearances, Nadja is a being who lives henceforth in us, with us.

We must now come back to earth, in search of events, disputes, controversies, everyday life.

In this same year 1928, friendships that seemed lasting were broken, men were growing older and susceptible to individual ambitions. The air of surrealism became too rarefied for some, who declared the movement dead or dying and sought to realize their own fate, to enjoy the careers for which they believed themselves destined. Expulsions followed: Artaud, Soupault, Vitrac; Desnos gradually withdrew; Naville broke off relations. The collaboration with *Clarté* came to an end. The Communist Party gave its new adepts blacker and blacker looks. It was the end of an epoch.

Breton and the friends who were still with him did not waste time patching things up, conciliating. Quite the contrary.

Artaud, who had been trained as an actor, felt increasingly lured by the footlights. With Robert Aron he founded the Théâtre Alfred-Jarry and put on Strindberg's *Dream Play* for reasons which were not, according to Breton, strictly artistic. Since Artaud had been expelled from the movement, one might assume Breton would have shown indifference to his fate. Nothing of the kind. Breton, in a fury, attempted to stop the performance. It took place, nonetheless, on June 7, 1928, the organizers having set the police on their ex-friends. Woeful extremities!

And yet surrealism had henceforth entered the city. Whether one regretted the fact or not, it existed. Here were books, paintings, even a film, *Un Chien andalou,* which showed its creative power. And here, finally, was the general exhibition at the "Sacre du Printemps" which suggested the extent of its achievement.

CHAPTER 12

THE CRISIS OF 1929

*What could men still concerned with
their status in the world hope for from
the surrealist experiment?*
—ANDRÉ BRETON

BRETON had been criticized for his excommunication mania,
exercised notably against Vitrac, Soupault, Artaud. He prided
himself upon it, and to permit everyone to realize the intransi-
gence he demanded from each member of the group, he made
public the agenda of exclusion during a meeting held at the café
Le Prophète at the end of November 1926. This agenda contained,
among other points:

Consideration of individual positions: *a*) are all these positions
defensible from a revolutionary viewpoint? . . . To what de-
gree are they tolerable?

We see, then, that in principle it was not a question of personal
differences or of petty jealousies. It was a question of the only
viewpoint which the surrealists adopted and were willing to
adopt: were certain activities reconcilable with the revolutionary
process that animated the group?

The same question was asked in 1929, but even more intensely,
for the *Clarté* experiment and adherence to the Communist Party
had intervened. Preparing a new purge, Breton now modeled his
methods on those of the revolutionary parties: a proposal of
common action made to groups or individuals often ideologically
remote but outlining a program they would accept, and a dis-
cipline they would pledge themselves to observe. Nonetheless,
like the Communist Party, he intended to put pressure on certain

individuals in whom he no longer had any confidence and whom he felt he could thus unmask, while confirming the degree of confidence he could still grant the others.

Thus on February 12, 1929, a letter was sent to a certain number of personalities close to and remote from surrealism or the Revolution, asking them for an account of their present ideological position with a view to individual or collective action to be determined thereby. Yet this letter, inquiring which individuals or groups the correspondents would seek common action with,[1] risked provoking troublesome personal reactions and thereby preventing the common action proposed.[2]

Naturally a certain number of the individuals contacted did not reply or did so "in a way which exempts them from attending a subsequent session." These individuals were expelled surrealists like Artaud and Vitrac, or those momentarily on distant terms with the movement like Boiffard, Gérard, Leiris, Limbour, Masson, Souris, Tual; editors of *Clarté* like Altman, Guitard, Morhange, Naville; all the editors of *L'Esprit* (formerly *Philosophies*); Bataille, who had just founded the review *Documents* (which published Desnos, Leiris, Prévert); Boully, the editor of *Le Grand*

[1] Text of the letter sent: "1) Do you believe that, all things considered (importance of questions of persons, real lack of external determinations, passivity and impotence in organizing younger elements, inadequacy of any new contribution, and consequent accentuation of intellectual repression in every realm), your activity should or should not be definitively limited to an individual form? 2) If *yes*, will you undertake, in behalf of what might unite the majority of us, to set forth your motives? Define your position. If *no*, to what degree do you believe that a common activity can be continued; of what nature would it be, with whom would you choose or consent to conduct it? . . ."

[2] Let us list the names of the persons to whom this letter was sent. We find, of course, all the surrealists of the moment: Alexandre, Arp, Baron, Breton, Carrive, Caupenne, Crevel, Desnos, Duhamel, Éluard, Ernst, Genbach, Goemans, Magritte, Malkine, Mesens, Miró, Morise, Nougé, Prévert, Man Ray, Sadoul, Tanguy, Thirion; Artaud (expelled); Boiffard, Gérard, Leiris, Limbour (estranged); the *Clarté* group: Bernier, Crastre, Fégy, Naville, Altman, Guitard; the editors of *Le Grand Jeu*: Daumal, Delons, Gilbert-Lecomte, Harfaux, Henry, Sima, Vailland, Boully; the editors of *L'Esprit*: Guterman, Lefebvre, Morhange, Politzer; former Dadaists: Duchamp, Fraenkel, Ribemont-Dessaignes, Tzara, Picabia; friends and sympathizers: Audard, Baldensperger, Bernard, Bousquet, Kasyade, Ristitch, Savitry, Valentin, Vidal, Bataille.

Jeu; P. de Massot, a former Dadaist and tutor to Picabia's children; and Picabia himself.

The others were invited to a session which was to be held "Monday, March 11 at 8:30 sharp, at the Bar du Château, 53 Rue du Château, at the corner of the Rue Bourgeois." They were informed at the same time, in a letter signed by Aragon, Fourrier, Péret, Queneau, and Unik, of the defections, and were offered "as a theme for discussion a critical consideration of the recent treatment of Leon Trotsky." The latter, indeed, after having been expelled from the government by Stalin, had been exiled. No one could suspect his revolutionary sentiments, and it was the duty of the men who claimed to work for the Revolution to be concerned with the fate of Lenin's comrade. To Pierre Naville, who had also not answered the first letter and whose deep affection for Trotsky's person was well known, a special letter was sent, asking him to participate, even if only as a witness.[3] Naville did not reply. Finally only seven persons were to be excluded: Baron, Duhamel, Fégy, Prévert, Man Ray, Tanguy and Vidal, "by reason of their occupations or their character." At the specified date and time, the meeting was opened under the presidence of Max Morise; present were Alexandre, Aragon, Arp, Audard, Bernard, Breton, Caupenne, Crevel, Daumal, Delons, Duhamel (though excluded), Fourrier, Gilbert-Lecomte, Goemans, Harfaux, Henry, Kasyade, Magritte, Mesens, Queneau, Man Ray, Tanguy (though these last two had been excluded as well), Ribemont-Dessaignes, Sadoul, Savitry, Sima, Thirion, Unik, Vailland, and Valentin.

First the letters received were read aloud. The tone of the most determined opposition was set by Georges Bataille: "Too many fucking idealists." Also opposed to a common action were: Leiris, Masson, Guitard, Bernier, Genbach, Fraenkel, Miró and Hooreman, while others advocated the pure and simple pursuit

[3] "Whatever you may regard as the adequacy of an activity exercised in other contexts, it cannot escape you that your abstention on this occasion implies, in our regard, a withdrawal all the more regrettable in that it is the attitude adopted by men whom we have always known you to oppose . . . Since it seems to us particularly important to induce everyone to speak out about a matter which is not indifferent to you (the recent treatment of Leon Trotsky), do you not think that, even if only as a witness, the author of *La Révolution et les intellectuels* should be present? . . . "

of surrealist activity: Bousquet, Kasyade, Malkine, Savitry, Ernst. In his letter, Breton regretted that violence, the "only adequate mode of expression, should pass into the service of quite absurd special interests and be dissipated in sterile disputes," while Queneau noted the inadequacy and the danger of individual action which can only fall back into skepticism and poetry, whereas collective action alone is effective and, to this end, must be the enterprise of morally clean individuals.[4] Each man present could feel himself singled out and accused, and, ultimately, it was indeed personal questions that were discussed. Debate on the treatment of Leon Trotsky was sidetracked. "First of all," Breton said, "the meeting must pronounce upon the degree of individual moral qualification."

And the inculpation of Le Grand Jeu began at once. What was the charge against its editors? Having preferred, in their list of admirations, Landru to Sacco and Vanzetti, having used the word "God," having participated in the activities of the Théâtre Alfred-Jarry, and finally having been defaulters, or worse, in the incident of the Ecole Normale Supérieure. This incident concerned a petition against military service signed by 83 students who, in the face of a concerted press campaign, withdrew their signatures. Only ten agreed to sign a more violent text proposed by one of them (Paul Bénichou), but refused to let it be published. Gilbert-Lecomte was criticized for being in relation with these students and not having published their text, for having returned it to them without even making a copy, thereby losing a splendid occasion for scandal. Gilbert-Lecomte cited the veto of the students, who had decided not to let their protests be published. Should this confidence have been violated and the protest published all the same? Yes, the surrealists felt; no, said the editors of Le Grand Jeu.

Less arguable was the journalistic activity of Vailland, another editor of Le Grand Jeu, who had published in Paris-Midi a defense of Jean Chiappe, the prefect of police. The case was argued.

[4] "Literature waits for its man at the crossroads of skepticism and poetry. Collective action alone can correct individual deviations . . . Hence it is a matter of overcoming the confusionism that seems to obnubilate most minds . . . We must not betray the workers who are making the Revolution: personal questions refer to traitors . . ."

Vailland semed to be making honorable amends, when Ribemont-Dessaignes, disgusted by the turn the discussion was taking, ostentatiously left the meeting.[5] Matters were to go no further that evening. The project of common action was buried before it had seen the light of day. It was not only the editors of *Le Grand Jeu* who were unwilling to suffer the rigors of an inquisitorial judgment, it was not only Ribemont-Dessaignes who asked that there be "a stop put to this testing of hearts and loins," it was all the nonsurrealists who, refusing to submit to Breton's demands, preferred to withdraw altogether.

Breton and Aragon attempted to draw conclusions from the abortive discussion. They were concerned to unmask once and for all the "harmless little boys," or those who momentarily seemed to be such, who were trying out the role of intellectual with a distressing lack of rigor. Anyone can attempt this role which appears too inconsequential and can be exercised with such impunity. But to reap the full benefit, one must accept the established order, install oneself in that order, and finally put oneself in the service of the enemy. This is what the surrealists could not permit and what made them so "intransigent" about the "moral qualifications" of even their closest friends. In their eyes, it is the fate of the necessary Revolution which is at stake.

The failure of the Rue du Château, had a broader consequence: it obliged Breton to redefine his position and that of surrealism as well; the movement would have to take "a new departure." This was the object of the publication of the *Second Manifeste du surréalisme*.

First of all, Breton insists once again on the notion of surreality, a fundamental notion whose elucidation is the justification

[5] For completeness' sake, let us quote Ribemont-Dessaignes' letter to Breton, dated the following day, which sets the tone of Breton's opponents: "So this is what your mutual deliberation comes to: judgment, judgment, judgment, and of what a nature! Indeed, have you ever done anything else? Has every collective attempt ever been anything but perpetual personal problems, and generally of schoolboy pettiness? . . . I strongly oppose the style you have adopted, the bad faith which prevailed during the meeting in the Rue du Château, and the badly organized (or efficient, if one adopts a 'commissariat de police' viewpoint) ambush concealed under the Trotsky pretext . . ."

of the movement's existence and activity of the movement, for, as he says:

> Everything suggests that there exists a certain point of the mind at which life and death, the real and imaginary, the past and the future, the communicable and the incommunicable, the heights and the depths cease to be perceived contradictorily. Now it is in vain that one would seek any other motive for surrealist activity than the hope of determining this point. . . .

Consequently, this demand renders futile any attempts to classify surrealism among past, present, or future movements. The artistic and philosophical attempts which claim to afford a solution appear ridiculous; as do those which oppose art or philosophy on the pretext that there cannot be a solution in these two realms. Surrealism contains and transcends these two attitudes; it has no concern for the figure it may cut, absorbed as it is in the search for that point where contradiction no longer exists.[6]

Breton repeats that this activity posits first of all a radical break with the world as given by the exercise of a constant and universal violence. If surrealism rests on a dogma, it is indeed on that of "absolute revolt, of total insubmission, of formal sabotage."[7]

Thereby Breton rejects all lineages, all the dead whom the surrealists once delighted to acknowledge as precursors: Rimbaud, Baudelaire, Poe ("let us spit in passing on Edgar Poe"), Rabbe, Sade; "in questions of revolt, none of us should need ancestors." Everything is *to be done*, all means should be employed to destroy the notions of family, nation, religion . . ." The surrealist position admits no compromises, it demands such rigor from those who have adopted it that it is doubtless not always possible for them to remain within it. No matter! The defection of the last

[6] "Surrealism is not concerned with what is produced around it on the pretext of art, or even anti-art, of philosophy or anti-philosophy, in a word, all that does not have as its purpose the annihilation of being in a blind and inward diamond, which is no more the soul of ice than that of fire . . ."

[7] "The simplest surrealist act would be to go out into the street, revolver in hand, and fire at random into the crowd. A man who has not had, at least once, the longing to be finished in this fashion with the petty system of corruption and cretinization now rampant has his place reserved for him in that crowd, belly at pistol-point . . ."

surrealist will not keep surrealism from living. Young men will appear who, loving rigor and purity, will continue and extend the experiment. It is for them, with a view to their future action, that there must be no backsliding as to the quality of the men who compose the movement today. Let the undesirables leave: the incorrigible *littérateurs*, the hardened rakes, the seekers of powerful emotions, the snobs, the society dilettantes and the entertainers, all those who wanted to "pass the time" without dealing with time itself, with life, with man as he is.[8] And Breton jettisons Artaud, Delteil, Gérard, Limbour, Masson, Soupault, Vitrac, fastening insulting epithets to their names as he does so.

Then come the others, who with a "good conscience" look down their noses and say: what counts is the direct action against the regime; enough empty talk about man's condition and fate; what we need is fighters, soldiers of the Revolution who may never have considered the "everyday wonder," but know what they want, and they want it. Breton would like to be among them, but he cannot. Surrealism acknowledges and proclaims that a social question exists. It rejects with contempt and horror a regime based on the exploitation of the majority; it takes its place at the side of the revolutionaries who claim to overthrow this regime. It has excluded from its midst those who refused to adopt this position. However, Breton adds, dialectical materialism, the acknowledged philosophy of the revolutionaries, has a much broader field than the politicians suppose. Why refuse to employ this instrument for the solution of extra-political problems?[9] Cannot a revolutionary be a lover, does he not dream like

[8] "Why should we continue to play fastidious? A cop, a few rakes, two or three pimps of the pen, several lunatics, one idiot, joined, to no one's surprise or objection, by a small number of reasonable, tough and honest men described as fanatics—is this not enough to constitute an amusing, harmless group, quite in the image of life itself, a group of men paid by the piece, winning by points? SHIT"

[9] "Why assume that the dialectical method can be validly applied only to the solution of social problems? Surrealism's entire ambition is to furnish it possibilities of application that do not offer any competition in the immediately conscious domain. I do not see, certain narrow-minded revolutionaries to the contrary, why we should abstain from raising—providing we envisage them from the same angle as that under which they, and we as well, envisage the Revolution—the problems of love, of the dream, of madness, of art and of religion . . ."

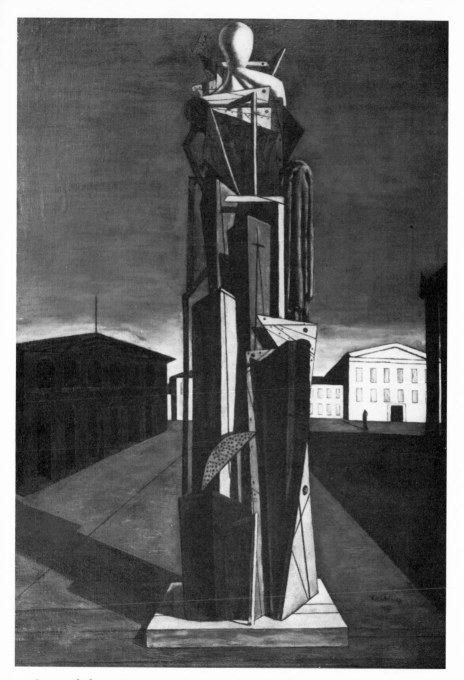

Some of the painters prominent in the surrealist movement and representative examples of their work. GIORGIO DI CHIRICO, *The Great Metaphysician*. 1917. Oil on canvas. Collection, The Museum of Modern Art, New York. The Philip L. Goodwin Collection.

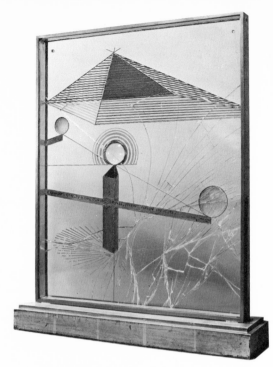

MARCEL DUCHAMP. *To be looked at with one eye, close to, for almost an hour.* 1918. Framed double glass panel with oil paint, collage of paper, lens, etc. Collection, The Museum of Modern Art, New York. Katherine S. Dreier Bequest.

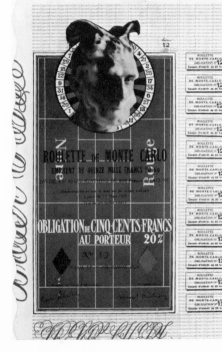

MARCEL DUCHAMP. *Monte Carlo Share.* 1924. Collage. Collection, The Museum of Modern Art, New York. Gift of the artist.

Francis Picabia. *Dada Movement, Chart.* 1919. Pen and ink. Collection, The Museum of Modern Art, New York. Purchase Fund.

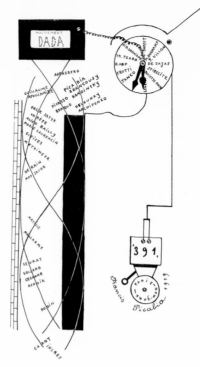

Jean (Hans) Arp, *Automatic Drawing.* 1916. Brush and ink on brown paper. Collection, The Museum of Modern Art, New York.

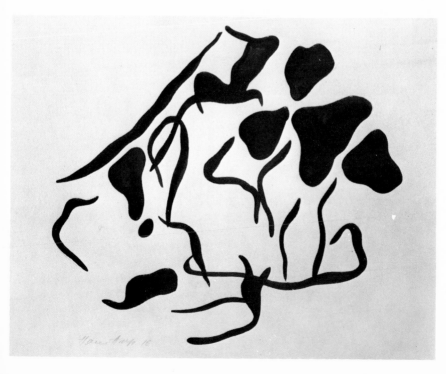

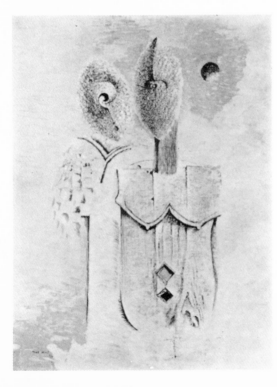

MAX ERNST. *Woman, Old Man, and Flower (Weib, Greis, und Blume)*. 1923-1924. Oil on canvas. Collection, The Museum of Modern Art, New York. Purchase.

MAX ERNST. *Two Sisters*. 1926. Oil and "frottage" with black lead on canvas. Collection, The Museum of Modern Art, New York. Gift of Mme. Helena Rubinstein.

MAX ERNST. *Birds above the Forest.* 1929. Oil on canvas. Collection, The Museum of Modern Art, New York. Katherine S. Dreier Bequest.

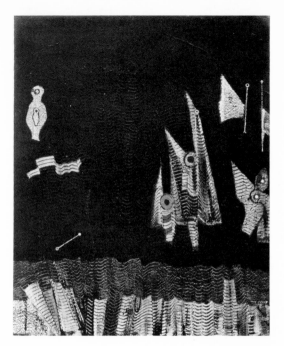

MAX ERNST. *Nature at Daybreak.* 1938. Oil on canvas. Collection, The Museum of Modern Art, New York. Gift of Samuel A. Berger.

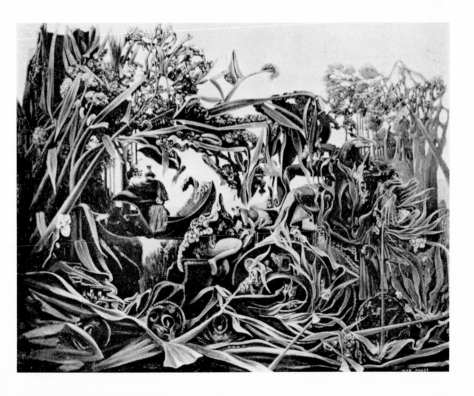

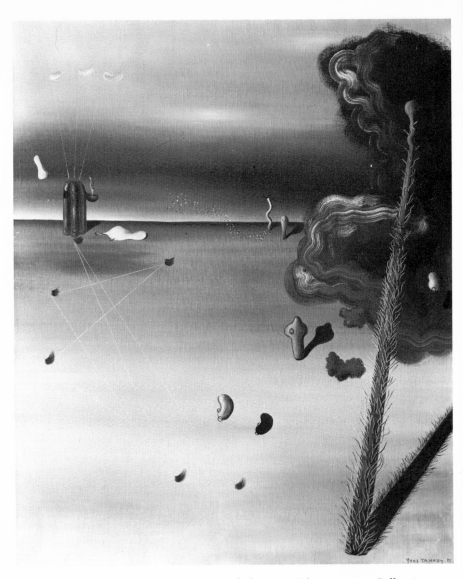

Yves Tanguy. *Mama, Papa Is Wounded.* 1927. Oil on canvas. Collection, The Museum of Modern Art, New York. Purchase.

René Magritte. *Souvenir de Voyage.* 1955. Oil on canvas. Collection, The Museum of Modern Art, New York. Gift of Mr. and Mrs. John de Menil.

SALVADOR DALI. Illustration (etching) for *Les Chants de Maldoror* by Lautréamont, published 1935 by Albert Skira, Paris. Collection, The Museum of Modern Art, New York.

any other man? Must one be limited to shutting up the mad, to killing off the believers in all religions and letting the artists chatter away in their cafés? A strange myopia, that refuses to envisage these problems. If, electively, the surrealists have seen them, by what right are they forbidden to attempt to solve them? In the name of the Revolution? A strange Revolution, that limits itself! It is because Breton claims to be a revolutionary, a materialist, a specialist in a particular domain, that he again turns on the Communist Party and old friends who have converted to political action. In passing, he mows down the *Esprit* group (Morhange, Politzer, Lefebvre) which had gone over to communism and from which he seeks to receive no lessons. Even Naville finds no mercy in his eyes this time.

After the negations, the destructions, the warnings, Breton comes to surrealism itself. It is no *satisfecit* which he accords to his group or to himself. He deplores, in fact, the failures, the deficiencies, the lack of rigor that have been manifest in the domain the movement has marked out for itself. Not only has the experiment not been carried to its conclusions, but automatic writing and dream accounts have not been thoroughly exploited—often, in fact, these enterprises were of no interest whatsoever. He sees the reason for this in the excessive negligence on the part of most surrealists who were merely astounded by their discoveries and content to limit themselves to them. The scientific, experimental side yielded, deplorably, to the artistic aspect of the venture. They passively noted the flow of the unconscious, and neglected to note what was happening within themselves at the same time. How to perfect, how to discipline this flow, how to make it into an instrument of discovery? By confusing automatism and passivity, merely yielding to a new routine? For Breton, the essentials of surrealism always reside in the manifestation of the unconscious, the submission to inspiration which, he remarks, we must cease to regard "as a sacred thing." "A day will come" when such a method will seem quite natural, when it will be acknowledged that the surrealists have led the way and were close to grasping the truth. On that day, Breton adds, people will also be astonished by "our" timidity, by our need to seek an artistic alibi. Far from limiting our effort to what is and can only be a means, let us have

the courage to proclaim that it is only a means, and be able, when we must, to do without it.

Deploring the lack of rigor in previous action, thet inadequacy of the work done in a realm almost entirely unexplored, it is without illusions but with courage and confidence in the destiny of surrealism that Breton exclaims:

> "It is the innocence, the anger of a few men of the future that will be responsible for disengaging from Surrealism what cannot fail to be still vital, to restore it, at the cost of a splendid carnage, to its proper goal . . ."

Breton, strong in this faith, can also "take leave" of one of those he loved best and who actually accomplished most: Robert Desnos.[10] Desnos had advanced farther than anyone else on the path which leads to the unknown. He believed that this temerity substituted for everything else, that it sufficed for everything. As a consequence of this boldness, he neglected to answer several harsh questions that faced surrealism. He proclaimed that "the Revolution could only be political and social," then withdrew, self-satisfied. This, too, showed a cruel lack of rigor, Breton declared. What was still more serious, he believed in his literary gifts and deliberately pursued his career as a poet. Finally, "to live" he surrendered to journalistic activity, that is consented, according to Breton, to his own moral suicide.

What had become of the direct inspirers of surrealism? Here was Marcel Duchamp, whose influence was scarcely less great than that of Jacques Vaché, engaged in an interminable chess game whose outcome, for Breton, could only be ridiculous; Ribemont-Dessaignes, sunk to writing for movie magazines; Picabia, "applying himself to his work" and proud of his good conscience. Must these men be considered dead? Only Tzara, out of the camp of the old Dadaists, seemed not to have abandoned "the shadow for the prey"; alone, since the famous incidents of the *Coeur à gaz* which Breton declared to have been merely *unfortunate*, his intellectual attitude had not ceased to be clear. Breton assured him of his respect, and begged him to take the place he deserved in the surrealist movement.

[10] "Desnos has played a necessary, unforgettable role in Surrealism, and now would doubtless be the worst possible time to contest it . . ."

On this occasion, elaborating further than ever before the analysis of the movement's destiny, it suddenly seems to Breton that surrealism cannot, must not neglect certain esoteric researches; he even sees the movement as the heir of the alchemists of the fourteenth century, à la Nicolas Flamel. Breton believes that like them, surrealism is in search of the "philosopher's stone" which would permit man's imagination "to take a brilliant revenge upon things." From this viewpoint, he can write that surrealism is still only in its "preparatory period" and regret that these preparations are still too *artistic,* that is, too far from the quest which must now be made and from which everything is to be expected. Consequently the surrealist movement can no longer be open save to initiates, men predestined, designated by the stars to perform this secret labor.[11]

Hence it is with assurance that after an attack on Georges Bataille, whose activity bordered on surrealism, Breton launched into his peroration:

Surrealism is less disposed than ever to sacrifice this integrity, to be content with what most men relegate to it between two little betrayals which they imagine they can justify by the obscure and odious excuse that a man must live. We know what to do with this charity of *talents.* What we ask is, we suppose, of a nature to involve a total consent or a total refusal, and not a game with words, the trifling of velleitary hopes. Is a man willing, yes or no, to risk everything merely for the joy of

[11] "The public must absolutely be kept from *entering* if we wish to avoid confusion . . . *I demand the profound, true occultation of Surrealism.*" And this in a note: "Baudelaire's horoscope, which offers the remarkable conjunction of Uramus with Neptune, thereby remains uninterpretable. Of the conjunction of Uranus with Saturn, which occurred between 1896 and 1898, *and which appears only every 45 years*—the conjunction which characterizes Aragon's horoscope, Éluard's, and mine—we know only through Choisnard that, still obscure in astrology, it 'signifies in every likelihood: profound love of knowledge, research into the mysterious, need for learning.' (Of course Choisnard's vocabulary is suspect.) 'Who know,' he adds, 'if the conjunction of Saturn with Uranus will not engender a new school of science? This planetary aspect, well located in a horoscope, may correspond to the quality of a man endowed with reflection, sagacity, and independence, capable of being an investigator of the first order.' These lines, taken from *Influence astrale,* were written in 1893, and in 1925 Choisnard noted that his prediction seemed to be coming true." André Breton: Note to the *Second Manifeste.* Does not Breton suggest himself as the man thus awaited?

glimpsing in the distance—at the very bottom of the crucible in which we propose to fling our wretched conveniences, what remains of our good reputation and our doubts pell mell with the pretty gewgaws of sensibility, and the radical notion of impotence and the stupidity of our so-called duties—*the light which will no longer be the one that fails?*

Breton himself regarded the *Second Manifeste* as a reminder of *principles,* and the task in which he was engaged as a "purging of surrealism." It is undeniable that no one has entertained a higher idea of the mission he communicates, and no one has defended it with more intransigence. It matters little whether his blows have been dealt with more or less severity, with more or less discernment. Surrealism—it was a fact—risked slipping, because of individuals and their reluctance to hold fast to those high summits Breton insisted they inhabit, toward art from the moment he had refused to take the path indicated by Pierre Naville. Yet this rejection of commitment signified no form of disinterest or "contemplation." No one has ever doubted Breton's active sympathy with the Revolution, and if some were amused at one point or another, it was precisely because they refused to follow him to the point he himself had reached. That he also attacked those who were sacrificing surrealism to political action, with whatever arguments, we will understand easily enough if we remember that for Breton surrealism included the Social Revolution *as well.* It is not a question of absolving or of judging, but of understanding, and given the heroic role Breton insisted each man play, it is not surprising that a number did not feel they had the strength to do so. How could they help showing their fatigue in the grueling chase Breton led them! Certain youths had become men who did not bear the imperious yoke of this leader gratefully, even when it was tempered by unforgettable moments; especially since this man had preferences that were often inexplicable, astonishing changes of attitude, sudden antipathies and sympathies that had to be adopted. Further, almost all these young men believed they had gifts of their own— in fact it was precisely because they were not ordinarily endowed that they had given themselves so ardently to this Revolution, and they balked at finding it indefinitely postponed, indefinitely re-

moved. After having exhausted the joys of automatic writing and dream narratives, they felt they possessed creative forces which the atmosphere of the group prevented them from releasing. Let us venture the word: they no longer felt *free*, they wanted to take their risks alone, for themselves. This tendency was all the stronger among the "literary men" because the painters did not incur Breton's thunders to the same degree. They sold their canvases, lived by their work then to a certain degree, and Breton found this quite natural. That "a man has to live" Breton rejected with scorn, but if he had solved the problem for himself, others could not content themselves with expedients indefinitely. As a matter of fact, there were few, among those whom Breton castigated, who turned into businessmen pure and simple. The others, pure of all compromise, can be blamed only for playing the ordinary game of life. Who is entitled to cast the first stone at them?

Yet new forces would replace the old ones. In the evening of this epoch rose the star of Salvador Dali, whose personality and activity were to cause the entire movement to take a new step.

"IN THE SERVICE OF
THE REVOLUTION"

*It is spring, the needle goes wild in the
compass . . .* —JACQUES PRÉVERT

1930 marks the end of the quarrel with the ex-friends who had
been denounced in the *Second Manifeste* and who, outraged by
Breton's treatment of them, published against him a pamphlet of
an extreme violence: *Un Cadavre*. It also marks, as we have
said, the appearance of new forces: Salvador Dali, Luis Buñuel,
Georges Hugnet, René Char, Georges Sadoul, Albert Valentin,
André Thirion, while Yves Tanguy and Man Ray, momentarily
suspect, returned to grace. But already one could glimpse the
germ of future divisions, following the line of least resistance
between the two antagonistic tendencies in surrealism that
Naville had discerned. While in fact Breton and Éluard delved
deep in the surrealist terrain by publishing *L'Immaculée Con-
ception*, George Sadoul and Aragon were making a trip to
Russia that was to have many consequences. Breton, who had
been unable to continue his militant's work in the "gas" cell in
which the confidence (?) of the Communist Party had placed
him, drew farther and farther away from the latter,[1] while on
the other hand he put the new organ of the movement at the
orders of the Third International. These contradictions were
finally to determine a new crisis in the years to come.

For the moment, the crisis of 1929, as it reached its end,

[1] Breton himself tells how, obliged to present a report consisting entirely
of statistics referring to the situation in Italy, he had been quite unable to
perform this task.

stirred up a great deal of noise. Like that of 1926–27, it was basically caused by the same factors, which we can henceforth reduce to a single one: was it proper to put the movement at the disposal of the Communist Party which demanded its abjuration, or was it better to let the movement continue on its autonomous way? Breton was for a middle solution, which concealed the contradictions instead of letting them appear: to continue to work autonomously, while proclaiming that the movement was working for the Revolution, that it was pursuing the same objects on parallel paths. This solution had not satisfied Naville in the past, and it did not satisfy, though for contrary reasons, those whom Breton had "dismissed." Attacked in the manner we have described, they answered publicly, and aiming beyond Breton's person, they went so far as to bury surrealism with him. Hence no dissident school was formed, though a certain minimum of understanding existed among Breton's opponents. After this one-day union in invective, they were to return to their individual occupations, for the most part alien to surrealism.

The participants in the "Cadavre" of 1930 were, in effect, various: an ex-Dadaist, Ribemont-Dessaignes; ex-surrealists: Vitrac, long since expelled, Limbour, whose temperament found nothing congenial in the surrealist agitation and scandals, Morise, Breton's ex-henchman, Jacques Baron, Michel Leiris, Raymond Queneau, J.-A. Boiffard, Robert Desnos, Jacques Prévert; and one man who had never belonged to the group but who had been particularly mauled by Breton: Georges Bataille. Pierre Naville, though solicited, did not choose to contribute.

The attacks were mostly personal. The most frequently employed epithets were *cop* and *curé*: "The revelations concerning, for example, Naville and Masson have the character of the daily blackmail waged by the newspapers in the pay of the police" (Ribemont-Dessaignes); "Friar Breton, who has served up his sermon in a mustard sauce, never speaks except from the pulpit these days" (Ribemont-Dessaignes); "One day he rants against the priests, the next he thinks he's a bishop or the Pope in Avignon" (Jacques Prévert). But he is also a "false friar": "He spits all over the place, on the ground, on his friends, on his friends'

wives" (Jacques Prévert); "I had a true friend [Breton is sup-
posed to be speaking], Robert Desnos. I cheated him, lied to him,
gave him my word of honor and deceived him." (Robert Desnos);
"He practiced, on a tremendous scale, the friendship swindle"
(Vitrac). He was also a false revolutionary and a false communist:
"If André Breton should take a fancy to pigs' feet à la poulette,
you'll suddenly find these are confirmed Revolutionaries"
(Morise); "He sent the comrades to the Ballets Russes to shout
'Vivent les Soviets!' and the next day, at the Galerie Surréaliste,
received Serge Diaghilev, who had come to buy pictures, with
open arms" (Baron). Leiris and Desnos accused him of having
"always lived on corpses": Vaché, Rigaut, Nadja; while Vitrac
and Bataille brought down surrealism: "the surrealist boutique"
(Vitrac), "his religious corporation" (Bataille). The conclusion
was the same that Breton had written apropos of Anatole
France: "Once dead, this man must not make any more dust,"
printed on the cover above a huge photograph of Breton with
his eyes closed, a tear of blood in the corner of his eyelids, his
forehead bound with a crown of thorns.

The virulence of the attacks against Breton suffice to prove
that the so-called moribund was in a condition to riposte. He
did so when the Deuxième manifeste du surréalisme was pub-
lished as a book, merely setting on opposite pages the previous
and present appreciations of his ex-friends as to his person and
activity. It is true that they could have produced the same
parallels.

The surrealist movement was not noticeably affected by this
crisis, though it was the most serious of those that agitated it.
It marks, of course, the end of an epoch, the finest, most fruitful
and most inspiring epoch, but if we consider the period as a
whole, the fate of surrealism does not differ from that of the
other currents of ideas at the time.

Indeed 1930 marks the end of the postwar period. New mecha-
nisms—economic (the crisis in the United States, and soon after
in Europe: Germany, England), political, social—were invisibly
set in operation, their effects discerned only ten years later. In
France, Briand's failure and that of official pacifism had more

than one symbolic value, it was a symptom: the First World War was liquidated and capitalism, falling back into its fundamental contradictions, could escape them only by preparing a new massacre.

The only true pacifists being, in every period, the revolutionaries, each man returned to his destined place, rejoined his natural milieu, and Breton moved closer and closer to the revolutionary movement: which happened to be the Communist one at the time, despite the personal disappointment he had suffered at its hands. The movement's new organ was called: *Le Surréalisme au service de la révolution*—showing that there was less question than ever of a "surrealist revolution"—and opened with a telegraphic correspondence with Moscow in which the surrealists proclaimed their desire to put themselves at the service of the Revolution immediately.[2] Breton believed the "meanwhile" period was past. Aragon and Sadoul went further: they made the pilgrimage to Moscow. What they did there, and how they returned, we shall see later on. Meanwhile the temperature was rising: Breton wrote an article on the suicide of the Bolshevik poet Mayakovsky in which we find sentences like this:

> The inspiring life of the proletariat in its struggle, the stupefying and destructive life of the mind a prey to its own beasts—for our part it would be futile to choose only one of these two distant dramas in which to figure. Let no one expect any concession from us, in this domain.[3]

This defense of Mayakovsky against the incomprehension of the editors of *L'Humanité* who found it preposterous that anyone should commit suicide in the "country of socialism" was

[2] "Question: International Bureau Revolutionary Literature please reply following question: what will be your position if imperialism declares war on Soviets stop address post box 650, Moscow. Answer: Comrades if imperialism declares war on Soviets our position will follow directives Third International position of members of French Communist Party. If you consider better use of our faculties possible, are at your disposal for precise mission requiring any other use of ourselves as intellectuals stop offering suggestions would presume on our role and the circumstances. In present situation of non-armed conflict useless delaying offer of means which are especially our own."

[3] André Breton *"La barque de l'amour s'est brisée contre la vie courante,"* reprinted in *Point du Jour* (1934).

also conducted physically against the attacks of the reactionaries: Aragon administered a beating to M. André Levinson, editor of *Les Nouvelles littéraires*[4] and guilty of having calumniated Soviet Russia.

For the record's sake, let us add the escapade of Georges Sadoul and Jean Caupenne who, one drunken night, sent a threatening letter to a certain Keller, first in his class at the military academy of Saint-Cyr, in which they demanded his resignation, on pain of a "public spanking." Once the legal machinery began working, Jean Caupenne chose to make public apologies to M. Keller before the troops at the École de Saint-Cyr, and Georges Sadoul employed in his defense arguments that one would have preferred to be more "surrealistic." Which, moreover, did not keep him from being sentenced to three months in jail. Perhaps, on this occasion, the surrealists realized that there was some danger in "concretely" attacking the bourgeoisie.

If 1930 marked the movement's acceptance of "orders" from the social and political Revolution, it also marked a plunge into surrealism's deepest waters. It was, in fact, during this year that Breton and Éluard published *L'Immaculée Conception*.

This was an astonishing series of poems in prose, more brilliant than those of either Breton or Éluard on his own, and though the reader may discover an image particular to one poet or the other, this collaboration nonetheless produced something that surpassed them both. The first part: *L'Homme*, is an attempt to recreate the capital moments of life, from conception to death. Here they recreate the shattering states of man in love:

> One would have to stay the same, always, with that disconcerting athlete's manner, with that ridiculous way of holding one's head. But now the statue falls into dust, refuses to keep its name . . . Here there are walls you will not climb, walls I shall

[4] "Aragon went to Levinson's house. The latter, fearing for his bones and hiding behind his wife, claimed that he could not defend himself, 'having recently broken his arm.' Aragon, disgusted by such cowardice, began flinging the crockery out the window. The police were called. And it was in the officers' presence that Aragon landed his fist on the critic's face . . ." (*L'Humanité*, June 3, 1930).

cover with insults and threats, walls forever the color of stale blood, of blood spilled . . .

They attempt to enter into communication with the vegetative life of the foetus:

Of all the ways the sunflower has of loving the light, regret is the loveliest shadow on the sundial. Crossbones, crosswords, volumes and volumes of ignorance and knowledge. The doe, between bounds, likes to look at me. I keep her company in the glade. I fall slowly from the heights, as yet I weigh only what minus a hundred thousand yards will weigh . . .

They evoke the "trauma of birth," the deficit of life:

The powers of despair, with their soap roses, their oblique caresses, their poorly-dressed dignity, their moving answers to questions of granite seize him. They lead him to the school of slag, after rigging him out in a fiery apron . . .

Then the return to nothingness:

Here is the great stammering square. The sheep arrive at top speed, on stilts.

This attempt to write a new genesis was coupled with an experience which astonished the psychiatrists and must have revolutionized the history of mental diseases. Here were two men more or less well adapted, since they were living in it, to a society based on the recognition in man of states which it qualifies as normal (because they are the attribute of the majority) and who were able, without any trickery and solely by the power of poetry, of their poetry, to simulate demented states: mental debility, acute mania, general paralysis, dementia praecox; then, on the other hand, to return to their habitual state of equilibrium, described as normal. What did they seek to prove? That there exists no barrier between the normal man and the so-called "abnormal" man; that there exists no state starting from which one can be certain that this man is mad and another rational; that every judgment of these states lacks a scientific basis, being no more than a question of fashion, of opinion.[5] That they were able to achieve these

[5] ". . . Then it would all be up with the proud categories in which we play at confining the men who have had a score to settle with human

states experimentally by means of the poetic instrument suggests the value of this instrument, and also the power of the mind, capable of creations whose possibility it does not know at "normal" times, when it is not "aroused poetically."

If all that remained of the movement were the pages of *L'Immaculée Conception,* man, alerted, could not turn away from the astounding mystery of his condition, and could only desire to exercise his power to its farthest, final reaches.

reason, that same reason which daily denies us the right to express ourselves by the means instinctive to us . . ."

PART FOUR

THE PERIOD OF
AUTONOMY,
1930–1939

THE ARAGON AFFAIR

*I propose nothing: neither, as those
who follow me with a collector's eye
would prefer, a Collected Works in the
genre of the* Comédie Humaine; *nor,
as those who reach out their natural-
ists' hands to me suggest, an heroic,
exemplary destiny.*

—ARAGON (1924)

H ENCEFORTH, surrealism pursued its course on two parallel
paths: that of the political Revolution, that of the ever
widening exploration of the unknown forces of the unconscious.
The leaders of the two factions were respectively Aragon, who,
with Sadoul, participated in the Second International Congress
of Revolutionary Writers in Kharkov, and Dali, who applied to
the production of so-called "surrealist" objects his thesis of
paranoia-criticism. Breton's role was one of conciliation and
arbitration, though he remained the only man capable of achiev-
ing the fusion, which he sought to make complete, of these two
methods; in doing so he continued to control the movement
authoritatively.

The prelude of what was to become the "Aragon Affair" began
in the third number of *Le Surréalisme au service de la révolution.*
In an article entitled "Le Surréalisme et le devenir révolutionnaire,"
Aragon, back from Kharkov, presented his fever chart, which he
wished to be the group's as well. As to the role he had played
in Kharkov, nothing as yet was known, except that having left
Paris with the best surrealist intentions, he returned a communist,
after uttering many *mea culpa*'s before the members of the Con-

gress. For the moment, there was no question of a break with the group: Aragon still declared himself a surrealist. From his article, let us quote the formulas by which he defines the direction he wanted to see surrealism take:

> The acknowledgment of dialectical materialism as the sole revolutionary philosophy, the comprehension and unreserved acceptance of this materialism by intellectuals of idealistic tendencies, no matter how consistent such idealism may be, with regard to the concrete problems of the Revolution—these are the essential features of the development of the surrealists . . .

He assigned this development a goal which the surrealists (Breton and previously himself) had never desired to achieve: "the recognition in the domain of actual practice of the Third International as the only revolutionary action."[1] What were the limitations of this "domain of actual practice"? Did they not seem to be infinitely extensible, capable of swallowing up all surrealist activity?

Turning to the crisis which had just ended with the departure of former friends, Aragon noted:

> The entrance into the surrealist group of certain elements (Char, Dali, Buñuel) whose means of expression are extremely precious for the life of this group and the extension of its action has more than compensated for the departure of so many vacillating triflers and mere *littérateurs*. The group thus reinforced has founded a review: *Le Surréalisme au service de la révolution*, manifesting, by this modification of the former title (*La Révolution surréaliste*), the general anti-individualist and materialist meaning of its development . . .

He also remarked that surrealism, by refusing to acknowledge art as an end in itself, was exposed to the open or concealed repression of the bourgeoisie: Breton "in private life suffers all the persecutions that legal machinery can bring to bear upon him"; Georges Sadoul was condemned to three months in prison

[1] "This development implies more firmly than ever—with the firmness afforded by such a philosophical basis—the recognition, in the realm of practice, of the action of the Third International as the only revolutionary action, and implies the necessity of supporting, with the various means available to prominent intellectuals, the action in France of the French section of this International . . ."

(we have seen why), Éluard found himself prohibited by the police from leaving France; "Crevel and I are no longer *permitted* to be published . . . *L'Immaculée Conception* has been removed from bookshop windows . . ." And, destroying "the legend that makes us into writers *for* snobs," he added: "If we are confined (by coercive means in the pecuniary realm) to that public which we have never considered with anything except disdain, this very confinement is a perfected form of repression."

Indeed, the limited editions of luxury publications were not destined for those whom the surrealists claimed they particularly wanted to reach. And it was the formation of a cult of titled and wealthy snobs around surrealism that accounted for the mistrust in which Breton and his friends were held by the political revolutionaries, the handicap they had to surmount before finding their true audience.

Coming, finally, to the Moscow trip, Aragon declared:

> As you may know, at the end of 1930, Georges Sadoul and I went to Russia. We went there more willingly in Russia than elsewhere, much more willingly: that is all I have to say about the reasons for our departure!

Which was not much.

At least he had written Breton from Russia that if he participated in the Kharkov Congress he would defend the "surrealist line." In particular he would attack Barbusse's *Monde*, a new review of proletarian culture. However, if the communists acknowledged the sentimental confusionism of *Monde*, they were unwilling to alienate Barbusse, whom they counted on using later (in the Amsterdam-Pleyel anti-war Congresses), and they even elected him to the Presidium of the Kharkov Congress. Did Aragon rebel? Anything but. On the contrary, he approved. Further: with Sadoul he sent, or at least signed, a letter to the International Writers' Union in which he denounced idealism, Freudianism, and Trotskyism as a form of idealism, and in which, finally, he proclaimed his adherence to the "general line." Giving a proof of his dedication, he composed the poem *Front Rouge*, published by *Littérature de la Révolution mondiale*, organ of the International Writers' Union, and returned to Paris.

Upon his return, he protested that the signature affixed to his letter to the International Writers' Union had been extorted from him; however, he refused to demand a rectification. At the same time he declared that his agreement with Breton and the rest of the group was for him "a matter of life or death," and published a Manifesto: *Aux intellectuels révolutionnaires* in which he defended the psychoanalytic method he had just denounced as "idealistic" in Kharkov.[2]

Front Rouge produced a considerable effect in France. It was a revolutionary poem . . . "in the line." In it, Aragon not only called for the murder of the leaders of the regime, but also of the "trained bears of social democracy." The government reacted by prosecuting Aragon for provocation to murder. He risked incurring a penalty of five years in jail. The surrealists, Breton at their head, immediately came to the defense of their comrade, launching a petition which said:

> We protest against this attempt to interpret a poetic text for judiciary ends, and demand the immediate cessation of the prosecution.

This petition, in a few days, had received over three hundred signatures.

The affair did not end there. If the government seemed to evade the absurdity of the prosecution, the debate shifted to a dispute among Breton and certain intellectuals like Romain Rolland and Gide, interpreters of a broader current which affected even the revolutionaries and which censured the surrealists for avoiding their responsibilities. To assume responsibility for one's writings is indeed, for a revolutionary, the same moral stance as to assume responsibility for one's acts. But the surrealists, as we have already seen apropos of the *Traité du style,*

[2] "Certain revolutionary intellectuals, and especially the surrealists, have been led to employ the psychoanalytic method against the bourgeoisie. This weapon, in the hands of men who champion historical materialism and who intend to apply it, notably facilitates the attack on the family, despite the defenses the bourgeoisie multiplies around it. Psychoanalysis has served the surrealists in studying the mechanism of inspiration and in mastering it. It has helped them abandon any individualist position. Psychoanalysis cannot be held responsible for certain applications of itself made by the various tendencies which claim to derive from it . . ."

had declared that they did not regard themselves as obliged to relate their acts to their words, and that in any case the latter—this was Breton's thesis—could not, in a poem, the supreme manifestation of the unconscious, commit their author. Hence the reproach to which the surrealists were liable: to participate in the revolutionary struggle without being willing to accept its risks, ultimately to withdraw behind the screen of "the art which excuses everything." For all Breton's arguments, an assumption of responsibilities by the group as a whole would have had a different effect.

In any case, these were his arguments: he protested first of all against the inculpation in so far as it created a scandalous precedent of repression with regard to poetry as a public misdemeanor. Hitherto only prose texts had been subject to prosecution, because prose is the expression of rational, discursive thought. Of course Baudelaire had been prosecuted for the immorality or obscenity of some of his poems, but even here the courts were not so absurd as to isolate certain expressions or certain lines from their context. Was it necessary to detach from Aragon's poem such expressions as "Wipe out the Police, Comrades!" or "Fire on the trained bears of social democracy" to see them as a conscious and premeditated provocation to murder? The problem was a broader one.

Widening the field of his argument, Breton discussed the value to be conceded to the poem:

> The poem is not to be judged on the successive representations it involves, but on its power to incarnate an idea, to which these representations, freed of any need for rational connection, serve only as a fulcrum. The bearing and meaning of the poem are *different* from the sum of what the analysis of the specific elements it employs would permit discovering in it, and these specific elements cannot, in and of themselves, determine its value or effect to any degree whatsoever.

In other words, the poem is a whole which may be judged as such, but from which certain ideas or images cannot be abstracted without causing them to lose their meaning.

Coming to the actual value of Aragon's poem, Breton confessed that he did not like it. He regarded it in fact as an occasional

poem. Personally, he had always refused to write such things: he had no taste for it and such a form of poetry seemed retrogressive. Citing Hegel's *Aesthetik*, Breton declared:

> *Front Rouge* does not open a new path for poetry; it would be futile to propose it to today's poets as an example, for the excellent reason that in such a domain an objective point of departure can be only an objective point of arrival, and that in this poem we find the *return to the external subject* and especially to the *emotional subject* with all the historical lessons to be learned today from the most developed poetic forms. In these forms, a century ago (cf. Hegel), the subject could already be no more than and can henceforth no longer be fixed a priori . . . Hence one must avoid being influenced by the "intoxicating" circumstances of history, for "if the social drama exists, the poetic drama exists too, and quite as much as the other."

Aragon, by yielding to the temptation to express the former, had missed the latter, according to Breton.

Aragon approved the intellectuals' protest in favor of his poem, he even approved the contents of Breton's pamphlet in his defense,[3] but by reason of the veiled attacks it contained against the Communist Party and its "literary" policy, he declared its publication inopportune and assumed a position apart.

Matters had reached this point when a paragraph in *L'Humanité* announced that Aragon disavowed Breton's pamphlet and that he "disapproved its contents in its totality" by reason of the attacks it contained against the Communist Party. Aragon had once again operated behind his friends' backs, and the latter were obliged to wonder: When is Aragon sincere? With his surrealist friends, or with his communist friends? Further, the surrealists learned by this paragraph of the establishment of the French section of the International Writers' Union, which they were not permitted to join. They made a request for affiliation which remained unanswered.

Putting all these facts together, the surrealist group realized what had happened. They declared that having gradually evolved an acceptance of dialectical materialism, they intended to pursue this policy and to participate in an increasingly effective fashion

[3] *Misère de la poésie (l'affaire Aragon devant l'opinion publique).*

in the struggles of the revolutionary proletariat: "As surrealists, we have no intention of making poetry an excuse for rejecting political action." Was it possible to hope that this outspoken declaration would silence the prejudices of the Communist Party in their regard? This attempt was to have no more success than the preceding ones.

Was it possible to learn a lesson from this "Aragon affair"? We may, now that we know the facts, wonder what its meaning was. It led to Aragon's break with the group he had helped found, of which, with Breton and Éluard, he was one of the acknowledged mainstays. Did his departure have a general meaning for surrealism, or should it be regarded as no more than a phenomenon of individual significance? Often, in the texts dealing with surrealism, and hence merely repeating an idea whose source is Breton, Aragon is said to have followed the same path as Naville to a position of "political opportunism." Both had, in effect, broken with surrealism to join the Communist Party, but according to methods and in periods that were entirely different. Naville openly put the question, not of simply joining the Communist Party, which would have had a merely formal significance, but of a shift to means of revolutionary action which would have led *the entire movement* to Marxist policy, then represented by the Third International. And at that time his determined adversary was Aragon, who qualified political action as "dishonoring."

Aragon himself *individually* took the step which has always separated surrealism from political action, from Marxism; that is, he *renounced* surrealism to become a communist. And since for several months his attitude was not at all defined, the surrealists soon came to regard it as a maneuver of intimidation in order to induce them to come out in favor of the literary policy of the Communist Party. They could see nothing else in the Communist Party's demands in their regard than an abjuration and a submission to the literature of propaganda.

More important still, Naville's evolution and Aragon's did not occur at the same period. Aragon merely followed the current that with increasing power swept the advanced intellectuals of every nation toward the USSR, at a time when this adherence no

longer occasioned any disadvantage for those who adopted it, quite the contrary. The surrealists did not choose to regard Aragon's move as a development, but as a palinode, "a betrayal" which they were to censure him for bitterly down through the years.

Aragon's departure was a noticeable loss for the group as a whole. With him, surrealism lost not only one of its founders, but a poet of remarkable gifts whose fame was already great, and who by his personal achievements had helped give the movement that countenance we have seen it to possess.

DALI AND
PARANOIA-CRITICISM

*At the climactic moment of the dance,
the backcloth is suddenly torn across
by a dozen roaring motorcycles, sway-
ing on long ropes, while at the same
time several sewing-machines and
vacuum-cleaners, falling from the flies,
crash onto the stage and the curtain
slowly falls.*

—SALVADOR DALI
William Tell, Portuguese ballet

A RAGON's departure led to no others. Reinforced by the
elements we have already mentioned (Dali and Buñuel had
just made the great surrealist film *l'Age d'or*, whose first showing
had provoked the wrath of the *Jeunesses patriotes*[1]), the group
continued to express itself in *Le Surréalisme au service de la
révolution*, of which two numbers appeared in 1931 and two
more in 1933. Dali even revived the movement's youth by effect-
ing its adoption of his method of analysis known as "paranoia-
criticism."

Paranoia, as we know, is delirious interpretation of the world,
and of the ego, which is given an exaggerated importance. But
what distinguishes this disease from other forms of delirium is
a perfect and coherent systematization, the accession of a state
of omnipotence which often leads the sufferer, moreover, to
megalomania or persecution mania. It naturally assumes a num-

[1] Who rioted in the theater and flung filth at the screen.

183

ber of forms, coherent from their point of departure, and is accompanied by hallucinations, delirious interpretations of real phenomena. The paranoiac enjoys normal physical health, suffers from no organic disturbance, and yet lives and functions in an alien world. Far from submitting to this world like most "normal" people, he dominates it, molds it according to his desires. Dr. Lacan's thesis,[2] published at this time, greatly interested the surrealists and provided serious confirmation of Dali's position.

As early as *La Femme visible* (1930), Dali had announced the imminence of the moment when it would be possible to "systematize the confusion and to contribute to the total discrediting of the world of reality":

> Paranoia makes use of the external world to impose the obsessive notion with the disturbing particularity of .naking valid the reality of this notion for others. The reality of the external world serves as an illustration and a proof, and is put in the service of the reality of our mind.

But what would paranoia-*criticism* be? According to Dali, a spontaneous method of irrational knowledge "based on the critical and systematic objectivation of delirious associations and interpretations," in other words, as Breton commented:

> It is a question of speculating ardently on that property of *uninterrupted* transformation of any object on which the paranoiac activity seizes, in other words, the ultra-confusional activity which takes its source in the obsessive idea. This uninterrupted transformation permits the paranoiac to regard the very images of the external world as unstable and transitory, if not as suspect, and it is, disturbingly, in his power to impose the reality of his impression on others . . . We find ourselves in the presence of a new assertion, with formal proofs in support of the *omnipotence of desire* which has remained since the beginning surrealism's only act of faith . . .

Where and how is this activity carried out? Everywhere—in the poem, where it is most at its ease, in the painting, which would be merely the "hand-made color photograph of concrete irrationality and of the imaginative world in general," in sculpture, which would be the "hand-made model of concrete irration-

[2] *De la psychose paranoiaque dans ses rapports avec la personnalité.*

ality . . . ," etc. It also applies to the cinema, to the history of art "and even, if necessary, to all kinds of exegesis." Dali's paranoia-criticism of Millet's *Angelus* and his apologia for *art nouveau*[3] are too well known to need further illustration here.

Let us say only that for Dali, automatism and the dream itself are *passive* states, especially when they are isolated from the external world in which they should function freely; they become refuges, "idealistic evasions," whereas paranoia is a systematized activity which aims at a scandalous intrusion into the world of man's desires, of all the desires of all men.[4]

The way was thus open to the notion of "surrealist objects." What is a surrealist object? One might say roughly that it is any *alienated* object, one out of its habitual context, used for purposes different from those for which it was intended, or whose purpose is unknown. Consequently, any object which seems gratuitously made, without any other purpose than the satisfaction of its maker; further, any created object that realizes the desires of the unconscious, of the dream. Marcel Duchamp's "ready-mades" fulfilled these conditions before the fact. What makes the *Bottle-rack* or the *Chocolate grinder* so mysterious is that they are the "found" materialization of their creator's unconscious desires, corresponding all the more to what we are accustomed to ask of the work of art since these same desires can be shared by the spectator. Consider a bottle-rack, a banal object if there ever was one, confer upon it artistic value by isolating it from its habitual context, oblige others to consider it in itself and to forget its purpose, and you have created a strange object, catalyst of a host of unconscious desires.

Had not Picasso long since emphasized the value of the object

[3] Whose finest achievements are to be found in Barcelona, though there are also the Paris Métro entrances . . . and in general the *"style 1900"* wherever applied.

[4] "Delirium assumes the tangible and incontrovertible character which places it at the antipodes of the stereotypy of automatism and the dream. Far from constituting a passive element propitious to interpretation and open to intervention, paranoiac delirium already constitutes a form of interpretation in and of itself; it is precisely this active element, resulting from the 'systematic presence,' which, beyond the preceding general considerations, intervenes as the principle of this contradiction in which, for me, the poetic drama of surrealism resides . . ."

in itself? Was there any other reason for the shreds of news-paper, the bits of string, even the excrements he had put in his pictures? The technique of collage itself, practiced by Max Ernst, Georges Hugnet, already signified a victorious explosion of the object into realms where it was not expected, an effraction of consciousness even in the dark domain of the unconscious.

If we consider any object capable, by the desire of the man who chooses it, of filling this role, since the number of objects is limitless, the range of the sensations they cause becomes infinite. It can be a meteorite, a "conic anamorphosis" by Dali, an *objet trouvé* (which corresponds all the better to the finder's desire the more unexpected the circumstances of its finding), or the materialization of an unconscious quest. For this reason, the flea market was a repeated source of treasures for Breton and his friends. Anyone who has seen in his home the many things he has found there, from the mandrake root to the spoon with the sabot-base, has some sense of what I mean. Let us follow Breton on his hunt for marvels. He stops in front of an object:

> The first of them that really attracted us, that exerted the lure of the unknown, was a metal half-mask, of striking rigidity though violently adapted to an unknown necessity. The first, whimsical impression was that we were in the presence of a very highly developed descendant of the helmet which had been persuaded to flirt with a velvet carnival mask. Then, by trying it on, we were able to convince ourselves that the eye-holes, striated with horizontal scales of the same substance slanted at various angles, permitted perfect visibility . . . The flattening of the face proper around the nose, accentuated by the rapid yet delicate curve up to the temple . . .

It is apparent that these considerations of Breton's are inspired by the fact that he has never seen the object in question, that he does not suspect its use. Now this was nothing more nor less than a gas-mask used by the French army at the beginning of World War I, which we ourselves have seen at the Val-de-Grâce military museum. Joë Bousquet pointed this out to Breton: the mystery gone, the object became banal once more.

Yet its significance did not stop there. On that day, Breton had been accompanied by the sculptor Giacometti, and the latter, after odd hesitations, purchased the mask. It turned out that

Giacometti had unconsciously been looking for this mask to figure in a sculpture he had been working on, whose face, inexplicably, he had only been able to rough out. It was in this sense that Breton spoke of the *catalytic* role of the found object:

> Here the *found object* rigorously performs the same function as the dream, in the sense that it liberates the individual from paralyzing affective scruples, comforts him, and makes him realize that the obstacle he may have supposed insurmountable is overcome.

Still more expressive would be, for those who wish to refer to it, Breton's elucidation of the conditions of finding, in the same place and on the same day, a curious wooden spoon, which refers him back to an earlier dream that was also obscurely seeking its realization.

There is no need to demonstrate the pertinence of Breton's explanation. We need only refer to our own experience, to contemplate the objects we like to have around us, to wonder why we have bought this one, why that one has suffered eclipses of attachment and detachment, and to elucidate if we can the reasons for these affective states in their regard.

Rather than to trust to chance, which was not always so munificent, would it not be possible to *fabricate* "surrealist objects" which would best express the forces of the unconscious, the desires of the dream, which would be the materialization of barely glimpsed states and forms? Breton had anticipated this creation; he wanted to put in circulation objects seen in dreams and whose production would gradually realize a plan glimpsed down to its smallest details.[5] Surrealism has often been accused of an excessive, tormented imagination, generally of a morbid one as well. Yet in the surrealist objects, there is often not a grain of imagination. The maker has only attempted to translate in substance a form he has dreamed, to disengage from the rational matrix in which it was smothered the *trouvaille* unconsciously seeking to be born. Invention, volition, intention, attention, ingenuity? Rather, by a submission to the unconscious, the automatic translation of a text already read, letter by letter.

[5] A. Breton, *Introduction au discours sur le peu de réalité*.

Another advance into this realm was made by Dali with the "objects of symbolic function." He had started with a sculpture by Giacometti: *L'heure des traces*, which may be roughly described as consisting of two solids: one in the shape of a quarter of an orange resting on its rind, the two upper planes forming a sharp ridge, the other solid a sphere split at its base and suspended by a thread over the first. This sphere was therefore mobile and swung over the lower solid so that the latter's ridge was in contact with the split base of the sphere. This contact was not a penetration. Now, everyone who has seen this object function has felt a violent and indefinable emotion, doubtless having some relation with unconscious sexual desires. This emotion has nothing to do with satisfaction, rather with irritation, the kind provoked by the disturbing perception of a *lack*. Henceforth the way lay open to the production of a great many objects of this kind. Dali constructed many, but so did Breton, Man Ray, Oscar Dominguez.

There was no minimizing this progress in the realm of automatism. Automatism as written, painted (Picasso), sculptured (Giacometti), and photographed (Man Ray), had not escaped from its representations. But here it was in the realm of everyday life: here, rather, life was in the service of the unconscious. Was it not always so? In this regard, one had only to consider fashion, so revealing of certain tastes, certain desires. Yet in such an episodic, wavering, imperfect way. The surrealists, acquiring an awareness of their new gifts, believed themselves capable, by launching an infinite number of such objects into the world, of putting life entirely in the service of the unconscious, of creating a practical, usual world in accord with man's desires. It is in this sense that we must understand surrealism's *will to objectivation* as Breton defined it. The domain in which it functioned and would function seemed to be limitless.

Moreover, did not life often resemble a dream? Who could define the frontier separating the two states, of which one seemed to belong to a world created by us, the other to a harshly material world? What if this distinction were only an appearance? The world of our dreams is as real at the moment we experience it as the waking world, and in our daytime life do we not experience

events "as in a dream"? The same absence of logic, of rigor, the same presence of beings we have not sought out, the same imbroglio of acts imposed upon us, dictated by fortuitous resemblances, by accidents we have not chosen . . . "One commits suicide the way one dreams," the surrealists had already said. But "one also lives the way one dreams."

This is what Breton undertook to demonstrate in *Les Vases communicants*. Retracing a certain period of his life, he observed in the dreams of that period, which he interpreted psychoanalytically, a simple transposition of the events of his everyday life; while the events of this life took their course, as in the dream, around his preoccupations, his feelings, his desires: these latter are nothing but encounters, associations of ideas, plays on words, ludicrous or pathetic intertwinings of incomplete events. What guides him through daily life is a fantasy in accord with desire, and no more reasonable than in the dream. Material obligations, the satisfaction of our organic needs have no more importance, he remarks, than the need to breathe when we are asleep. And is breathing what counts for the sleeper? What must be explained is why, when I am awake, I should be here or there, seduced by the eyes of this woman, finding that same color in the eyes of another, and fixing on her *for that reason alone*, why I decide on a certain activity which is no more necessary or indifferent to me than any other, why a certain letter from a certain friend comes today and not from some other friend, and why his name bears a relation to other ideas foreign to it in other respects, etc. . . .[6]

In truth, dream and waking are communicating vessels in which a single force is manifested: desire. We may note:

how the demand of desire in search of the *object* of its fulfillment strangely deploys the data of the external world, egoistically tending to retain only what can serve its cause. The vain agitation of the street has become no more trouble-

[6] "What is this interrogation of real life, on the pretext that sleep gives the illusion of that life, an illusion discovered on waking, whereas in sleep real life, supposing that it is an illusion, is never criticized, held to be illusory? Would we not therefore be authorized because drunks see double to assert that to the eye of the sober man, the repetition of an object is the consequence of a 'slightly different' intoxication?"

some than the rustling of the sheets. Desire is there, cutting to pieces the fabric that changes too slowly, then letting its sure, fragile thread run between the fragments. It yields to no objective regulator of human conduct . . .

Hence we must no longer speak of heterogeneous, even antagonistic realms. "Dream and action"—another false antinomy. It seems that logic is comfortable only amid these analyses, these divisions, these oppositions: the normal and the mad, the unconscious and the conscious, words and acts, thine and mine, when in reality there are only different and not opposed terrains for the application of desire. This desire Breton makes into the great motive force, and also the great unifier: it is ultimately what best expresses man, what constitutes his essence. Throttled, persecuted, diverted from its applications, it manages *in spite of everything* to achieve its goals. Surrealism sought nothing more than to deliver it from its chains, from the tinsel in which it was sometimes obliged to disguise itself. It was not enough to proclaim desire's omnipotence, it would have to be freed of the obstacles that hampered its fulfillment, those which related to society as well as those which related to the human condition. The true revolution, for the surrealists, was the victory of desire.

A literary utopia, if at the time they had not sought to bring all their efforts to bear on the revolution to be achieved first: the revolution which conditions changes in life, manners, feelings: the social revolution, which would destroy the intolerable conditions of the present facing the majority of men. Thus they experienced, along with their true activity which was revealing new terrain, and at the same time as this activity, an impulse to play a still larger role in political life, and this throughout the years to come. There existed, from 1933 on, a "surrealist politics" which was to find itself increasingly cramped in the communist structure, finally breaking free and standing by itself. It is this surrealist politics which we shall now consider.

CHAPTER 16

SURREALIST POLITICS

We long since announced our adherence to dialectical materialism, all of whose tenets we have adopted.

—ANDRÉ BRETON

I T W A S D E F I N E D in 1931 by three tracts against the Colonial Exposition and by an active participation in the communists' anti-colonial exposition. Aragon and Éluard, notably, had installed and decorated certain exhibits. After Aragon's break with the group, relations with the French Communist Party became more strained. Especially memorable was the massive mobilization of the Amsterdam-Pleyel Congresses which, led by Barbusse and Romain Rolland, were to take a stand against war. The surrealists had no confidence in the humanitarian pacifism of these two men and, claiming to be better disciples of Lenin than the communists themselves, launched the famous watchword: "If you want peace, prepare for civil war."[1]

It was at this time (the end of 1933) that Breton, Éluard and Crevel were expelled from the Communist Party, not only because they attacked the new communist initiative, but because they were accused of championing, and indeed because they did champion, an article by Ferdinand Alquié published in *Le Surréalisme au service de la révolution*. This author denounced the "wind of cretinization blowing from the USSR," notably in such films as *The Road of Life* which celebrated conformist values, especially that famous love of work, the surrealists' bête

[1] In a tract entitled *La mobilisation contre la guerre n'est pas la paix* and signed by Breton, Caillois, Char, Crevel, Éluard, Monnerot, Péret, Rosey, Tanguy, Thirion.

noir. Crevel was to return to favor a few months later, even
collaborating on *Commune*, the organ of the International Writers'
Union. Breton and Éluard (the latter for several years) were to
move farther and farther from official communism, and were
ultimately led to oppose it.

Their first skirmishes as political figures freed from the in-
fluence of the Third International began at once.

1934 was marked, it will be recalled, by the eruption of the
masses in the streets, the temporary wreck of parliamentary
government in France. This form of government, discredited by
the Stavisky and Prince affairs which had swelled into enormous
scandals, survived until the declaration of the war which was
to bury it. It seemed as if the opposing camps henceforth sought
combat outside its factitious arena, and as if it would be the first
victim of the unsuccessful coup d'état of February sixth. The
fascists and social reactionaries, if they did not actually succeed
in overthrowing the regime, showed clearly that the solution
had to be found outside the Chamber of Deputies. And of course
it was not a parliamentary government that was being defended
by the working masses, mobilized at the time of the general strike
that followed . . . But the affair was a serious warning for the
revolutionaries. Were they, as in Italy, as in Germany, to permit
the advocates of political and social reaction to appear to be the
only groups capable of effecting a change of regime, or were they
to reorganize their forces, uniting and emphasizing the immediate
necessity of the radical change they had always preached?

Amid these eddies, the surrealists raised their voice. They
sided of course with the revolutionaries, and on February tenth
launched an *Appel à la lutte* in which they demanded the im-
mediate formation of a united front including all workers' or-
ganizations and the formation of an organism "capable of making
it a reality and a weapon." They were far from being the only
signers (it seems, moreover, that the initiative had been taken
elsewhere) and they rallied a large number of intellectuals who
were later to swell the ranks of the "Committee of Intellectual
Vigilance."[2] On February eighteenth, a new tract was sent to the

[2] Along with the names of the surrealists, we find those of J.-R. Bloch,
Félicien Challaye, Louis Chavance, Élie Faure, Ramon Fernandez, Jean

same organizations on the same subject, including an inquiry into the means of achieving this "proletarian united front." The surrealists were, this time, in the thick of the struggle. Breton had not lied when he asserted that when the time came the surrealists would take their place in the ranks![3] They shortly joined the "Committee of Intellectual Vigilance," signing the Manifesto of March 25, 1935, which condemned any return to *l'Union sacrée.* This was because an important event had occurred meanwhile: the signing of the Franco-Soviet mutual assistance treaty in case of war, marked by Pierre Laval's trip to Moscow, with a concomitant rallying of the French communists to their country's foreign policy.

It was apparently on the same level of Franco-Soviet rapprochement that the Congress of Writers for the Defense of Culture was organized. Just as they had denounced the Amsterdam-Pleyel pacifist congresses, while proclaiming their desire to express themselves in it, the surrealists asked to participate in this Congress, which was to include the advanced intellectuals of all nations. But they called the attention of the directors to two facts: first of all, they could not unconditionally advocate a "defence of culture," the latter being nothing but the culture adopted by the bourgeoisie; second, they had no desire to attend a major public spectacle in which each member would proclaim his pacifist and anti-fascist faith, ignoring the important and difficult questions for the sake of a verbal unity. Their request was ignored. They were kept out of the organizational procedures of the Congress, were not indicated as participants on the posters or programs, and only one of them was allowed to speak in their

Guéhenno, Henri Jeanson, Fernand Léger, André Lhote, Maximilien Luce, André Malraux, Marcel Martinet, Paul Signac, etc.

[3] A less important fact alerted them at this moment: Leon Trotsky was extradited by the French government, which he had asked for asylum after having been driven from Russia and then leaving Turkey. The surrealists rose to protest this measure and made it a point of honor to salute in particular the author "of that formula which is a permanent reason for us to live and to act: 'Socialism will mean a leap from the domain of necessity to the domain of freedom, also in the sense that man today, beset by contradictions and without harmony, will blaze a new trail for a new, happier race.'" (Text of the tract published on this occasion.)

name. René Crevel pleaded with his communist friends to respect this last concession, at least; but it was apparently only because of Crevel's suicide that same day, for reasons which have remained obscure (but which he had established philosophically, as we have seen), that Éluard was permitted to read a text written by Breton, which the latter was not permitted to read himself because of an incident of several days before involving himself and a member of the Soviet delegation.[4] The recollection of this incident, the fear of sabotage by the surrealists, had exasperated the public. Éluard delivered his address in pandemonium and in *L'Humanité* the next day Barbusse reported that "Éluard spoke against the Franco-Soviet pact and against a cultural collaboration between France and the USSR," deliberately distorting what had been said.

Breton, however, had merely warned his revolutionary friends against the politics of the French bourgeoisie:

> If the Franco-Soviet rapprochement becomes a fact, this is less than ever the moment to take leave of our critical senses: it is our responsibility to keep very close watch on the *modalities* of this rapprochement . . .

The public, though composed of intellectuals, was inaccessible to such nuances and preferred to regard such words as no less an attack against the Soviet Union. Breton's declarations were received coldly when, loyal to the surrealist tradition, he once again denounced the notion of *patrie* which the communists henceforth adopted as their own. He refused to follow them on this new terrain:

> For our part, we refuse to reflect in literature as in art the ideological about-face recently expressed in today's revolutionary camp by the abandonment of the watchword 'transformation of imperialist war into civil war' . . . We will not work for the asphyxiation of German thought . . . so active yesterday, and from which the revolutionary German thought of tomorrow cannot fail to come . . .

The intervention was not limited to political considerations, it extended to art. Let us note at this point this evolution of

[4] Ilya Ehrenburg, like Claudel in the past, had qualified the surrealist activity as "pederastic." Breton, happening to meet him on the street, had corrected him.

surrealism: it regarded itself as a cultural movement formed of artists rallying to the revolution, having become "fellow travelers" and leaving the task of direction to politicians. Yet, said Breton:

> The work of art lives insofar as it ceaselessly regenerates emotion, insofar as an increasingly general sensibility derives from it, day by day, a more necessary sustenance. . . .

The work of art is not affected by social upheavals to the degree that it achieves a perfect equilibrium of the external (form) and the internal (manifest content). It is only in this case that Breton declares himself ready to "defend culture." The classical works preferred by bourgeois society are not to be saved, but only the prophetic works of Nerval, Baudelaire, Lautréamont, Jarry. Extending his analysis, he seeks to distinguish Courbet the wrecker of the Vendôme Column from Courbet the painter, to explain that Rimbaud has not come down to posterity because he was a "young sniper of the Revolution" but because he was above all else a revolutionary in poetry.[5] That is, once again Breton opposes the notion of an art of propaganda or circumstance, championing an art which contains its revolutionary force when it is the product of men who feel and think as revolutionaries.

The Congress, however, had already made up its mind; Breton's declarations, spoken by Éluard, were not taken into consideration. Hence, in a brochure[6] summarizing the lessons of the Congress, the surrealists wrote apropos of the creation of the "International Association for the Defence of Culture" and its Bureau of 112 members (selected by the communists):

> As for this Bureau and this Association, we can do nothing but give them formal notice of our defiance.

At the same time they declared themselves unwilling to "accept unconditionally the present watchwords of the Congress and approve a priori the modalities of their application." Finally, after citing various examples drawn from the Soviet press, they

[5] " 'Transform the world,' Marx said; 'change life,' Rimbaud said—these two watchwords are for us one and the same." (Breton)

[6] *Du temps que les surréalistes avaient raison.* (August 1935)

offered their defiance to the present regime of Russia and to its leader.[7]

This time the break with the Russian Communist Party and its French section was permanent and formal, but this was not a break with the Revolution.

Breton proved this by publishing that same year *Position politique du surréalisme*, a tract in which he opposed the providential role forced on those who had created the Russian Revolution and consequently the admiring attitude the communists decreed as the sole reaction of the Western revolutionaries to what had happened and was happening in Russia. On the one hand, Breton said, a veritable taboo was being constituted, and on the other, the capacity *to reject* was denied, though it was the only genuine motive force of revolutionary activity. Breton refused to take refuge in this retrograde attitude as he saw it; instead, in order to restore a necessary, immediate *action*,[8] he announced the founding of *Contre-Attaque*, "the Battle Union of the revolutionary intellectuals."[9]

The participants in this movement first of all opposed the ideas of nation and *"patrie,"* capitalism "and its *politicienne* institutions." They denounced the nascent Popular Front, whose

[7] "Let us confine ourselves to recording the process of rapid regression which maintains that after the nation, it is the family which emerges intact from the dying Russian Revolution. Nothing else remains, in that country, but to reestablish religion—why not?—and private property, to annihilate all the finest victories of socialism. Though we may provoke the rage of their thurifers, we ask if any further accounting is needed to condemn by its works a regime, in this instance the *present* regime of Soviet Russia, and its omnipotent leader under whom this regime is turning into the very negation of what it should be and of what it has been. As for this regime and this leader, we can do nothing but give them formal notice of our defiance."

[8] "Beyond the considerations which follow and which are those to which I have been led by my ten-year concern to reconcile surrealism as a *mode of creation of a collective myth* with the much more general movement of the liberation of man which tends first to the basic modification of the bourgeois form of ownership, the problem of *action*, of the immediate action to be taken, remains integral."

[9] Whose manifesto, dated October 7, 1935, was signed not only by Breton, Éluard, Pastoureau, Péret, but also by former surrealists like Boiffard, by sympathizers like Claude Cahun, Maurice Heine, by intellectuals like the actor Roger Blin, P. Aimery, etc., and by Breton's former enemy Georges Bataille, mainspring of the movement.

failure they predicted for the simple reason that it sought power in the context of bourgeois institutions.

Aside from these negations, they proclaimed that their cause was "that of the workers, of the peasants," but refused on the other hand to "assert, out of demagoguery, their life as the only good and genuinely human one." Consequently the organization was open to all revolutionaries, whether Marxist or not, who acknowledged as postulates:

> the evolution of capitalism toward a destructive contradiction, the socialization of the means of production as the goal of the present historical process, the class struggle as an historical factor and the source of essential moral values.

These positions already constituted a certain originality of the movement, which was marked, further, by the fact that these men were obsessed by the facility with which the fascists had managed, in various nations, to disorganize the revolutionary forces, to defeat them and gain power. Hence they proclaimed the necessity of breaking with the traditional tactics of the workers' parties, of applying, in the attack against the present regime, "a renewed tactic" based on the observation that fascism had been able to utilize the political weapons "created by the workers' movement" and that there was no disadvantage, quite the contrary, in the proletarian revolutionary movement's utilizing in its turn the weapons created by fascism: notably the fundamental aspiration of men to affective exaltation and fanaticism.[10] It followed that, "without any reservations, the Revolution must be entirely aggressive, can only be entirely aggressive . . ."

Evidently the program of *Contre-Attaque*, though silent on many questions which were not solved by formulas alone, opposed the current of resignation which seemed to sweep the masses of the period toward fascist servitude. The experiment of the Popular Front, conducted, according to the words of its leader Léon Blum, "in order to avoid Revolution," could only confirm the lucidity of these intellectuals. Their movement was to fail pre-

[10] "It is not a shapeless insurrection that will seize power. What will decide social destiny today is the organic creation of a vast composition of forces, disciplined, fanatical, capable of exercising, when the time comes, a pitiless authority . . ."

cisely because they were no more than intellectuals, that is, without roots in the proletariat, and particularly without contact with the vital forces of history, momentarily annihilated, hypnotized by the approach of the war. *Contre-Attaque,* after a vegetative life of several months, was to join the countless well-intentioned plans that pave the road to revolutionary emancipation.

TOWARD A "SURREALIST ART"

Fast and light as a cop clubbing a worker. —BENJAMIN PÉRET

T HIS political activity accompanied an artistic activity that was not negligible. Indeed it was at this moment that surrealism actually left France, bearing fruit beyond the frontiers among increasingly numerous groups of intellectuals, that groups, united around Breton's theoretical notions, sprang up everywhere: aside from the already mature Belgian group and the Czechoslovakian group founded in 1933, others appeared in Switzerland, in England, even in Japan. The exhibitions which ensued in these countries had more than a *succès de scandale* (London 1936). Breton became the tireless traveling salesman of the movement: lectures in Prague, Zürich, the Canaries; interviews in foreign newspapers in which he tirelessly defined intentions, destroyed legends, offered solutions, provoked sneers or enthusiasm. He was invited to London, Copenhagen, Barcelona, New York, Buenos-Aires, where there were men who offered to collaborate in the movement and often did so. In Paris itself, there was the opening of a "Systematic cycle of lectures on the more recent positions of surrealism"[1] which Breton presented in these terms:

[1] Here is the tempting program of the four lectures of the Cycle: (June 1935):
 I *Why I am a surrealist* by XXX. Breton will discuss slides of several convulsive-flashing images (by Lautréamont, Jarry, Péret, Picasso, Chirico, Duchamp). Images by Man Ray. Dali, costumed appropriately, will read his poem "I eat Gala." Friendly advice, by Max Ernst.
 II *Will surrealism disappear with bourgeois society?* Discourse on the

Surrealism would betray itself in its own eyes if it claimed to have given a definitive solution to any problem whatever. It is by the objectivation of its very process, and of its process alone, that we intend at each moment to sustain and recreate the confidence placed in us.

A declaration identical almost word for word with that of the first number of *La Révolution surréaliste*. But who would accuse the surrealists of having gone stale in a tradition?

We can even add that for the last ten years, the surrealist stone had gathered no moss, since Breton indicated in the presentation of this program of lectures "the impossibility of pursuing our action on the strictly autonomous level that we had adopted, on which we had succeeded in maintaining it for ten years." Translation: We have no organ of our own to express ourselves. This was indeed the case: the last number of *Le Surréalisme au service de la révolution* bears the date May 15, 1933. No new surrealist review succeeded it. The surrealists had collaborated, however, for some time on a lavish art magazine published by Skira and edited by Tériade: *Minotaure*, and after the elimination of its editor, managed to make it, during the last years of its appearance, a surrealist organ. The illustrations constituted an important part of the publication, and afforded a viewing for a number of surrealist painters: Arp, Bellmer, Brauner, Dali, Delvaux, Dominguez, Ernst, Giacometti, Magritte, Miró,

ruins, by Breton. Surrealist physiognomy of a street, by Malet (with presentation of lacerated posters). Dali will discuss paranoia-criticism, taking for his example the enigma of Millet's *Angelus* . . . This lecture will be illustrated by 30 slides and accompanied by a tragic-atmospheric pantomime between the male and female characters of the *Angelus*.

III *On poetic evidence*, by Éluard. This lecture will be illustrated by 30 slides. Surrealist woman, by Arp. Presentation by Hugnet. Lecture on love, by Péret (with presentation of the loved object). On objective chance as the pivot of the surrealist conception of life, by Breton. This discussion will be followed by the reconstruction of several phenomena of objective chance occurring upon the publication of *Nadja* (directed by Max Ernst).

IV Breton will discuss *The surrealist situation of the object*, and correlatively *The situation of the surrealist object*. Hugnet: surrealism and everyday life: the ordinary object (objects capable of becoming ordinary, by Tanguy). Dali will present the latest surrealist objects and object-beings, will make them function in public, and will explain the symbolic truculence of their mechanisms. Breton will offer his first poem-objects.

Paalen, Penrose, Man Ray, Remedios, Seligmann, Tanguy, etc., while Picasso, Masson, Chirico, and Duchamp in turn illustrated the covers.

Here, once again, the questionnaire constituted the favorite surrealist means of prospecting the terrain. Breton and Éluard opened a new investigation: "Can you tell us what was the decisive encounter of your life? To what degree did this encounter give—does it give—the impression of the fortuitous, of the necessary?" The replies were to be discussed later on. In addition Breton introduced the latest poetic productions of surrealism,[2] notably those of Gisèle Prassinos, a girl of fourteen who according to the strict methods of automatic writing combined with a constant felicity the most preposterous and disconcerting images. This "Alice in Wonderland" lived among wonders all the time, and afforded Breton an opportunity to define this last notion, "sole source of eternal communication among men." For Breton, the marvelous or the wonderful was a pure and simple surrender to the laws of the unconscious, consequently a gratuitous gift not to be confused, as the symbolists supposed, with the search for a deliberate, artificial, false mystery. The marvelous was endowed with an eternal youth, whereas symbolism had consigned to the death of oblivion the productions in which it made an extensive use of mystery. This was because mystery was only a factitious and absurd expedient, whereas the marvelous was the very law of life. A more general law resulted from this opposition, relating to surrealism's basic discoveries. If, since Baudelaire, poets have realized that language led an autonomous life, and that words in particular were susceptible of a thousand combinations, it is odd to note that those who sought to master these combinations—the leaders of the Mallarmé school—generally failed, whereas those who surrendered quite submissively to the monster—Lautréamont, Cros, Rimbaud, Corbière, Jarry, Maeterlinck—received in return a kind of poetic grace. In other words, automatism freed the forces of the unconscious, the only poetics, whereas the intelligence annihilated and, in its learned constructions, sidestepped the true poetry.

The surrealist group thus continued to be passionately con-

[2] *Minotaure*, No. 6 (December 1931).

cerned with poetic problems, which moreover it refused to sepa-
rate from revolutionary problems. If some saw a certain futile
subtlety, a certain Byzantinism in the former, Breton did not
attempt to defend himself against the charge. He noted that there
exists a certain divorce between the artist and the worker, both
combatants in the same revolutionary army, and could not, by
his own strength alone, prevent this divorce from existing. The
artist, he said, benefits from the culture afforded by the bourgeoisie
and finds himself engaged—willy nilly—in a secret adventure
full of sorcery and discovery. The danger lies precisely in that
this inner voice can drown out all the others and become the only
one that is audible. How can the proletariat, which has not bene-
fitted by the same cultural advantages, understand this secret
labyrinth in which it finds the artist concealed? How, especially,
can it help accusing the artist of having abandoned the struggle
for the satisfaction of a selfish goal? Breton saw this divorce and
deplored it; implicity, he acknowledged himself incapable of
surmounting it.

It is from this moment, the moment when Breton classifies him-
self, whether willingly or not, in the category of the *artists,* that
we must date the failure of the surrealist movement.

Surrealism in fact started from a collective effort, as yet never
attempted, of revolution on the level of mind. It was obliged, in
order to make its first steps, to abandon this level and to fling itself
into the political melée. The adherence to the political Revolution
required the deployment of all the surrealist forces, and conse-
quently the abandonment of the particular philosophy which had
constituted the movement's very being at its origin. Was surreal-
ism going to consent to its own suicide? It hoped to escape by a
manifestation: adherence to the Communist Party. Yet, here too,
the surrealists did not participate in the struggle as communists,
but as surrealists, until the day they were obliged to break off
relations. They attempted to conceal the antinomy of their posi-
tion by amalgamating the interests of the mind and those of the
working class, and by creating for themselves a specialization
which ultimately left the task of the Revolution to the politicians.
Each crisis expressed the collision, within the movement, of the
surrealist forces and the communist forces, or the disharmony

between the level of mind and that of facts: the surrealist Robert Desnos was unwilling to become a communist, the communist Aragon could no longer be a surrealist. If the two paths were parallel, they could no longer intersect. Surrealism would remain alive only so long as Breton, managing to operate on both levels, could sustain it on its own contradictions. From this point of view, the *Deuxième Manifeste* expressed the farthest advance on these two levels: on that of mind, research—to the point of occultism and esoteric initiation; on the level of action, the readiness to accept the orders of militant communism.

Dali's arrival afforded the movement a new youth, in that it reoriented it to its earlier goal: the omnipotent mind, capable of molding, by its very delirium, the harshly material world of facts. And the surrealists could suppose the problem solved once they felt able to influence objects, to manipulate them according to desires unknown even to themselves. Yet how could they enable the rest of the world to share their madness? Upon the economic, social and political world they exerted no influence; at most they influenced only a rather thin stratum of intellectuals. And to do so, what other channel was there besides that of art? What other recourse was there except to fall back on art, transcended of course, denied, no longer having anything in common with what had been done in the past, but still in the limited realm which had formerly seemed so easy to dispense with? This also meant falling back on individualist values (however multiplied), which great efforts had been made to discard. There had been a step to be taken which surrealism, for all its ambition and all its efforts, had not been able to take. Breton vaguely realized this. The fact that he counted himself among the artists and that he became and remained a great revolutionary artist, that surrealism as a whole would be and remain a great revolutionary artistic movement, having its influence on life to the degree that art influences life, did not have anything to do with the fact that the surrealists could not fulfill the initial mission they had taken as their own: "the radical destruction of a whole world."

Hence, from this moment, we must record purely artistic and political *manifestations* which are in a sense the efflorescence of

the movement, an explosion of fireworks that fades away, lacking powder. The former surrealists, expelled or departed, had come more rapidly to art or to revolution. They merely preceded the whole of the movement, which soon split in these two directions, exploding the hinge that held these antagonistic forces together. Breton's merit was to have unified them throughout the entire history of the movement.

On the political level, the surrealists were still in the lists. They joined their efforts to those (there were still a few in 1937-1938) who had not given up. Unfortunately, a world was crumbling. Benjamin Péret went to Spain to join the volunteers of ten nations making a final revolutionary attempt; Éluard vilified the assassins of Guernica in one of his finest poems; Breton demanded aid for the endangered Russian Revolution. They were shouting in a cave: blind events are stronger than lucid men.

On the level of art, too, they fought: they proclaimed the truths they had conquered. In the context of the 1937 Exposition,[3] Éluard gave a lecture on "The future of poetry" in which he launched his famous aphorisms:

> It has been said that it is not our right but our duty to start with words and their relations in order to study the world scientifically. It should be added that this duty is that of living itself, not in the fashion of those who bear their death within them, and who are already blind walls, or vacuums, but by uniting with the universe, with the universe in movement, in process.

> Poetry will become flesh and blood only when it is reciprocal. This reciprocity is entirely a function of the equality of happiness among mankind. And equality in happiness will bear happiness to a height of which we can as yet have only a faint notion.

> This felicity is not impossible.

[3] Also in the context of the Exposition: Michéle Alfa, Marcel Herrand, Jean Marchat, J.-L. Barrault, Sylvain Itkine, Paul Éluard recited poems by Borel, Baudelaire, Nerval, Lautréamont, Rimbaud, Nouveau, Cros, Jarry, Maeterlinck, Saint-Pol-Roux, Apollinaire, Reverdy, Jouve, Breton, Tzara, Éluard, Michaux, Péret, Char, Picasso, uniting in a single embrace those who had not despaired of man and his fate.

Also in the context of the Exposition, Breton spoke at the Comédie des Champs-Elysées on *Humour noir,* whose wellspring he saw in Jacques Vaché with whom this UMOUR assumed an "initiational and dogmatic" character. He published that same year *L'Amour fou* which systematized a surrealist value that was not at all new: *objective chance.* Already in *Nadja* and *Les Vases communicants* he had chosen to dwell on a number of external incidents: encounters, accidents, unexpected events, coincidences impossible to relate by a logical link but which resolved inner debates, materialized unconscious or avowed desires. Life and the dream, he had shown, were two communicating vessels, in which events were homologous, it being impossible for the individual to assert that the latter was more real than the former. This time he went further: he abolished any frontier between the objective and the subjective. There exists, according to Breton, between man and the world, a perpetual and continuous correspondence. There exists, above all, a continuity of events which can be antecedently perceived and whose correspondences remain invisible. Yet self-analysis permits their observation. Breton offers a personal illustration of this in the famous *Nuit du Tournesol.*

He turns back to 1923, a period when he had written a poem of a slight poetic value, he acknowledges, and which he had consequently forgotten. Eleven years later, he finds himself at grips with events which follow the course of the poem quite literally. The woman he meets is the very one he described in his poem without knowing her; the places where they spend time together are those he formerly described; the gestures, sensations, even the "atmosphere" have been anticipated and described, down to the smallest details. Further: the presence of certain dross corresponds to the deliberate and hence unfortunate revisions made after the fact by the poet.

Could such phenomena be interpreted differently? Is the poet subject to an illusion analogous to the impression of the *déjà vu?* It is difficult to think so when we compare a poem already written and published, which everyone has thus been able to read, and facts which we cannot suspect the poet of having "arranged." Breton proposes his solution: this corroboration of imaginary

events by the facts derives from a "common denominator, situated in the mind of man and which is nothing other than his desire." Just as desire sought in waking life the answers to the questions of the dream, and vice-versa, it seems that this same desire seeks out events which afford it a justification: chance is no more than "the encounter of an external causality and an internal finality, a form of manifestation of the external necessity which makes its way in the human unconscious." One might say more generally: in the labyrinth of the events of his life, a man naturally chooses those which suit him, which suit his ultimate self, including misfortunes, diseases, individual catastrophes of all kinds.

This is to hold cheap, it will be said, the social conditions which more than any other determine the vicissitudes of our life, and for this reason some have censured Breton for not having completely closed the door to "mysticism." Breton posits a man sufficiently freed from social conditioning (but does such a man exist?) to obey only his own caprice and to receive orders only from his unconscious. That such a man exists is quite unlikely, but at least there are circumstances of life in which these exceptional conditions *can* be fulfilled, in which we adopt a "lyric behavior," in which we escape to a degree the constraining social necessities, in which reason, logic, the proprieties retreat before the unexpected, the marvelous, the *coup de foudre:* these conditions are fulfilled in love. Passion and *l'amour fou*—two expressions of a single state, a state of grace which unites the possible and the impossible, "natural necessity and human or logical necessity."

It is the pursuit of this state which best manifests (since passion tends to avoid social coercion) that objective chance which inflects events according to an omnipotent desire. "What has been the decisive encounter of your life?" the surrealists asked, in the questionnaire we have cited. What they wanted to find in the answers was precisely the share of chance, of the fortuitous and the accidental, which for most men determines the life they lead, then "how the reduction of this data functioned subsequently." They might thus have shown that this "combination of circumstances"—unforeseeable and often unlikely—"is not at all inextricable"; the subtle, fugitive, disturbing links of dependency

which unite the two causal series (natural and human) sometimes shed light on man's most uncertain paths.

In *L'Amour fou*, the author never abandons the search for and exploration of reality which the surrealists had taken as their goal. Moreover, this is one of Breton's works in which we find most explicitly the entire range of the surrealist *charmes*.

WAR AGAIN

*For those of us who place the artist's
rights considerably above the caste in-
terests which others combine so skill-
fully with their professional interests,
we do not believe it is rash to assert
that in all circumstances our means of
expression must be kept apart from the
requisitioning of minds.*
—MAURICE HEINE, (*Clé*, No. 1,
January 1939)

IN 1938, it seemed that surrealism was eager to show its achieve-
ments, on both the political and the artistic level. There was, first
of all, early in the year, the "International Exposition of Surreal-
ism" which brought together at the Galerie des Beaux-Arts the
works of seventy artists of fourteen nations:[1] paintings, sculptures,
objects, books, drawings, prints, photographs, mannequins were
offered to the eyes and hands of a numerous public, in an appro-
priate setting. Did not the program announce: "Ceiling covered
with 1200 coal-sacks, 'Revolver' doors, Mazda lamps, Echoes,
Odors from Brazil, and the rest in keeping"? The success was enor-
mous: for two months, a curious, mocking but generally astounded
and amazed crowd came to learn what surrealism had produced.
In the air already crackling with bullets, surrealism seemed more
than ever to be a provocation. A provocation "to Paris, France,
French taste, French art, art itself." The critics vented their out-
rage all over again. They cried "Scandal!" and indeed there was

[1] Austria, Belgium, Czechoslovakia, Denmark, England, France, Germany,
Italy, Japan, Rumania, Spain, Sweden, Switzerland, the United States.

one, deliberate and premeditated, carefully organized but indicating at the same time the victory won by surrealism on the artistic level.

On the political level, surrealism undertook to unite the revolutionary intellectuals refractory to any marshaling. Breton, who had gone to Mexico during the year, met the Mexican painter Diego Rivera and the exiled Trotsky there. He found men who were familiar with his activity and who approved of it. Above all, he found in Leon Trotsky an open and understanding mind, aware that art, in 1938, in order to keep a revolutionary character, must be independent of all forms of government, must refuse all orders and follow its own line, its own process of development. These conditions were sufficient for art, too, to become a weapon that would serve the emancipation of the proletariat. "The struggle for artistic truth" in the sense of "the artist's unshakable loyalty to his inner self" was the only valid watchword, Trotsky believed. Breton, in recent years, had said nothing different. Hence, electrified by this community of outlook, he communicated with many artists in both the old and the new world to establish a "Federation of Independent Revolutionary Art." With Rivera, he launched a Manifesto: *Pour un art révolutionnaire indépendant*[2] in which, on the basis we have just suggested, they invited the revolutionary artists of all nations to unite.

Back in Paris, Breton undertook to describe his trip in *Minotaure,* demolished "nationalism in art,"[3] and set about creating a French section of the Federation. A national committee was formed at once,[4] representing in a kind of united front the various tendencies of revolutionary art in France. The forces were joined; a monthly bulletin, *Clé,* was started.

Clé's first number appeared after Munich. It bore the mark of events, which were henceforth to move rapidly. In an editorial signed by the national committee and entitled *"Pas de patrie,"* *Clé* undertook to defend foreign artists residing in France and suddenly found to be "undesirable":

[2] Largely written by Trotsky; Rivera served mostly as a figurehead.
[3] Article in *Minotaure,* Nos. 12-13.
[4] Consisting of Yves Allégret, André Breton, Michel Collinet, Jean Giono, Maurice Heine, Pierre Mabille, Marcel Martinet, André Masson, Henry Poulaille, Gérard Rosenthal, Maurice Wullens.

Art has no more fatherland than the workers. To advocate today a return to "French Art," as not only the fascists but even the Stalinists do, is to oppose the maintenance of that close link necessary to art, to work for division and lack of understanding among peoples, it is to produce a premeditated example of historical regression.

In the second number, illustrated by Masson, Trotsky declared in a letter to Breton that:

truly independent creation in our period of convulsive reaction and return to savagery cannot fail to be revolutionary by its very spirit, for it can no longer seek a solution in an intolerable social asphyxiation. But art in its entirety and each artist in particular must seek this solution by individual means, without waiting for some external order, without tolerating it, rejecting it and covering with scorn all those who submit to it . . .

This was the last number of *Clé*. The moment was no longer one for art, especially independent art. Further, dissensions within the surrealist group (expulsion of Georges Hugnet because of his friendship with Éluard, who had broken with the group to go over to the communists) unfortunately spread to the Federation. Further, "proletarians" like Marcel Martinet and Henry Poulaille protested against a surrealist predominance in the organization. Instead of counterbalancing it by an equivalent contribution, they withdrew. An interesting attempt to reunite independent artists on the revolutionary level, the Federation entered its deliquescence even before having begun its task.

Then came mobilization.

What would the surrealists do? "We shall never pull on the abject, sky-blue overcoat again," they had said in 1925. They had long since transcended that anarchist position: those who were mobilizable: Breton, Éluard, Péret, etc., took arms once again. Yet their attitude was not at all ambiguous.

Still others had not agreed to participate in the massacre, and before September 3, 1939, had taken refuge abroad: Calas, Dali, Tanguy. While Péret, under surveillance since his return from Spain, was jailed a few months after mobilization for his revolutionary activities. Escaping during the exodus, he was the only notable surrealist in Paris in 1940–41, until he left for Mexico. Masson and Breton had by then joined their friends in New York.

With them the movement was expatriated, assuming a swifter and larger extension in this new terrain than in Europe. Breton made new converts, expressed himself in the review *VVV* and published *Prolegomènes à un Troisième Manifeste du Surréalisme ou non.* In France, several young poets grouped around J.-F. Chabrun and Noël Arnaud vainly attempted to revive the group. They could only follow in the same footprints. Such an experiment is not repeated.

It had borne fruit that all could henceforth taste for themselves, it had formed men who were among the great artists of the period, it had influenced others who, without it, would not have become entirely themselves. In spite of itself, surrealism had achieved its place in the artistic movement of the times. Better than any other movement of ideas, it represents the period on the level of art. We cannot doubt that in this capacity it will be accepted in the succession of French artistic movements.

EPILOGUE

BRETON IN THE
UNITED STATES

W AITING to leave for the States, Breton gathered around
 him, in Marseilles, a number of personalities from various
circles. The surrealist activity continued for several months under
conditions anything but favorable. Then Breton left France, land-
ing in Fort-de-France, Martinique, where he discovered—or rather
rediscovered, for he had already known him in Paris—a native
poet: Aimé Césaire. In the United States, he made final his break
with Salvador Dali (whom he rebaptized Avida Dollars), now
a Franco supporter. Indeed, Dali had long since tended toward
fascism, and as early as 1934 the group had asked him to account
for his curious description of Hitler as a surrealist innovator.[1]
In 1939 he defended a murky theory of the preeminence of the
Latin race, in which it was not difficult to see a Spanish transposi-
tion of certain northern ideas. In the United States, Dali col-
laborated with the Marx brothers, offered advice to dress designers
of New York, and cynically cashed in on his art through all kinds
of advertising schemes. Having fallen into Franco's arms, the
next step would be to fall into the Pope's.

 As for Breton, he found it difficult to acclimate himself. He
spoke on the radio in favor of "Free France," for which he became
one of the regular broadcasters and, in a lecture to the French
students of Yale University,[2] discussed the "situation of surreal-
ism between the two wars." After having stigmatized Pétain,
Hitler, and Mussolini as epiphenomena of a pathological situation
which demanded other remedies than a world war every twenty

[1] A document provided by Georges Hugnet.
[2] December 10, 1942.

years, he asked the young men listening to him not to let them-
selves be trapped in the conformism of the newspapers, to keep
their minds from being "victimized by contagion." Apropos of
surrealism, he remarked that it was "the only organized move-
ment that has succeeded in covering the distance separating"
the two wars. He saw its flowering in Julien Gracq's novel *The
Castle of Argol,* "in which doubtless for the first time surrealism
freely turns around to confront the great experiments in sensibility
of the past and to evaluate, either from the viewpoint of emotion
or from that of clairvoyance, the extent of its achievement."
Breton then contested the death of surrealism, for it could only
die, he averred, if there arose "a more emancipating movement,"
to which he would rally, moreover. In the absence of this move-
ment, he was obliged to note that surrealism still stood "in the
avant-garde." It had expressed the repercussion of the First
World War on "psychological and moral life," "the rapid appre-
hension of the Second," and declared itself with youth, its hopes,
its exaltation, its marvelous scorn of consequences: "it possesses
an intrinsic virtue, which is to recover the states of inadequate
consicousness which have provoked the return (of waves of
youth) in a delirium of fire and sword." "Surrealism is born of an
affirmation of faith in the genius of youth."

Breton then traced the history of the surrealist movement. We
may note that he expresses a new admiration for Apollinaire
who "was much closer than anyone else to realizing that to
improve the world it was not enough to reestablish it on fairer
social bases, but that one must actually affect the essence of
the Word," and that he forgets Jacques Vaché. Once again he
pays homage to Freud, whose teaching he regards as still valid,
because far from adding one more conformism to the others, it
permits man to enjoy his most fundamental possession: freedom.
It is on freedom that surrealism is based, it is to the exaltation
of freedom that surrealism has labored. And Breton attributed
the divisions and quarrels with which the movement was marked
to the fact that those whom he had attacked, or who had left,
"had become unworthy of freedom": those who had returned to
fixed forms in poetry, those who had abandoned personal expres-
sion, those who have committed themselves "to anyone." "Free-

dom is both wildly desirable and quite fragile, which gives it the right to be jealous." After this war, it would be necessary, Breton proclaimed, to consider the surrealist propositions once again if a solution to "the desperate situation of man in the middle of the twentieth century" was to be reached. Yet he would not want these propositions to hamper young people "preparing to set out: whatever their ambitions to know and their temptations to act, I know that at twenty, they are ready to yield all to the power of a woman's gaze which focuses all the world's attraction in itself."

After these considerations of the past and this reminder of principles, Breton described the state of his thought at the time in the *Prolegomènes à un Troisième Manifeste du Surréalisme ou non.* The title is modest; what Breton offered was a long way from the innovating discoveries of the First and the splendid intransigence of the Second.

He first attacked systems of every kind, which he had never understood except through individuals. He deplored their universal collapse into vulgarization and banality. Robespierre, Marx, Rimbaud, Freud—what "charlatans" and "falsifiers" have not claimed descent from them, with "stupefying confidence"? "Even surrealism has been beset, in the twenty years of its existence, by the evils which are the liability of any favor, any fame. The precautions taken to safeguard the movement's integrity from within—generally considered much too severe— had nonetheless made impossible the false witness of an Aragon, as well as the picaresque imposture of the neo-falangist night-table Avida Dollars."

Men must realize not only their social condition, but their condition as men "and the latter's extreme precariousness . . . Young minds no longer think as we do, and will soon no longer understand our systems. It is they who will mold the future, they who will solve the problems we have not solved." Breton hands the reins over to them: "Not only must the exploitation of man by man cease, but the exploitation by the so-called 'God' of absurd and provocative memory. The problem of the relations between man and woman must be entirely revised without a trace of hypocrisy and in a manner that can have nothing dilatory

about it. Man must side with man in the human predicament. No more weaknesses, no more childishness, no more indignity, no more torpor, no more showing off, no more flowers on the graves, no more civic education between two gym classes, no more tolerance, no more vipers."

Everyone creates his own "system of coordinates." Breton offers his: "Heraclitus, Abelard, Eckhart, Retz, Rousseau, Swift, Sade, Lewis, von Arnim, Lautréamont, Engels, Jarry and several more . . . And what is the worth of any submission to what one has not promulgated oneself?" Breton attacks the revolutionary parties narrowly subject to the social. He notes their failure at the outbreak of the war, their absence as it rages. If this failure continues, he will be obliged to withdraw his confidence from them in order to apply himself fully to the task which now seems to him decisive: to construct a social myth "in relation to the society we regard as desirable." With a view to the construction of this myth, he will readily accept the charge of "mysticism."

Citing the fact that rationalist thought has always seemed to "accommodate itself to the strangest complacencies," for example that "a mind of an exceptional vigor and acuteness"[3] believed in a dog's *friendship*,[4] Breton accommodates his own to still stranger ones. Suddenly discovering that "man is perhaps not the center, the focus of the universe," he adds: "We may allow ourselves to believe that there exist beyond him, in the animal scale, beings whose behavior is as alien to him as his might be to the may-fly or the whale." Such beings would manifest themselves to us "in fear and the feeling of chance." "There is no doubt," he adds, "that the greatest speculative range lies open to this idea" and he calls to witness William James, Novalis, and Émile Duclaux, "former director of the Institut Pasteur, 1840–1904." Not choosing to reveal the extremes of his thought because he prefers to conceal the abysses it contains, Breton concludes his Manifesto on a question mark: "A new myth? Must we convince these beings that they proceed from a mirage, or give them the occasion to reveal themselves?"

[3] Breton is alluding to Leon Trotsky.
[4] "I persist in believing that this anthropomorphic view of the animal world betrays a regrettable facility in our way of thinking."

CONCLUSIONS

It is by boredom [ennui] that we recognize a man; it is boredom that differentiates a man from a child. What distinguishes boredom from the other affective states is its character of legitimacy. —JACQUES RIGAUT

It is dark truths which appear in the work of the true poets; but they are truths, and almost everything else is a lie. —PAUL ÉLUARD

A T THE END of this history of the surrealist movement we cannot dissimulate its gaps. We might have recounted, to enliven the matter, a greater number of anecdotes, practiced the delicate art of portraiture, or confined ourselves to the purely poetic or pictorial aspect of surrealism.[1] We have preferred to retrace surrealism's evolution as a movement of ideas of a period and of a group, being convinced that the problems which the surrealists attempted to solve are those that still face the younger generation today. Naturally we hope that they will burn their wings in the surrealist fire, and prefer that they should use this fire for something besides their own consumption.

Starting from an abstract inquiry into the possibilities of language as a poetic instrument, surrealism first led to a total subjectivism, language appearing as an essentially personal property, which each man could use as he saw fit. The external

[1] Cf. Marcel Raymond, *From Baudelaire to Surrealism*; François Cuzin, *Situation du surréalisme* (*Confluences*, No. 20, June 1943).

world was denied for the sake of a world which the individual found inside himself and sought to explore systematically: whence the importance given to the unconscious and to its manifestations, expressed in a new, liberated language. Arriving at an intense consciousness of his being, the surrealist set it in opposition to the world and sought to inflect the world to his desires. Whence a revolutionary individualism of mental omnipotence which by contagion was to transform other men's thought and their very lives. Far from being enclosed within the secrets of a "school," surrealism gave each man the means of realizing this "state of fury," primary condition of a true transformation of life, which must lead to the resolution of contradictions within a surreality embracing and transcending conscious and unconscious, man and the world, natural and supernatural. The exploration of this state was pursued collectively and with all the characteristics of scientific experiment.

It concluded in failure: the world continued to live as if the surrealists had not existed; the ways of thought and behavior they had attempted to influence were not transformed by their action. This was because, in fact, these ways could be influenced only mediately, through the forms of the physical world over which they voluntarily refused to exercise any control. The second phase of the surrealist process was to transform this world objectively, to transcend subjectivism by a materialism capable of acting on things directly. The surrealists then found themselves on the chosen terrain of the political revolutionaries with whom they tried to collaborate. However, their ambitions were different: if indeed the social and economic revolution seemed to them a necessary condition of the total transformation of life, it was not sufficient, limited as it was to *homo economicus*. What they demanded was not only man's right to subsist, but also to dream, to love, to enjoy, and they preferred inquiring immediately into the conditions which would permit the satisfaction of these desires rather than remaining content with the language of the politicians, which promised such things into the bargain. These conditions were given by the poetic exercise in which they engaged. In other words, by a detour, they returned to the *subject* from which they had never been able, in fact, to detach

themselves. The moment they observed that the "new man" being created in the USSR did not differ essentially from the man they knew, they broke with the communists who passed for the authentic representatives of the political and social revolution.

This break engendered a clearer view of their role and of their possibilities. In contact with the facts, they realized their impotence to engender by their own forces alone the total revolution they demanded. They understood that the first act must be performed by the politicians and that they would have only a dependent role. Their ambition was henceforth limited to shedding light on the way, to keeping the goal constantly before the eyes of the marchers: the resolution of antinomies within a surreality. This resolution in its turn raised new problems which would require new answers.

Hence it is easy to speak of the surrealist failure, when those who do so want to ignore the motivating ambitions of the movement, and to substitute for them a desire to institute a new literature and a new painting; why not a new humanism?

This is to forget too quickly that, like the Romantics, the surrealists were animated by a profound despair. Not Lamartine's sweetish *"vague à l'âme,"* not Leopardi's "melancholy," not Baudelaire's "spleen," so often soluble in the love of a rediscovered God, but a despair analogous to that of Rimbaud, who posited everything here on earth in order to recreate an animal life, an aggressive pessimism like that of Lautréamont, who attacked God, the world, all "good and pure values." Let us recall Naville's lines in *Mieux et moins bien,* and Aragon's in *Traité du style.* On the scale of this pessimism, how absurd appear man, the world, God, life, and man's many expedients to escape the nightmare.

Before the surrealists, as a matter of fact, men had attempted to tame the monster. He had merely shown his horns in Vigny, and yet this had been enough to make the spectator shudder; Baudelaire had led him to the Church and into the *"paradis artificiel"*; Rimbaud had shouldered him into the Red Sea; Lautréamont, after having mastered him, had released him onto the world; Jarry had fallen a victim to him. The surrealists, though, lived *with the beast,* in a constant confrontation, their eyes fast-

ened on his, for he is quick to take advantage of the slightest moment of distraction to wreak his carnage: he has only to sink his claws in a little deeper, to extend his fangs a little farther, and it is over: was this not what happened to Jacques Vaché, to Rigaut, to Nadja, to Artaud, to Crevel? Rigaut: "You are all poets, and I—I'm on death's side."[2] Crevel: suicide is "the most evidently just and definitive solution."[3] and these penetrating questions asked by the living: "Why do you write? . . . Is suicide a solution? . . . What kind of hope do you put in love?" It is as if these men merely repeated "What is the use of living, of functioning in the world?"

And yet they lived and functioned. Strangely, it must be admitted. Did they not proclaim the refusal to succeed, to "arrive" in a world they scorned? And did they not go to the point of scrupulously keeping their word, so long as they belonged to the movement? They acknowledged demoralization as a prime value, systematically sought it out and cultivated it for itself, as if the very reason for living must be extirpated like a weed. And culture? Did not disabused but intelligent men find a welcoming refuge there? They spurned that *summa* of knowledge accumulated from the most immemorial antiquity which says to man: "Believe and Hope!" The surrealists observed that this famous enrichment of humanity down through the ages has not enlarged man but, in its least damaging effects, has covered him with a hard, thick shell, impervious to communications with the world. By their anti-culture, the surrealists aimed at breaking this carapace. So that, *in spite of everything,* they hoped for the dawn of a golden age which they claimed to recreate for the use of all.

Should we see this as a way out of the surrealists' fundamental pessimism? Without a doubt, as well as one of its manifestations. For all the values they extolled partake of this double character. This is the *dream* to which they abandoned themselves. It is a way out indeed, but offering only an illusory exit: a double door, only one of whose leaves was open. They knew that behind the

[2] Jacques Rigaut, *"Papiers posthumes"* (Au Sans Pareil).
[3] Answer to the questionnaire: "Is suicide a solution?" (*La Révolution surréaliste,* No. 2).

other they would find the enemy, crouching in the sunlight, ready to return to its prey. Breton's efforts to mingle the dream with reality came to no conclusion. The dream was only a passing and endlessly recommenced revenge which did not afford victory. With Dali, they assumed that victory was theirs at last: here they were molders of a world to their measure. Alas! even the loveliest hallucinations faded away, leaving on the shore of the mirage a man all the more desperate for having glimpsed paradise, and having lost it.

Hence it is in life itself, in the realm of harsh realities, that man must measure himself against his destiny. Here too, the surrealists chose to use different means. One of these had permitted Lautréamont, Jarry, Vaché to triumph momentarily over the world by surmounting it: *humor*, which Breton and his friends always venerated as the chief god in their pantheon and to which they made continual sacrifices. By the phenomenon of catachresis which it operates on the world, humor permits man to take some revenge on life and on death. But through this gate, one passes alone, and surrealism's ambition was not to endow each man with an individual password, but to furnish an *open sesame* valid for all.

On the way, one conquers love, an exit through which humanity passes in pairs. Oneself and "the other," that is already the beginning of the collective, the opening of the individual jail. On condition that one does not make it into a jail for two, which happens all too often. Whence their criticism of love as their contemporaries conceived and did not experience it, seeing in it only an enlargement, and not a transcendence of individual egoism. Whence their proclamation of *amour fou, amour unique; fou* in that it broke down all barriers within which society wanted to imprison it, in that it takes all the licenses compatible with its nature; *unique* in that it makes the beloved, the "other" into the epitomized and living world which it is henceforth permissible to possess, in which it is henceforth possible to lose oneself. Men can no longer love, after Breton and Éluard, as they did before them: the Woman whom they have magnified more than any other poets has become the living bread of every day, the sky of Sumerian countries, the alpha and omega of every search,

the comestible world within mouth's reach: "I eat Gala," Dali had written. They sought to make love into a revolutionary force, overcoming in its course, and with a splendid scorn of the consequences, all obstacles that kept it from taking its flight and filling its measure. Once again, if this was apparent in what they wrote or painted, it was infinitely more visible in each of their lives. Examples we cannot cite crowd upon us to show that their solutions were first of all vital, experienced in the flesh, and that the confidences they may have let escape from their pens were pure concessions to an artistic alibi which we may rejoice they were not able to do without, because of the singular illumination they afford us.

All the same, love was still only a "strait gate" from which they discovered philosophical—in other words, metaphysical— horizons in relation to the monster that lacerated them. The Revolution: here at last was the true evil through which a man could pass with all his fellows, and for a moment this seemed so evident that Breton was certain it had vanquished forever the famous despair that wracked them all. Only here could they effectively exert their action as a group and at the same time cement their union.

And their collective activity was considerable.

They were the first to dare to write collective poems, eliminating thereby the role of the poet legislating from atop some Sinai, or even simply of the *littérateur* who too often supposes himself the sole author of what he writes. For them, the poet was a man among men, walking with them "in broad daylight," and reciprocally, every man was a poet. They daily indulged in collective games and experiments that involved much more than killing time: the game of folded paper, the game of questions and answers, *cadavres exquis,* the game of truth or consequences, in which they achieved not only creations of which each would have been individually incapable, but a deepened knowledge of each man by all the others.

The manifestations too, of all kinds, helped establish that collective climate, instituted actions capable of conquering the enemy. We have tried to revive them; we shall not recount them again, but we may observe that they were always less gratuitous

than is thought, and less inspired than is supposed by the pursuit of scandal for its own sake.

From the level of episodic manifestation the surrealists shifted, almost immediately, to the level of a generalized manifestation against society and its values, to the level of Revolution, the highest collective values, and the most likely to transform their original pessimism into a rational optimism. For a moment they believed the threshold had been crossed, and rejoicing in this deliverance, they celebrated it in the highest terms. Yet they were mistaken. Naville, from the other side, tried to help them by persuading them that the revolutionaries, too, were radical pessimists, and that consequently they must not be discouraged if they did not find in the Revolution the optimism they naïvely supposed was its motive force. Nothing availed, disillusions came, and the collapse among the monsters. Reduced to the role of docile and conscientious revolutionaries, it is unlikely that they would even have been content with the success of the Revolution.

Yet it would be a mistake to suppose that the surrealist lesson was confined to a bitter acknowledgment of reality. Nothing is more deliberate than the destiny of Breton and the group, whose road we have seen paved at every moment with asserted determination. On their way, they had discovered a value that could effectively counter the pessimism that had always inhabited them. This value, again, they had not created but discovered in the heart of man, under the dead debris, and common to all men: Desire. Their constant labor had been for nothing so much as to bring to light, to acknowledge and release it in the world, armed with its full powers. Was it not in essence protean, revolutionary, and capable of disguising itself in order to conquer? Was it not the most fundamental expression of man and his most original force? If it was limited, at bay, overcome with timidity, the fault was that of the society whose decrees it would break, and consequently of men too easily convinced that they did not require their own freedom. Whence the surrealists' double revolutionary determination: "to transform the world," "to change life" by an objectivation of desire, the omnipotent force capable of producing every miracle.

July 1944

THIRTEEN YEARS
LATER . . .

T H I S *History,* written during the last months of the Occupation at full tilt and with the means at my disposal at the time, suggests more than ever before its inadequacies and weaknesses. The former have been compensated, the latter repaired by the many authors who have treated the subject since, and by André Breton himself in the *Entretiens* broadcast in 1952. I had the excuse of coming first. Without false modesty, I believe it is also my only merit, and it is not without irritation that I find myself regarded, *faute de mieux,* as the "historian of surrealism."

Not that I renounce any of the preceding pages. The hopes formulated in them, the exaltation naïvely revealed, are still mine. But thirteen years have passed, which permit us a clearer view of the surrealist movement and which, for me, have been years of discovery, of experience, and to a certain degree of reflection. I no longer see things in quite the same way. Yet I have neither the time nor the courage to rewrite my work for the present edition, confining myself to applying certain formal corrections. It should be taken first of all as a *testimony,* and one that openly bears its date.

Surrealism was based on a revolutionary conception of man and the world, in a period when the traditional conceptions of their relations had foundered in the Great War. Never before had man's submission to the world seemed so unendurable, that submission of which an intense awareness and a desire to bring it to an end are precisely what make the artist: it is because he seeks to put

226

a stop to his alienation that the poet, the painter, the writer seeks to create new personal relations with that world. They succeed by their works, but without anything having changed around them. What they achieve is a personal adventure, often dramatic, sometimes tragic, an adventure which, for each, always begins over again at zero. Whether it finds its end in itself or leads to silence, on the essential point it is sealed by a defeat: books are added to books, canvases to symphonies without any other effect than to enchant a prison from which the artist escapes only ideally. There is no great writer, no matter how much he counts on posterity, who does not die in despair.

It was the ambition of surrealism to transcend the limits of subjectivity, and it did not mean to be content with words. For those who founded it, after the Dada experiment, it was no longer a question of everything beginning as before. Man was not that creature molded by a century of positivism, of associationism and "scientism," but a being of desires, instincts and dreams as psychoanalysis revealed him. In Russia, a society was being constructed on a new basis. Even more than Rimbaud or Lautréamont, those poets of inspired intuitions, Marx and Freud figured as the prophets of the new age. According to their particular modalities, the surrealists became Marxists and Freudians, putting the accent on the double evolution to be effected: "to transform the world," "to change life." They believed they could achieve this by a totalitarian activity of creation, starting from man himself taken as a totality and by means of an instrument, poetry, which was identified with the mind's very activity. This creative continuity was to be exercised in an unconditional freedom of feeling and action, beyond the comparmentalizations of life and art, in order to recuperate man as a whole. Whence the emphasis on the night side of being, on the imagination, on instinct, desire, and the dream, on the irrational or merely ludic forms of behavior, in order to have done with man mutilated, confined, alienated, reduced to categories of "doing" and "having." Surrealism opened a field of total renewal to man, by relation to his own life as much as to the life of men in groups, to the evolution of forms of thought, morality, art, and literature.

After the Second World War, surrealism's claims remained the

same, and it is a sign of myopia to criticize it for having been unable to integrate new currents of sensibility or new forms of thought. The philosophy of the absurd, a certain romanticism of despair and even of existential commitment have long since been practiced by surrealism, and *all the way*—that is, to suicide (Rigaut, Crevel), to madness (Artaud), to revolutionary militancy (Aragon, Éluard, Péret), and for some, to a definitive "artistic" silence. If the surrealists suddenly seemed to be lacking in "presence" (I am thinking of the disappointing 1947 Exposition at the Galerie Maeght), it was because they had actually transcended the situation that was our own, because the movement had to a certain extent played its historic role. In the history of societies, there is no lack of those situations in which great movements and great men, whose urgent need they postulate, are at the same time afflicted with statutory limitations. Babouvism vegetated over a century after Babeuf without influencing the labor movement; one of the two great artisans of the Russian Revolution was doomed to exile and then murdered in an age when his thought and action might have played a decisive role in the destiny of Soviet society. Indeed, this was the moral, intellectual, emotional situation after the Second World War, which did not show itself to be "equal to" surrealism.

After vainly seeking to make contact, Breton did not insist. He inflected the movement in a direction that had been one of its permanent temptations: the exploration of the sources of poetic activity, the inventory of its ways and means, the search for the metaphysical foundations of this particular form of knowledge. He recalled the existence of an "initiatory tradition" from which the great inspired creators down through history had to one degree or another derived: alchemists, occultists, magicians, and several poets, among whom were those most charged with mystery. To him it appeared of the greatest importance to reaffirm "the hieroglyphic key of the world which more or less consciously pre-exists all high poetry"; to follow "the paths of that internal revolution whose perfect achievement may well blend with that of the Great Work, as it was understood by the alchemists." Nicolas Flamel, Albertus Magnus, Fabre d'Olivet, Swedenborg, and among the poets, Hugo, Nerval, Baudelaire,

Jarry, Roussel reasserted their stature as accursed seekers, nocturnal explorers, initiates. Modern poetry's mission was to continue their quest, to pursue the course they had taken, the trails they had blazed, toward that famous point where all contradictions are resolved. But were internal revolutions made in the market place, in groups, and by simple fiat or decree? Today surrealism is greedy for works which may serve us as landmarks.

How, nonetheless, can we help but envisage this falling back of surrealism onto its poetic minima, its transformation into a school of esotericism as the avowal of defeat? De we not find at the very basis of its affirmation a hidden vice: the postulation that it is enough for thought to exist in order to become immediately operative, and for any task?

If poetry, which was to be freed of its artistic fetters, which was to function outside of any convention and any censorship, which was to become, according to Lautréamont's term, a common possession, is equivalent to the very activity of the mind, how can it find its point of impact in things, modify the reified world of social relations? Surrealism postulated the existence of a human order which it specifically proposed to sustain, and it came into conflict with an order that was chiefly economic, social, political, and artistic which thought alone was impotent to transform, because if this order is indubitably a human creation, it is also that of a man pinioned by history and time, exceeded by his own object which contains him and of which he is a prisoner. Between thought and action, there exists an indispensable mediation: the very history of men. Outside of a few attempts at political intervention (in the broadest sense), episodic and generally anarchic, surrealism did not possess the means for such intervention. It sought to compensate for this by preaching a greater and more radical revolution: the mind itself becoming the subject and the object of its own revolution. This was assuredly the only domain in which thought could become immediately operative.

Still, there exist certain societies situated precisely outside of time and history, in which thought becomes immediately operative: the shaman makes rain; the witch-doctor cures his patient by pronouncing certain formulas; game is killed not by the

arrow but by the virtue of certain rites; the child born into the world does not always proceed from his fleshly mother. The mental universe of these societies is not thereby incoherent or illogical. It is a universe in which thought, carried by language, is substituted for facts and determines the event. Of little importance are the rational explanations which, we attempt to convince the men of these societies, are alone acceptable. All the experience of their daily life orders them to reject such explanations as inadequate, infinitely secondary. They live in a magical universe.

We may wonder if the present temptation of surrealism would not be to constitute—within our hyperlogical world that tends toward self-destruction by the very progress of a knowledge acquired with a view to its mere "utility"—the magic universe which would suit the men of this time, a universe based on the profound and generally unexploited resources of man, on the mysterious laws of a reality at whose threshold the conjectural explanations of science cease, on the desire to establish between microcosm and macrocosm a few essential "correspondences" whose inventory, verified in the form of laws, would serve to institute a new knowledge, and a new mastery. But then, in the fashion of the gnostic sects, of the Pythagorean schools or even of Saint-Simonism, the surrealist adherents would have to aim by every means (from the secret society to the political party) at directly influencing the government of men and things, we should have to believe them capable of educating scientists, philosophers, men of action, even militants.

Until further notice, we must resign ourselves to considering surrealism as a literary school, quite different from all those which have preceded it, and the most wonderful of those that have come into being since romanticism. Willy nilly, it must pass through all the stages, incarnate all the mediations by which a movement of thought ultimately determines, among other causes, and on condition that history lends it life, the consciousness of men.

Then after it will come, perhaps, those who will truly put an end to metaphors.

November 1957

FAMOUS MANIFESTOS AND DOCUMENTS

1924

A CORPSE

He had become so hideous that when he passed his hand over his face he felt his own ugliness.
— ANATOLE FRANCE *(Thaïs)*

THE MISTAKE

Anatole France is not dead: he will never die. In a dozen years some gallant writers will have invented a new Anatole. There are people who cannot do without this comic and empty character, "the greatest man of the epoch" or "a *master* writer." His conversations are recorded, his sentences studied under a magnifying glass, and then we bleat: "How fine that is, really splendid—magnificent! The eternal *master* . . ."

The man who has just left us, however, was not very sympathetic. He never thought of anything but his own petty interests, his own petty health. He was expecting death, it seems. A nice solution. But aside from that, seriously, what has he done? what has he thought? Since, today, our only concern is to leave a palm on his coffin, let it be as heavy as possible, to smother this memory.

A little dignity, Gentlemen of the family! Shed all the tears in your bodies. Anatole has given up what was called his soul. You have nothing further to expect of this dry, flabby memory. It's over!

Night is already falling. One is amazed, when one has the courage to glance through the obituaries, by the poverty of the praises granted the late France. What pathetic celluloid wreaths!

233

Barrès' remark is regularly reported: "He was a conserver." What cruelty! The conserver of the French language—it sounds like an adjutant or a very pedantic schoolmaster. I think it's a remarkable idea to waste any time addressing farewells to a corpse from which the brain has been removed! And since it's over, let's not talk about it any more.

Today I witnessed some fine ceremonies. Bickering undertakers, walking in front of a coffin. And I saw a woman in mourning, veiled in crepe, going to the hospital to chat with her dying husband and show him the splendid, brand-new clothes she had bought that morning while waiting for him to die.

PHILIPPE SOUPAULT

AN OLD MAN LIKE THE REST

The face of glory, the face of death—the face of Anatole France living or dead. Your kind, corpse, we don't like. Yet how many good reasons they have for lasting, like the beauty and the harmony that fill them with comfort, that put a broad smile on their lips, a paterfamilias smile. Beauty, corpse, we know what that is, and if we give in to it, it's not exactly because it makes us smile. We've only come to love fire and water since we began wanting to throw ourselves in. Harmony, ah harmony! the knot of your necktie, my dear corpse, and your brains separate, carefully arranged in their casket, and the tears that are so sweet, aren't they?

Life, which I can no longer imagine without tears coming to my eyes, still appears today in silly little things to which tenderness alone lends any support now. Skepticism, irony, cowardice, France, the French spirit—what are they? A great wave of oblivion sweeps me far away from it all. Perhaps I have never read or seen anything of what dishonors Life?

PAUL ÉLUARD

REFUSAL TO INTER

If, in his own lifetime, it was already too late to talk about Anatole France, let us confine ourselves to casting a glance of

gratitude at the newspaper that sweeps him away, the nasty daily that had brought him in the first place. Loti, Barrès, France, any year deserves a gold star that lay these three sinister gentlemen to rest: the idiot, the traitor, and the policeman. And I should have no objection to wasting a word of special scorn on the third. With France, a bit of human servility leaves the world. Let the day be a holiday when we bury cunning, traditionalism, patriotism, opportunism, skepticism, realism, and lack of heart! Let us remember that the lowest actors of the period have had Anatole France as their accomplice and let us never forgive him for adorning the colors of the Revolution with his smiling inertia. To bury his corpse, let someone on the quays empty out a box of those old books "he loved so much" and put him in it and throw the whole thing into the Seine. Now that he's dead, this man no longer needs to make any more dust.

ANDRÉ BRETON

HAVE YOU EVER SLAPPED A DEAD MAN?

If by some mechanical lassitude I happen to glance at the newspapers, I fly into a rage. This is because they manifest some of that regulation thinking on which, for better or worse, they happen to agree one fine day. Their existence is based on a belief in this agreement, that is all they celebrate, and for a man to gain their approval, indeed for a man to gain the approval of the least of men, he must be an obvious figure, a materialization of this belief.

The municipal councils of localities indistinct to my eyes are today moved by a death, and on the pediments of their schools have set plaques where a name can be read. This should be enough to disqualify the man who has just died, for one does not imagine Baudelaire, for example, or anyone else who stood at that extremity of spirit which alone defies death, celebrated by the press and his contemporaries like a vulgar Anatole France. What was there about the latter that managed to move all those who are the very negation of emotion and greatness? A precarious style, which everyone supposes himself authorized to judge by its possessor's own wish; a language universally vaunted

when language, moreover, exists only beyond, aside from, vulgar estimates. He wrote quite badly, I assure you, this man of irony and common sense, this pathetic discount broker of the fear of the ridiculous. After all, it doesn't mean very much to write well, to write at all, compared to what deserves a single look. All that is mediocre about the man, the narrowness, the timidity, the compromises, the feeble speculation, the complacency in defeat, the self-satisfaction, the bourgeois, stupid, "thinking reed" genre—come together in this hand-rubbing Bergeret whose sweetness is lost on me. Thanks, I am not going to spend the rest of a life which is not concerned with excuses and reputations in that easy climate.

I consider any admirer of Anatole France a degraded being. It delights me that the *littérateur* hailed simultaneously today by the imbecile Maurras and the senile Moscow, and (by an incredible gullibility) by Paul Painlevé himself, should have written, for the money to be made out of an abject instinct, the most dishonoring of prefaces to a tale of Sade's, who spent his life in prison to receive today the kick of this official ass. What flatters you in him, what makes him sacred, may I be left in peace, is not even the extremely arguable talent, but the baseness that permits the first hooligan who comes along to exclaim: "Why didn't I ever think of that before!" Execrable mountebank of the mind, did he really have to incarnate French ignominy for this obscure nation to be so happy to have lent him its name? Stammer all you want, then, over this rotting thing, this worm which in his turn the worms will possess, you leavings of humanity, shopkeepers and chatterboxes, servants of the State, servants of the belly, creatures sprawling in filth and money, you who have just lost such a fine valet of sovereign compromise, that goddess of your hearths and of your genteel felicities.

Today I stand in the center of this dry-rot, Paris, where the sun is pale, where the wind confides its languorous tread to the chimneys. Around me stirs the wretched process of a universe where all greatness has become the object of derision. My interlocutor's breath is poisoned by ignorance. In France, they say, everything ends in a song. Then let this man who has just expired

amid general beatitude go up in smoke, in his turn! Little enough
of a man is left: even so, it's revolting to imagine, about this one
that in any case *he has been!* There are days I dream of an eraser
to rub out human filth.

LOUIS ARAGON

OPEN LETTER TO
M. PAUL CLAUDEL,
FRENCH AMBASSADOR
TO JAPAN

*As for the present movements, not
one can lead to a genuine renewal or
creation. Neither Dadaism nor surre-
alism which have only one meaning:
pederasty.*
*Many are surprised not that I am a
good Catholic, but a writer, a diplo-
mat, French ambassador, and a poet.
But I find nothing strange about this.
During the war, I went to South
America to buy wheat, tinned meat,
and lard for the army, and managed
to save my country some two hundred
million francs.*

Il Secolo, interview with
Paul Claudel, reprinted by
Comoedia, June 17, 1925.

Sir,

The only pederastic thing about our activity is the confusion
it introduces into the minds of those who do not take part in it.

We are not concerned with creation. We fervently hope that
wars and colonial insurrections will annihilate this Western civili-
zation whose vermin you protect in the East, and we appeal to
this destruction as the state of affairs least inacceptable to the
mind.

For us, there can be neither equilibrium nor great art. For a long time now the idea of beauty has been stale. Only a moral idea subsists, for example, that one cannot be both French ambassador and a poet.

We take this opportunity to dissociate ourselves publicly from all that is French, in words and in actions. We assert that we find treason and all that can harm the security of the State one way or another much more reconcilable with Poetry than the sale of "great quantities of lard" in behalf of a nation of pigs and dogs.

It is a singular ignorance of the true faculties and possibilities of the mind which periodically sends boors of your kind in search of their salvation in a Catholic or Greco-Roman tradition. For us, salvation is nowhere. We regard Rimbaud as a man who despaired of his salvation, and whose life and work are pure testimonies to perdition.

Catholicism, Greco-Roman classicism, we abandon you to your infamous sanctimoniousness. May they benefit you in every way; grow fatter still, burst under the admiration and respect of your fellow-citizens. Write, pray, and slobber on; we demand the dishonor of having treated you once and for all as a pedant and a swine.

Paris, July 1, 1925.

MAXIME ALEXANDRE	MICHEL LEIRIS
LOUIS ARAGON	GEORGES LIMBOUR
ANTONIN ARTAUD	MATHIAS LÜBECK
J.-A. BOIFFARD	GEORGES MALKINE
JOË BOUSQUET	ANDRÉ MASSON
ANDRÉ BRETON	MAX MORISE
JEAN CARRIVE	MARCEL NOLL
RENÉ CREVEL	BENJAMIN PÉRET
ROBERT DESNOS	GEORGES RIBEMONT-DESSAIGNES
PAUL ÉLUARD	PHILIPPE SOUPAULT
MAX ERNST	DÉDÉ SUNBEAM
T. FRANKEL	ROLAND TUAL
FRANCIS GÉRARD	JACQUES VIOT
ERIC DE HAULLEVILLE	ROGER VITRAC

1925

DECLARATION OF
JANUARY 27, 1925

WITH REGARD to a false interpretation of our enter-
prise, stupidly circulated among the public,
We declare as follows to the entire braying literary, dramatic,
philosophical, exegetical and even theological body of contempo-
rary criticism:

1) We have nothing to do with literature;
But we are quite capable, when necessary, of making use of
it like anyone else.

2) *Surrealism* is not a new means or expression, or an easier
one, nor even a metaphysic of poetry.

It is a means of total liberation of the mind *and of all that
resembles it.*

3) We are determined to make a Revolution.

4) We have joined the word *surrealism* to the word *revolution*
solely to show the disinterested, detached, and even entirely
desperate character of this revolution.

5) We make no claim to change the *mores* of mankind, but
we intend to show the fragility of thought, and on what shifting
foundations, what caverns we have built our trembling houses.

6) We hurl this formal warning to Society: Beware of your
deviations and *faux-pas*, we shall not miss a single one.

7) At each turn of its thought, Society will find us waiting.

8) We are specialists in Revolt.

There is no means of action which we are not capable,
when necessary, of employing.

9) We say in particular to the Western world: *surrealism*

exists. And what is this new ism that is fastened to us? Surrealism is not a poetic form. It is a cry of the mind turning back on itself, and it is determined to break apart its fetters, even if it must be by material hammers!

Bureau de Recherches Surréalistes,
15, Rue de Grenelle

LOUIS ARAGON	MICHEL LEIRIS
ANTONIN ARTAUD	GEORGES LIMBOUR
JACQUES BARON	MATHIAS LÜBECK
JOË BOUSQUET	GEORGES MALKINE
J.-A. BOIFFARD	ANDRÉ MASSON
ANDRÉ BRETON	MAX MORISE
JEAN CARRIVE	PIERRE NAVILLE
RENÉ CREVEL	MARCEL NOLL
ROBERT DESNOS	BENJAMIN PÉRET
PAUL ÉLAURD	RAYMOND QUENEAU
MAX ERNST	PHILIPPE SOUPAULT
T. FRANKEL	DÉDÉ SUNBEAM
FRANCIS GÉRARD	ROLAND TUAL

LEGITIMATE DEFENSE
(SEPTEMBER 1926)

FROM THE OUTSIDE IN, from the inside out, as surrealists we continue to be able to testify only to that total and for us unprecedented *summons*, by virtue of which we are chosen to give and to receive what no men before us have given or received, to preside over a kind of dizzying exchange, without which we would be unconcerned with the meaning of our lives, if only out of sloth, out of fury and to give free rein to our debility. This debility exists: it keeps us from presenting ourselves each time the occasion arises, even in relation to ideas which we are certain we do not share with others and which we know quite well outlaw us with regard to action. Without desiring to shock anyone, I wish to say without any particular emphasis that we regard the presence of M. Poincaré at the head of the French government as a grave obstacle to thought, a virtually gratuitous insult to the *mind,* a savage joke which should not be allowed to pass. It is known, further, that we are not likely to flatter the liberal opinion of these times, and it is understood that the loss of M. Poincaré seems to us actually acceptable only at the price of that of the majority of his political opponents. It is no less true that the features of this man admirably suffice to institute our repugnance. The sinister "Lorrainese" is already an old acquaintance of ours: we were twenty. Without being obsessed by personal rancor and refusing to derive our private anguish on every occasion from the social conditions imposed upon us, we are obliged to turn around at every moment, and to hate.

Our situation in the modern world, however, is such that our



adherence to a program like the communist program—an adherence of enthusiastic principle, although obviously this represents in our eyes a minimum program[1]—has not been received without the greatest reservations as if, ultimately, it had been judged inacceptable. Free as we were of any critical intention with regard to the French Communist Party (the contrary, given our revolutionary faith, would have been scarcely in accord with our methods of thought), we protest so unjust a sentence today. I am saying that for over a year we have been subjected, from this quarter, to a concealed hostility, which has lost no opportunity to manifest itself. Upon reflection, I do not know why I should abstain any longer from saying that *L'Humanité*—childish, declamatory, unnecessarily *cretinizing*—is an unreadable newspaper, utterly unworthy of the role of proletarian education it claims to assume. Beneath these quickly read articles, clinging to actuality so closely that there is no perspective to be had, shouting into the particular, presenting the admirable Russian difficulties as if they were wild facilities, discouraging all extra-political activity but sports, glorifying unskilled labor or vilifying common-law prisoners, it is impossible not to remark in those who have written them an extreme weariness, a secret resignation to what exists, with the concern to keep the reader in a more or less generous illusion as cheaply as possible. Let it be understood that I am speaking technically, from the viewpoint of the general effectiveness of a text or of any group of texts. Nothing here

[1] Let me explain. We do not have the impertinence to oppose the communist program by any other. As it is, it is the only one which seems to us to be validly inspired by the circumstances, to have settled its object once and for all in relation to its total opportunity of achieving it, to afford, in its theoretical development as in its execution, all the characteristics of fatality. Elsewhere we find only empiricism and reverie. And yet we find ourselves lacunae which all the hope we put in the triumph of communism does not satisfy: is not man an enemy to man, will boredom not put an end to the world, is not any assurance as to life and honor futile, etc.? How avoid such questions, involving particular arrangements which it is difficult to leave out of account? Arrangements of profound involvement, arrangements which the consideration of economic factors, in nonspecialized and by nature hardly specializable men, is not always enough to overcome. If our renunciation, our withdrawal on this point, must be obtained at any price, then let it be obtained. If not, we shall continue despite ourselves to offer reservations to the complete surrender to a faith which like any other presupposes a certain state of grace.

seems to me to contribute to the desirable effect, neither in surface nor in depth.[2] Of a real effort, aside from the constant reminder of immediate human interest, of any effort which tends to call the mind to anything that is not the search for its fundamental necessity—and it can be established that this necessity can only be the Revolution—I see nothing at all, nor any serious attempt to dissipate the often formal misunderstandings bearing only on means and which, without the division into misleadingly labeled camps, would not be capable of endangering the cause defended.[3] I cannot understand that on the road of Revolt there should be a right and a left. Apropos of the satisfaction of this immediate human interest which is almost the only motive considered suitable to assign to revolutionary action[4] in our time, let me add that I find more disadvantages than benefits in its exploitation. Class instinct seems to me to have everything to lose which the instinct of individual preservation has, in the most mediocre sense, to gain. It is not the material advantage which each man may hope to derive from the Revolution which will dispose him to stake his life—*his life*—on the red card. Hence he must be given all the reasons for sacrificing the little he may hold for the nothing he risks having. These reasons we know, they are our own. They are, I think, those of all revolutionaries. From the exposition of these reasons would rise another light, would spread another trust than those to which the communist press seeks to accustom us. Far be it from me to entertain the project of distracting to any degree the attention sought by the leaders of the French Communist Party for the problems of the hour; I confine myself to denouncing the errors

[2] With the exception of the collaboration of Jacques Dortiot, Camille Fégy, Marcel Fourrier, and Victor Crastre, which offers some reassurance.

[3] I believe in the possibility of reconciliation among the anarchists rather than the socialists, I believe in the necessity of overlooking in certain prominent men such as Boris Souvarine their errors of character.

[4] I repeat that many revolutionaries of various tendencies conceive of no others. According to Marcel Martinet (*Europe*, May 15), the surrealists' disappointment occurred only after the war, and resulted from "a thin wallet." "If the Boches had paid, no disappointment; and the question of the Revolution would not have come up, any more than after a strike that brings a four-sou raise." An assertion whose responsibility we assign to the author, and whose evident bad faith dispenses me from answering his article point by point.

of a propaganda method which seems to me deplorable and to the revision of which care cannot, as I see it, be brought too soon.

It is without any presumption, and therefore without timidity, that I offer these few observations. Even from the Marxist point of view, they cannot rationally be denied me. The action of *L'Humanité* is far from being irreproachable. What we read there is not always likely to be memorable, *a fortiori* tempting. The true currents of modern thought are less evident there than anywhere else. The life of ideas is almost nil in that organ. Everything is presented in vague grievances, idle denigrations, little speeches. Occasionally there appears some more character- ized symptom of impotence: the writer proceeds by quotations, entrenches himself behind authorities, even manages to rehabili- tate traitors like Guesde and Vaillant. Must this be passed over in silence at any price? In the name of what?

I say that the revolutionary flame burns where it lists, and that it is not up to a small band of men, *in the period of transition we are living through,* to decree that it can burn only here or there. One must be quite sure of oneself to decide matters thus, and *L'Humanité,* resolved as it is upon self-determined exclusions, is not every day the splendid, ardent journal we should like to have in our hands.

Among the services which, by an inconceivable narrowness, it forgoes to be almost unintelligible echo of the loud voice of Moscow, are our own, which special as they are, would be en- tirely at its disposal and concerning which I should like to say a word. If our contribution to revolutionary action, in this sense, were accepted, we should be the first not to seek to overstep the limits it involves and which are in agreement with our means. Perhaps it is not too much to ask that we not be regarded as a negligible quantity. If any are entitled today to use a pen, without the slightest professional arrogance, and if only because they alone have banished chance from their writings—all chance: fortune and bad luck, profit and loss—it is ourselves, it seems to me, who moreover scarcely write at all and leave to those who will be freer than ourselves, some day, the task of judgment. There was nothing for me to do in 1926, not even answer this letter from M. Henri Barbusse:

My dear colleague,

I am assuming the literary editorship of *L'Humanité*. We We seek to make this paper a great popular organ, whose influence will be exerted in all the broad paths of contemporary activity and thought.

L'Humanité will publish in particular a short work of fiction every day. I am writing to ask for your collaboration in principle for this department.

Further, I should be grateful if you will submit ideas and proposals for press campaigns which fall within the framework of a great proletarian newspaper destined to enlighten and instruct the masses, to prepare the indictment of the retrograde tendencies, the inadequacies, abuses and perversions of modern "culture," and to welcome that great human and collective art which we believe to be increasingly necessary and imminent in our time.

With the best will in the world, I cannot comply with M. Barbusse's requests. I should doubtless yield to the desire to submit proposals for a press campaign to *L'Humanité*, if the thought that M. Barbusse is its literary editor did not completely deter me from doing so. M. Barbusse once wrote an honest book entitled *Under Fire*. Actually it was more of a huge newspaper article, of incontestable propaganda value, reestablishing in their elementary truth a series of facts which there was at the time every interest in concealing or betraying; the book was more of a documentary, acceptable though inferior to any actual reel of film reproducing scenes of carnage before the amused eyes of the *same* M. Poincaré, and of which spectacle we have been deprived to this day. The little I know beyond this of M. Barbusse's productions confirms me in the opinion that if the success of *Under Fire* had not taken him unawares and had not made him, from one day to the next, a tributary to the violent hope of thousands of men expecting, almost demanding that he become their spokesman, nothing marked him out to be the soul, the *mouthpiece* of a multitude. Now, intellectually speaking, there is not, on the other hand, among the writers we surrealists profess to admire, an *enlightener*. M. Barbusse is, if not a reactionary, at least a loiterer, which is perhaps not much better these days. Not only is he incapable of externalizing, like Zola, the feeling he may have of the public difficulty so that he sends against even

delicate skins the terrible wind of poverty, but he does not even participate in the interior drama which has been enacted for years among a number of individuals and whose outcome it will perhaps some day be seen was of interest to all men. As for myself, the importance I attach to this latter subject and the emotion it inspires in me are such that I have no leisure to publish "short works of fiction" even in *L'Humanité*. I have never written stories, having neither time to waste nor to make others waste. The genre, I believe, is exhausted, and I am judging not according to fashion, but according to the general sense of the interrogation to which I am submitting. Today, in order to intend to write, or to read, a "story," one must be a poor wretch indeed. Whether M. Barbusse likes it or not, sentimental stupidity has served its term. Aside from any literary "department," the only stories that we accept, that we acknowledge, are those *L'Humanité* gives us about the revolutionary situation when it takes the trouble not to filch them from other newspapers. Monsieur Barbusse and his henchmen will not succeed in filling our minds with mist and moonshine.

Granted that M. Barbusse is an easy prey. Yet here is a man who enjoys, on the same level as that on which we function, a credit which nothing valid justifies: who is not a man of action, not a light of the mind, and who is actually, in positive terms, nothing. On the excuse that his last novel won him several threatening letters, he complains in *L'Humanité* of September 1 and 9 of the aridity of his task, of the difficulties of his relations with the proletarian public, "the only public whose approval matters," to which he is "profoundly attached," etc., etc. Thence he arrives "apropos of words, the raw material of style," at reopening clumsily enough a debate on the subject of which we should have everything to say and in which we find ourselves not involved: "In my article last week, I suggested the powerful current of the renewal of style which is manifesting itself today and which I believe to be worthy of being called revolutionary. I attempted to show that this renewal, which remains unfortunately[5] on the level of form alone, in the superficial zone of the manner of exprssion [?], is in the course of altering the entire

[5] That "unfortunately" is a whole poem.

aspect of literature." Which is to say? Whereas we have unceasingly taken so many precautions to control our researches, anyone can come along in a confusionist intention which is all too understandable, identifying our attitude, and beyond us, Lautréamont's attitude, for example, with that of the most diverse *littérateurs* to whom M. Henri Barbusse wants to be agreeable! I extract the following lines from the *Bulletin de la Vie artistique* of August first: "Not all the surrealist activity is reduced to automatism alone. They use literature in an entirely voluntary fashion, contradictory to their understanding of this automatism, and for purposes which there is no reason to examine here. One may simply observe that their acts, and their painting which finds its place among them, belong to that enormous enterprise of re-creating the universe to which Lautréamont and Lenin dedicated themselves entirely." One cannot, it seems to me, put the matter better, and the rapprochement of the two names which this last sentence affords can pass neither as arbitrary nor amusing. These names do not seem to us at all contradictory to each other, and we hope to make it understood why. Monsieur Barbusse should heed what we say, for it would keep him from abusing the confidence of the workers by praising Paul Claudel and Cocteau, authors of infamous patriotic poems, of nauseating Catholic professions of faith, ignominious profiteers of the regime, and arrant counterrevolutionaries. They are, he says "innovators," and of course no one would dream of saying as much of Monsieur Barbusse, the celebrated old bore. Let it pass that Jules Supervielle and Luc Durtain seem to him to represent, most validly and authoritatively, the new tendencies: you know, Jules Supervielle and Luc Durtain, those "two writers so remarkable as writers" (*sic*)—but Cocteau, but Claudel! Why not, as well, by a political editor of *L'Humanité*, apropos of the next monument to the dead, an impartial apology for Monsieur Poincaré's talent? M. Barbusse, if he were not a fraud of the worst kind, would not pretend to believe that the revolutionary value of a work and its apparent originality were the same thing. I say: apparent originality, for the recognition of the originality of the works in question can only inform us as to the ignorance of M. Barbusse. I want it to be understood that the publication in

L'Humanité of the article "Apropos of words, the raw material of style" stands for me as a *sign of the times* and deserves to be noted as such. It is impossible to do a worse job in passing (and I mean in passing) than M. Barbusse.

We have always declared and still maintain that the emancipation of style, to a certain degree possible in bourgeois society, cannot consist in a laboratory operation bearing abstractly on words. In this domain as in another, it seems to us that revolt alone is creative, and that is why we consider that all subjects of revolt are valid. Hugo's finest lines are those of an irreducible enemy of oppression; Borel, in the portrait that illustrates one of his books, holds a dagger in his hand; Rabbe felt he was "one of life's supernumeraries," Baudelaire cursed God and Rimbaud swore not to be of this world. There was no salvation for their work outside of this position. It is only knowing this that we can, in relation to ourselves, regard them as *released*. But as for letting ourselves be imposed on by what tends today to present itself externally from the same angle as these works without offering their substantial equivalent: never. For it is indeed *substance* that is involved, even in the philosophical sense of a fulfilled necessity. The fulfillment of necessity alone is of a revolutionary order. Hence we cannot say of a work that it is of a revolutionary essence unless, contrary to what is the case for those M. Barbusse recommends to us, the "substance" in question is not entirely lacking.

It is only afterward that we can come to words and to the more or less radical means of acting upon them. Actually, the operation is generally an unconscious one—among those who have something to say, of course—and one must be the most naïve of men to grant any attention to the futurist theory of "words at liberty," based on the childish belief in the real and independent existence of words. This theory is even a striking example of what can be suggested to a man infatuated with novelty alone by the ambition of resembling the proudest and the greatest of his predecessors. We have opposed this theory, like many others that are no less precarious, by automatic writing, which introduces into the problem an element which cannot

yet have been taken adequately into account, but which prevents it to a ceratin degree from being raised.

Until it is no longer raised at all, we shall nonetheless make sure to prevent its pure and simple avoidance. It is not at all a question for us of awakening words and submitting them to a learned manipulation in order to make them serve the creation of a style, however interesting. To observe that words are the raw material of style is no more ingenious than to present letters as the basis of the alphabet. Words are, indeed, something quite different, they are even, perhaps, *everything*. Let us pity men who have understood no more about them than the literary use they can put them to, and who boast thereby of preparing "the artistic renaissance which tomorrow's social renaissance requires and suggests." What does this artistic renaissance matter to us? Long live the social Revolution, and it alone! We have a serious account to settle with the mind, we are too uncomfortable in our thought, we suffer too painfully the weight of the "styles" dear to M. Barbusse, to have the slighest attention to give anywhere else.

Once again, all we know is that we are endowed to a certain degree with speech and that thereby something great and obscure tends imperiously toward expression through us, that each of us has been chosen and assigned to himself among thousands in order to formulate what, while we are alive, must be formulated. This is an order we have received once and for all and which we have never had the leisure to dispute. It may appear to us, and even rather paradoxically, that what we say is not what is most necessary to say, and that there might be a way to say it better. But it is as if we were condemned to it for all eternity. To write—I mean to write with such difficulty—and not in order to seduce, and not (in the usual sense in which it is ordinarily meant) in order to live, but, rather, at best to be adequate to oneself morally, and being unable to remain deaf to a singular and tireless appeal—to write in this way is neither to play games nor to cheat, that I know of. We are perhaps merely required to liquidate a spiritual succession which it would be to the interest of each of us to renounce, and that is all.

We greatly deplore that the complete perversion of Western

culture should today involve the impossibility, for anyone speaking with a certain rigor, of making oneself understood by the majority of those for whom one speaks. It seems that everything henceforth prevents such a coming together. What is thought (for the mere glory of thinking) has become incomprehensible to the mass of men, and is virtually untranslatable for them. Apropos of the general intelligibility of certain texts, it may even be a question of initiation.

And yet it is still a question of life and death, of love and reason, of justice and crime. The game is not a disinterested one!

The whole meaning of my present criticism is here. I do not know, as I humbly repeat, how we can hope to reduce in our times the crucial misunderstanding which results from the apparently insurmountable difficulties in objectifying ideas. We had, on our own account, placed ourselves at the heart of this misunderstanding and claimed to make sure it would not be made any worse. From the revolutionary point of view alone, the reading of *L'Humanité* would tend to prove that we were right. We thought to be playing our role by denouncing, from this point of view, the impostures and deviations that appeared to be most characteristic around us, and also we believed that having nothing to gain by placing ourselves directly on political terrain, we could, in matters of human activity, appropriately utilize the reminder of principles and serve to our best ability the cause of the Revolution.

Within the French Communist Party, there has been a continual, more or less open disapproval of this attitude, and even the author of a pamphlet recently published under the title: "The Revolution and the Intellectuals. What can the Surrealists do?" attempts to define it from the communist viewpoint with a maximum of impartiality, accuses us of still vacillating between anarchy and Marxism and calls upon us to decide one way or the other. Here, moreover, is the essential question he puts to us: "Yes or no, is this desired revolution that of the mind *a priori* or that of the world of facts? Is it linked to Marxism, or to contemplative theories, to the purgation of the inner life?" This question is of a much more subtle turn than it appears to be,

though its chief malignity seems to me to reside in the opposition of an interior reality to the world of facts, an entirely artificial opposition which collapses at once upon scrutiny. In the realm of facts, as we see it, no ambiguity is possible: all of us seek to shift power from the hands of the bourgeoisie to those of the proletariat. Meanwhile, it is nonetheless necessary that the experiments of the inner life continue, and do so, of course, without external or even Marxist control. Surrealism, moreover, tends at its limit to posit these two states as one and the same, making short work of their so-called practical irreconcilability by every means, starting with the most primitive of all, whose use it would be difficult to justify if this were not the case: I refer to the appeal to the marvelous.[6]

But so long as the fusion of the two states in question remains purely ideal, so long as it cannot be said to what degree it will finally come to pass—we are at the stage of indicating, for the moment, that it is conceivable—there is no cause to set us in self-contradiction with regard to the various meanings we are led to give certain words, certain buffer words such as the word "Orient." This word which plays, in fact, like many others, on various double meanings, has been uttered more and more in recent years. It must correspond to a special anxiety of this period, to its most secret hope, to an unconscious foreboding; it cannot recur with such insistence for no reason. It constitutes of itself an argument which is as good as another,

[6] The context of this study does not permit me to expatiate on this subject. Does it still remain to be proved that surrealism has proposed any other goal? It is time, we still vehemently assert, it is more than ever time for the mind to revise certain purely formal oppositions of terms, such as the opposition of act to speech, of dream to reality, of present to past and future. The basis of these distinctions, in the deplorable conditions of European existence at the beginning of the twentieth century, even from the practical point of view, cannot be defended for a moment. Why not mobilize all the powers of the imagination in order to remedy this situation? If poetry, with us, gains thereby, so much the better or so much the worse, but that is not the question. We are in agreement with Count Hermann Keyserling, as to the path of a *monotonous* metaphysic: "It never speaks except of the one being, in which God, the soul, and the world come together, of the one which is the deepest essence of all multiplicity. And it is focused only on life itself, that nonobjective from which objects explode like incidents."

and today's reactionaries know this well, losing no occasion to put the Orient in question. "Too many signs," writes Massis, "make us fear that the pseudo-oriental doctrines, enrolled in the service of the powers of disorder, serve ultimately only to reanimate the dissensions which, since the Reformation, have seized upon the European mind, and that 'Asiaticism,' like the recent Germanism, is only the first message of the barbarians." Valéry insinuates that "the Greeks and the Romans have shown us how to handle the monsters of Asia." It is a belly which speaks: "Moreover, the question, in these matters, is only one of *digestion*." For Maurras, M. Albert Gareau informs us, all unreason comes from the murky powers of the Orient. "All the great catastrophes of our history, all the great disturbances are interpreted by the hot spells of the same Jewish and Syrian miasma, by the bitter madness of the Orient and its hysterical religion, and the thirst for the holocaust thereby proposed to tired minds." Why, under these conditions, should we not continue to claim our inspiration from the Orient, even from the "pseudo-Orient" to which surrealism consents to be merely an homage, as the eye hovers over the pearl? Tagore, that wicked Oriental mind, believes that "Western civilization will not perish, if it seeks now the harmony which has been broken to the advantage of its material nature." Between us, it is quite impossible, and hence a civilization is doomed. What we cannot tolerate, I say, and this is the entire subject of this article, is that the equilibrium of man, broken, it is true, in the West, for the sake of its material nature, should hope to recover itself in the world by consenting to new sacrifices to its material nature. Yet this is what certain revolutionaries believe in good faith, notably within the French Communist Party. There exists a moral domain in which like is not cured by like, in which homeopathy is worthless. It is not by "mechanism" that the Western peoples can be saved—the watchword "electrification" may be the order of the day, but it is not thereby that they will escape the moral disease of which they are dying. I am convinced, with the author of the pamphlet "The Revolution and the Intellectuals," that "wages are a material necessity which three-fourths of the world's population are constrained to live by, independent of the philosophical

conceptions of the so-called Orientals or Westerners" and that "under the lash of capital, both are exploited," but I cannot share his conclusion that "the disputes of the intelligence are absolutely futile before this unity of condition." I believe, on the contrary, that man must less than ever abandon his discriminative power; that here doctrinaire surrealism ceases precisely to be in question, and that upon a deeper examination, which deserves to be made, *wages* cannot pass for the efficient cause of the present state of affairs; that it would admit another cause for itself, in search of which intelligence, in particular our intelligence, is entitled to be applied.[7]

We protest that we have encountered the gravest obstruction in this direction. Even if we were suspected of passivity with regard to the various piratical undertakings of capitalism, this might be understandable, but this is not the case. We would not, for anything in the world, defend an inch of French territory, but we would defend to the death in Russia, in China, an infinitesimal conquest of the proletariat. Being here, we aspire to perform our revolutionary duty as elsewhere. If we perhaps lack political spirit, at least we cannot be censured for living withdrawn in our thought, as in a tower around which others are shooting each other. Of our own free will, we have never sought to enter that tower, and we shall not permit ourselves to be locked up within it. It is certainly true that our attempt at cooperation, in the course of the winter of 1925–1926, with the most vital elements of the *Clarté* group with a view to a specific external action concluded, in practical terms, in failure,

[7] There is no question of disputing *historical materialism*, but once again materialism *tout court*. Is it necessary to recall that in the minds of Marx and Engels, the former was born only in the exasperated, definitive negation of the latter? No confusion is permitted in this regard. As we see it, the idea of historical materialism, whose inspired character we could contest less than ever, can be sustained, and as is necessary, be exalted in duration, and also can force us to envisage its consequences concretely, only if it constantly gains knowledge of itself, only if it fearlessly opposes all antagonistic ideas, beginning with those which it has first had to vanquish in order to come into existence and which tend to represent themselves under new forms. It is these latter which it seems to us are slyly gaining ground in the minds of certain leaders of the French Communist Party. May we ask them to meditate on the terrible pages of Théodore Jouffroy: *How Dogmas End.*

but if the envisaged agreement could not be made manifest, I deny that it was "by an incapacity to resolve the fundamental antinomy which exists in surrealist thought." I believe I have made it clear that this antinomy does not exist. What has been the obstacle in our way is the fear of proceeding against the true intentions of the Communist International and the impossibility of attempting to do no more than obeying the orders (disconcerting at the very least) given by the French Communist Party. That is essentially why *La Guerre civile* was not published.

How avoid begging the question? I have again been assured, with full knowledge of the case, that in the course of this article I am committing an error by attacking, from outside the Party, the editors of one of its organs, and I have been informed that this action, apparently well-intentioned and even praiseworthy, is of a nature to give arms to the enemies of the Party which I myself regard, in terms of revolution, as the only force on which we may count. This has not escaped me, and I may say that it is why I have long hesitated to speak, why I have resolved to do so only reluctantly. And it is true, rigorously true, that such a discussion, which proposes nothing less than weakening the Party, should have been pursued within the Party. But by the very admission of those who are there, this discussion would have been reduced to a minimum, supposing it were even permitted to be pursued. There was not, for myself, for those who think as I do, anything else to expect, precisely. In this regard I have known since last year what to look for, and that is why I have decided it was useless to be *registered* in the French Communist Party. I do not want to be arbitrarily cast into the "opposition" of a party to which I adhere with all my might, but which should, I believe, possessing Right on its side, have an answer to everything if it were better led, if it were truly itself, in the realm where my questions are raised.

I conclude by adding that in spite of everything, I am still waiting for that answer. I am not ready to turn elsewhere. I merely hope that from the absence of a great number of men like myself, held back by motives as valid, the ranks of those who are usefully and with full understanding preparing the proletarian

Revolution are clearer, especially if there glide among them ghosts, that is, beings concerning whose reality they are mistaken and who do not desire this Revolution.

. .

Legitimate defense?

<div align="right">ANDRÉ BRETON</div>

1927

WITH YOUR PERMISSION

Without surrealism, I should have understood Rimbaud less.

—ERNEST DELAHAYE

Paris, October 23, 1927

To: the Representatives of the Ardennes,
the Mayor of Charleville, members of the
town council, and the President of the
Society of Ardennais Poets,

Gentlemen:

You are taking, it appears, the responsibility of inaugurating today, for the second time, a monument to the memory of Arthur Rimbaud, and of organizing in this regard a small regional celebration. It is regrettable that official consecration has not yet been granted to your enterprise, but it is only postponed, we assure you. Have you not managed to disturb M. Louis Barthou, to distract him, even if only for a moment, from his preoccupation with communism, wakening in him the bibliophile which has lately been eclipsed behind the jail-stocker?

You will admit, Gentlemen, that the occasion is perhaps an ill-chosen one on which to abandon oneself to patriotic delirium, he whom you are celebrating having had nothing but gestures of disgust and words of hatred for your kind, and rejoicing forever in a glory quite contrary to that of the writers who died for France, those "Knights of the spirit in whom is concentrated all that France defended during the last war."[1]

It is true that you do not know who Rimbaud is, and again you make this quite clear:

[1] Herriot

257

My home town is superlatively stupid among all country towns; as to that, you know, I have no illusions. Because it is near Nezières—a town you can't find—because it sees two or three hundred foot-soldiers wandering through its streets, this imbecile population gesticulates, with bourgeois ferocity, quite differently from the besieged townspeople of Metz or Strasbourg! It's terrifying to see the retired grocers pulling on their uniforms again! And amazing to see the lawyers, masons, tax-collectors, carpenters and all the big bellies in town, rifles over their hearts, marching up and down on their patrols at the gates of Mézières; my fatherland is rising! I prefer, frankly, to see them sitting down; don't stir up the dust, that's my principle.

[August 25, 1870]

We are curious to know how you can reconcile the presence in your town of a monument to those who died for their country and of a monument to the memory of a man who incarnates the highest conception of defeatism, of the active defeatism that in wartime you put in front of the firing squad.

War: no siege of Mézières. When? No one talks about it . . . Here and there, sniping, abominable prurigo of idiocy, that's the spirit of the population. Speechmaking. It's enough to dissolve your brain.

[November 2, 1870]

I dearly hope that the Ardennes is occupied and put under worse and worse pressure. But it's all quite banal.

[June 1872]

The day before yesterday I went to see the Prussians at Vouziers, a sub-prefecture of 10,000 souls, seven kilometers from here. It made me feel good all day.

[May 1873]

In any case, France disgusted him. Her mind, her great men, her manners, her laws symbolized for him everything that was lowest and most insignificant in the world.

What a mess, this French countryside . . . What a sty! and what monsters of innocence, these farmers. You have to go at least two miles, or more, at night, to get something to drink. Mother really dropped me in a pathetic hole.

[May 1873]

Musset is fourteen times execrable to us, suffering and visionary generations—whom his angelic sloth has insulted! Oh, the tales and the insipid proverbs! O "Les Nuits," O "Rolla," O "Namouna," O "La Coupe." How French it all is—that is, loathesome to the supreme degree; French, not Parisian! Another work of that odious genius which has inspired Rabelais, Voltaire, Jean La Fontaine! With commentary by M. Taine! Springlike, Musset's mind! Charming, his love! A painting in enamels, pure poetry! "French" poetry will be savored for a long time—but in France.

[May 5, 1871]

Rimbaud? He did not allow anyone to salute the dead in his presence, he wrote "shit on God" on the walls of churches; he did not love his mother, "as rigid as 73 lead-helmeted administrations."

Rimbaud? A communard, a *bolshevik*, according to the testimony of Ernest Delahaye himself:

There are certain necessary destructions . . . There are other age-old patches of shade whose pleasant habit we are losing. This society itself. The axes, the picks, the leveling rollers will pass over it. "Every valley shall be filled, and every mountain and hill shall be brought low; and the crooked shall be made straight and the rough ways shall be made smooth." The rich shall be struck down, and the proud humbled. A man will no longer be able to say: "I am more powerful, wealthier." Bitter envy and stupid admiration will be replaced by peaceful concord, equality, the labor of each for all.

Rimbaud? He lived the way you think men ought not to live: he got drunk, picked fights, slept under bridges, had lice.
But he loathed work:

I will never work. . . .
It disgusts me to work . . .
We shall never work, O floods of fire! . . .
I loathe all jobs. Masters and workers, all peasants, ignoble. The hand holding the pen is worth as much as the hand holding the plough. What a century for hands! I'll never have my hand.

Without hope, either on earth or elsewhere, he thought only of leaving, a prey to that terrible boredom that you will never

know; he pursued across the world, in the most desolate places, the most desolating image of himself and of us.

> Alas! I no longer care about life, and if I live, I am used to living on exhaustion . . . and feeding on despairs as vehement as they are absurd, in dreadful climates. . . . If we could enjoy a few years of real rest in this life, and *luckily this life is the only one there is, obviously,* since you can't imagine another life more boring than this one!
>
> [Aden, May 25, 1881]

Everything that constituted your nasty little life revolted him, he spat it out. He was always against everything that exists, you are merely pretending to have forgotten it. Don't try and cheat: you are not setting up a statue to a poet "like the others," you are setting up this statue out of rancor, out of pettiness, out of vengeance. You want to reduce a man who admired "the incorrigible convict on whom the prison colony always closes" to a grotesque bust in an ignoble site: Charleville, Place de la Gare.

> A strange reversion of things here on earth, [wrote Paul Berrichon] the monument put up in 1901 to Rimbaud's memory stands, bronze and granite in that Place de la Gare where, as always, the inhabitants of Charleville go on Thursdays to listen to the band play marches; and it was the band that, at the monument's inauguration, played the adaptation of Emile Ratez's symphony, inspired by *Le Bateau Ivre.*

Marches! A band! You have forgotten the singers:
The flag goes with the filthy *landscape,* as your faces are made for
"the putrid kiss of Jesus."

The shadow seems to darken every day over the invading marshes. Hypocrisy extends its hideous hand over men; we love to make them serve the preservation of what they have always opposed. It goes without saying that we are not fooled as to the extent of such confiscations, that we are not excessively alarmed by your shameful and habitual maneuvers, convinced as we are that a force of total fulfillment is marshaling against you every-

thing that has been truly inspired in the world. It matters little to us that you have inaugurated a statue to ——, that you have published the complete works of ——, that you derive whatever advantage you can from the most subversive intelligence, since their marvelous venom will forever continue infiltrating the soul of the young, to corrupt or increase them.

The statue inaugurated today will perhaps suffer the same fate as its predecessor. This latter, which the Germans removed, was melted down for the manufacture of shells, and Rimbaud would have gleefully waited for one of them to smash to smithereens your Place de la Gare or reduce to dust the museum in which base preparations are being made to traffic in his glory.

Priests, professors, masters, you are making a mistake in handing me over to justice. I have never been a Christian. I belong to the race that sang under torture; I do not understand the laws; I have no moral sense, I am an animal; you are making a mistake.

MAXIME ALXANDRE	MICHEL LEIRIS
LOUIS ARAGON	GEORGES LIMBOUR
ARP	GEORGES MALKINE
JACQUES BARON	ANDRÉ MASSON
PIERRE BERNARD	MAX MORISE
JACQUES BOIFFARD	PIERRE NAVILLE
ANDRÉ BRETON	MARCEL NOLL
JEAN CARRIVE	PAUL NOUGÉ
ROBERT DESNOS	BENJAMIN PÉRET
MARCEL DUHAMEL	RAYMOND QUENEAU
PAUL ÉLUARD	GEORGES SADOUL
MAX ERNST	YVES TANGUY
JEAN GENBACH	ROLAND TUAL
CAMILLE GOEMANS	PIERRE UNIK
PAUL HOOREMAN	

1927

HANDS OFF LOVE

WHAT CAN BE INVOKED, what exerts force in the world, what is valid, defended before anything else, at any cost, what inevitably brings charges against a man whatever the conviction of a judge, and just think for a moment what a judge is, how much you depend at each moment of your life on a judge to whom suddenly the slightest accident hands you over, in short what puts everything else to rout, genius for instance—that is what a recent trial suddenly places in a glaring light. Both the nature of the defendant and of the charges against him make it worth while to examine Mrs. Chaplin's suit against her husband (as reported in *Le Grand Guignol*). It should be understood that what follows here is based on the belief that the document is an accurate report, and though of course it is Charlie Chaplin's right to deny any of the alleged actions and remarks imputed to him, we have taken their authenticity for granted. It is a matter of seeing what arguments are used against such a man, of judging the means used to bring him down. These means afford a strange image of the average moral opinion in the United States in 1927, that is, of one of the major human agglomerations, an opinion which will tend to spread and prevail everywhere, insofar as the enormous reservoir choked with consumer goods in North America is also an enormous reservoir of nonsense ever ready to spill over onto us, and in particular to cretinize altogether the amorphous clientele of Europe, always at the mercy of the latest bargainer.

It is quite monstrous to think that if a professional secrecy exists for physicians, a secrecy which is after all merely the safeguard of a false shame and which nonetheless exposes its

262

betrayers to implacable repression, on the other hand there is no professional secrecy for married women. Yet the married woman's condition is a profession like the rest, from the day a woman claims as her due an alimentary and sexual ration. A man whom the law obliges to live with only one woman has no other choice than to share his own habits with that woman, putting himself at her mercy. If she hands him over to public malignity, how can it be that the same law which has given the wife the most arbitrary rights will not turn against her with all the rigor merited by so revolting an abuse of confidence, a defamation so obviously linked to the most sordid interests? And further, how does it happen that such mores should be a subject for legislation? What an absurdity! To confine ourselves to the extremely episodic *scruples* of the *virtuous* and *inexperienced* Mrs. Chaplin, there is something comic about considering *abnormal, contra naturam, perverted, degenerate and indecent* the practice of fellatio.[1] (All married couples do it, Chaplin has justly observed.) If the free discussion of mores could be reasonably undertaken, it would be normal, natural, healthy, decent to dismiss the suit of a wife guilty of having *inhumanly* rejected practices so general and so utterly pure and defensible. How can such stupidity permit, moreover, an appeal to love, as this woman, who at sixteen years and one month of age *knowingly* entered into matrimony with a man both wealthy and in the public eye, now dares to do, with her two babies, doubtless born through her ear since *the defendant has never had conjugal relations with her as is customary between man and wife,* her babies which she brandishes like the filthy evidence of her own private demands? All these italics are our own, and the revolting language which they emphasize comes from the plaintiff and her lawyers who, above all, seek to oppose a living man by the most revolting conventionalism of mindless magazines, the image of the mother who calls her legitimate lover Daddy, and this with the sole purpose of levying on this man a tax which the most demanding State has never dreamed of, a tax which burdens his very genius most, which even tends to dispossess him of that genius, in any case to discredit its very precious expression.

[1] For example.

Mrs. Chaplin's five chief charges read as follows. 1) This lady was seduced. 2) The seducer advised her to seek abortion. 3) He agreed to the marriage only when obliged and forced, and with the intention of seeking a divorce. 4) For this reason, following a preconceived plan, he behaved injuriously and cruelly to her. 5) The proof of these accusations is demonstrated by the habitual immorality of Chaplin's speech and actions, and by his theories with regard to all things regarded as most sacred.

The *crime* of seduction is usually a hard one to define, since what constitutes the *crime* is merely the circumstantial side of the seduction proper. This offence in which the consent of both parties is involved but the responsibility of only one, is further complicated by the fact that nothing can humanly prove the *victim's* share of initiative or provocation. But in this case, the innocent party had chosen wisely, and if the seducer did not intend to make an honest (and rich) woman of her, the fact remains that it was the victim who with all her naïveté prevailed over this demoniacal being. One wonders at so much perseverance and determination in so young and defenceless a person. That is, unless it seemed to her that the only way of becoming Mrs. Chaplin was to sleep with him first, then . . . but then seduction is out of the question; this was business, with its various risks, the possibility of desertion, pregnancy.

At this point, being pressed to undertake an operation she describes as *criminal,* the *victim,* pregnant at the time of the marriage, refuses to do so for reasons that deserve scrutiny. She complains that her condition may become known, that her fiancé has done everything in his power to bring this about. An obvious contradiction: for who would profit by this publicity, who would refuse the sole means of averting what in California constitutes a scandal? But once married the victim is fully armed; she can circulate the fact that an abortion was demanded of her. This is a decisive argument, and not the least of the criminal's remarks concerning this matter, which is a *great crime against society, both legally and morally, and thereby repugnant, horrifying, contrary to the instincts of motherhood and to her sense of the maternal duty of protection and preservation,* will be allowed to go unnoted. Everything is henceforth recorded,

the intimate daily phrases, the circumstances, even the dates. Once it occurred to the future Mrs. Chaplin to make use of her *instincts*, to pose as a monument of normality (though not yet legally married, she continued, she says, to love her fiancé, despite his horrifying suggestions), she becomes a spy in the house, she keeps a kind of martyr's diary; not a tear is left out. Can the third charge that she brings against her husband be taken to apply first and foremost to herself? Did she *enter into marriage* with the definite intention of emerging therefrom rich and respected? As to the fourth charge, that of the cruel treatment she suffered during her marriage, once examined in detail it becomes necessary to decide whether this is a distinct attempt on Chaplin's part to demoralize his wife, or whether it is the logical result of the daily attitude, of a wife bent on amassing grievances, evoking them and taking pride therein. Incidentally, let us note a gap in the evidence: Mrs. Chaplin omits to give us the date on which she ceased to *love* her husband. But maybe she still loves him.

To back up her allegations, she adduces (as so many moral proofs of the existence of a premeditated plan, which becomes visible in the rest of the evidence) certain remarks of Chaplin's, after which an honest American judge can only consider the defendant as a cad and a scoundrel. The perfidy of this maneuver and its efficacy will be clear to all. Here we have the idea of Charlot, as we call him in France, his private opinions on the most burning issues suddenly thrust before us, and in such a direct manner that they cannot fail to throw a singular light on the morality of those films from which we have derived more than mere pleasure, that is to say, an almost unequaled critical interest. An unfavorable report, especially in that narrow zone of observation to which the American public confines its favorites (and the example of Fatty Arbuckle is notable) can ruin a man in the space of a day. This is the card played by this model wife. It turns out that her revelations have an importance quite unsuspected by her. She supposed she was denouncing her husband, the stupid cow, whereas she simply occasioned the spectacle of the greatness of a mind which, accurately conceiving so many deadly things in the society in which his life and even his genius

confine him, has found the means of giving his thought a perfect and vigorous expression without betrayal, an expression whose humor and power, whose poetry, in a word, suddenly suffers before our eyes an enormous setback in the light of the little bourgeois lamp shaken over his head by one of those bitches out of whom, in every country of the world, are made *good* mothers, *good* sisters, *good* wives, those plagues, those parasites of feeling and love.

Given that during cohabitation of plaintiff and defendant, defendant declared to plaintiff on diverse occasions too numerous to be specified in detail that he was not a partisan of the habit of marriage, that he would be unable to tolerate the conventional restraint imposed by marital relations, and that he was of opinion that a woman could honestly and without disgrace bear children to a man when living with him out of wedlock; given that he also ridiculed and mocked plaintiff's belief in the moral and social conventions pertaining to the state of marriage, the relation of the sexes and the rearing of children, and that he was unconcerned by the laws and statutes of morality (regarding which he remarked one day to plaintiff that "a certain couple had had five children without being married," adding that this was "an ideal way for a man and a woman to live together")— this brings us to the essential point of Charlot's vaunted *immorality*. It is to be noted that certain very simple truths still pass for monstrosities, and it is to be hoped that one day they will be recognized as mere human common sense, the nature of which in this case appears startling by reason of the nature of the accused himself. For everyone who is neither coward nor hypocrite is bound to think the same. And besides, by what argument can we claim the sanctity of a marriage that was contracted under threat, even if the woman has borne her husband a child? Let her complain that her husband used to go straight to his own room, that once, to her horror, he came in drunk, that he did not dine with her, that he did not take her out in society— such arguments are worth no more than a shrug of the shoulders.

But it would seem that nonetheless Chaplin tried in all good faith to make their conjugal life possible. But no such luck. He came up against a wall of silliness and stupidity. Everything

appears criminal to this woman who believes or pretends to
believe that her sole reason for existence is the procreation
of brats—of brats who will beget future brats. A noble idea
of life! "What do you want to do—repopulate Los Angeles?"
Chaplin asks, outraged. Yet as she demands, she shall have a
second child, only now she must leave him alone, he wants
paternity forced on him no more than he wanted marriage. How-
ever, to please Mother he would have to play the fool with the
children. That is not his style. He is to be bound less and less *in
the home*. He has his own conception of life; it is being threat-
ened, attacked. And what could bind him to a woman who re-
fuses to do everything he desires, and who accuses him of
"undermining and denaturing [her] normal impulses," of "de-
moralizing her ideas of the rules of decency," of "degrading her
conception of morality," and all because he has tried to make her
read certain books in which sexual matters are treated clearly,
because he wanted her to meet certain people whose way of life
had a little of that freedom to which she shows herself such an
inveterate enemy. And again, four months before their separation,
he makes an effort: he suggests they invite a young girl (who
later is said to have the reputation of "abandoning herself to
acts of sexual perversion") and tells the plaintiff "they might
have a little fun." This is the last attempt to transform the
domestic incubator into a rational being capable of conjugal
affection. Books, the example of others—he has recourse to
everything to try and make this blockhead perceive all she is
incapable of understanding for herself. But at the end of all this
she is amazed at the inequalities of temper in the man whose
life she turns into such a hell. "Just you wait, if I suddenly go
mad some day, I'll kill you"; and naturally this threat is saved
up by her for the list of charges, but on whom does the responsi-
bility for it rest? For a man to become aware of such a possi-
bility, i.e., insanity, murder, seems surely to indicate that he has
been subjected to a treatment capable of driving him to insanity
and murder? And during these months, while a woman's wicked-
ness and the danger of public opinion force an insufferable farce
on him, he remains nonetheless in his cage, a living man whose
heart has not died.

"Yes, it's true," he said one day, "I am in love with someone and I don't care who knows it; I shall go see her whenever I please and whether you like it or not; I don't love you and I live with you only because I was forced to marry you." This is the moral foundation of this man's life, and what it defends is— Love. And in this entire matter, it so happens that Charlot is simply and solely the defender of love. He tells his wife that the woman he loves is "wonderful," that he would be glad to introduce her to his wife, etc. This frankness, this honesty, all that is most admirable in the world, is now used against him. But the chief argument is a pair of children born against his will.

Here again, Chaplin's attitude is very clear. Both times he entreated his wife to have an abortion. He told her the truth: that this can be done and is done and that other women do it, have done it—*for me*. *For me* signifies not from social concern nor for convenience, but *for love*. It was useless to invoke love with Mrs. Chaplin. Her children were born to her only so she might proclaim that "the defendant never showed any normal or paternal interest or affection" [note the nice distinction between the two words] "for the two children of the plaintiff and the defendant," those infants who are doubtless just one more link in his fetters to him, though to the mother the basis of perpetual claims. It is her wish to have a wing added to the house for them. Charlot refuses: "It is my house, and I don't want it spoiled." This eminently reasonable answer, the milk bills, the telephone calls—those made and those that weren't—the husband's comings and goings, the time he fails to see his wife, the times he *does* come to see her when she is entertaining bores, which may displease him if he has friends to dinner, if he takes his wife out, if he leaves her at home—all this, to Mrs. Chaplin, constitutes a cruel and inhuman treatment—but to us it signifies the paramount will of a man to overcome all that is not love, all that is merely its fierce and hideous caricature. Better than any book or treatise, this man's conduct makes a case against marriage, against the insensate codification of love.

We recall that admirable moment in *The Imposter* when suddenly in the middle of a social ceremony, Charlot sees a very beautiful woman go by, she could not be more alluring, and

immediately he abandons his adventure (the role he is playing) to follow her from room to room and out onto the terrace until finally she disappears. At the command of love—he has always been at the command of love, and this is what is consistently demonstrated by his life and by all his films. A sudden and immediate love, before all else the great irresistible summons. At such moments, everything else is to be abandoned, as for instance, at the minimum, the home. The world and its legal fetters, the housewife with her brats backed up by the figure of the'policeman, the savings bank—from these, indeed, the rich man of Los Angeles is forever running away, as is that other poor devil, the Charlot of wretched suburbs in *The Bank Clerk* and *The Gold Rush*. All the moral fortune in his pocket is precisely that one dollar's worth of seduction that is perpetually getting lost, the dollar we see eternally falling onto the tiles through his torn trouser-pocket in the café scene of *The Emigrant*, a dollar perhaps only in appearance, a dollar that can be bent between the teeth, a mere sham that won't be accepted but that enables you for one brief moment to invite to your table a woman like a flash of lightning, the *"wonderful"* one whose face henceforth eclipses the sky for you. In this way Chaplin's art finds in his own life that morality constantly expressed in his work with all the circuitousness imposed by social conditions. And finally, when Mrs. Chaplin informs us—and she knows the most telling kind of argument by which to do so—that the unpatriotic American, her husband, intended to export his capital, let us remember the tragic spectacle of the steerage passengers labeled like cattle on the deck of the ship landing Charlot in America; the brutalities of the law's representatives, the cynical examination of the emigrants, the dirty hands fumbling the women on arrival in the land of Prohibition, under the classic stare of *Liberty Lighting the World*. What the torch of this particular liberty projects through all his films is the threatening shadow of the cops who run down the poor, popping up at every street corner, suspecting everything, beginning with the vagabond's wretched suit, then his perpetually falling cane (which in a curious article Charlot has called his "assurance"), then the hat, the mustache, and so on down to the frightened smile. Let us

make no mistake, despite some happy endings, the very next time we shall find him in misery again, this terrifying pessimist who realizes the full meaning of that expression equally current in English and in French—a dog's life, *une vie de chien.*

A Dog's Life. At this very moment, the life of a man whose genius won't win his case for him; of a man on whom everyone's back will be turned, who will be ruined with impunity, whose whole means of expression will be taken from him, who is being demoralized in the most outrageous fashion for the benefit of a wretched, spiteful little *bourgeoise,* and the sake of the greatest public hypocrisy imaginable. A dog's life. Genius is nothing to the law when matrimony is at stake, the blessed state of holy matrimony. And anyway, as we know, genius is never anything to the law. But this case of Charlot's, above and beyond the public curiosity and all the underhanded business of the lawyers involved in the shameless probings into a private life henceforth forever tarnished by the law's lurid light—this case of Charlot's today signifies his fate, the fate of genius. It is far more significant than any work on the subject, and establishes the true role and the real worth of genius. That mysterious ascendancy that an unequaled power of expression suddenly confers is suddenly understandable: we understand now just exactly what place in the world genius has. Genius seizes on a man and makes him an intelligible symbol and the prey of sinister creatures. Genius serves to point out to the world the moral truth which universal stupidity obscures and endeavors to destroy. Our thanks, then, to the man who, over there on the immense Western screen, beyond the horizon where the suns decline one by one, projects your shadow, O great realities of mankind, perhaps the sole realities, moral truths whose worth is greater than that of the whole universe. The earth sinks beneath your feet. Our thanks to you above and beyond the victim. We offer you our thanks, we are your humble servants.

MAXIME ALEXANDRE	JACQUES-ANDRÉ BOIFFARD
LOUIS ARAGON	ANDRÉ BRETON
ARP	JEAN CARRIVE
JACQUES BARON	ROBERT DESNOS

MARCEL DUHAMEL
PAUL ÉLUARD
MAX ERNST
JEAN GENBACH
CAMILLE GOEMANS
PAUL HOOREMAN
EUGENE JOLAS
MICHEL LEIRIS
GEORGES LIMBOUR
GEORGES MALKINE
ANDRÉ MASSON
MAX MORISE

PIERRE NAVILLE
MARCEL NOLL
PAUL NOUGÉ
ELLIOTT PAUL
BENJAMIN PÉRET
JACQUES PRÉVERT
RAYMOND QUENEAU
MAN RAY
GEORGES SADOUL
YVES TANGUY
ROLAND TUAL
PIERRE UNIK

OBJECTIVE CHANCE:
DIVINATION

NADJA

So as not to have to walk too much, I go out about four, intending to stop in at the "Nouvelle France," where Nadja is supposed to meet me at five-thirty. This gives me time to take a stroll around the boulevards, not far from the Opéra. I have to pick up my pen at a shop where it is being repaired. For a change I decide to take the right sidewalk of the Rue de la Chausée-d'Antin. One of the first people I prepare to meet there is Nadja, looking as she did the first day I saw her. She advances as if she didn't want to see me. She seems quite unable to explain her presence here in this street where, to forestall further questions, she tells me she is looking for Dutch chocolate. Without even thinking about it, we have already turned around and go into the first café we come to . . . When the dessert is served, Nadja begins looking around her. She is certain that an underground tunnel passes under our feet, starting at the Palais de Justice (she shows me which part of the building, slightly to the right of the white flight of steps) and circling the Hôtel Henri IV. She is disturbed by the thought of what has already occurred in this square and will occur here in the future. Where only two or three couples are at this moment fading into the darkness, she seems to see a crowd. "And the dead, the dead!" The drunkard lugubriously continues cracking jokes. Nadja's eyes now sweep over the surrounding houses. "Do you see that window up there? It's black, like all the rest. Look hard. In a minute it will light up. It will be red." The minute passes. The window

272

lights up. There are, as a matter of fact, red curtains. (I am sorry, but I am unable to do anything about the fact that this may exceed the limits of credibility. Nevertheless, in dealing with such a subject, I should never forgive myself for taking sides: I confine myself to *granting* that this window, being black, has now become red, and that is all.) I confess that this place frightens me, as it is beginning to frighten Nadja too. "How terrible! Can you see what's going on in the trees? The blue and the wind, the blue wind. I've seen that blue wind pass through these same trees only once before. It was there, from a window in the Hôtel Henri IV, and my friend, the second man I told you about, was going to leave. And there was a voice saying: 'You're going to die, you're going to die.' I didn't want to die but I felt so dizzy . . . I'd certainly have fallen if he hadn't held me back." I decide it is high time we leave. As we walk along the quais, I feel that Nadja is trembling all over. She is the one who wanted to walk back toward the Conciergerie. She is very abandoned in her behavior, very sure of me. But she is looking for something, she insists that we walk into a courtyard, a courtyard of some police station, which she rapidly explores. "It's not here . . . Listen, tell me why you have to go to prison? What is it you're going to do? I've been to prison too. Who was I? It was ages ago. And you, then, who were you?" Now we are walking along the iron railing again, when suddenly Nadja refuses to go any farther. Here on the right is a low window that overlooks the moat, and she cannot take her eyes off it. It is in front of this forlorn-looking window that we must wait, she knows that much. It is from here that everything can come. It is here that everything begins. She holds onto the railing with both hands so that I will not pull her away. She virtually stops answering my questions. For the sake of peace I wait until she is ready to continue of her own free will. She has not forgotten about the underground tunnel and probably imagines she is at one of its exits. She wonders who she might have been, in Marie-Antoinette's circle. The footsteps of passers-by make her shudder for a long time. I am concerned, and lifting her hands from the fence one after the other, I manage to make her follow me . . .

ANDRÉ BRETON

1929

NOTES ON POETRY

A POEM must be a debacle of the intellect. It cannot be anything but.

Debacle: a panic stampede, but a solemn, coherent one; the image of what one should be, of the state in which efforts no longer count.

> In the poet:
> the ear laughs,
> the mouth swears;
> It is intelligence, alertness that kills;
> It is sleep that dreams and sees clearly;
> It is the image and the hallucination that close their eyes:
> It is lack and the lacuna that are *created*.

Poetry is the opposite of literature. It rules over idols of every kind and over realistic illusions; it happily sustains the ambiguity between the language of "truth" and the language of "creation."

Poetry is a pipe.

Lyricism is the development of a protest.

How proud a thing it is to write, without knowing what language, words, comparisons, changes of ideas, of tone are; neither to conceive the *structure* of the work's duration, nor the conditions of its ends; no *why*, no *how!* To turn green, blue, white from being the parrot . . .

We are always, even in prose, led and willing to write what we have not sought and what perhaps does not even seek what we sought.

Perfection
is *laziness*.

ANDRÉ BRETON AND PAUL ÉLUARD

Notes sur la poésie (La Révolution surréaliste, No. 12, December 15, 1929)

A CORPSE

DEATH OF A GENTLEMAN

Alas, I shall never see again the illustrious Paladin of the Western World, the one who made me laugh!

When he was alive, he wrote to shorten his time, he said, to find men, and when he happened to find them, he was mortally afraid, and pretending an overpowering affection, lay in wait for the moment when he could cover them with filth.

One day he thought he saw a Ghost Ship passing in a dream and felt the gold braid of Captain Bordure growing on his head. He looked at himself seriously in the mirror and discovered he was handsome.

That was the end, his heart began to stammer and mixed everything up, despair and liver trouble, the Bible and Maldoror, God and God, ink and sperm, the barricades and Mme. Sabatier's divan, the Marquis de Sade and Jean Lorrain, the Russian Revolution and the Surrealist revolution.[1]

A lyrical pawn, he handed out diplomas to the great lovers, indulgences to the debutants of hope, and lamented over the great pity of the poets of France.

"Is it true," he wrote, "that the Nations seek the blood of their great men as soon as they can get it?"

An excellent musician, he played on the lycée harp for some time under the windows of the communist party, received bricks on his head, and went away disappointed, embittered, to sing in love's night-school.

He could not play without cheating, and cheated quite badly, moreover, and kept billiard balls hidden in his sleeves; when

[1] *Still . . . and forever the most scandalous of the world.*

they fell to the ground with a disagreeable sound in front of his embarrassed disciples, he said that was humor.

He was a great man of honor, sometimes put on his judge's cap over his military one and preached Morality or art criticism, but found it diffⁱcult to conceal the scars left on him by the phynancial fangs of modern painting.

One day he cried out against the priests, the next he took himself for a bishop or the Pope in Avignon, bought a ticket to see for himself and came back a few days later more revolutionary than ever and soon wept huge tears of rage on May first because he hadn't been able to find a taxi to take him across the Place Blanche.

He was also very sensitive: over a line in the newspaper, he kept to his room for eight days, and spat, spat everywhere—on the ground, on his friends, on his friends' wives. And his friends often permitted this, being too much in love to protest. He also spat on Poe and on Dufayel. He was not very sure of himself, he spat on the dinner that was not ready on time, he flew into dreadful rages at the sight of a sardine can, he was lugubriously droll, painful to see but always very dignified.

Sometimes stupidity masked his face. He suspected as much, for he was cunning and then took refuge behind capitalized Love, Revolution, Poetry, Purity. His choirboy Jean Genbach, his de-frocked creature in whom he had put all his conceit, rang the little bell and bobbed his head up and down, but some looked up and saw behind the tabernacle Breton-Fregoli adjusting his occult-Christ's beard.

That was a good one!

Alas, the director of the Palace of Mirages, the ticket-taker, the Gross Inquisitor, the Coil of the dream has ceased to exist, let's not mention him again.

JACQUES PRÉVERT

1930

ANDRÉ BRETON:
SECOND SURREALIST
MANIFESTO

BEFORE

Preoccupied with morality, that is, with the meaning of life, and not with the observance of human laws, André Breton, by his love of an exact life and of adventure, restores its true meaning to the ˌword "religion."

ROBERT DESNOS / *Intentions*

Dear friend, my admiration for you does not depend on a perpetual upheaval of your virtues and your errors.

GEORGES RIBEMONT-DESSAIGNES / *Variétes*

My dear Breton, I may never return to France. Tonight I

AFTER

And the last vanity of this ghost will be to stink eternally among the stinks of the paradise consigned to the imminent and certain conversion of the confidence-man André Breton.

ROBERT DESNOS / *Un cadavre*, 1930

The *Second Surrealist Manifesto* is not a revelation, but it is a success. One cannot do better in the hypocrite, false-brother, mealy-mouthed, sacristan and, in a word, cop-and-curé genre.

GEORGES RIBEMONT-DESSAIGNES / *Un cadavre*, 1930

have insulted all that can be insulted. I am exhausted. Blood is running out of my eyes, nostrils, and mouth. Do not abandon me. Defend me.

GEORGES LIMBOUR / *July 21, 1924*

*Arriving Paris—thanks. Limbour
July 23, 1924*

. . . I know exactly what I owe you and I also know what ideas you have taught me during our conversations which have allowed me to arrive at certain discoveries. We are following parallel paths. I want you to believe me when I say that my friendship for you is no laughing matter.

JACQUES BARON / *1929*

I am one of André Breton's friends by reason of the confidence he shows me. But this is not a confidence. No one has that. It is a grace. I wish it for you. It is grace that I wish you.

ROGER VITRAC
/ *Le Journal du Peuple*

It would give me pleasure to see you with a nosebleed.

GEORGES LIMBOUR
/ *December 1929*

This was the righteous Breton, the fierce revolutionary, the severe moralist. O yes, a nasty customer!

Barnyard aesthete, this cold-blooded creature has never contributed anything except the blackest confusion to whatever he's stuck his nose in.

JACQUES BARON
/ *Un cadavre, 1930*

As for his ideas, I don't think anyone has ever taken them seriously, except for a few conceited critics he flattered, a few retarded schoolboys and some women laboring to give birth to monsters.

ROGER VITRAC
/ *Un cadavre, 1930*

The first version of this manifesto was published in number 12 of *La Révolution surréaliste*, December 15, 1929.

1930

THE SURREALIST
CONCEPTION OF
"SEXUAL FREEDOM"

L A S T M A Y, on the train between Cambronne and Glacière, a man of about thirty, sitting opposite a very pretty girl, skill-fully separated a magazine he was pretending to read, in such a way that the girl was presented with the sight of his penis, erect, complete and magnificent. Some fool's discovery of this exhibition-ist act, an act which had plunged the girl into a tremendous and delicious confusion, but without the slightest protest, was enough to cause the exhibitionist to be apprehended and expelled by the other passengers. We can only express our vehement indignation and our contempt for such abominable behavior against one of the purest and most disinterested acts a man is capable of performing in our age of corruption and moral degradation.

SALVADOR DALI
(*Le Surréalisme au Service de la Révolution*, No. 2)

MADNESS:
AN ATTEMPT TO SIMULATE
GENERAL PARALYSIS

M Y GREAT BIG adorable girl, beautiful as everything upon earth and in the most beautiful stars of the earth I adore, my great big girl adored by all the powers of the stars, lovely with the beauty of the billions of queens that adorn the earth, my adoration for your beauty brings me to my knees to beg you to think of me, I throw myself at your knees, I adore your beauty, think of me, my adorable beauty, my great beauty whom I adore, I roll diamonds in the moss higher than the forests your highest hair thinks of me—don't forget me, my little girl, on my knees now, beside the fire, on the emerald sand—look at yourself in my hand which serves me as a mirror of everything in the world for you to recognize me for what I am, my blonde-brunette, my beauty and my beast, think of me in paradise, my head in my hands.

I didn't have enough of the hundred and fifty *châteaux* where we went to make love, tomorrow I will have a hundred thousand others constructed, I have hunted peacocks, panthers, and lyre-birds in the baobab forests of your eyes, I will imprison them in my strongholds and we shall walk together in the forests of Asia, of Europe, of America which surround our *châteaux* in the admirable forests of your eyes which are accustomed to my splendor.

You have only to await the surprise I want to give you for your birthday which happens to be today, the same day as mine—I am giving it to you right away because fifteen times over I've waited for the year one thousand before giving you the surprise of

asking you to think of me, of hide-and-seek—I want you to think of me, my eternal girl, laughing. I have counted, before going to sleep, clouds and clouds of tanks full of beets for the sun, and I want to take you at night to the astrakhan beach that they are building with two horizons for your wartime petroleum eyes, I'll take you there down roads of diamonds paved with primroses, emeralds, and the ermine cloak I want to dress you in is a bird of prey, the diamonds that your feet will trample I have had cut in the shape of butterflies. Think of me, thinking only of your luster, in which slumbers the sun-drenched luxury of an earth and of all the stars I have conquered for you, I adore you and I adore your eyes and I have opened your eyes, open to all those they have seen and I shall give to all the beings your eyes have seen clothes of gold and crystal, clothes they must fling down when your eyes will have tarnished them with their scorn. I am bleeding in my heart from the mere initials of your name which are all the letters and of which Z is the first in the infinite of alphabets and civilizations in which I shall still love you since you want to be my wife and think of me in the countries where there is no longer any average. My heart bleeds upon your mouth and closes over your mouth, over all the pink chestnut trees of the avenue of your mouth where we are going, in the brilliant dust, to lie down among the meteors of your beauty which I adore, my great big lovely creature, so lovely that I am happy to deck my treasures in your presence, your thought and your name which multiplies the facets of the ecstasy of my treasures, of your name I adore because it finds an echo in all the mirrors of beauty of my splendor, my original wife, my rosewood scaffolding, you are my sin of my sin of my great sin as Jesus Christ is the wife of my cross—twelve times twelve thousand one hundred and forty-nine times I have loved you with passion on the way and I am crucified in the north, the east, the west, and the north for your radium kiss, and I want you and you are in my mirror of pearls the breath of the man who will not bring you back up to the surface and who loves you in adoration my wife lying down standing when you are sitting and combing your hair.

You will come, you are thinking of me, you will come, you will run to me on your thirteen full legs and on all your empty

legs which beat the air with the swaying of your arms, a multitude of arms that will seek to entwine themselves around me kneeling between your legs and your arms to embrace you without fear that my locomotives will keep you from coming to me, and I am yours and I am before you to stop you, to give you all the stars of the sky in a kiss on your eyes all the world's kisses in a star on your mouth. Yours in a torch.

P.S. I'd like a directory for the mass, a directory with a knotted cord to mark the pages. You can also bring me a Franco-German flag that I will set up in the empty lot. And a pound of Menier chocolate with the little girl who pastes up the posters (I don't remember any more). And then also nine of those little girls with their lawyers and their judges, and you are coming in the express train with the speed of light and the Wild West outlaws who will distract me a moment which explodes here unfortunately like champagne corks. And a skate. My left garter has just broken, I was lifting the world like a feather. Can you do me a favor? Buy a tank, I want to see you coming like the fairies.

ANDRÉ BRETON AND PAUL ÉLUARD
L'Immaculée Conception (1930)

FREE UNION

MY WIFE with her wood-fire hair
 With her thoughts of heatsparks
With her hour-glass figure
My wife with her figure of an otter between the tiger's teeth
My wife with her cockade mouth, her mouth a bouquet of final
 stars.
With her teeth white mousetracks on the white earth
With her tongue of cloudy amber and ground glass.
My wife with her tongue of a pierced host
The tongue of a doll that opens and closes its eyes
The tongue of incredible stone
My wife with lashes a child's writing stick
With eyebrows the edge of a swallow's nest
My wife with temples the slate of a hothouse roof
The panes misted
My wife with champagne shoulders
Shoulders of a dolphin-headed fountain under the ice
My wife with matchstick wrists
My wife with fingers of chance, ace-of-hearts fingers
With fingers of mown hay
My wife with armpits of marten and beechnut
Of Saint-John's Eve
Of privet and scalare's nest
With seafoam arms, arms of the mill-race
And a mixture of wheat and the mill
My wife with rocket legs
With movements of clockwork and despair
My wife with calves of elder marrow

My wife with initial feet
With feet of bunches of keys with feet of drinking caulkers
My wife with a neck of pearled barley
My wife with her *Val d'or* throat
Of the rendezvous in the very bed of the stream
With night breasts
My wife with breasts of a deepsea molehill
My wife with breasts of a ruby crucible.
With the breasts of the spirit of the rose under the dew
My wife with the belly a day's fan unfolding
The belly of a giant claw
My wife with a bird's back escaping upward
With a quicksilver back
A back of light
With a neck of crushed stone and wet chalk
And the fall of a glass from which one has just drunk
My wife with coracle hips
With hips of luster and arrow feathers
And stems of white peacock feathers
Of imperceptible swaying
My wife with buttocks of soapstone and amianthus
My wife with swansback buttocks
My wife with springtime buttocks
With gladiolus sex
My wife with the sex of placer and duckbill
My wife with the sex of algae and old dancy
My wife with a mirror sex
My wife with tear-filled eyes
With eyes of violet panoply and magnetic needle
My wife with savanna eyes
My wife with watery eyes to drink in prison
My wife with wooden eyes always under the axe
With eyes of water level air level earth and fire level

ANDRÉ BRETON (1931)

RED FRONT

S OMETHING NICE for my dog
A drop of champagne Certainly Madame
We are at Maxim's the year nineteen
Thirty
Mats are put under the bottles
So their aristocratic bottoms
do not come in contact with life's difficulties
carpets to conceal the floor
carpets to extinguish
the sound of the waiters' soles
Drinks are consumed through straws
drawn out of a little safety envelope
Delicacy
There are cigarette-holders between the cigarette and the man
silencers on the cars
service stairs for those
carrying packages
and tissue paper around the packages
and paper around the tissue paper
as much paper as you want it costs
nothing neither the tissue paper nor the straws
nor the champagne or next to nothing
neither the publicity ashtray nor the publicity
blotter nor the publicity
calendar nor the publicity
lights nor the publicity
pictures on the walls nor the publicity
furs on Madame the publicity

toothpicks the publicity
fan and the wind nothing costs anything
nothing the living servants hand you leaflets in the street
Take one it's free
the leaflet and the hand handing it to you
Don't close the door
the man will take care of it Kindness
Even to the stairs that can go up by themselves
in the big stores
The days are felt-lined
men of fog Padded world
without shock
You aren't crazy Some beans My dog
hasn't been sick yet

O traveling clocks traveling clocks
have you made the lovers dream enough on the boulevards
and the Louis XVI bed on a year's credit
In the cemeteries the people of this well-oiled nation
lie with the propriety of marble
their little houses look
like mantelpiece ornaments

How much do chrysanthemums cost this year
Flowers for the dead flowers for the great artists
Money is also spent on the ideal
And besides charity makes black dresses trail
down the stairs that's all I'm telling you
The princess is really too kind
For all the gratitude it brings you
You're lucky if they thank you
It's the example of the Bolsheviks
Poor Russia
The USSR
The USSR or as they say the SSSR
SS what's that SS
SSRSSRSSSR o darling please

Well think SSSR
SSSR SSSR SSSR

When the men came down from the suburbs
and in the Place de la République
the black flood coagulated like a closing fist
the shops wore their shutters over their eyes
to keep from seeing the flash go by
I remember the first of May nineteen seven
when the terror ruled in the gilded salons
The children were forbidden to go to school
in that western suburb where the distant echo
of wrath only came dimly
I remember the Ferrer demonstration
when the ink flower of infamy
exploded against the Spanish embassy
Paris it wasn't so long ago
that you saw the procession given Jaurès
and the Sacco-Vanzetti torrent
Paris your intersections still twitch their nostrils
Your stones are still ready to leap into the air
Your trees to bar the roads to soldiers
Turn great body summoned
Belleville
Hey Belleville and you Saint-Denis
where the kings are captives of the reds
Ivry Javel and Malakoff
Call them all with their tools
the galloping children bringing the news
the women with the heavy buns of hair the men
coming out of their work as though out of a nightmare
feet still unsteady but eyes clear
There are always armorers in the city
cars at the doors of the bourgeois
Bend the lampposts like wisps of straw
Send the kiosks dancing, the benches, the fountains
Kill the cops
comrades

Kill the cops
Farther, farther west where the rich
children are sleeping and the first-class whores
past the Madeleine Proletariat
your fury sweeps the Elysée
You have every right to the Bois de Boulogne during the week
Someday you'll blow up the Arc de Triomphe
Proletariat learn your strength
Learn your strength and release it
It is preparing its hour Learn how to see better
Listen to that murmur from the prisons
It is waiting for its hour it is waiting for its hour
its minute its second
when the blow delivered will be mortal
and the bullet so sure that all the social-fascist doctors
leaning over the victim's body
will extend their searching fingers under the lace nightshirt
auscultating with precision instruments the already rotting heart
they will not find the usual remedy
and will fall into the hands of the rioters who will paste them
 against the wall
Fire on Léon Blum
Fire on Boncour Frossard Déat
Fire on the trained bears of social democracy
Fire Fire I hear death
passing as it flings itself on Garchery Fire I tell you
Under the leadership of the Communist Party
the SFIC
You are waiting finger on the trigger
Fire
but Lenin
the Lenin of the right moment
from Clairvaux rises a voice nothing can stop
It is the spoken newspaper
the song of the wall
the revolutionary truth on the march
Hail Marty the glorious rebel of the Black Sea
He will be delivered yet that uselessly imprisoned symbol

Yen-Bay
What is that syllable which reminds us that you do not gag
a people that you do not subjugate them
with the executioner's scimitar
Yen-Bay
To you yellow brothers this promise
For each drop of your life
The blood of a Varenne will flow

Listen to the screams of the Syrians killed by aerial darts
by the Third Republic aviators
Listen to the shouts of the Moroccans dead
without mention being made of their age or their sex

Those who are waiting teeth clenched
to achieve their vengeance at last
whistle a tune that says a lot
a tune a tune US
SR a tune happy as steel SS
SR a burning tune it is hope the tune SSSR
the song the song of October with its
brilliant fruit
Whistle whistle SSSR SSSR patience
will have only one temp SSSR SSSR SSSR
In the crumbling plasterwork
among the faded flowers of old decorations
the last doilies and the last whatnots
emphasize the strange life of bibelots
The worm of the bourgeoisie
vainly tries to unite its divided segments
Here convulsively agonizes a class
the family memories fall into fragments
Set your heel on these awakening vipers
Shake these houses so that the coffee spoons
Fall with the bedbugs the dust the old men
How sweet it is how sweet it is that groaning that rises from the
 ruins.

I am here at the elimination of a useless world
Here with intoxication at the destruction of the bourgeois
Has there ever been a finer hunt than the pursuit
of this vermin huddling in every corner of the cities
I sing the violent domination of the Proletariat over the bour-
 geoisie
for the annihilation of this bourgeoisie
for the total annihilation of this bourgeoisie

The finest monument that could be raised over a square
the most surprising of all statues
the boldest and loveliest column
the arch that is comparable to the prism of the rain itself
is not worth the splendid and chaotic heap
Try and see
what can easily be done with a church and a little dynamite

The pick makes a hole in the ancient docilities
the falling masonry is a song in which the sun turns
The old men and walls fall, stricken by the same thunderbolt

The explosion of fusillades adds to the landscape
a new gaiety
They are executing engineers doctors
Death to those who endanger the October conquests
Death to the saboteurs of the Five-Year Plan

Your turn Communist Youth
Sweep away the human debris where there linger still
the incantatory spider of the sign of the cross
Volunteers of socialist construction
Drive before you the past like a dangerous dog
Rise up against your mothers
Abandon night pestilence and family
You hold in your hands a laughing child
a child such as has never been seen before
He knows before speaking all the songs of the new life
He will run away from you already he is laughing

the stars descend familiarly on earth
and the least they burn as they land
is the black carrion of the selfish
The stone and cement flowers
the long creepers of iron the blue ribbons of steel
have never dreamed of such a spring
the hills are covered with giant primroses
these are the cradles of the kitchens for twenty thousand diners
houses houses clubs
like sunflowers like four-leaved clovers
the roads form knots like ties
Dawn mounts over the bathrooms
Socialist May is announced by a thousand swallows
In the fields a great battle is joined
the battle of the ants and the wolves
One cannot help oneself how we need machine-guns
against routine and stubbornness
but already 80% of this year's bread
comes from the Marxist wheat of the Kolkhozes . . .
The poppies have become red flags
and new monsters munch the ears of wheat
Unemployment is no longer known here
The sound of the hammer the sound of the sickle
rise from the land is it
the sickle is it
the hammer the air is full of crickets
corn-crakes and caresses
USSR
Shots Whiplashes Shouts
Heroic youth
Steelworks cereals SSSR SSSR
The blue eyes of the Revolution
gleam with a necessary cruelty
SSSR SSSR SSSR
SSSR
For those who claim this is not a poem
for those who regret the lilies or Palmolive Soap
turn their cloudy heads from me

for the Stop you're kidding
for the disgusted the sneerers
for those who will not fail to discover
the sordid intentions of the author the author
Will add these few simple words

The intervention was to begin by the action of Rumania on the pretext, for example, of a frontier incident, involving the official declaration of war by Poland and the unification of the neighbor ing States. This intervention would be joined by Wrangel's troops, which would have crossed Rumania . . . Upon their return from the energetic conference in London, arriving in the USSR by way of Paris, Ramzine, and Leritchev have organized the liaison with the Torgprom by means of Riabouchinski who was main-taining relations with the French government in the person of Loucheur . . . In the organization of the intervention the leading role belongs to France, which has conducted its preparation with the active aid of the British Government

The dogs the dogs the dogs are conspiring
and just as the pale treponema escapes the microscope
Poincaré flatters himself he is a filtering virus
The race of dancers of daggers of tsarist pimps
the mannequin grand dukes of the new casinos
The informers at 25 francs a letter
the great dry-rot of the emigration
slowly crystallizes in the French bidet
The Polish snot and the Rumanian drool
the vomit of the whole world
gathers on all the horizons of the country where socialism is
 being constructed
and the tadpoles rejoice
seeing themselves toads already
decorated
deputies who knows ministers
Dirty water suspend your foam

Dirty water you are not the Deluge
Dirty water you will fall back into the western mire
Dirty water you will not cover the plains where the wheat of
 the future grows
Dirty water Dirty water you will not dissolve the future's sorrel
You will not soil the staircase of collectivization
You will die on the burning threshold of dialectics
of dialectics with its hundred towers bearing scarlet flames
a hundred thousand towers spitting fire from thousands of cannons
The universe must hear
a voice shouting the glory of materialist dialectics
marching on its feet on its thousands of feet
shod in military boots
on its feet magnificent as violence
holding out its host of arms bearing weapons
to the image of victorious Communism
Glory to materialist dialectics
and glory to its incarnation
The Red
Army
Glory to
The Red
Army
A star is born of earth
A star today leads toward a burning pyre
Boudenny's soldiers
Forward march Boudenny's soldiers
You are the armed conscience of the Proletariat
You know bearing death
toward what admirable life you are marching
Each of your bodies is a falling diamond
Each of your worms a purifying fire
The flash of your rifles sends back the ordure
France first of all
Spare nothing Boudenny's soldiers
Each of your cries bears on the glowing Breath
of the Universal Revolution

Each time you breathe you propagate
Marx and Lenin in the sky
You are red like the dawn
red like anger
red like blood
You avenge Babeuf and Liebknecht
Proletarians of the world unite
Voices Call them Prepare the
way for these liberators who will join with yours
their Proletarian weapons of every country
Here is the catastrophe tamed
Here at least is the leaping panther docile
History led on a leash by the Third International
the red train starts up and nothing will stop it
US
SR
US
SR
US
SR
No one remains behind
waving handkerchiefs Everyone is marching
US
SR
US
SR
Oppositional Unconscious
There is no brake on the machine
Choked shout but the wind sings
US
SR SS
SR US
SR SSSR
The dregs of the earth standing
SS
RR
SS
The past dies the moment crushes

SSSR SSSR
the wheels leap forward the rails grow hot SSSR
The train roars toward tomorrow
SSSR still faster SSSR
In four years the Five-Year Plan
SSSR down with man's exploitation of man
SSSR down with the old servitude down with capital
down with imperialism
SSSR SSSR SSSR

What swells like a shout in the mountains
When the stricken eagle suddenly loosens its talons
SSSR SSSR SSSR
The song of man and his laughter
The train of the red star
burning the stations the signals the tunes
SSSR October October the express
October through the Universe SS
SR SSSR SSSR
SSSR SSSR

<div align="right">ARAGON</div>

THE POVERTY OF
POETRY: THE ARAGON
AFFAIR BEFORE
PUBLIC OPINION

... The special feature of the problem raised by the inculpation of "Red Front" is that, as I see it, the problem offers two faces: a *social* face and a *poetic* face, which from the surrealist viewpoint are equally deserving of consideration.

If bourgeois "justice," in the profascist period we are now traversing, becomes daily more savage and expeditive, if in France it appears hard pressed enough for the poets in their turn to seem worthy of its attack, this cannot be a reason for us to abandon all critical spirit to the point of mistaking the profound meaning of the poetic act, to the point of permitting poetry and art to get stuck in a rut.

I do not expect to be followed in these considerations, and I am the first to deplore that on the occasion of a socially rather eloquent act: the arraignment of Aragon, I have not been spared the purely technical considerations which follow. But it is inadmissible that surrealism, at grips with the most serious accusations with regard to its tendency, should appear suddenly without arms. We have said that the "poem" was such that with regard to its interpretation the consideration of its literal meaning was not sufficient to exhaust it, we have maintained that it could not be identified before the law with any kind of text corresponding to the desire for *exact* expression, in other words an expression of thought *measured* and *weighed*. First of all, I might remind anyone who suggests that this constitutes a new attitude on our part, all too obviously dictated by events, that eight years ago, in the

Manifeste du Surréalisme, I insisted, in the name of the poetic conception my friends and I maintained, on disengaging the author's responsibility entirely in cases when certain texts of incontestable "automatic" character were incriminated. I then was careful to emphasize the extreme fragility of the accusation, for example, of provocation to murder under which, perhaps, one of these texts might have fallen. Certainly, I affirmed, the man owed no more accounting for this to justice than for his dreams. Hence it is an instance of bad faith to declare that surrealism is here caught in a flagrant contradiction. Of course I am not claiming that the poem "Red Front" corresponds to the definition of an "automatic" text (I shall even try to show later on how it differs from such a text), but on the other hand, I believe that the poetic position which is determined today for Aragon by the twelve or fifteen books he has written can in no way be sacrificed to the agitation which some find opportune to provoke around one of his poems which they by exception turn into a model of conscious thought. I say that this poem, by its situation in Aragon's work, on the one hand, and in the history of poetry on the other, corresponds to a certain number of formal determinations which do not permit the isolation of any one group of words ("Comrades, kill the cops") in order to exploit its literal meaning, whereas for some other group ("the stars descend familiarly on earth") the question of this literal meaning does not come up. Who would dare claim that in prose, in the course of an article, Aragon would have permitted himself to write, "Comrades, kill the cops," whereas such an injunction, without real bearing moreover, is contrary to the very watchwords of the Communist Party? Hence it is a question, in the mind of French justice, of identifying today the common language with a particular language which offers no relation of common measure with the former. As poets, it is up to the surrealists to show the new iniquity which this enterprise constitutes, the noticeable progress it marks, in 1932, in the deliberate application of *villainous laws.*

To my mind, it is to play on words to advance that the poem "exceeds" in meaning and in significance its immediate content. It escapes, by its nature, the very reality of that content. The poem is not to be judged on the successive representations it

makes, but on its power to incarnate an idea, to which these representations, freed of any need for rational connection, serve only as a starting point. The meaning and significance of the poem are *different* from the sum of all that the analysis of the specific elements it involves permit to be discovered in it, and these specific elements cannot, to any degree, determine its value or process in and of themselves. If this were not the case, poetic language would have long since been abolished in the prosaic, and its survival until now is the best guarantee of its necessity. "If," Hegel declares, "prose has penetrated with its particular mode of conception into all the objects of human intelligence and has everywhere left its imprint, poetry must undertake to recast all these elements and to imprint them with its original seal. And since it must also vanquish the scorn of the prosaic spirit, it finds itself surrounded on all sides by many difficulties. It must wrench itself from the habits of ordinary thought, which prefers the in-different and the accidental, must in all relations transform the mode of expression of prosaic thought into a poetic expression, and despite all the reflection necessarily demanded by such a struggle, must preserve the perfect appearance of inspiration and the free-dom which art requires."

I think that such an opinion, which has nothing specifically idealist about it, has no need to be revised. It is just to regard poetry and prose as two distinct spheres of thought, just to assert that the reprisals usually employed against poetry con-stitute, on the part of the bourgeois powers, an intrusion still more intolerable than the others (a matter of judging rationally matters irrational by definition); an incomparably more arbitrary and profound offense to the freedom of thought (in a realm where the way of thinking is inseparable from the way of feeling). To refuse to acknowledge this is not to evidence a moral purity or a revolutionary severity, but merely to manifest toward poetry the disdain of the prosaic spirit of which Hegel speaks, merely to class oneself among the scorners of poetry or, more generally, among the philistines. . . .

. . . Too rare have been, during the war, the public acts which bear witness to such an independence of mind and of the nonab-dication of every kind of courage or even *sang-froid* for me to

refuse, on the other hand, to take into consideration the opinions of Jules Romains and of Romain Rolland. I do not believe, however, that the periodical *Europe,* for reasons which derive purely from Romain's poetic technique (which in itself is as valid as one could wish but which greatly limits the extent of his public), can ever have seriously alarmed the government, and the fact is that the censor let it pass. The case of "Red Front" is not, thereby, comparable. I should further object to Romains, who must know it as well as I, that the virtue of the poem, if not alien at least transcendent to the choice of its words, cannot be, even with the poet's co-operation, the object of any discussion with a *judge.* I shall confess to him, lastly, that I am distressed to find him today so exaggeratedly ambitious for another, though he showed no reluctance, during the performances at the Théâtre Pigalle, to changing to *Donogoo* the initial title of his play *Donogoo Tonka* in order to spare the feelings of Monsieur Tardieu.

Romain Rolland's error seems to me to be essentially of another order. To return to his letter, there is a radical underestimation of the very viewpoint of poetic freedom, the condition of any poetry's existence, that is, of the viewpoint which, temporarily setting aside any other, we believe it is our *professional* obligation to maintain. Romain Rolland will not object to my proposition that a revolutionary poem falls under two kinds of considerations: revolutionary on the one hand, poetic on the other, and that to exhaust its substance and also its instructional value, there is reason to examine it from both these angles. The social drama exists, the surrealists have announced on many occasions that they would not be content to remain spectators of this drama. The poetic drama also exists, and like the other, it has had, if only in the last century, its heroes who, in this country, are named Borel, Nerval, Baudelaire, Rimbaud, Cros, Lautréamont, Jarry. As surrealists, it is not in our power to efface these names, to deny or even permit the interception of the light which we have received from them. And who knows if their voice will not be heard better and more widely the day when there are no longer any classes, when the World Revolution will have come to pass? These determinations define us under two rather distinct relations, as I believe I can in all confidence explain to Romain Rolland. Better than

anything else, this might enlighten him as to what may be the sentiment of *honor* among the surrealists. But I must still discuss with him the means of defence which he advocates in his letter, or which he would have advocated if, according to him, we were not already so drastically beside the point. Romain Rolland chooses to assert that the arraignment for provocation to murder must not be maintained for the excellent reason that Maurras remained unpunished after the murder of Jaurès, which he had indisputably provoked. The striking disadvantage of such a method of struggle is that not only does it identify a poetic text with various texts of crapulous journalism, but it also suggests ("And here we have the indubitable link between the text and the act.") that a phrase such as "Fire on the trained bears of social democracy" could involve a real likelihood of execution, which is absurd. It may be a question, at best, of judging a *provocation* on its effect or lack of effect, which, moreover, does not seem to me a criterion (everything depending on the moment at which one judges); it cannot be a question, on the mere opinion of a judge, and this for whatever ends, of agreeing to see a provocation where there is not, where there *cannot be* a provocation.

The fact is that "Red Front" has been brought, by events quite external to poetry, to the foreground of poetic actuality and has benefited by a curiosity on which no other poem for some time has been able to pride itself, that is, in relation to what surrounds it in its own sphere and no longer in its accidental extensions. Does "Red Front" mark a distinct change of orientation in the course we believe we may assign to poetry in our time, is this course to be disturbed, modified by the poem? Supposing, as a matter of fact, that its formula were new, exploitable, sufficiently general and containing in itself, objectively, the greatest number of previous poetic possibilities and impulses, such a poem would go far in making us realize the imminent point of resolution of the conflict which sets in conflict man's thought and his lyrical expression, a conflict which impassions to the highest degree the poetic drama to which I previously referred. It would invite us to break without delay with the indirect language which, in poetry, to this day, has been our own; it would establish for us a program of

immediate agitation which, in verse as in prose, we could not, without cowardice, evade.

My friends and I should be only too happy to accept this augury if certain historical considerations did not oblige us to abandon such high hopes very quickly. I shall recall here, only for the sake of memory, how Hegel, in his *Aesthetik,* was led to characterize the various cycles art has passed through: symbolic, classic, romantic. This last manner of being, Hegel observes, has as its consequence the absolute negation of all that is finite and particular. It is the simple unity which, concentrated within itself, destroys every external relation, cancels out the movement which involves all the beings of nature in their successive phases of birth, growth, death, and renewal; in a word, repulses all that imposes limits on this spirit. All the particular divinities dissolve in this infinite unity. In this pantheon, all the Gods are dethroned. The flame of *subjectivity* has devoured them.[1] When Hegel indicates, further, the two great reefs on which such an art cannot help but founder, that is, *the servile imitation of nature in its accidental forms,* the very consequence for man of his profound disaffection, and *humor,* the consequence of the personality's need to achieve its highest degree of independence, when he finally gives, as the only place of resolution possible for these two tendencies, what he calls *objective humor,* one cannot, considering the various artistic movements which have followed each other since his death (naturalism, impressionism, symbolism, cubism, futurism, Dadaism, surrealism), contest the tremendous prophetic value[2] of

[1] A correction is necessary here with regard to Hegel's idealist error of conceiving of real things only as the degree of realization of the absolute idea. One might say that in art as elsewhere, this conception has given way to one according to which "the ideal" is nothing but the material, transposed and translated in the minds of men. But this cannot contradict the dialectical movement assigned to art by Hegel.

[2] I regret being unable to insist further here on the very remarkable oscillation between these two poles: (1) imitation of the accidental external aspect; (2) humor, which characterizes all artistic action for over a century. On the one hand the imitation of the most deliberately "earthy" aspects of life (naturalism), the most fugitive aspects of nature (impressionism), of the object considered as volume and substance (cubism), of the object in movement (futurism); on the other, humor, particularly striking in disturbed periods and testifying in the artist to the imperious need to dominate the accidental when the latter tends to prevail objec-

his assertion. The truth is that romantic art in its broadest sense as Hegel understood it is far from having reached the end of its days and that, the general forms of art's development not permitting a given individual any appreciable licence, we are probably, in art, whether we choose to be or not, in the phase of objective humor. To what degree is this situation compatible with what the Revolution demands of us?

We know that the directives given to the writers and artists by the International Conference of Proletarian and Revolutionary Writers, held in November 1930 in Kharkov, was not at all inspired by such considerations, which does not mean that from the Marxist viewpoint the latter are idle: it would be difficult to see how history and the philosophy of art could be suddenly considered as two dead branches of the tree of knowledge which historical materialism has brought to new leaf in every part. I am certain that preoccupations of a very different order of actuality were the sole deciding factors in this case, and I do not hesitate to acknowledge that such preoccupations were the only ones justifiable at such a time, in such a place. Each man must, as I see it, continue to participate in this struggle in the direction of his individual and particular qualification. If he is a revolutionary, he must do so and he must, further, aid the revolutionary action with all his other means. This is the very condition of his equilibrium. Without the right to pursue his investigations in the domain which is his own, sooner or later this man will be lost to himself and to the revolution. It is extremely important not to let the break be consummated, imminent as it may be, between the professional revolutionaries and the other categories of revolutionary intellectuals. It is important not to let what Lenin called "the treasure of knowledge amassed by humanity" be corrupted in the latter's hands merely because they are its temporary depositories. Indeed, proletarian culture, as he has admirably put it, is not given *ready made,* it does not spring from the brain of some specialists in proletarian culture. It would be pure stupidity to think so. "Proletarian culture must appear as the natural result

tively. First, symbolism with Lautréamont, Rimbaud, corresponding to the Franco-Prussian War; pre-Dadaism (Roussel, Duchamp, Cravan) and Dadaism (Vaché, Tzara) corresponding to that of 1914.

of knowledge won by humanity under the capitalist yoke and under the feudal yoke."

To return to "Red Front" and to the artificial opposition in which one might try to put it with the milieu from which it has come, I must declare that it does not blaze a new trail for poetry and that it would be futile to propose it to today's poets as an example to follow, for the excellent reason that in such a realm, an objective point of *departure* can only be an objective point of *arrival,* and that, in this poem, the *return to the external subject* and especially to the *emotional subject* is in disagreement with the entire historical lesson that we may learn today from the most highly developed poetic forms. In these forms, a century ago (Cf. Hegel), the subject could already be described only as indifferent, and it has even ceased, since then, to be able to be posited *a priori.* Hence I must, considering the poem as a whole, its continual reference to particular accidents, to the circumstances of public life, recalling finally that it was written during Aragon's stay in the USSR, regard it not as an acceptable solution to the poetic problem as it is presented in our day, but as an exercise apart, as captivating as one could wish, but without future because poetically regressive, in other words, as a *poem of circumstance.* Having worked the matter through, we find ourselves at the same point we were at in our own researches before doing so.

If we have just lost thereby the occasion we might have supposed that Aragon, in writing "Red Front," had given us to participate lastingly, by poems, in revolutionary action, if we have not succeeded in admitting that for the goal of poetry and of art—which has been, since the beginning of time "while soaring above the real, to render it, even externally, in conformity with the inner truth that constitutes its substance"—another goal could be substituted, which was, for example, one of instruction or revolutionary propaganda (art no longer being used, then, save as a means), we need not maintain that we are therefore the last adherents of "art for art's sake" in the pejorative sense in which this conception deters those who abide by it from action with a view to anything but the production of the beautiful. We have never ceased to attack such a conception and to demand that the writer, the artist participate actively in the social struggle. . . .

ANDRÉ BRETON

THE POET'S FUNCTION

T H E P O E T of the future will surmount the depressing notion of the irreparable divorce of action and dream. He will hold the magnificent fruit of the tree whose roots are intertwined and will be able to persuade those who taste it that there is nothing bitter about it. Borne by the current of his time, he will assume for the first time without distress the responsibility for the reception and transmission of signals which press upon him from the depth of souls. He will maintain at any price in each other's presence the two terms of the human relation, by whose destruction the most precious conquests would instantaneously become null and void: the objective awareness of realities, and their internal development in what, by virtue of a sentiment individual on one hand, universal on the other, is magical about it until proved otherwise. This relation can pass for magical in that it consists of an unconscious, immediate action of the internal on the external, so that there readily slips into the summary analysis of such a notion the idea of a transcendent mediation which would be moreover, that of a demon more than of a god. The poet will oppose this simplistic interpretation of the phenomenon in question: in the immemorial prosecution of intuitive knowledge by rational knowledge, it will be the poet's responsibility to produce the capital evidence that will put an end to the dispute. The poetic operation, henceforth, will be conducted in broad daylight. We shall renounce picking quarrels with certain men who will tend to become all men, renounce manipulations long suspect to others, long equivocal in themselves, in which we have indulged in order to keep eternity in the moment, to dissolve the general in the particular. We shall no longer cry miracle! each time that, by

the more or less involuntarily compounded mixture of these two colorless substances which are existence subject to the objective connection of beings and existence concretely escaping this connection, we manage to achieve a precipitate of a lovely, lasting color. We shall already be outside, mingling with the others in the light of day, and will not have to look with an expression of greater complicity and intimacy than theirs on the truth when it shakes its hair streaming with light at the dark window.

ANDRÉ BRETON
Les Vases Communicants (1932)

MONSIEUR AA,
ANTIPHILOSOPHER

CAPTAIN!
the rockets, the open forces of the waterfall threaten us; the serpents' knot, the whip of chains advances triumphantly in the countries contaminated with perpetual fury;
Captain!
all the accusations of the mistreated animals, engraved over the bed, yawn in rosettes of blood, the rain of stone teeth and the patches of excrement in the cages bury us in cloaks as endless as the snow;
Captain!
the brilliance of the coal becoming seal, lightning, bug before your eyes, the squadrons of madmen, the wheel monsters, the cries of the mechanical somnambulists, the liquid stomachs on silver tablets, the cruelties of the carnivorous flowers will invade the simple rural day, and the cinema of your sleep;
Captain
watch out for blue eyes.

TRISTAN TZARA
L'Antitête. (1933)

1935

SALVADOR DALI'S
CONCRETE IRRATIONALITY
BY PARANOIA-CRITICISM

W E K N O W that the sensational and brilliant progress of the exact sciences, glory and honor of the "space" and the period in which we live, involves on one hand the crisis and the overwhelming disgrace of "logical intuition," and on the other the consideration of irrational factors and hierarchy as new, positive and specifically productive values.

. . . For in effect the irrational famine of our contemporaries finds itself at a cultural banquet table, on which are set on the one hand only the cold and insubstantial remains of art and literature, and on the other the scorching analytical specifications of the exact sciences, inaccessible, for the moment, to a nutritive synthesis on account of their excessive extension and specialization, and in any case totally unassimilable, outside of speculative cannibalisms.

Whence appears the colossal nutritive and cultural responsibility of surrealism, a responsibility which becomes increasingly objective, invading and exclusivist at each new cataclysm of the collective famines, at each new gluttonous, gluey, ignominious and sublime crunch of the masses' terrible jaw in the swollen, bloody and *par excellence* biological cutlet which is that of politics.

. . . For we surrealists . . . are not precisely artists, nor are we precisely true men of science; we are caviar, and caviar, believe me, is the extravagance and the intelligence of taste itself . . . For if caviar is the sturgeon's vital experiment, it is also that of the

surrealists, for like the sturgeon, we are carnivorous fish who . . . swim between two levels of water, the cold water of art, the hot water of science, and it is precisely in this temperature, and swimming against the current, that the experiment of our life and of our fertilization achieves that troubled depth, that irrational and moral hyperlucidity which can only be produced in this climate of Neronian osmosis . . .

. . . How do you expect them to understand [my paintings] when I myself who am after all the man who has made them do not understand them either. The fact that I myself, at the moment I paint, do not understand the meaning of my paintings does not mean that these paintings have no meaning; on the contrary, their meaning is so profound, complex, coherent, involuntary, that it escapes the simple analysis of logical intuition . . . All my ambition, on the plastic level, consists in materializing, with the most imperialistic fury for precision, the images of concrete irrationality.

. . . If the Greeks . . . materialized their psychology and their Euclidean sentiments in the nostalgic and divine muscular clarity of their sculptors, Salvador Dali, in 1935, with regard to this agonizing question which is that of Einsteinian space-time, is not content to produce anthropomorphism, nor libidinous arithmetic, nor, I repeat, to create flesh; he creates cheese, for you may be sure that the famous soft watches of S.D. are nothing but paranoia-critical camembert, tender, extravagant, solitary in time and space.

SALVADOR DALI
La Conquête de l'irrationel (1935)

1936

HELLO

MY PLANE in flames my castle flooded with Rhinewine
My black iris ghetto my crystal ear
My rock sliding down the cliff to crush the gamekeeper
my opal snail my air mosquito
my bird-of-paradise eiderdown my black foam hair
my exploded grave my rain of red grasshoppers
my flying island my turquoise grape
my collision of wise and foolish autos my wild flower bed
my tulip bulb in the brain
my gazelle lost in a midtown movie house
my sun-nut my volcano fruit
my hidden pond laugh where the absentminded prophets go to
 drown
my flood of black-currant my mushroom butterfly
my blue waterfall like a lead blade that makes the spring
my coral revolver whose mouth attracts me like the eye of a shiny
 well
frozen like the mirror where you watch the flight of the birdflies
 of your stare
lost in an exhibition of white framed in mummies
I love you

<div align="right">

BENJAMIN PÉRET
Je sublime (1936)

</div>

HEAD AGAINST
THE WALLS

THERE were only a few of them
In all the earth
Each one thought he was alone
They sang, they were right
To sing
But they sang the way you sack a city
The way you kill yourself.

Frayed moist night
Shall we endure you
Longer
Shall we not shake
Your cloacal evidence
We shall not wait for a morning
Made to measure
We wanted to see in other people's eyes
Their nights of love exhausted
They dream only of dying
Their lovely flesh forgotten
Bees caught in their honey
They are ignorant of life
And we suffer everywhere
Red roofs dissolve under the tongue
Dog days in the full beds
Come, empty your sacks of fresh blood
There is still a shadow here

A shred of imbecile there
In the wind their masks, their cast-offs
In lead their traps, their chains
And their prudent blind-men's gestures
There is fire under rocks
If you put out the fire
Be careful we have
Despite the night it breeds
More strength than the belly
Of your wives and sisters
And we will reproduce
Without them but by ax strokes
In your prisons

Torrents of stone labors of foam
Where eyes float without rancor
Just eyes without hope
That know you
And that you should have put out
Rather than ignore

With a safety pin quicker than your gibbets
We shall take our booty where we want it to be

PAUL ÉLUARD
Les Yeux fertiles (1936)

BEAUTY WILL BE
CONVULSIVE OR WILL
NOT BE AT ALL[1]

THE WORD "convulsive" which I have used to qualify the
beauty which alone, as I see it, must be served, would lose in
my eyes all meaning if conceived in movement and not in the exact
expiration of that very movement. There cannot, I say, be beauty
—convulsive beauty—except at the cost of the affirmation of the
reciprocal relation which links the object considered in its move-
ment and in its repose. I regret not having been able to furnish, as
a complement to the illustration of this text, the photograph of a
powerful locomotive which had been abandoned for years to the
madness of the virgin forest. Aside from the fact that the desire
to see such a thing has long been accompanied for me by a
special exaltation, it seems to me that the surely magical aspect of
this monument to victory and to disaster, better than any other
would have been of a nature to stabilize ideas . . . Shifting from
force to fragility, I see myself again back in a grotto of the Vau-
cluse, contemplating a little calcareous construction resting on the
dark ground and perfectly imitating the shape of an egg in an
eggcup. Drops falling from the cave ceiling regularly splattered
against its smooth and blindingly white upper surface. In this
glow seemed to me to reside the apotheosis of the adorable *Prince
Rupert Drops*. It was almost distressing to watch the continuous
formation of such a marvel. In another cave, the Fairies' Grotto
near Montpellier, where you walk between walls of quartz, your
heart skips a beat at the spectacle of this gigantic mineral cloak,

[1] [—The last line of *Nadja*.]

known as an "imperial mantle," whose drapery defies statuary forever and which the floodlights cover with roses, as though in order that it may have nothing to envy, even in this regard, in the nonetheless splendid and convulsive cloak made of the infinite repetition of the single tiny red feather of a rare bird, worn by the ancient Hawaiian chiefs.

But it is quite independently of these accidental figurations that I am led to write the praise of crystal here. No higher artistic lesson seems to me possible than that of crystal. The work of art, by the same token, moreover, as any fragment of human life considered in its gravest meaning, seems to me without value if it does not afford the hardness, the rigidity, the regularity, the luster, on all its outer and inner surfaces, of crystal. Let it be understood that this affirmation stands in opposition, for me, in the most categorical, most constant way, to everything that attempts, esthetically as morally, to base formal beauty on a labor of voluntary improvement to which it would be a man's choice to commit himself. On the contrary, I am continually led to the apology for creation, for spontaneous action, and this to the very degree that crystal, by definition not ameliorable, is its perfect expression. The house I live in, my life, what I write: it is my dream that these should appear from a distance the way cubes of rock salt appear close to . . .

. . . To these two first conditions which convulsive beauty must satisfy in the profound sense of the term, I judge it necessary and sufficient to adjoin a third which fills all gaps. Such beauty can only appear from a poignant sentiment of the thing revealed, from the integral certainty afforded by the eruption of a solution which, by reason of its very nature, could not reach us by ordinary logical means. It is a question, in such a case, then, of a solution rigorously adapted, of course, and yet superior to mere need. The image, as it is produced in automatic writing, has always constituted a perfect example of this for me . . .

. . . Convulsive beauty will be erotic-veiled, explosive-fixed, magic-circumstantial or will not be at all.

ANDRÉ BRETON
L'amour fou (1937)

L'AMOUR FOU,
L'AMOUR UNIQUE

1

There is no sophistry more dreadful than the one that consists in presenting the performance of the sexual act as being necessarily accompanied by a decline in erotic potential between two beings, a decline whose return would gradually involve them in no longer satisfying each other. Thus love would be exposed to dilapidation to the very degree that it pursues its own realization. A shadow would fall over life in layers of a thickness proportional to each new explosion of light. Existence, here, would be obliged to lose its elective character gradually, to assume another, it would be led against its will to essence. It would one day be snuffed out, victim of its own radiance. The great nuptial flight would provoke the more or less slow combustion of one being in the eyes of the other, a combustion at the end of which, other creatures acquiring for each of them mystery and charm, having returned to earth, they would be free to make a new choice. Nothing more insensitive, more horrifying than this conception. I know of none more widespread and thereby more likely to give a notion of the pathetic state of the world today. Thus Juliet, continuing to live, would not be always *more* Juliet to Romeo! It is easy to disentangle the two fundamental errors which govern such a way of seeing the matter: one of social, the other of moral cause. The social error, which can be remedied only by the destruction of the very economic basis of present-day society, derives from the fact that the initial choice in love is not per-

mitted, *really* permitted except to the very degree that it tends exceptionally to prevail in an atmosphere of nonchoice extremely hostile to its victory. The sordid considerations set against it, the secret war waged upon it, still more the violently antagonistic representations always ready to assail it which abound around it, are, we must confess, too often of a nature to confound it. But this love, *bearer of the greatest hopes which have been expressed in art for centuries,* will not be kept from triumphing in the new conditions of life. The moral error which, concurrently with the preceding one, leads to representing love, in duration, as a declining phenomenon resides in the incapacity of the majority of men to free themselves, in love, from any prèoccupation alien to love, from any fear as from any doubt, to expose themselves without defence to the lightninglike gaze of the god. Artistic as well as scientific experience is here of great assistance, showing that everything which is constructed and remains has first required this abandon in order to *be.* We can apply ourselves to nothing better than causing love to lose that bitter aftertaste which poetry, for example, does not have. Such an enterprise can only be entirely successful when we have done away with the infamous Christian notion of sin. There has never been a forbidden fruit. Only temptation is divine. To feel the need to vary the object of this temptation, to replace it by others, is to testify that one is ready to forfeit, that one has doubtless already forfeited *innocence.* Innocence in the sense of absolute nonguilt. If the choice has truly been free, this cannot be contested under any pretext by the culprit. The guilt starts there and not elsewhere. I here reject the excuse of habit, of lassitude. Reciprocal love, as I envisage it, is an arrangement of mirrors which reflects back to me, by the thousand angles which the unknown can take for me, the faithful image of the one I love, always more surprising by divination of my own desire and more brilliantly gilded with life.

2

The perfect adequacy which tends to be that of love between two beings no longer meets with any obstacle at this moment.

The sociologist should perhaps beware, who, under European skies, confines himself to casting a misty glance from the smoky and roaring mouth of the factories to the dreadful restive peace of the fields. It has not stopped occurring there, perhaps it is more timely than ever to recall that this adequacy is one of the goals of human activity; that economic and psychological speculation, however hostile to each other they appear in our times, coincide in focusing upon it. Engels, in *The Origin of the Family*, does not hesitate to make *individual sexual love*, born of this *higher form of sexual relations which is monogamy, the grestest moral progress* accomplished by man in modern times. Whatever inflections one attempts today to give to Marxist thought on this point, as on so many others, it is undeniable that the authors of the *Communist Manifesto* unceasingly opposed the hopes of a return to "disorderly" sexual relations which marked the dawn of human history. Once private property is abolished, "it can be affirmed with reason," Engels declares, "that *far from disappearing, monogamy will be rather for the first time achieved.*" In the same work, he insists several times over on the *exclusive* character of this love which, at the cost of what deviations—I know both miserable and grandiose ones—has finally *found* itself. This view of what is doubtless most enthralling in the consideration of the human condition and future can only be corroborated more clearly by that of Freud, for whom sexual love, even as it is already given, *breaks the collective links created by the race, transcends national differences and social hierarchies, and thereby contributes to a great measure to the progress of culture.* These two conceptions, which assign the less and less frivolous conception of love as the principal fundamental to moral as well as cultural progress, seem to me in themselves of a nature to constitute the finest part of poetic activity as a tested means of focusing the perceptible and moving world on a single being as well as a permanent force of anticipation.

ANDRÉ BRETON
L'amour fou (1937)

BIBLIOGRAPHIES

BIOGRAPHICAL NOTES

INDEX

PRINCIPAL WORKS IN
WHICH THE SURREALIST
SPIRIT HAS BEEN
MANIFESTED: AN
UNSYSTEMATIC
BIBLIOGRAPHY

Alexandre, Maxime: *Les desseins de la liberté* (1927); *Le corsage* (Éditions surréalistes, 1931); *Mes respects* (1931); *Secrets* (1932); *Mythologie personnelle* (Cahiers libres, 1933).

Aragon, Louis: *Feu de joie* (Au sans pareil, 1920); *Anicet ou le panorama* (Nouvelle Revue Française, 1921); *Les aventures de Télémaque (Ibid.,* 1923); *Les plaisirs de la capitale* (Berlin, n.d.); *Le libertinage* (N.R.F., 1924); *Une vague des rêves* (Privately printed, n.d.); *Le mouvement perpétuel* (N.R.F., 1925); *La peinture au défi (Ibid.,* 1926); *Traité du style (Ibid.,* 1928); *La Grande gaieté (Ibid.,* 1929); *Persécuté persécuteur* (Éditions surréalistes, 1930).

Artaud, Antonin: *L'ombilic des limbes* (Nouvelle Revue Française, 1924); *L'opium pendu (Ibid.,* 1925); Le pèse-nerfs (Les Cahiers libres, 1927); *Correspondance avec Jacques Rivière* (N.R.F. 1927); *Héliogabale ou l'anarchiste couronné* (Denoël, 1934); *Le moine de Lewis (Ibid.,* 1935); *Le théâtre et son double* (N.R.F. 1938); *Au pays de Tarahumanus* (Fontaine, 1945); *Le théâtre de Séraphin* (Denoël, n.d.); *Lettres de Rodez* (G.L.M., 1946); *Pour en finir avec le jugement de Dieu* (Éditions K., 1948); *Oeuvres complètes* (Vol. I., N.R.F., 1956).

Baron, Jacques: *L'allure poétique* (N.R.F., 1925).

Bellmer, Hans: *La poupée* (G.L.M., 1936); *Œillades ciselées en branche* with Georges Huget (J. Bucher, 1939); *3 tableaux, 7 dessins,*

1 *texte* (Revel, 1944); *Les jeux de la poupée* with Paul Éluard
(Vrille, 1946); *Anatomie de l'inconscient (Ibid.*, 1950).

Breton, André: *Mont de piété* (Au sans pareil, 1919); *Les champs
magnétiques* with Philippe Soupault (*Ibid.*, 1921); *Clair de terre*
(Littérature, 1923); *Les pas perdus* (Nouvelle Revue Française,
1924); *Manifeste du surréalisme* (Kra., 1924); *Légitime défense*
(Éditions surréalistes, 1926); *Introduction au discours sur le peu de
réalité* (N.R.F., 1927); *Le surréalisme et la peinture (Ibid.*, 1928);
Nadja (Ibid., 1928); *Ralentir travaux* with Paul Éluard and René
Char (Éditions surréalistes, 1930); *Second manifeste du surréalisme*
(Kra., 1930); *L'immaculée conception* with Paul Éluard (Éditions
surréalistes, 1931); *L'union libre (Ibid.*, 1931); *Misère de la poésie*
(*Ibid.*, 1932); *Le revolver à cheveux blancs* (Cahiers libres, 1932);
Les vases communicants (Ibid., 1932); *Qu'est-ce que le surréalisme?*
(R. Henriquez, 1934); *Point du jour* (N.R.F., 1934); *L'air de l'eau*
(Cahiers d'art, 1934); *Position politique du surréalisme* (Sagittaire,
1935); *Au lavoir noir* (G.L.M., 1936); *Notes sur la poésie* with
Paul Éluard (*Ibid.*, 1936); *De l'humour noir (Ibid.*, 1937); *Le
château étoilé* (Minotaure, 1937); *L'amour fou* (N.R.F., 1937);
Trajectoire du rêve (G.L.M., 1938); *Dictionnaire abrégé du sur-
réalisme* with Paul Éluard (*Ibid.*, 1938); *Anthologie de l'humour
noir* (Sagittaire, 1940); *Fata Morgana* (Lettres Françaises, 1942);
Pleine marge (Nierendorf, 1943); *Arcane 17* (Brentano's, 1945);
Situation du surréalisme entre les deux guerres (Fontaine, 1945);
"Young Cherry Trees Secured Against Hares" (View, 1946); *Le
surréalisme et la peinture* (Brentano's, 1946, rev. ed.) *Yves Tanguy*
(P. Matisse, 1947); *Les manifestes du surrealisme* (Sagittaire, 1946,
rev. ed.); *Arcane 17* (Ibid., 1947, rev. ed.); *Ode à Charles Fourier*
(Fontaine, 1947); *Martinique, charmeuse de serpents* with André
Masson (Sagittaire, 1948). *La lampe dans l'horloge* (R. Marin,
1948); *Poèmes* (N.R.F., 1948); *Flagrant délit* (Thésée, 1949);
Anthologie de l'humour noir (Sagittaire, 1950, rev. ed.); *La clé des
champs (Ibid.*, 1953); *Entretiens* (N.R.F., 1953); *L'art magique*
with Gérard Legrand (Club français du livre, 1957).

Calas, Nicolas: *Foyers d'incendie* (Denoël, 1939).

Césaire, Aimé: *Les armes miraculeuses* (Nouvelle Revue Française,
1946).

Char, René: *Arsenal* (Privately printed, 1929); *Le tombeau des secrets*
(*Ibid.*, 1930); *Ralentir travaux* with André Breton and Paul Éluard
(Éditions surréalistes, 1930); *Artine (Ibid.*, 1930); *Hommage à*

D.-A.-F. de Sade (Privately printed, 1931); *L'action de la justice est éteinte* (Éditions surréalistes, 1931; *Paul Éluard* (Privately printed, 1933); *Le marteau sans maître* (Éditions surréalistes, 1934).

Crevel, René: *Détours* (Nouvelle Revue Française, 1924); *Mon corps et moi* (Kra., 1925); *La mort difficile* (*Ibid.*, 1926); *Babylone* (*Ibid.*, 1927); *L'esprit contre la raison* (Cahiers du Sud, 1928); *Êtes-vous fous?* (N.R.F., 1929); *Paul Klee* (*Ibid.*, 1930); *Salvador Dali ou l'antiobscurantisme* (Éditions surréalistes, 1931); *Le clavecin de Diderot* (*Ibid.*, 1952); *Les pieds dans le plat* (Sagittaire, 1933).

Dali, Salvador: *La Femme visible* (Éditions surréalistes, 1930); *L'amour et la mémoire* (*Ibid.*, 1951); *Babaouo* (Cahiers libres, 1932); *La conquête de l'irrationnel* (Éditions surréalistes, 1935); *Metamorphoses de Narcisse* (Corti, 1936).

Desnos, Robert: *Deuil pour deuil* (Kra., n.d.); *C'est les bottes de sept lieues cette phrase je me vois* (Simon); *La liberté ou l'amour* (Kra., 1927); *The Night of Loveless Nights* (S.L., n.d.); *Corps et biens* (Nouvelle Revue Française, 1930).

Éluard, Paul: *Le devoir et l'inquiétude* (Gonon, 1917); *Poèmes pour la paix* (Privately printed, 1918); *Les animaux et leurs hommes* (Au sans pareil, 1920); *Les necessités de la vie et les conséquences des rêves* (*Ibid.*, 1921); *Répétitions* (*Ibid.*, 1922); *Les malheurs des immortels* with M. Ernst (Six, 1922); *Mourir de ne pas mourir* (Nouvelle Revue Française, 1924); *152 proverbes mis goût de jour* with B. Péret (Éditions surréalistes, 1925); *Capitale de la douleur* (Nouvelle Revue Française, 1926); *Les dessous d'une vie ou la pyramide humaine* (Cahiers du Sud, 1920); *Défense de savoir* (Éditions surréalistes, 1928); *L'amour et la poésie* (N.R.F., 1929); *Ralentir travaux* with A. Breton and R. Char (*Ibid.*, 1930); *A toute épreuve* (*Ibid.*, 1930); *Dons* (Privately printed, 1931); *La vie immédiate* (Cahiers libres, 1932); *Comme deux gouttes d'eau* (Éditions surréalistes, 1933); *La rose publique* (N.R.F., 1934); *Nuits partagées* (G.L.M., 1935); *Les yeux fertiles* (*Ibid.*, 1936); *L'évidence poétique* (*Ibid.*, 1936); *Notes sur la poésie* with A. Breton (*Ibid.*, 1936); *Les mains libres* (J. Bucher, 1937); *Quelques uns des mots aui jusqu'ici étaient mystérieusement interdits* (G.L.M., 1938); *Cours naturel* (Sagittaire, 1938).

Ernst, Max: *La Femme 100 têtes* (Éditions surréalistes, 1929); *Rêve d'une petite fille qui voulut entrer au Carmel* (Carrefour, 1930); *Les Sept péchés capitaux* (J. Bucher); *Histoire naturelle* (J. Bucher).

Gerard, Francis: *Les dragons de vertu* (Kra., 1927).

Hénein, Georges: *Déraisons d'être* (Éditions surréalistes, 1938).

Henry, Maurice: *Les abattoirs du sommeil* (Sagesse, 1937); *Les paupières de verre* (L'âge d'or, 1946).

Hugnet, Georges: *40 poésies de Stanislas Boutemer* (La montagne, 1928); *Le droit de varech* (*Ibid.*, 1930); *Ombres portées* (*Ibid.*, 1932); *Enfrances* (Cahiers d'art, 1933); *La belle en dormant* (Cahiers libres, 1933); *Onan* (Éditions surréalistes, 1934); *Petite anthologie poétique du surréalisme* (J. Bucher, 1934); *La lampe de l'imaginaire* (G.L.M., 1937); *Une écriture visible* (*Ibid.*, 1938); *Œillades ciselées en branches* with H. Bellmer (J. Bucher, 1939).

Jean, Marce: *Mourir pour la patrie* (Cahiers d'art, 1935); *Pêche pour le sommeil jeté* (Sagesse, 1937); *Mnésiques* (Hungaria, 1942); *Maldoror* with A. Mézie (Corréa, 1947); *Genèse de la pensée moderne* with A. Mézie (*Ibid.*, 1948); *L'histoire de la peinture surréaliste*, with A. Mézie (Le Seuil, n.d.).

Leiris, Michel: *Simulacre* (Simon, 1925); *Le point cardinal* (Kra., 1927); *Aurora* (Nouvelle Revue Française, 1946).

Lély, Gilbert: *Arden* (1938); *Je ne veux pas qu'on tue cette femme* (1936); *La Sylphide ou l'étoile carnivore* (1938); *Ma civilisation* (1946).

Limbour, Georges: *L'enfant polaire* (Simon, 1922); *Soleil bas* (*Ibid.*, 1925).

Malet, Léo: *Ne pas voir plus loin que le bout de son sexe* (Éditions surréalistes, 1936); *L'arbre comme cadavre* (Sagesse, 1937); *Hurle à la vie* (1939).

Mayoux, Jehan: *Trainoir* (Corti, 1935); *Maïs* (*Ibid.*, 1937), *Le fil de la vie* (Tchann, 1938); *Ma tête à couper* (G.L.M., 1939).

Naville, Pierre: *Les reines de la main gauche* (Nouvelle Revue Française, 1924); *La révolution et les intellectuels* (*Ibid.*, 1927).

Nougé, Paul: *Correspondance 1924-1925* with C. Goemans and M. Lecomte; *Quelques écrits et quelques dessins de Clarisse Juranville* (1927).

Pastoureau, Henri: *Cri de la Méduse* (J. Bucher, 1937); *Le corps trop grand pour un cerceuil* (Éditions surréalistes, 1936); *La rose n'est pas une rose* (*Ibid.*, 1939).

Péret, Benjamin: *Le passager du transatlantique* (Au sans pareil, 1921); *Au 125 Boulevard Saint-Germain* (Littérature, 1923); *Immortelle maladie* (Littérature, 1924); *152 proverbes mis au goût du jour* with P. Éluard (Éditions surréalistes, 1925); *Il était une boulangère* (Kra., 1925); *Dormir, dormir dans les pierres* (Éditions surréalistes, 1925); *Le grand jeu* (Nouvelle Revue Française, 1928);

Et les seins mouraient (Cahiers du Sud, 1928); *De derrière les fagots* (Éditions surréalistes, 1934); *Je sublime* (*Ibid.*, 1936); *Je ne mange pas de ce pain là* (*Ibid.*, 1936); *Trois cérises et une sardine* (G.L.M., 1937); *La parole est à Péret* (Mexico, 1942); *Le déshonneur des poètes* (1944); *Feu central* (Éditions K., 1947); *Au mexicain* (Le Ferrain vague, 1950); *Anthologie de l'amour sublime* (Albin Michel, 1957); *Le gigot: Sa vie son oeuvre* (Le Terrain vague, 1957).

Picasso, Pablo: *Le désir attrapé par la queue* (Nouvelle Revue Française, 1945).

Prassinos, Gisèle: *Quand le bruit travaille* (G.L.M., 1937); *La sauterelle arthritique* (*Ibid.*, 1935); *Sondue* (*Ibid.*, 1938).

Prevert, Jacques: *Paroles* (Nouvelle Revue Française, 1945); *Histoires* (1948); *Prés au clercs* with André Verdet; *Spectacles* (N.R.F., 1951); *La pluie et le beau temps* (*Ibid.*, 1955).

Queneau, Raymond: *Le chiendent* (Nouvelle Revue Française, 1933); *Les derniers jours* (*Ibid.*, 1935); *Odile* (*Ibid.*, 1937); *Chêne et chien* (Denoël, 1937); *Les enfants du limon* (N.R.F., 1938); *Gueule de pierre* (N.R.F., 1938); *Un rude hiver* (*Ibid.*, 1939); *Les temps mêlés* (*Ibid.*, 1941); *Pierrot mon ami* (*Ibid.*, 1943); *Les Ziaux* (*Ibid.*, 1943); *Foutaises* (Privately printed, 1944); *Loin de Rueil* N.R.F., 1945); *Bucoliques* (*Ibid.*, 1947); *Exercises de style* (*Ibid.*, 1947); *Saint Glinglin* (*Ibid.*, 1948); *Si tu t'imagines* (*Ibid.*, 1950); *Bâtons, chiffres et lettres* (*Ibid.*, 1950); *Petite cosmogonie portative* (*Ibid.*, N.R.F.); *Une trouille verte* (Editions de Minuit, 1947); *L'instant fatal* (N.R.F., 1948); *Le dimanche de la vie* (*Ibid.*, 1951).

Rigaut, Jacques: *Papiers posthumes* (Au sans pareil, 1934).

Rosey, Guy: *La guerre de 34 ans* (Cahiers libres, 1932); *Drapeau nègre* (Éditions surréalistes, 1933); *André Breton* (*Ibid.*, 1934).

Soutenaire, Louis: *Les haches de la vie* (G.L.M., 1937); *Le retard* (Sagesse, 1938); *Les secours de l'oiseau* (Parisot, 1938); *Frappez au miroir* (Wellens, 1939).

Soupault, Philippe: *Le champs magnétiques* with A. Breton (Au sans pareil, 1921); *Chansons des futs et des rois* (1928); *Georgia* (1925); *Poésies complètes* (G.L.M., 1937).

Tzara, Tristan: *La première aventure céleste de M. Antipyrine* (Dada, 1916); *Vingt-cinq poèmes* (*Ibid.*, 1918); *Cinéma calendrier du coeur abstrait maisons* (Au sans pareil, 1920); *7 manifestes dada* (J. Budry, 1920); *Mouchoir de nuages* (Simon, 1925), *Indicateur des chemins du coeur* (J. Bucher, 1928); *Des nos oiseaux* (Kra.,

1929); *L'arbre des voyageurs* (La montagne, 1930); *L'homme approximatif* (Fourcade, 1930); *Où boivent les loups?* (Cahiers libres, 1932); *L'antitête* (*Ibid.*, 1933); *Grains et issues* (Denoël, 1935); *La main passe* (G.L.M., 1935); *Le coeur à gaz* (*Ibid.*, 1938).

Vitrac, Roger: *Les mystères de l'amour* (Nouvelle Revue Française, 1935); *Cruautés de la nuit* (Cahiers du Sud): *Connaissance de la mort,* (N.R.F., 1926); *Georges di Chirico* (*Ibid.*, 1927); *Théâtre,* Vol. I and II (*Ibid.*, 1946-1948).

SURREALIST PERIODICALS, MANIFESTOS, TRACTS, LEAFLETS, CATALOGUES, FILMS, AND CRITICAL WORKS

325

Buddhist schools, to the directors of insane asylums, to the rectors of European universities.

Illustrations: Chirico, Klee, Masson, Man Ray, Sunbeam.

NO. 4—JULY 15, 1925

Editor: André Breton

Cover: Mannequin climbing stairs: "And war on work!"

Contents: Breton, Aragon, Éluard, Morise, Leiris, Soupault, Noll, Malkine, Péret, Desnos, Boiffard.

Illustrations: Chirico, Ernst, Masson, Miro, Picasso, Man Ray, Roy.

NO. 5—OCTOBER 15, 1925

Cover: Montage representing the surrealist publications of the past and including the present number: "The Past."

Contents: Gengenbach, Brasseur, Queneau, Éluard, Sunbeam, Boully, Chirico, Leiris, Desnos, Ristitch, Morise, Baron, Breton, Artaud, Péret, Aragon.

Illustrations: Chirico, Ernst, Masson, Miro, Picasso.

NO. 6—MARCH 1, 1926

Cover: Veiled forms: "France."

Contents: Éluard, Breton, Soupault, Aragon, Péret, Desnos, Leiris, Viot, Baron, Unik, Crevel, Crastre, Masson.

Illustrations: Arp, Braque, Chirico, Ernst, Masson, Picasso, Man Ray.

NO. 7—JUNE 15, 1926

Cover: Crowd looking up: "The last conversions."

Contents: Artaud, Breton, Noll, M. Leiris, Desnos, Soupault, Éluard, Aragon, Arp, Massot, Péret, Crevel, Fourrier, Alexandre.

Illustrations: Arp, Chirico, Malkine, Masson, Picasso, Man Ray, Roy, Sunbeam, Tanguy.

NO. 8—DECEMBER 1, 1926

Cover: Montage representing various objects and persons in a man's head. "What these gentlemen lack is dialectic" (Engels).

Contents: Éluard, Péret, Unik, Puget, Aragon, Morise, Breton, Leiris, Massot, Artaud, Brasseur, Desnos, Ribemont-Dessaignes, Noll, Gengenbach.

Illustrations: Ernst, Malkine, Masson, Miró, Man Ray, Tanguy, Uccello.

NO. 9–10—OCTOBER 1, 1927

Cover: Girl sitting on a desk: "Automatic writing."

Contents: Ernst, Aragon, Naville, Desnos, Forneret, Nougé, Éluard,

Queneau, Baron, Desnos, Unik, Freud, Péret, Breton, Fénelon, Leiris.

Illustrations: Arp, *"Cadavre exquis,"* Chirico, Ernst, Masson, Picasso, Man Ray, Tanguy, Vaché.

NO. 11—MARCH 15, 1928

Cover: Lightning in the landscape: "What kind of hope do you put in love?"

Contents: Second surrealist manifesto (Breton), Tzara, Char, Goemans, Éluard, Thirion, Koppen, Magritte, Aragon, Buñuel, Dali, Fourrier, Crevel, Frois-Wittmann, Sadoul, Picabia, Alexandre, Péret.

Illustrations: Arp, Chirico, Dali, Ernst, Magritte, Miró, Tanguy.

Le Surrealisme au service de la revolution
Editor: André Breton

NO. 1—JULY 1930. NO. 2—OCTOBER 1930

NO. 3–4—DECEMBER 1931

NO. 5–6—MAY 1933

Contents: Breton, Sade, Heine, Char, Sadoul, Éluard, Aragon, Valentin, Duchamp, Crevel, Péret, Frois-Wittmann, Thirion, Alexandre, Dali, Yoyotte, Nougé, Caillois, Savinio, Monnerot, Lély, Bousquet, Giacometti, Henry, Knutson, Lero, S. Monnerot, Moro, Unik, Tzara, Mayoux, Alquié, Freud, Harfaux, Reich, Buñuel, Tanguy, Ernst, Bellon, Arp, Hugnet, Rosey.

Illustrations: Giacometti, Magritte, Ernst, Breton, Éluard, Dali, Valentine Hugo, Tanguy, Duchamp, Ernst, Man Ray.

Minotaure
Editor: E. Tériade; publisher: A. Skira

NO. 1–2—JUNE 1, 1933. NO. 3–4—MAY 1934

NO. 5—MAY 1934. NO. 6—DECEMBER 1934

NO. 7—JUNE 1935. NO. 8—JUNE 1936

NO. 9—OCTOBER 1936. NO. 10—DECEMBER 1937

NO. 11—MAY 1938. NO. 12—OCTOBER 1938

Editorial Committee: Breton, Duchamp, Éluard, Heine, Mabille

Contents (from No. 10). Muller, Breton, Forneret, Kafka, Posada, Péret, Mabille, Lévy, Ubac, Man Ray, Heine, Éluard, Duchamp, G.-H. Lichtenberg, Courthion, Landsberg, Seligmann, K. Muller, Menard, Córcuff, Giono, etc . . .

Illustrations: Arp, Bellmer, Brauner, Brignoni, Cornell, Dali, Delvaux, Dominguez, Duchamp, Espinoza, Ernst, Hugnet, Magritte, Miró, H. Moore, Nash, Paalen, Penrose, Remedios, Seligmann, Styrsky, Tanguy, Masson, Rivera, Chirico, O. Ford, F.-K. de Rivero, Frances, Matta, Ubac, Géricault, Friedrich, A. Bravo.

VVV

Editors: André Breton, Marcel Duchamp, Max Ernst; publisher: David Hare.

NO. 1—OCTOBER 1942

NO. 2–3—MARCH 1943

NO. 4—FEBRUARY 1944

Contents: Breton, Péret, Mesens, Lamantia, Rollin, Césaire, Parker, Mabille, Waldberg, Lebel, Duthuit, Brunius, Hénein, Duits, Carrington, Scabrook, Métraux, Rougemont, Brauner, Kiesler, Cravan, Seligmann, Tanning, Roditi, Arenas, Llona, Abril, Apollinaire, Benedicta, Bosquet, Cacéres, Gomez-Correa, Hare, Rios, Sekula, Abel, Caillois, Calas, Etiemble, Ford, Lévi-Strauss, Levitt, Matter, Penn, Penrose, Ritter, Rosenberg, Styles, Williams.

Illustrations: Bouchard, Brauner, Breton, Carrington, Chagall, Chirico, Dominguez, Duchamp, M. Ernst, J. Ernst, D. Hare, S. Hare, Hérold, Kamrowski, Kiesler, Lam, Lamba, Laughlin, Masson, Matta, Miró, Reis, Less, Sage, Sekula, Seligmann, Tanguy, Tanning, de Diego, Donati, Frances, Gerszo, Maria, Sommer, I. Waldberg, Hopkins, Kircher, Motherwell, Onslow-Ford, Picasso, Calder.

Neon

Editors: Alexandrian, Heisler, V. Hérold, Rodanski, Tarnaud
NO. 1–2–3–4–5—1948

BIBLIOGRAPHIES 329

Contents: Baskine, Demarne, Duits, Jouffroy, Lecomte, Mabille, Saint-Aude, Breton, Bédouin, Cacéres, Gracq, Péret, Pastoureau, Puel, Heine, Schuster.

Illustrations: Matta, Kiesler, Brauner, Hérold, Toyen, Bouvet, Brielle, Donati, Henry, Jean, Styrsky.

Medium
Editor: Jean Schuster

1⁰ SERIES: NOS. 1, 2, 3, 4, 5, 6, 7, 8.
2⁰ SERIES: NO. 1, Illustrations by Hantai—NOVEMBER 1953
NO. 2, Illustrations by Paalen—FEBRUARY 1954
NO. 3, Illustrations by Svanberg—MAY 1954
NO. 4, Illustrations by Lam—JANUARY 1955

Contents: Goldfayn, Legrand, Péret, Breton, Bédouin, Benayoun, Mitrani, Pierre, Schuster, Valorbe, Zimbacca, Dax, Gracq, Paalen, Hantaï, Roger, Seghers, Toyen, Alleau, Vendryes, Estienne, Flamand, Cardan, Arnim, Abellio, Pieyre de Mandiargues, Savinio, Bruno, Mayoux, Markale, Lengyel, Fort, Prinzhorn, Duchamp, Patri, Ionesco, Canseliet, Munch.

Le Surréalisme, même
Editor: André Breton; director: Jean Schuster

No. 1 — 1956
Contents: Breton, Mitrani, Alleau, Bédouin, Saint-Aude, Sénelier, Darien, Mansour, Benayoun, Pieyre de Mandiargues, Cirlot, Goldfayn, Ferré, Palau, Estienne, Janover, Pierre, Patri, Legrand, Schuster.

Illustrations: Carrington, Crépin, Dax, Degottex, Duvillier, Gayoso, Heisler, Krisek, Mesens, Paalen, Ray, Svanberg, Zeid, Zötl, Lapicque, Toyen, Loubchansky.

No. 2 — 1957
Contents: Legrand, Mansour, Lengyel, Gracq, Breton, Pierre, Nanot, Lebel, Péret, Reynal, Carrington, Dax, Benayoun, Brunius, Flamand,

Markale, Mitrani, Pessoa, Bédouin, Schuster, Silbermann, Gance, Kaplan, Estienne, Mayoux, de Massot, Duchamp.

Illustrations: Carrington, Dax, Jaoüen, Ray, Remedios, Sugal, Styrsky, Toyen, Wilson, Degottex, Paalen, Oppenheim.

No. 3 — 1957

Contents: Breton, F. Tristan, Axelos, Bédouin, Legrand, R. Lebel, Paz, Mesens, Chariarse, Joubert, Palou, Mayoux, Mitrani, Péret, Schuster, Mansour.

Illustrations: Bona, Duchamp, Elléouët, J.-J. Lebel, Maréchal, Max, Dax.

PERIODICALS WHICH DEVOTED SPECIAL NUMBERS TO SURREALISM

Le Disque vert (June 1925)
Variétés. Surrealism in 1929 (June 1929)
Les Cahiers du Sud (1929)
This Quarter (1932)
Spektrum (1933)
L'Amour de l'art (March 1934)
Documents. Surrealist intervention (June 1934)
Cahiers d'art. No. 5–6 (1935); No. 1–2. The surrealist object (1936)
Contemporary Poetry and Prose (June 1936)
Arts. Brief dictionary of surrealism (1938)
Cahiers G. L. M. Dream trajectory No. 7 (March 1938)
View. Series 5, No. 1. Marcel Duchamp (1945)
Derrière le miroir. Surrealism (1947)
Les Quatre vents. Surrealist evidence (1947)
La Nef. No. 71–72. Poetic humor. (December 1950)

OTHER PERIODICALS TO WHICH THE SURREALISTS CONTRIBUTED

N. R. F. (from 1920)
Clarté (1925–1927)
L'Humanité (1930)
Paris–Journal (1934)
Cahiers d'Art (from 1934)

Cahiers G. L. M. (1936–1939)
View (1940–1945)
Labyrinthe (1944–1945)
Fontaine (1945)

FOREIGN PERIODICALS

Distances (Brussels)
Dyn (Mexico)
L'Échange Surréaliste (Toyko)
Gaceta de Arte (Madrid)
Infra-Noir (Bucharest)
L'Invention Collective (Brussels)
Konkretion (Copenhagen)
London Bulletin (London)

Mandragora (Santiago)
Nadrealistow (Warsaw)
Nadrealizam Danas i Ovde (Belgrade)
La Part du Sable (Cairo)
Le Salut Public (Brussels)
Surrealism i Norden (Stockholm)
Surrealismus (Prague)

CUBIST, DADAIST, AND PARASURREALIST PERIODICALS

Les Soirées de Paris. Starting with no. 18 (November 15, 1913); editors: Guillaume Apollinaire and Jean Cérusse. No. 26–27 (last): July–August 1914.

Maintenant. Editor: Arthur Cravan. Published irregularly during 1913, 1914, 1915.

Sic. Editor: P. Albert-Birot. No. 1: January 1916; No. 54 (last): December 30, 1919.

Nord-Sud. Editor: Pierre Reverdy. 1917.

391. Editor: Francis Picabia. 1920–21.

Proverbe. Editor: Paul Éluard. 5 issues: No. 1: February 1, 1920.

Cannibale. Editor: Francis Picabia. 2 issues: April 25 and May 25, 1920.

L'Invention et Proverbe. 6. Editor: Paul Éluard. 1 issue: July 1, 1921.

Œsophage. 1921. Editor: E.L.T. Mesens.

Littérature. First series: March 1919 to August 1921; editors: L. Aragon, A. Breton, Ph. Soupault. Second series: March 1922 to June 1924; editor: André Breton.

L'Œuf dur. 1921–22–23. Editor: Gérard Rosenthal.

Correspondance. 1924–1925. Directors: Paul Nougé, C. Goemans.

Le Grand Jeu. 1928. Editors: R. Gilbert-Lecomte, R. Daumal, J. Sima, R. Vailland.

Marie. 1926. Editor. E.L.T. Mesens.

Documents. April 1929–June 1930. Director: Georges Bataille.

Clé. 1939. Director: André Breton.

Acéphale. 1939. Director: Georges Bataille.

Le surréalisme révolutionnaire. 1945–1948. Director. Édouard Jaguer.

La Main à plume. 1942–1945. Director: Noël Arnaud.
La Révolution la nuit. 1946–1947. Director: Yves Bonnefoy.
Les Deux soeurs (Brussels).

SURREALIST FILMS

Francis Picabia and René Clair: *Entr'acte* (1924).
Marcel Duchamp: *Anemic cinema* (1925).
Man Ray: *Emak Bakia* (1926).
 L'étoile de mer (1928).
Antonin Artaud: *La coquille et le clergyman* (1928).
Georges Hugnet: *La perle* (1929).
Luis Buñuel et Salvador Dali: *Un chien andalou* (1929); *L'âge d'or* (1930).
Hans Richter: *Dreams that money can buy* (1944).

SURREALIST MANIFESTOS, PROSPECTUSES, CATALOGUES, AND BROCHURES

Exposition Jean Miró (1925).
Papillons surréalistes (1925).
Communisme et révolution (1925).
Le bureau des recherches surréalistes (1925).
A table (1925).
Protestation (1926).
Exposition Max Ernst (1926).
Leaflet for *Capitale de la douleur* (1926).
Lautréamont envers et contre tout (1927).
Au grand jour (1927).
Exposition Yves Tanguy (1927).
A la grande nuit (1927).
Exposition Arp (1927).
Le feuilleton change d'auteur (1927).
Exposition Chirico (1925).
Avis (1928).
A suivre (1929).
Exposition Émile Savitry (1929).
Exposition Dali (1929).
Troisième manifeste du surréalisme (1930).
Leaflet for *Immaculée conception* (1930).
Leaflet for *Judas* (1930).

L'âge d'or (1931).
Au feu! (1931).
Ne visitez pas l'exposition coloniale (1931).
Premier bilan de l'exposition coloniale (1931).
Paillasse (1932).
Certificat (1932).
L'AEAR (1933).
La mobilisation contre la guerre (1933).
Leaflet for *De derrière les fagots* (1934).
L'angélus de Millet (1934).
La planète sans visa (1934).
Botte rose blanche (1934).
Discours pour la défense de la culture (1935).
Contre-Attaque (1935).
Exposition surréaliste d'objets (1936).
Il n'y a pas de liberté ... (1936).
Neutralité? (1936).
Pour un art révolutionnaire indépendant (1938).
Leaflet for *Clé* (1938).
Editorial in *Clé* (1939).
A bas les lettres de cachet (1939).
Le Jeu de Marseille (1940).
Dieu est-il français? (1945).
La lettre hors commerce (1947).
L'Art brut (1948).
Le cadavre exquis; son exaltation (1947).
Exposition Jindrich Styrsky (1947).
Cause surréaliste (1947).
La cause est entendue (1947).
Rupture inaugurale (1947).
A la niche (1948).
Comme. Baskine's preface to an exhibition of young surrealist painters
 (1948).

CRITICAL WORKS ON SURREALISM

Books

Charles Baudelaire. *L'Art romantique* (Calmann-Lévy, 1885); Re-
 printed as *Variétés critiques* (Crès, 1924)
Pierre de Massot. *De Mallarmé à 391* (Saint-Raphaël, 1922)
André Billy. *Apollinaire vivant* (La Sirène, 1923)

René Lalou. *Histoire de la littérature française contemporaine* (Crès, 1923; Reprinted by P. U. F.

Bernard Fay. *Panorama de la littérature française contemporaine* (Sagittaire, 1926)

Philippe Soupault. *Apollinaire ou les reflets de l'incendie* (Cahiers du Sud, 1927)

E. Bouvier. *Initiation à la littérature d'aujourd'hui* (Renaissance du Livre, 1928)

André Berge. *Esprit de la littérature contemporaine* (Plon, 1929)

Léon Pierre-Quint. *Le comte de Lautréamont et Dieu* (Cahiers du Sud, 1930; reprinted by Sagittaire)

J.-D. Maublanc. *Surréalisme romantique* (La Pipe en écume, 1934)

Claude Cahun. *Les Paris sont ouverts* (Corti, 1934)

Guy Mangeot. *Histoire du Surréalisme* (R. Henriquez, Bruxelles, 1934)

Georges Hugnet. *Petite Anthologie poétique du Surréalisme* (Introduction) (J. Bucher, 1934)

Jean Cassou. *Pour la poésie* (Corréa, 1935)

David Gascoyne. *A short survey of surrealism* (Cobden-Sanderson, London, 1935)

Julien Levy. *Surrealism* (The Black Sun Press, New York, 1936)

Herbert Read. *Surrealism* (Faber and Faber, London, 1936)

Armand Guibert. *Poésie d'abord* (Les Cahiers de Barbarie, Tunis, 1937)

Jean Cazaux. *Surréalisme et Psychologie* (Corti 1938)

Em. Ægerter. *Regards sur le surréalisme* (Imprimerie du Palais, 1939)

Nicolas Calas. *Foyers d'incendies* (Denoël, 1939)

Marcel Raymond. *De Baudelaire au surréalisme* (revised edition, Corti, 1940)

Francis Dumont. *Naissance du romantisme contemporain,* (doctoral thesis, 1940)

Louis Parrot. *Paul Éluard* (Seghers, 1944)

Ivan Larrea. *Le surréalisme entre l'ancien et le nouveau monde* (Mexico, 1944)

Jules Monnerot. *La poésie moderne et le sacré* (N. R. F., 1945)

Claude Roy. *Aragon* (Seghers, 1945).

Jean-Paul Sartre. *Situations II* (N. R. F., 1948)

Claude Mauriac. *André Breton* (Ed. de Flore, 1949)

Julien Gracq. *André Breton* (Corti, 1949)

Michel Carrouges. *André Breton et les données fondamentales du surréalisme* (N. R. F., 1950)

Breton, André. *André Breton, essais et témoignages* (La Baconnière, 1950)

Victor Crastre. *André Breton* (Arcanes, 1952)

Ferdinand Alquié. *La philosophie surréaliste* (Flammarion, 1955)

Ado Kyrou. *Le surréalisme au cinéma* (1955)

ARTICLES IN GENERAL PERIODICALS

Jacques Rivière. *Introduction à la métaphysique du rêve* (*Nouvelle Revue Française*, November, 1909)

Guillaume Apollinaire. *L'Esprit nouveau* (*Mercure de France*, December 1, 1918)

Jacques Rivière. *Reconnaissance à Dada* (*Nouvelle Revue Française*, August 1, 1920)

Benjamin Crémieux. *Sincérité et imagination* (*Nouvelle Revue Française*, November 1, 1924)

P. Drieu la Rochelle. *La véritable erreur des surréalistes* (*Nouvelle Revue Française*, August 1925)

G. Ribemont-Dessaignes. *Histoire de Dada* (*Nouvelle Revue Française*, June–August 1931)

Tristan Tzara. *Le papier collé ou le proverbe en peinture* (Cahiers d'Art, 1931)

R. de Renéville. *Dernier état de la poésie surréaliste* (*Nouvelle Revue Française*, February 1, 1932)

Georges Hugnet. *L'esprit dada dans la peinture* (*Cahiers d'art*): I. Zurich et New-York (1932); II. Berlin (1918–1922) (1932); III. Cologne et Hanovre (1932); IV. Paris (1934).

Jean Cassou. *Le dadaïsme et le surréalisme* (*L'Amour de l'Art*, March 1934).

René Huyghe. *La nouvelle subjectivité* (*ibid.*)

P.-O. Lapie. *L'Insurrection surréaliste* (*Cahiers du Sud*, January 1935)

R. de Renéville. *Les Problèmes actuels de la poétique. Surréalisme* (Encyclopédie française permanente)

François Cuzin. *Situation du surréalisme* (*Confluences*, June 1943)

Léon Pierre-Quint. *Le surréalisme fut-il un échec?* (*Confluences*, June–July 1945)

Pierre Mabille. *Message de l'étranger* (*ibid.*)

Maurice Blanchot. *A propos du surréalisme* (*L'Arche*, August 1945)

BIOGRAPHICAL NOTES

Agrippa de Nettesheim, Heinrich-Cornelius (1486–1534). German. Physician and cabalistic philosopher, author of occultist works.

Alexandre, Maxime (born 1899). French. "The Virgil of Surrealism." Poet, member of the surrealist group from 1923—when he first met Aragon—to 1933.

Allais, Alphonse (1854–1905). French. Author of humorous tales.

Apollinaire, Guillaume (Guillaume de Kostrowitsky; 1880–1918). French, born in Rome, of Polish parentage. Poet, inventor of the word *surréalisme* (*Les Mamelles de Tirésias*).

Aragon, Louis (born 1897). French. Poet and novelist, member of the surrealist group from 1924 to 1932. Subsequently, member of the Communist Party. He has been director of the Maison de la Culture, editor of the newspaper *Ce Soir*, director of the Maison de la pensée française, etc.

Arnim, Achim von (1781–1834). German. Author of tales of fantasy (*Contes bizarres*).

Arp, Hans (born 1887). French. "The eel of the dunes." Poet, painter, and sculptor, founder, with Tzara, of Dada in 1916 in Zurich. Member of the surrealist group from 1930.

Artaud, Antonin (1896–1948). French. "The magic cudgel." Actor, founder with Vitrac and Robert Aron of the Théâtre Alfred Jarry, poet, member of the surrealist group from 1924 to 1927. Confined at Rodez from 1942 to 1947.

Baron, Jacques (born 1905). French. Poet, member of the surrealist group from 1924 to 1930.

Bellmer, Hans (born 1902). German. Poet and painter, constructor of articulated dolls. Member of the surrealist group from 1933.

Berkeley, George (1685–1753). Irish. Bishop and philosopher.

Bertrand, Louis (called Aloysius; 1807–1841). French. Poet, author of *Gaspard de la nuit*.

Blake, William (1757–1827). English. Mystic, poet and painter, precursor of the Romantic Movement.

Borel, Petrus (1809–1859). French. Romantic storyteller (*Madame Putiphar*), translator of Defoe.

Bousquet, Joë (1897–1950). French. Parasurrealist poet and novelist, wounded in 1918 at Vailly during the last German offensive, in which Max Ernst participated.

Brauner, Victor (born 1903). Rumanian. "Pink-white boot." Painter and sculptor, member of the surrealist group from 1932 to 1948.

Braque, Georges (1882–1963). French. Painter, inventor of the *papier-collé* in the cubist period.

Breton, André (born 1896). French. "The glass of water in the storm," Poet, promoter of surrealism.

Brisset, Jean-Pierre. French. "Prince of thinkers." Writer, precursor of surrealism.

Brunius, Jean-Bernard (born 1906). French. Parasurrealist writer and film-maker.

Buñuel, Luis (born 1906), Spanish. Film-maker, member of the surrealist group from 1928 to 1932.

Carrington, Leonore (born 1917). English. Painter and poet, member of the surrealist group from 1938.

Carroll, Lewis (1832–1898). English. Mathematician and poet, author of *Alice in Wonderland*.

Char, René (born 1907). French. Poet, member of the surrealist group from 1930 to 1937.

Chavée, Achille (born 1906). Belgian. Poet, member of the Belgian surrealist group from 1935.

Cheval, Ferdinand (1836–1924). French. Postman, constructor of a fanciful monument at Hauterives in the Drôme department.

Chirico, Giorgio di (born 1888). Italian. Pre-surrealist painter, founder of metaphysical painting, and author of a novel, *Hebdomeros* (1929).

Colinet, Paul (born 1898). Belgian. Poet, member of the Belgian surrealist group from 1935.

Corbière, Tristan (1845–1875). French. Poet, author of *Les amours jaunes*.

Cravan, Arthur (1881–1920). American. Boxer, "deserter of seventeen countries," founded the magazine *Maintenant* in 1912 and became a gymnastics teacher in Mexico, where he disappeared in 1920.

Crevel, René (1900–1935). French. "The most beautiful of the surrealists." Novelist and essayist, member of the surrealist group from 1922 to 1935.

Cros, Charles (1842–1888). French. Inventor and poet.

Dali, Salvador (born 1904). Spanish. "Prince of Catalonian intelli-

gence, colossally rich." Painter and writer, member of the surrealist group from 1929 to 1939.

Delvaux, Paul (born 1897). Belgian. Painter, member of the Belgian surrealist group from 1935.

De Quincey, Thomas (1784–1859). English. Essayist, author of *Murder Considered as One of the Fine Arts* and *Confessions of an English Opium-Eater.*

Desnos, Robert (1900–1945). French. Poet and journalist, member of the surrealist group from 1922 to 1929. Arrested in 1944 by the Gestapo, died the following year in the Terezin camp in Czechoslovakia.

Dominguez, Oscar (1906–1957). Spanish. "The dragon tree of the Canaries." Painter, member of the surrealist group from 1934 to 1940.

Duchamp, Marcel (born 1887). French. "Benevolent technician." Painter, writer, chess-player, founder of Dada in New York in 1913, external member of the surrealist group from 1924.

Duprey, Jean-Pierre (born 1930). French. Poet.

Éluard, Paul (Eugène Grindel; 1895–1952). French. "The stars' nurse." Poet, member of the surrealist group from 1924 to 1938.

Ernst, Max (born 1891). German. "Loplop, the Superior of the Birds." Painter, poet, and theoretician of surrealism from its foundation. Inventor of the collage and the *frottage.*

Ferry, Jean (Jean Lévy; born 1906). French. Poet and commentator on the work of Raymond Roussel.

Feuerbach, Ludwig Andreas (1804–1872). German. Philosopher who, breaking with Hegelianism, exalted the beauty of the physical world. His *Theses* were discussed by Marx.

Fichte, Johann Gottlieb (1762–1814). German. Philosopher, the disciple of Kant and the master of Schelling.

Flamel, Nicholas (1330–1418). French. Alchemist.

Forneret, Xavier (1810–1885). French. "The black man." Romantic poet "discovered" by the surrealists.

Fourier, Charles (1772–1837). French. Socialist philosopher.

Freud, Sigmund (1856–1939). Austrian. Psychiatrist, founder of psychoanalysis.

Gascoyne, David, (born 1916). English. Poet and writer, member of the surrealist group from 1926 to 1939.

Gérard, Francis (Gérard Rosenthal; born 1903). French. Poet, editor of the magazine *L'Œuf dur,* member of the surrealist group from its foundation to 1938, lawyer (anti-fascist trial of 1934).

Giacometti, Alberto (born 1901). Swiss. Sculptor, member of the surrealist group from 1929 to 1936.

Grabbe, Christian-Dietrich (1801–1836). German. Dramatist, author of *Don Juan and Faust*, and *Wit, Satire, Irony, and Hidden Meaning*.

Hénein, Georges (born 1914). Egyptian. Poet, member of the surrealist group from 1936. Editor of the magazine *La Part du Sable*.

Henry, Maurice (born 1907). French. Painter, poet, collaborated on the magazine *Le Grand Jeu*; member of the surrealist group from 1932 to 1950.

Hoddis, Jacob van (1884–1921). Dadaist poet.

Holbach, Paul-Henri, Baron d' (1723–1789). French. Materialist philosopher and atheist.

Hugnet, Georges (born 1906). French. "The warbler's trouser." Poet, member of the surrealist group from 1932 to 1939.

Huysmans, Joris-Karl (1848–1907). French. Writer whose early work—before his conversion to mysticism and Catholicism—derives from symbolist poetry.

Jarry, Alfred (1875–1906). French. "He who fires a revolver." Poet and dramatist, author of *Ubu roi*.

Jean, Marcel (born 1900). French. Painter and writer, member of the surrealist group from 1932 to 1950.

Klee, Paul (1879–1940). Swiss. Parasurrealist painter.

Lacenaire, Pierre-François (1800–1836). French. Poet.

Laclos, Pierre Choderlos de (1741–1803). French. Artillery officer, author of *Les Liaisons dangereuses*.

Lam, Wifredo (born 1902). Cuban. Painter, member of the surrealist group from 1940.

La Mettrie, Julien Offroy de (1709–1751). French. Physician and materialist philosopher.

Lautréamont, (Isidore Ducasse, le comte de; 1846–1870). French. Poet, author of *Les Chants de Maldoror*.

Leiris, Michel (born 1901). French. Writer and poet, member of the surrealist group from 1924 to 1929.

Lély, Gilbert (born 1904). French. "The scabrous lamp." Poet, member of the surrealist group from 1933 to 1945.

Lewis, M. G. (1775–1818). English. Gothic novelist, author of *The Monk*.

Lichtenberg, George-Christoph (1742–1799). German. Author of humorous aphorisms, inventor of the "handleless knife lacking a blade."

Lübeck, Mathias (1903–1944). German. Poet, co-editor with Francis Gérard of the magazine *L'Œuf dur* from 1921 to 1924. Member

of the surrealist group from 1924 to 1930. Shot by the Gestapo.

Lulle, Raimond (1235–1315). Catalonian. "The illuminated." Writer and alchemist, author of the *Ars Magna*.

Magritte, René (born 1898). Belgian. "The cuckoo's egg." Painter and theoretician, founder of the Belgian surrealist group in 1924.

Malet, Léo (born 1909). French. Poet, inventor of the *décollage*, member of the surrealist group from 1931 to 1939.

Masson, André (born 1896). French. "The feather-man." Painter and writer, member of the surrealist group from 1923 to 1948.

Matta (Matta Eschaurren; born 1908). Chilean. Painter, member of the surrealist group from 1938 to 1948.

Maturin, Charles (1782–1824). English. Gothic novelist, author of *Melmoth the Wanderer*.

Mayoux, Jehan (born 1904). French. Poet, member of the surrealist group from 1923.

Messens, E.L.T. (born 1903). Belgian. "The Morse-man." Poet, member of the Belgian surrealist group from 1935.

Miró, Juan (born 1893). Spanish. "The sardine tree." Painter, member of the surrealist group from 1922.

Moore, Henry (born 1898). English. Sculptor, member of the surrealist group from 1935 to 1939.

Naville, Pierre (born 1903). French. Surrealist writer from 1924 to 1929. Has subsequently devoted himself to political action and scientific and philosophical investigations.

Neveux, Georges (born 1900). French. Dramatist, member of the surrealist group from 1924 to 1929.

Nezval, Vitezslaw (born 1897). Czech. Poet and writer, founder of the Czech surrealist group, editor of the magazine *Surrealismus*.

Nougé, Paul (born 1895). Belgian. Writer, member of the Belgian surrealist group from 1927.

Nouveau, Germain (1852–1920). French. Poet, converted to Catholicism in 1905, author of *Valentines*.

Novalis (Friedrich von Hardenberg; 1772–1801). German. Romantic poet, author of the *Hymns to the Night*.

O. Henry (William Sydney Porter; 1862–1910). American. Humorist and short-story writer.

Paalen, Alice. French. "The black bee." Poet, member of the surrealist group from 1935.

Paalen, Wolfgang (born 1905). German. "The beaver of the thirteenth dynasty." Painter, ethnologist, and member of the surrealist group since 1935.

Pastoureau, Henri (born 1912). French. "The reed ear." Poet, member of the surrealist group from 1932 to 1950.

Penrose, Roland (born 1900). English. Painter, member of the surrealist group from 1935 to 1939.

Péret, Benjamin (1899–1958). French. "The Mandarin orange." Poet and surrealist storyteller from the origin of the movement.

Picabia, Francis (1879–1953). French. Parasurrealist painter and poet, founder, with Marcel Duchamp and Man Ray, of Dada in the U.S.A.

Picasso, Pablo (born 1881). Spanish. "The Benin bird." Painter, inventor of cubism, participated objectively in surrealism from 1926 to 1940. Author of surrealist poems (1935–1938).

Poe, Edgar Allan (1809–1849). American. Poet and storyteller.

Prassinos, Gisèle (born 1920). French. "Alice II." Poet, whose surrealist activity extends from 1934 to 1939.

Prévert, Jacques (born 1900). French. "He who gnaws the heart." Poet, whose surrealist activity extends from 1926 to 1929.

Queneau, Raymond (born 1903). French. Poet and novelist, member of the surrealist group from 1926 to 1929.

Rabbe, Alphonse (1786–1829). French. Historian, journalist and moralist, author of L'Album d'un pessimiste.

Radcliffe, Ann (1762–1823). English. "The infatuated specter." "Gothic" novelist, author of The Mysteries of Udolpho.

Ray, Man (born 1890). American. "He paints to be loved." Photographer, inventor of solarization and Dadaist and surrealist painter; member of the group from its origin.

Read, Herbert (born 1893). English. Art critic, writer, and poet, promoter of the surrealist movement in England.

Reverdy, Pierre (born 1899). French. Parasurrealist poet.

Richter, Hans (born 1888). Swiss. Dadaist and surrealist film-maker.

Richter, Jean-Paul Friedrich (1763–1825). German. "Jean Paul." Romantic and humorous poet and novelist, author of Hesperus.

Rigaut, Jacques (1899–1929). French. Surrealist writer who in 1919 condemned himself to death, the sentence to be carried out in ten years, which occurred.

Rivera, Diego (1886–1957). Mexican. Parasurrealist painter from 1935 to 1939.

Roussel, Raymond (1877–1933). French. Writer and chess-player, author of Impressions d'Afrique.

Roy, Pierre (1880–1950). French. Parasurrealist painter.

Sade, Donatien-Alphonse-François, Comte de (called Marquis de;

1740–1814). French. "The divine Marquis." Novelist and philosopher, author of *The 120 Days of Sodom.*

Savinio, Alberto (1891–1952). Italian. Parasurrealist storyteller, brother of Giorgi di Chirico.

Scève, Maurice (1510–1564). French. Poet, author of *Délie, objet de plus haute vertu.*

Scutenaire, Louis (born 1905). Belgian. Poet, member of the Belgian surrealist group from 1935.

Seligmann, Kurt (1900–1962). Swiss. "The sheaf of wings." Painter and occultist, member of the surrealist group from 1934 to 1944.

Smith, Hélène (1861–1929). Swiss. Celebrated medium, painter, and inventor of languages.

Soupault, Philippe (born 1897). French. Poet and journalist, member of the surrealist group from 1924 to 1927.

Swift, Jonathan (1665–1745). English. Satirist and poet, author of *Gulliver's Travels.*

Synge, John Millington (1871–1909). Irish. Poet and dramatist, author of *The Playboy of the Western World.*

Tanguy, Yves (1900–1953). French. "Guide to the mistletoe Druids." Surrealist painter from the origin of the movement.

Trotsky, Leiba Bronstein (Lev Davidovitch; 1879–1940). Russian. Revolutionary, founder of the Red Army, exiled by Stalin in 1929, founder of the Fourth International, murdered in Mexico.

Tzara, Tristan (1896–1964). Rumanian. Poet, founder of Dadaism in Zürich in 1916, member of the surrealist group from 1930 to 1934.

Vaché, Jacques (1896–1919). French. "Umorist." Parasurrealist poet, a meeting with whom determined André Breton's vocation; Vaché made his life (until his suicide) a monument to humor.

Vanel, Hélène. French. "The rainbow of the mists." Surrealist dancer (1937–1938).

Villiers de L'Isle-Adam, August, Comte de (1840–1889). French. Symbolist storyteller and novelist.

Vitrac, Roger (1899–1959). French. Poet and dramatist, member of the surrealist group from 1924 to 1929, founder with Artaud and Robert Aron of the Théâtre Alfred Jarry.

Young, Edward (1681–1765). English. Poet, author of *Night Thoughts,* precursor of the Romantic Movement.

INDEX